THROUGH ANOTHER LENS

THROUGH ANOTHER LENS

My Years with Edward Weston

CHARIS WILSON and Wendy Madar

NORTH POINT PRESS / FARRAR, STRAUS AND GIROUX / NEW YORK

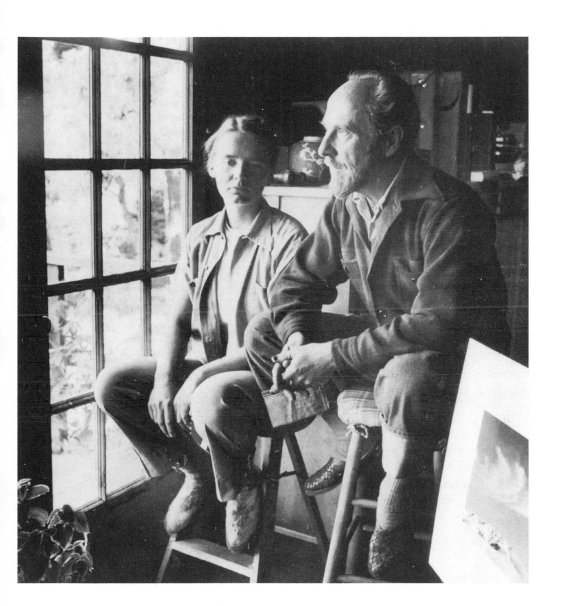

North Point Press
A division of Farrar, Straus and Giroux
19 Union Square West, New York 10003

Distributed in Canada by Douglas & McIntyre Ltd.
Printed in the United States of America
Designed by Jonathan D. Lippincott
First edition, 1998

Library of Congress Cataloging-in-Publication Data
Wilson, Charis, 1914-
 Through another lens : my years with Edward Weston / Charis Wilson and Wendy Madar.
 — 1st ed.
 p. cm.
 Includes index.
 ISBN: 0-86547-521-0 (alk. paper)
 1. Weston, Edward, 1886-1958. 2. Wilson, Charis, 1914- . 3. Photographers—United
States—Biography. 4. Photographers' spouses—United States—Biography. I. Madar, Wendy.
II. Title.
 TR140.W45W55 1998
770'.92—dc21
[B] 97-18119

Art credits:
Photographs 1–8, 10, 15–17, 19, 28, 42–43, 47–48, 53, 57, 60–62, 64, 77, courtesy of the
author; 14, 18, 21–27, 29, 31, 33, 35–36, 38–41, 44, 50–52, 59, 63, 67–73, 84–86 © The
Lane Collection, courtesy of the Museum of Fine Arts, Boston; 11–13, 20, 30, 34, 74–75, 82–
83 © 1981 Center for Creative Photography, Arizona Board of Regents; 45, 49, 55, 58, 78–81,
Collection Center for Creative Photography, courtesy of the Holgers family; 9, 54, 56, courtesy
of Seema Weatherwax; 65–66, courtesy of Elizabeth Lyle Starr Joseph; 32, courtesy of Jason
Weston; 37 © 1998 by the Trustees of the Ansel Adams Publishing Rights Trust. All rights
reserved

Grateful acknowledgment is made for permission to reprint the following material:
Quotes from *The Daybooks of Edward Weston* by permission of the Center for Creative Photog-
raphy, Arizona Board of Regents, © 1981; the correspondence of Edward Weston and George
Macy by permission of Sid Shiff, Publisher, Limited Editions Club, and Thomas F. Staley, Di-
rector, Harry Ransom Humanities Research Center, University of Texas; letters from Merle Ar-
mitage to Edward Weston and George Macy by permission of Chama Armitage Rogate; "Letter
to Rachel, Negative, The Art of Seeing," from *Signatures* by Joseph Stroud, BOA Editions Ltd.,
by permission of the author; letters from Beaumont and Nancy Newhall by permission of the
Beaumont and Nancy Newhall Estate, courtesy of Scheinbaum & Russeck, Ltd., Santa Fe, New
Mexico; letters from Ansel Adams by permission of the Trustees of the Ansel Adams Publishing
Rights Trust

For my daughters -
Anita Kathryn Harris -
who never completed her story
and
Rachel Fern Harris -
who graces the world with hers

and for Wendy Lee Madar -
who allowed me to finish my own

with special thanks to
Peter J. Copek, Director
The Center for the Humanities
Oregon State University

CONTENTS

PREFACE I

After an absence of more than half a century I stand once more on the rim of Death Valley at the spot called Dante's View. Edward and I always thought the name unfortunate, because this is not a view of hell—or purgatory, or heaven—though there may be traces of all three. This is a view of space and time, of the bare bones of the earth seen fifty miles distant, of a valley floor a mile below where a dry lake has left a salt pan that shines white—so white that it made Edward shake his head in disbelief and leap for his camera. This strip-tease of nature seems to promise an explanation for everything, if I can read the open book. It excites me as much now as it did then.

I stand here with the double vision of one trying to fit what lies before her with the image that has been held in her head for over fifty years. Surprisingly, the place seems not to have changed at all, and yet I realize that the scene that has stayed in memory so long is the photographic image that I know so well. Here, as everywhere we traveled, when Edward made a picture it became the "real" thing to me, because the intensity of the experience merged with the intensity of the image. When Edward first photographed Dante's View, his excitement was so great he could hardly concentrate on the routine of reading light, setting exposure, or adjusting lens shade, and the prints he made still glow with the splendor of a place like no other on earth.

Unlike a photograph, a life is not immutable once the person who lived it has died. The life is remade by those who remain, the friends with immediate knowledge, and those who try to reconstruct a human being from evidence they have at hand. Much has been written about Edward since his death in 1958, including *Edward Weston: Fifty Years*, a biography by Ben Maddow published by Aperture in 1973. The shock I suffered on reading the book was only the first; more shocks followed as, in article after article, I watched the man I loved being transformed into someone I could never have loved. This flesh-and-blood man was becoming a cliché-ridden myth created by people who had never known him.

Edward Weston and I were together for eleven years in a marriage and partnership that brought each of us abiding pleasure and many solid accomplishments before its painful end. After we divorced, I married again and raised two daughters and a stepson, but Edward remained a powerful presence for me. He had left such a stamp on my character and way of seeing the world that he never seemed far away. While friends and family members knew that history, it made little difference in my daily activities as a mother, PTA member, Unitarian, and political activist. This might have continued forever were it not for the painful jolt I received on reading Maddow's biography and the swelling tide of articles and books that followed.

It's difficult to put together the pieces missing from someone else's portrait of an intimate figure in one's own life, but this much at least was clear in Maddow's case: he makes Edward out to be something of a fanatic—humorless and egotistic. The truth is that Edward loved jokes, spoofs, and general rigmarole, and cared nothing for conventional notions of dignity.

Another critic wrote: "Above all it is the quality of Weston's unshakable anxiety that gives the photographs of his last ten working years their contemporary feel." Anxiety? Edward enjoyed life too much to be anxious.

Reading about myself in the biography was equally strange; to my surprise, I discovered that I was a "type."

"Charis was a new sort of a person," wrote Maddow, "common in Europe at the time, but just beginning to flourish in America: well-to-do, well-educated, quick, frank, aristocratic, but coarse and open about sex and the less interesting functions."

Most who wrote about Edward gave too narrow an interpretation of both the man and his work. It's not unusual for an artist to suffer this posthumous distortion; too often the reputation becomes identified with one part of the work rather than with the whole. In Edward's case, this might be close-ups of vegetables or shells, nudes, or Point Lobos rocks and cypress. His character suffered the same sort of narrow reading, largely because most personal information about him is drawn from only two sources: the daily journals that came to be known as his *Daybooks* and descriptions written by people who knew him in later years when Parkinson's disease had begun to take its toll.

Because Edward's *Daybooks* cover his formative years as an artist when his writing style was often fevered and overblown, it is easy to find quotations to confirm the view that he was dogmatic, fierce, uncompromising, licentious, obsessed by death, and so on. Edward recognized this himself. During the summer of 1948, he reread the Mexican portion of the *Daybooks* before giving it to photo-historian Nancy Newhall, who was to prepare it for publication. As he wrote to Nancy: "I find far too many bellyaches; it is too personal, and a record of a not so nice person. I usually wrote to let off steam so the diary gives a one-sided picture which I do not like."

Unfortunately, those who write about Edward generally fail to recognize the diary's limitation, just as they fail to discover that accounts dating from his final decade paint a sick man and not the robust lover of life he had always been, a man who found the world endlessly fascinating. With his camera he pored over it, probed it, sought to comprehend it, and to render for others its beauty, complexity, and inexhaustible mystery. My awareness of the world was conditioned by him forever after. Even today a pang of loss assails me when I come upon a scene or object or quality of light that would have prompted him to set up his camera.

I gave up reading warped accounts by others and began to make notes for a memoir. I sought out people we had known, but by this time there was not a great range of survivors. Most of the friends we shared had been of Edward's generation. Talking to those who were still around proved to be a disconcerting exercise, for several reasons. I was younger than most in our circle and had always been blessed with a prodigious memory, so my recollections were often sharper. And, with old friend after old friend, I encountered the same phenom-

enon and recognized that it must be universal, particularly when recalling men or women of note: in the minds of survivors, the one who has died becomes reduced to the sum of a few anecdotes.

At about this point, in the mid-1970s, I was asked by Edward's youngest son, Cole, and Michael Hoffman, the editor of Aperture, if I would write the text for a book of Weston nudes. No longer married, I was living with an old friend in Rio del Mar, south of Santa Cruz, California. In addition to the memoir, I was working on a children's novel and was reluctant to be diverted, but after some thought, I decided to go ahead with the nude book. *Edward Weston Nudes* was published in 1977. One effect that I had not foreseen was a rush of attention in my direction. I was invited to give talks and pumped for information by students, scholars, and fans.

Interest in Edward's work was high, and suddenly I was a prime source—and a prime subject. It seemed that everywhere I turned I would see another image of myself, sitting in the doorway or stretched on the sand or perched on a model stand. I once emerged from a New York subway to face a soiled city wall plastered with posters of myself as I had looked fifty years earlier, sitting against a boulder in the High Sierra, my head swathed against mosquito attack, with a look of exhaustion on my face—since identified regularly by critics as "sensuality."

The appetite for reproducing my anatomy seemed to be endless. One friend suggested that, if only I had shown the wit to copyright my body back in the thirties, I would no longer be lying on a bed of shifting dune sand but on a rustling bed of bank notes. I imagined a Braille system for setting the copyright under my big toe: *None Genuine without This Mark.*

Even poets got in on the act. In *Death Valley and Other Poems of America* (1980) by Alan Ross, I found "Weston Recalled, Oceano, 1976."

> *Coming upon her in the dunes,*
> *Indifferent in her nakedness,*
> *It was as if the ocean*
> *had bleached her with other detritus—*
> *Haunches slung to the shape*
> *Of a hammock, buttocks smooth as stones . . .*

While some good work has been done on Edward by a number of historians and art critics since I started this memoir, the views still do not reveal the whole man I knew. For years I continued to record my memories while collecting letters, news clippings, and other materials that eventually filled my office and overflowed into a rental storage unit. Illness, frequent moves, and other troubles slowed me down; manuscript pages accumulated with discouraging slowness and the mass of material began to seem unmanageable. Not long after my eighty-first birthday, a friend offered to help, and I accepted with a mixture of relief and doubt. I had known Wendy Madar since she was twelve and watched her develop as a writer, but even if we succeeded in finding some stylistic common ground, how could another "I" speak for my memory?

Collaboration, it turns out, is a strange thing. We began by talking for six weeks, and then Wendy went home to Oregon for nine months with my notes, files, and manuscript pages. When she reappeared in July 1996 and read me the draft she had put together, all I could see was what was missing, not only important material, but a voice that really sounded like me. Wendy would read a passage, pause for my reaction, and I'd say, "I can't really tell what should go here until I have a sense of the whole manuscript." At last she exploded with frustration: "There will never be a whole manuscript if we don't build it piece by piece!"

So that's what we did—piece by piece, hour by hour, day by day. To the consternation of our editor and with the invaluable help of my daughter, Rachel, I was still fixing my imprint on the manuscript until the day it went to press. Now, through the alchemy of good collaboration, we have accomplished what I first set out to do: just as Edward's pictures of Death Valley remain faithful images of an extraordinary place, so this book is a faithful testimony to the Edward Weston I knew.

PREFACE II

When I met Charis Wilson, I was twelve and she was an old woman—she was all of forty-seven. Her hair grew straight and plain to the bottoms of her ears. She wore big skirts and pullovers in no-nonsense colors. When she looked at me, one eyebrow shot up and I was caught in her gaze like a rabbit in the headlights.

Her gaze, as I learned soon enough, was benign.

I was a newcomer to the drab mill town of Eureka in Northern California, and very happy to go with my parents to a party given by their new Unitarian friends, Charis and Noel Harris. The Harris house was small and crowded with intensely talking adults. Rachel—the younger daughter of the household—was my age, and within no time we were deep into rehearsing a musical variety show, with "Fi-li-mi-oo-re-ay" as a prime number, sung in mock Irish.

This little house on Pine Street became my second home and Rachel my constant companion for the next four years. If Rachel and I weren't walking to class together, we were on the telephone, or planning a back-yard circus, or sitting in our swimsuits in the bathtub while it filled with cold water to test who could go the longest without flinching. Weekends meant an overnight, most often at her house, where Charis would sit crocheting a flamboyant hat—

Rachel and I were nearly expelled from ninth grade for wearing Charis hats to school—and if we were lucky, she would tell us a Grab Bag Story.

"Put in a glass eye and a rusty knife," I would say from my mound of bedding.

"A parrot and a deaf vampire," Rachel would add, and then Charis would begin in her oh-so-deliberate voice, building a tale that would soon have us begging for mercy—Please, not so scary, not a real vampire, don't let the girl go in *that* room—until she would relent, shaking her head over this pair of 'fraidy cats.

Thirty-five years later, when I had become an old woman of forty-seven, I found myself helping to write a different kind of tale, the tale of Charis's partnership with Edward Weston. When I was twelve, I knew only vaguely about this ancient period in Charis's life; an aura of something special hung about her, and in her office there were fascinating naked pictures to look at if we wanted, but I was a lot more interested in the Grab Bag Stories and the novel she was writing about a pet rat.

I married, traveled, had two children, worked at various writing jobs, and was often far outside Charis's orbit, though never out of touch for long. When she said that she had begun a memoir, I looked forward to reading about her past with Weston. Charis is a deliberate and meticulous writer, so it wasn't surprising that the project stretched over a decade, but when another ten years passed and she turned eighty-one, it seemed the right time to ask a difficult question. Did she need help? "Good idea," she said with classic Charis directness. In the summer of 1995, she rented a small apartment for me in Santa Cruz, I installed my computer and coffee dripper, and we were launched.

Charis had done a wonderful job of collecting documents such as letters and newspaper clippings, making notes on her own memories, and interviewing important people from the past, but she had been plagued with personal sorrows, ill health, and numerous moves, and had written only a little of the finished manuscript. Her habit had been to work on pieces—a scene here, a description there—with the shape of the book existing mainly in her mind. Stepping into this very personal project was like taking over the building of a

house with no blueprint and only some studs standing to suggest the design. It was scary for both of us, for Charis to turn over her house and for me to start driving nails into an invisible wall.

When I headed home at the end of the summer, I took not only my own notes but many of Charis's files, including hundreds of bits of paper on which she had jotted her thoughts over the years. Some of her notes were typed, but many were dashed off on the backs of checks, grocery lists, and so on, and written in a simple code of her devising.

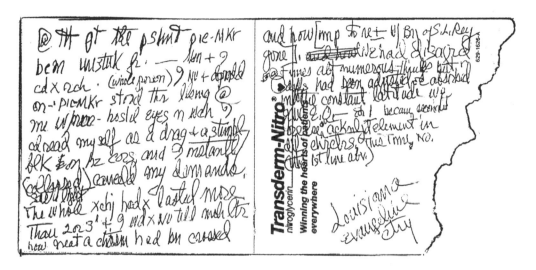

Only a few words proved really stubborn to crack, including this: nsfr°. At last I got it—insufferable—the degree symbol representing a bubble, which in turn suggests the generic suffix "-ble." Most of the notes, however, were not only legible but clear and expressive.

Throughout the fall, I read files, sorted notes, decoded Charis's jottings from the unusable to the revelatory, and felt less confident by the day. Unwilling to let her down or admit defeat so early, I slogged on, and gradually the material took shape. Charis's voice is so strong, in her notes and in her recounting of life as we talked, that it started to become the voice of the manuscript. For nine months I buried myself in the material and emerged in July 1996 with a working draft. By this time Charis had suffered a minor stroke, but her determination remained strong.

I returned to Santa Cruz and we worked nearly every day through July and August, one hour or many hours, depending on Charis's strength, with Rachel providing all kinds of support—jogging Charis's memory, digging in the storage room for letters and other documents, turning up with funny masks to give us a laugh break. We might be sitting in the garden that belonged to Charis's old friend Fern Strawn, or Charis might be propped on a bed with her legs straight out, her back against pillows, her face fixed in concentration while I read aloud from the manuscript and listened nervously for her reaction. Sometimes she laughed with amused appreciation, sometimes she said I'd written too much and I should cut it down, sometimes she said I was off to a good start on something but it wasn't the whole story, and sometimes she said I had it completely wrong—and she didn't want to include that subject in any case.

When we worked too late and forgot to eat, she could be cranky. "What about the time we took the ambassador to the beach," she would grumble. "You can't leave that out."

"I didn't include it because I didn't know anything about it," I would growl and, if I was very tired, remind her that these were not really *my* memories.

Mainly she was patient. She did not give vent to frustration at having to filter her story through another person to get it on the page. Most of the time she resisted expressing horror at my hasty way of working, just as I tried not to snap with impatience at her deliberate pace. Two years after I first waded into Charis's files, we completed this book. It isn't exactly what Charis would have written on her own, but I've come to think of it as her ultimate Grab Bag Story, with more contributions than she used to need from the likes of me—I'm afraid there are no deaf vampires or rusty knives here, but there is a glass eye.

December 9, 1934. I have not opened this book for almost 8 months,—and with good reason; I have been too busy, busy living. I notice the last entry was 4–20. On 4–22 a new love came into my life, a most beautiful one, one which will, I believe, stand the test of time.

I met C. a short time before going South on the P.W.A.P. work, saw her at a concert, was immediately attracted, and asked to be introduced. I certainly had no conscious designs in mind at the time, but I am not in the habit of asking for introductions to anyone which means that the attraction was stronger then than I realized. I saw this tall, beautiful girl, with finely proportioned body, intelligent face well-freckled, blue eyes, golden brown hair to shoulders,—and had to meet. Fortunately this was easy. Her brother was already one of my good friends, which I, of course, did not know.

I left for the south before our paths crossed again. While there a letter from S. said she had a new model for me, one with a beautiful body. It was C.—Poor S.— How ironical. But what happened was inevitable.

The first nudes of C. were easily amongst the finest I had done, perhaps the finest. I was definitely interested now, and knew that she knew I was. I felt a response. But I am slow, even when I feel sure, especially if I am deeply moved. I did not wait long before making the second series which was made on April 22, a day to always remember. I knew now what was coming; eyes don't lie and she wore no mask. Even so I opened a bottle of wine to help build up my ego. You see I really wanted C. hence my hesitation.

And I worked with hesitation; photography had a bad second place. I made some eighteen negatives, delaying always delaying, until at last she lay there below me waiting, holding my eyes with hers. And I was lost and have been ever since. A new and important chapter in my life opened on Sunday afternoon, April 22, 1934.

After eight months we are closer together than ever. Perhaps C. will be remembered as the great love of my life. Already I have achieved certain heights reached with no other love.

Domestic relations have been severely strained, quite to the breaking point, casting a shadow over my association with C. A change must take place and soon. I must have peace to enjoy, fulfill, this beauty.

Last regular entry in Edward Weston's *Daybooks*

CARMEL

ONE

Like the rest of the country in 1934, the coastal village of Carmel, California, is wrapped in the gloom of Depression, but even in hard times, music lovers go to concerts. It is nine o'clock on an early spring night, time for intermission. Released from the discomfort of folding chairs, my brother, Leon, and I stand at one side of the room discussing the concert and surveying the audience.

At nineteen I am a very self-conscious young woman. I have recently returned from a wild year in San Francisco to start work in my mother Helen's dress shop. My lavender piqué dress with stand-up ruffles around wide armholes is a present from her, or perhaps an extended loan; I am taller than she is, but we usually wear the same size. The dress makes me feel glamorous, and I'm looking around to see if anyone else thinks so. My eyes keep returning to a short man in brown clothes who is talking with friends across the room. He is wearing a jaunty corduroy jacket, tan slacks, and a pair of Mexican huaraches, and has about him an air of poised vitality suggesting equal readiness for instant action or total relaxation.

We have been keenly aware of each other for several minutes before he surprises me by making his way through the crooked lane of chairs and asking my brother to introduce us. Only then do I learn that he is the photographer

Edward Weston, and that he and Leon have already crossed paths in this small town and become friends. Close up I find him even more attractive, and take him to be in his late thirties. His handshake is firm and his voice has a dry huskiness. His features would seem homely were it not for the liveliness of his expression and the probing restlessness of his brown eyes. His springy red-brown hair is brushed back from the top and sides of his head, with no effort made to conceal the prominent bald dome, which is scattered with freckles and deeply tanned.

He looks at me with admiration, and the openness and intensity of that look would be embarrassing if he didn't, at the same time, make it seem playful— as though we were sharing a private joke. As the three of us stand chatting, I can feel his attention focused on me even when his comments are directed to Leon. I say I would very much like to see his work, and before the lights blink to end the intermission we arrange for me to visit his studio the following Sunday to look at prints.

On Friday Edward phoned with regrets: he was leaving for Los Angeles and might be away for several weeks. But I should come on Sunday in any case, because Sonya would be in the studio all afternoon and would be glad to show me prints. I knew Sonya Noskowiak from casual encounters in town; now I learned that she was Edward's assistant and a promising photographer herself. The Carmel gossip mill provided additional information: the two of them had lived together for five years, but that hadn't stopped him from being a notorious ladies' man. My disappointment over the change in plans was balanced by the realization that, away from the disturbing presence of the picture maker, I would be able to concentrate on the photographs more completely.

The upstairs studio in the Seven Arts Court was right around the corner from my mother's dress shop. The sign in the display case at street level said, EDWARD WESTON, PHOTOGRAPHER: UNRETOUCHED PORTRAITS/PRINTS FOR COLLEC-TORS. It seemed to shout defiance at the power of the Depression, which was relentlessly closing one Carmel business after another. I climbed the steep out-side staircase and walked down a short hall to the studio, where Sonya gave me

a friendly welcome. She was a small, shy woman with short brown hair and rather elfin features. I was a notoriously poor judge of age in those days and guessed her to be five or six years my senior when actually she was fourteen years older.

I said I hoped I wasn't imposing, and she assured me that she never tired of seeing the prints herself. While she was getting them out, I surveyed the big, loftlike room. There were no prints on the walls and there was very little furniture—a low bed in one corner, a tall desk in another, a couch against the long side wall, and some scattered wooden chairs. We lamented the demise of the tourist trade as I wandered over to the front window and looked down on Ocean Avenue; Carmel's main street was empty and silent.

Sonya set a stack of mounted 8 × 10–inch prints on a wooden stand and rolled a tall painter's easel around to face the light from the high north windows, talking as she worked. As I saw more of her, I realized that our styles were similar, which helped me feel at ease—straight hair, no makeup or nail polish, unshaved bare legs, and flat comfortable shoes, a simple sweater and skirt. It was partly lack of business, she said, that had sent Edward off to Los Angeles, where he had numerous contacts and might sell some prints or land a sitting. There had also been an offer to take pictures for the Public Works of Art Project, whose Southern California director was Edward's friend Merle Armitage. Edward would have waited to go until after Sunday, Sonya said, but a ride was available, and since he didn't drive he had to take advantage of it.

When she had adjusted the easel to her satisfaction, she seated me in a captain's chair in front of it and perched herself on a high stool. She put the first print up and I found myself staring with astonished delight at half an artichoke. Because the foggy central coast of California is home to this exotic vegetable, it had always been a common item in my diet. I had admired the colors in a halved specimen, from the dark green outer leaves to the pale yellow inner ones that were often edged with lavender, but I had never before noticed the delicate structure of those receding caves that now pulled my eye into the vegetable heart.

Next I was looking down the radiating rows of a lettuce field with their dotted lines of tiny plants marching off to infinity; then an ocean-polished rock

of creamy whiteness resting on a bed of wet black pebbles. That was followed by the vivid, black-fringed, white shafts of a pelican wing, and a skeletal cypress lying against a dark bank, surrounded by clustered stars of stonecrop.

Nearly four years earlier, when Leon and I were in high school in Hollywood, the art collector Walter Arensberg had told us about Edward, calling him "one of America's important artists." Since then I had seen some poor reproductions of his photographs, but nothing had prepared me for the real thing. Perhaps no preparation is possible for such a shock to the senses. I felt as though I had turned a corner into a cleaner, sharper, more exciting world—one in which any rock or cloud or weed patch might convey a message of cosmic significance. At first I tried to comment on the pictures as we went along, but I was soon reduced to occasional exclamations as one overwhelming image supplanted another. There were shells whose pale nacreous radiance made them self-luminous; inland ranches baking under summer sun; bas-reliefs of wave-washed rocks on a Point Lobos beach; the classic structure of a barn at Castroville holding sky and earth apart; green peppers whose complex topology seemed to hide secrets of creation. By the time we had gone through fifty prints I was exhilarated, but also exhausted.

In answer to my questions—which were undoubtedly as primitive as the ones I would be hearing others ask for the next eleven years—Sonya explained that these were all contact prints, which meant that Edward had made the negatives with an 8 × 10–inch view camera; that the lens was stopped down to the smallest aperture to gain greater depth; that they were all straight prints, which meant there was no manual interference with the camera image in the dark-room; and that he worked by visualizing his future print before making an exposure. I understood what she was telling me fairly well, because she explained it all in simple terms, but I still didn't know how to account for the visual force stored in those images—the pull that compelled my eyes to keep moving over the picture surface, feasting on newly discovered details and subtleties of design. What I did know, however, was that this near-hypnotic effect must lie beyond technical skill, in the powerful vision of the artist himself.

Sonya showed me a handsome book on Edward's work that Merle Armitage had designed and published the year before. Although the reproductions were

far better than those I had seen previously, they still seemed dead when com-
pared to the prints. Apparently the singing quality in the print tones that gave
such a vivid sense of life to the images could not be reproduced. It was my first
lesson in the registering of photographic values. When I asked to see some of
Sonya's photographs she begged off, saying that she was in the midst of re-
printing her work on a different paper because she was dissatisfied with the
results she'd been getting. Instead, she suggested that I might like to see some
of the nudes Edward had been making recently, and of course, I agreed.

Sonya explained that these were also contact prints, but made with a 4 × 5
Graflex reflex camera that made it possible to see the subject right up to the
moment of exposure. These pictures, too, were like nothing I had seen before.
Most of them showed only sections of bodies—arms wrapped around knees, a
down-pointing breast above the top of a thigh, the back view of a kneeling
figure with elbows pulled against the waist and buttocks resting on the soles of
the feet. Most of these forms were isolated against dark backgrounds which
accentuated the luminosity of the flesh tones and subtle variations in skin color
and texture. Once or twice there were faces visible, but even without such clues
to personality, the nudes retained a strong sense of individuality. I had no trou-
ble picking out the ones of Sonya, because she was small and thin, in contrast
to the fuller figures of other models.

Sonya asked me if I had done any posing, and I said I had, but only for
sketching classes with my clothes on. I thought staying still for fifteen or twenty
minutes was a bore, although it was always fun to see what people made of you.
It turned out that modeling for Edward was nothing like that. Sonya said you
simply moved around freely, and when Edward saw something that suited him,
he'd tell you to hold it. It would last only for a minute or two and then you
could go on moving. She thought I might like to try it. When I agreed with
alacrity, she said she knew Edward would be pleased because he was always on
the lookout for new models.

I decided the trip home was too short to put my thoughts in order. I drove
down to the south end of the beach and parked above Cooke's Cove, which
had taken its name from what had been my grandmother's house, a substantial
one for early Carmel. In my childhood the house had looked down on the bay

over low dunes of dazzling white sand, but by 1934 the dunes had disappeared under new streets and houses. The cove remained my favorite Carmel swimming spot, as well as a retreat from the working world—a place to park and watch the sun set or rise or, more likely, to stare at a rolling gray fog bank along which a few cormorants or pelicans might fly in formation.

I was caught up in some confused reactions to those magical photographs. Much of my understanding of art had been gained as a frequent guest in the Hollywood home of Walter and Louise Arensberg, where, as a teenager, I had wandered through rooms filled with modern masters that included Rousseau, Duchamp, Klee, Matisse, Picasso. From the Arensbergs I had learned to really look at a picture, to give it patient, receptive attention. I learned to avoid snap judgments and superficial comments so as not to disappoint Walter, who never seemed to lack an original view—or maybe several—of every picture he looked at.

Thanks to this early indoctrination, the question of whether photography could be art was a moot one for me. It was the drubbing these Weston pictures had given my ego that I now had to deal with. Where had I been all my life to have missed so much? I didn't mind conceding to Edward the rights of discovery to the Castroville barn and the Salinas lettuce field; I had driven past them often enough, but with a head full of other matters. Point Lobos was something else. This was my childhood playground, where I had climbed through the great jaws of the whale skeleton, dabbled in the tide pools, pic-nicked in the cypress groves, and swum in the icy green water of China Cove. Later I wrote poems about the shore rocks, etched with ripple wave patterns that echoed the salt tide which shaped them; poems about life and death in the tide pools, whose inhabitants I observed by the hour; poems about the twisting inlets I swam through, where purple urchins and bright orange starfish were lodged in beds of pink rockweed and waving green sea lettuce. What could I possibly have to learn about a place I knew so well from someone who had lived in Carmel for only five years?

A lesson in humility, for one thing. I fancied my own eye to be rigorously sharp and penetrating—that it could be superficial was a bitter pill to swallow. But worse, my Point Lobos poems now seemed unsubstantial when compared

with Edward's strong, precise, evocative images. His picture of kelp on the Carmel beach hung in my mind, testifying to my blindness; how many times had I passed, kicked, stepped on, leaped over those same chaotic tangles from which he had extracted a poetic revelation of order.

As I drove slowly home, I realized I was hooked—on the photographs and on the man who had made them.

When the day came to make good on my offer to model, I was surprised to find I had stage fright. It seemed to come less from fear of a new experience than from nervous qualms about how I would look to that all-seeing camera eye. Whatever the cause, Edward's matter-of-fact attitude reassured me. The studio looked a little different, because the couch had been pulled out into the middle of the room; the 4 × 5 Graflex, mounted on a sturdy wooden tripod, stood before it.

Edward ascertained at once that I knew nothing about photography and suggested that I might like to see how the camera worked before we began. He demonstrated its various movements, explained how the film pack worked and how the mirror was flipped away at the very moment of exposure. Then, while I peered down into the hood, he sat on the couch to serve as an example of the image size. I was astonished at the brilliance and clarity of the picture transmitted by the 4 × 5–inch mirror—you could see every detail. I noticed that the bristly hairs in his small mustache were several different colors, and that the fingernails on one of his hands were blackened. I was again struck, as I had been at the concert, by his absolute naturalness. He did not pose or make faces or witty remarks, outlets for tension I might have employed. He simply sat there, doing nothing, entirely at ease.

How I envied that comfortable poise. I longed to rid myself of the morbid burden of self-consciousness, so why not start at once? Ignoring Edward's offer of the bathroom off the entrance hall as a changing room, I undressed while we were talking and hung my bathrobe over my shoulders, thus making sure Edward had full opportunity to view the still-angry spider of an appendix scar that marred my abdomen. If I was to be rejected on that account, I wanted it to happen at once.

"Too bad about that scar," Edward said in wholly sympathetic tones, and

went directly on: "Why don't you try the couch for a start. If you don't feel comfortable on that, or get tired of it, you can shift to one of the model stands or try a blanket on the floor."

What followed was not the relaxed procedure that Sonya's description had led me to expect. Once Edward's full attention was focused on me through the camera, I found myself reacting with a matching concentration as I tried to visualize and enhance the image I was transmitting. Even Sonya's comment about freedom of movement proved misleading, since any slight adjustment in my position produced another request to "Hold it." I found it took a great deal of control to stop exactly on command.

An almost steady stream of encouragement and appreciation issued from behind the camera: "That's great! Can you hold it? . . . Beautiful! Just . . . like . . . that." (Slap of film being changed in the pack.) "Oh yes! That's fine! Hold it now . . ." As I became more relaxed and confident, I told Edward that this was the kind of "moving around freely" you might do if you were trying to slip out of your bed without disturbing a sleeping rattlesnake.

The studio was drafty, so when we took breaks at half-hour intervals I wrapped my bathrobe around me and we sat close to the small wood stove to talk. In the course of the afternoon we touched on a great range of topics and were continually surprised to find how often—in spite of the difference in our ages (I now knew Edward was forty-eight and in two weeks I would turn twenty)—our tastes, attitudes, and even our experiences coincided. Both of us had been sickly children, and had initiated regimens that transformed us into hardy physical types—Edward by converting the attic of his Chicago home into a gymnasium, I by swimming in the cold and often rough waters of Carmel Bay. We agreed on the pleasures of sunbathing, on a preference for simple food and clothing, and on an aversion to highbrow affectation and intellectual snobbery. We confessed our mutual shame at having tried and failed to give up smoking. We found we had enjoyed or disliked many of the same books, movies, and people, and that we both admired F.D.R., though of course such a leaning had to be soft-pedaled in Carmel—conservative despite its origins as an artists' colony. The community's early bohemianism had by now taken on an entrepreneurial and retired-on-a-small-income mentality, with the result that the

town had a distinctive morality, a blend of political conservatism and social tolerance. Edward and Sonya's five years of cohabitation, for instance, was equated in Carmel with marriage rather than sin.

The posing became more enjoyable as the afternoon passed. I became accustomed to making slow transitions and began to anticipate a "Hold it!" before the words were spoken. Whenever possible I faced toward Edward for the fun of watching him in action. Right off I discerned the reason for the horn-rimmed pince-nez that had been clipped to his jacket the night we met. He needed glasses when he peered down into the Graflex hood to focus, but he wanted them instantly out of the way when he looked over at me. The black neck cord they were attached to solved the problem neatly: he tossed the glasses over his shoulder and, when he needed them again, pulled the cord to retrieve them.

Every move he made followed a similar high-speed routine. He could adjust the focus by reaching around to the front of the camera while looking into the hood. Sometimes he moved the tripod slightly without lifting his head, and I imagined he was a five-legged creature from another world whose giant eye was insatiably curious about this one. But I decided at once that the metaphor was false; creatures from other worlds were clumsy in my imagining, and Edward's dance with his camera was remarkably graceful.

As the day wore on, we established such a warm and easy relationship that when Edward passed close to me to adjust the burlap screen he used for a background, I half-expected a friendly pat. I certainly wouldn't have objected, but I was even more impressed when it didn't come, especially since the electric charge that had been set off between us that first night at the concert was quite evidently still present. I ran into him in town the following day and he asked me to stop by to look at pictures. We went down to the little basement darkroom under his house, and again he made no move to touch me, although we stood close together in the semi-dark. He fished prints out of the water bath, where they were circling facedown, and stuck them up briefly on a slanting glass pane. The first one showed my scar in all its ugliness; it was beyond me to make any comment. The rest were scarless, and—to my mind—far more beautiful images than their subject. I was so astonished to see myself thus transfigured

that I couldn't say much about them either, but Edward was clearly pleased and said that he'd like to make more as soon as possible. I agreed to come again the following Sunday.

I returned to my office in a state of euphoria inspired by an entirely new view of my body. How silly to have agonized over how big my hips were when I could see from the photographs that they were just the right size for the rest of me. For years I had been self-conscious about my height; in those days 5'8" was conspicuously tall for a girl. Now I saw clearly that my height was just what it should be. Of course this perfection was really a trick of Edward's camera, but I was utterly happy to be the subject and to feel I had been made into a work of art.

In the days that followed, I had difficulty giving proper attention to my own work. A limited association with secretarial school had failed to clear up the mysteries of double-entry bookkeeping; my ability to keep track of the dress shop's business was due less to my supposed office skills than to an exceptionally good memory, and that particular faculty had become endangered. Edward's studio on Lincoln was a block away from his house on Monte Verde, and the Carmelita Shop faced Ocean Avenue halfway between the two, so he passed below my upstairs office window several times daily. Because his trips were irregular, and my view was limited to about ten yards of sidewalk, I would miss him if I wasn't looking out at exactly the right moment. The sight of this amazing human being striding along as if he could have been just anyone gave me the satisfying sense of having a great secret.

By the second session it seemed we were old friends, telling jokes and being playful. Edward did a wicked imitation of a bejeweled matron who had termed his price for portraits—$35 for a sitting and two prints—"simply outrageous!" I countered with an impersonation of a well-endowed customer straining every seam as she insisted on wiggling her way into a size 12 playsuit. At break time Edward produced a bottle of wine and we drank to a post-Depression future in which making a living would once more be a reasonable expectation rather than a dismal unlikelihood.

"Don't move!" Edward said sharply as he set down his glass and moved the camera to face me—and there I was, perched on a high stool, my bathrobe

hanging on my shoulders, arms crossed, one hand dangling a cigarette, the other a tumbler of wine. I was caught off guard, with no chance to adjust, but by then I had such confidence in the process that it didn't matter.

After all this loosening up I looked for a change in Edward's behavior, but he remained as circumspect as before, and I realized that his reputation as a Lothario was wildly exaggerated. I would have to take the first step. I did so, and even though it was only a very compelling look, it soon brought photography to a halt. What followed was as great a revelation as Edward's photographs. I thought of myself as a sophisticated woman of the world, but now I learned how limited all my previous experience had been, as what had always seemed to me to be a branch of playacting became unmistakably real.

When fading light reminded us of passing time and other commitments, we tried to look objectively at our new situation. It was clear that something important was happening between us, but what would it mean practically? My first question was "What about Sonya?" Edward said they had recently agreed that they were free to lead their private lives as they chose, and this assurance was sufficient to assuage my scruples, which were not terribly strong in those days in any case. However, it wouldn't satisfy the gossip-minded custodians of the town's morals, who looked on Sonya as Edward's wife. In order to avoid a scandal that could have economic as well as emotional repercussions, we decided to keep a low profile.

The discovery that mine was by no means a one-way infatuation—that Edward, although more cautious about revealing it, was as bewitched as I was—had given my morale a tremendous boost, and for the first time in many months the future looked radiant with promise. I was sure every problem had a simple solution and that patience and goodwill would find it. But when my work schedule, Edward's studio hours, and the need for discretion were added up, there was very little time left for us to be together.

Our encounters on the street or at public gatherings were those of casual acquaintances; we never mastered the art of encoding private messages in everyday comments about the weather or news. We were equally inept at making arrangements by phone if listeners were about. Neither of us seemed capable

of real dissimulation. We had only one reliable signal system: Edward put a card in the studio window when customers or visitors were there; from a block away I could see its message: No chance for a private word at present.

We relied mainly on the post office to communicate, and our letters became surrogates to tide us over the hours and sometimes days of separation. If I caught sight of Edward's bold black writing or the splash of the red wax he used to seal his envelopes when I picked up the Carmelita Shop mail, the daylight immediately became more brilliant and the weather several degrees warmer. As soon as a first reading was possible in the privacy of my office, I would instantly dash off a few lines in return, so as not to break the thread of connection.

We dated our letters according to a system I had once used for journal writing, in which date and time were strung together with commas to form a single number—thus 7:30 p.m., May 5, 1934, became 5,534,730p. Edward's letters were on letterhead, had blossoms enclosed, and were laced with the endearments he had brought back from three years in Mexico. I was his *amor*, his *alma*, his *corazón*, his *Charisita* or *Sita* for short. I was *linda*, I was his *más que linda*, which finally became simply *masque* to stand for all the rest. He signed himself as *your viejo* or *your idiota*.

I did not call him Eduardo, because other friends had called him that, and I certainly didn't call him Eddie; only those who presumed a greater familiarity with him than they really enjoyed called him Ed. For me he was always Edward.

My letters were hastily written love poems or droll accounts of the day's doings, scribbled on any scrap of paper I found on my desk. In green ink on pages torn from a bound notebook I wrote on a July night: "A faculty we share: the ability of self-directed laughter. God how much it means when it is as easy and delightful to laugh at oneself as it is to laugh at another . . . It's silly to miss you, and I'm silly, which is almost a halfhearted syllogism." One poem of many from that season:

> *Speak to me softly before you sleep*
> *Take my love and kiss me goodnight.*
> *During the day I have told a tree,*
> *Six little rabbits and a flock of quail,*

And three cows sleeping beside the road,
And four trucks, driving south through the fog,
And a white cat on another hill.
I have told them all of my love for you
And told them you'd kiss me before I slept.
I told them your house was by the sea
And that was how we could swim together.
But they knew I never swim any more
And thought I was lying about the rest.
Which is why I have asked you what I have—
In case they should come to see if it's true.
Take my love and kiss me goodnight,
And speak to me softly before you sleep.

We finally devised a way to be alone together. Edward would sleep at the studio and I would join him there in the pre-dawn hours. My early departures were never questioned at home, even though I had always been a notorious morning sluggard; my family did not make a habit of confiding, and they assumed I was going to the dress shop to catch up on the books. Turning on a light in the dark business district might have attracted attention, so Edward burned a small candle beside the low bed. By its flickering light I would discover some new Mexican artifact that he had ready for me—a doe-eyed Virgin of Guadalupe, or a whimsical four-footed creature whose tail provided a shrill whistle. There was a hot plate for making coffee, and Edward soon bought two yellow pottery mugs for our private use. From these we drank a ceremonial morning cup as early light warned of the advent of shopkeepers and the time for my departure.

Our behavior was discreet enough for everyone but Sonya. When Edward began spending frequent nights at the studio, she was quick to guess what was going on. Not quite so willing to let Edward go as he had suggested, she took revenge in a novel way. On nights when she knew he'd be sleeping at the studio, she dosed his evening meal with a prodigious amount of garlic, which made our early-morning trysts a testament to the transcendental nature of love.

Most of Edward's friends accepted me without question, and I soon became

one of the regulars in the group that gathered for Point Lobos picnics, parties at the studio, and photographic outings. A steady stream of visitors, down from San Francisco, up from Los Angeles, or passing through from elsewhere, arrived at Edward's studio to sit for portraits, to see his work, or just to share coffee and conversation while he touched up the spots that inevitably appeared on prints.

Despite the dark shadow of the Depression, those days unrolled a vivid tapestry of new experiences for me. I had long been looking forward to my twenty-first birthday, with its official stamp of adulthood, but as things turned out, it was this first summer with Edward that marked my coming of age.

TWO

When my grandmother Grace MacGowan Cooke arrived in Carmel-by-the-Sea in 1908, she found what she was looking for: a small community of like-minded artists and writers living simply and cheaply in splendid nature. Their cabins were scattered among trees on a slope above a perfectly blue bay rimmed with white sand. Unpaved tracks, more like paths than roads, wandered from house to house. The road that passed over the hills between Monterey and Carmel was traversed by foot as well as horse and stage. In her journal, Grace described Ocean Avenue, Carmel's main street, as "a wide sandy waste with a row of small pine trees down the middle of it, some bits of plank sidewalks here and there with a post office, a drug store, a grocery and a bakery, all looking closed, shut-eye and dozing."

Grace had come to Carmel with her two daughters, twelve-year-old Helen and seven-year-old Katherine, or "Kit," and her older sister and fellow writer, Alice MacGowan. Grace and Allie were born in Ohio, but had spent most of their lives in Tennessee. Their father, Colonel John E. MacGowan, a retired Union officer, had served with the First U.S. Colored Artillery in the Civil War, and then elected to stay on and help build a new South. He was the respected and influential editor of *The Chattanooga Times* from 1872 until his death in 1903.

Both his daughters had married and taught school before embarking on literary careers. Allie's marriage to a man many years her senior was unhappy and brief, but Grace was married to my grandfather, William Cooke, for twenty years before leaving him. Reminiscing about him in a letter to my brother, she wrote, "According to my estimate he was lazy about using his brains and laughed at people who theorized and tried to think things out." William described the incompatibility a little differently. Grace, his divorce petition stated, had made it clear that "she will have no other life than one of celibacy, retirement, and intellectual effort. Complainant avers that his marriage contract did not contemplate such a life."

When they left Tennessee in search of an ideal writing environment, the sisters went first to Helicon Hall, Upton Sinclair's utopian colony for writers in New Jersey. Not long after their arrival, the mansion caught fire and Grace and Allie both suffered serious back injuries when they jumped from a second-floor window. While recuperating, they stayed with friends in Douglastown, New York, where they were visited by Sinclair Lewis, who had worked as a furnace stoker at Helicon Hall. Then young and unknown, "Hal" Lewis hoped to collaborate on a novel with Grace and Allie. He was also interested in Helen. "You couldn't keep me from sending picture postcards to Helen C. were you even to lock me up. I'm going to marry that child," he wrote in code in his diary. At the time, Lewis was twenty-three and my mother twelve.

After a second visit, he wrote: "Helen, Kit & I went a-questing violets Sat. p.m. Helen had a cold, & became grouchy, whereupon Kit had to act as a messenger between our dissevered monarchies. Sat. morning, before any one else was up, a windy tramp. I certainly am in love with that glorious child, Helen. She pretended to be—or was—decidedly bored by me, Sunday, preferring her book; but ruet coelum, for did I not kiss her soft cheek at our season-long parting? God knows the answer, and is very close-lipped; she did not even want me to stroke her hand as I read to them. Will she fall in love with some beast with big muscles? Pray God he be a nice beast."

Another member of the writers' commune was Michael Williams, future editor of *Commonweal*. When he and his wife moved to Carmel-by-the-Sea, Grace and Allie followed and bought the house overlooking what would soon be

called Cooke's Cove. It was large by Carmel standards, and well suited for the writing life. An article from the February 28, 1909, *San Jose Mercury & Herald* by A.E.W. Mason, "Writers, Poets, and Artists Who Are Working at Charming Carmel-by-the-Sea," describes the situation in fine period style:

> *A study that seems as if it were purposely planned to keep one from working, so magnificent is the view of the blue bay and blue sky that its many windows frame, is that of Grace MacGowan Cooke and Alice MacGowan. But no one in all Carmel seems to have more work on hand than these sisters . . .*
>
> Judith of the Cumberlands *was the book that first brought Miss MacGowan popular success, and she is now at work on* The Wiving of Lance Cleaverage, *a story of the same mountain region . . . Mrs. Cooke is a most prolific writer and has to her credit:* Mistress Joy, *a colonial story;* The Grapple, *an economic story of mill conditions in the South;* Son Riley Rabbit and the Little Girl, *a child's book for which her own little daughter posed for the illustrations, and many magazine stories and articles.* The Power and the Glory, *a story of cotton mill life, will be the next from her pen.*

Grace and Allie joined the circle that centered on poet George Sterling, and included Mary Austin, James Hopper, Jack London, and others. Soon after the women were settled, Grace wired Sinclair Lewis that she would pay his fare out West if he would work half time as their secretary. He arrived in January 1909, on foot from Monterey. Grace found him a cabin, paid the rent, and continued to lend him money for some time, even though their proposed collaboration fizzled and he shirked his secretarial duties. The free-and-easy Carmel social life—beach picnics, rambles by moonlight, amateur theatricals at the Forest Theater—evidently swept him away, but it wasn't frivolity that got him banished from the MacGowan-Cooke household. It was a remark he made in German about Helen that Grace overheard and understood but whose substance hasn't come down in family lore. Her diary entry was terse: "Hal proved impossible, went his way."

In 1910, two years after Grace and Allie arrived, my father, novelist and humorist Harry Leon Wilson, settled in Carmel. At forty-three, he was older than most of the other local writers and far more commercially successful. Not only did his own work sell well but a play he had written with Booth Tarkington, *The Man from Home*, was a long-running Broadway hit that earned him the then fabulous sum of $200 a week.

Harry—"H.L." to his friends—bought eight acres south of Carmel at Carmel Highlands, built the twelve-room redwood house we would know as Ocean Home, and, at age forty-five, married my mother. Helen was sixteen years old and could not have foreseen the kind of life she was signing up for. Harry Leon Wilson was a figure of glamour, a writer with a national reputation who was at home in New York and Europe. Marrying him was bound to widen her horizons. As it turned out, he was in love with the Pacific Coast and the home he had built, and probably saw Helen as the final lovely piece required to complete his domestic paradise.

Besides H.L. and Sinclair Lewis, several other men had been smitten with Helen, among them poet William Rose Benét and photographer Arnold Genthe. The latter photographed her in pictorial style—clad in billowing draperies at Carmel Point and (in autochrome, an early color process) kneeling in a field of golden California poppies. Helen captivated these men not only with her beauty but with a poise and seeming maturity that belied her years. In truth, she was still a girl, unprepared and unsuited for the isolation and boredom that marriage to a man like H.L. forced upon her.

His former wife was Rose O'Neill, a popular illustrator and the creator of Kewpie dolls, the cunning little potbellied, Cupidlike creatures, as ubiquitous in their day as Barbies. Rose described her husband as a "silent man, except for occasional witticisms, very exact and pungent. His eyes were full of blue but his head and face were square with an effect of granite will . . . Harry had an unusual faculty for keeping his serious moments strictly apart from his convivial ones. Most people, even when serious, are apt to be surprised by the stray gregarious impulse—toward evening, say. But Harry never played when he worked or worked when he played. While writing a book for several months at a stretch, nothing could induce him to touch the cup that cheers or to cheer anybody else's cup."

H.L. was now married to a much younger woman, and he didn't want his wife socializing without him. Helen had many friends in town and played prominent parts in several Forest Theater productions, but travel then was by horse and buggy, and the five miles between Ocean Home and Carmel provided a natural barrier that kept her captive at home. Luckily she was an avid reader, and she soon became adept at creating projects—landscaping, painting, interior decorating—to fill the long days her husband spent pacing his study and typing his novels.

Helen was seventeen when my brother, Leon, was born at Ocean Home in 1913. The country doctor who delivered him left her so damaged that she was taken to a hospital in San Francisco for my arrival a year later. Even so, it was a difficult birth, and for much of my infancy I wasn't expected to live. I was told that the love and tender ministrations of my Spanish nurse, Mrs. Dutra, were all that kept me in the world.

Leon and I were named after our parents—Harry Leon Wilson, Jr., and Helen Charis Wilson (Charis is the Greek for Grace, which was unavailable since my grandmother didn't approve of saddling children with relatives' names; she said she was busy using "Grace" herself). Both of us ended up using our middle names, Leon from childhood and I from my mid-teens, when, taller than my mother, I finally rebelled at being called "Little Helen."

Our mother told Leon and me that we were both born in May, on the fifth and ninth respectively, she thought. When I sent for my birth certificate in 1941, I discovered that I was the one born on the fifth, and that I had lived a quarter of a century celebrating the wrong birthday. Helen's vagueness about our birth dates was not mere absentmindedness. She hadn't been ready for children and she was not at all maternal. She turned over our care to a series of live-in governesses, and when forced to deal with us herself, she kept us on a very short leash, insisting on proper deportment at all times. We were never, for instance, to call adults by their first names, no matter how well we knew them.

"How do you do, Mrs. Deverich," we would say, Leon with a bow and me with a curtsy, when Helen's good friend Loretta, a silent-film actress, made one of her regular visits. Years later she told us, "I never saw you two wistful things without wanting to hug you."

Loretta's view was corroborated by writer Booth Tarkington when Leon wrote to him in 1940, recalling walks he had taken with us in 1918. Our family spent the summer with his in Kennebunkport, Maine, while he and H.L. collaborated on a play, and on our walking excursions with him we magically found treasure at every turn. Tarkington responded: "What a memory you have! Sowing pennies—that opened a dusty lid in the back of my head and I could see two children stooping to peer and discover. Their extreme, over-severe training in decorum wasn't infringed even then; but there was a chirping and something like the gaiety other children had oftener."

Sometimes when our parents went out they left us with Grace and Allie, whom we addressed as "Mama Grande" and "Tia Grande," due to the early influence of Mrs. Dutra. The sisters had moved from Cooke's Cove to a house on 13th Street, which, like so many Carmel houses, was buried in trees. These visits were always pleasant occasions since we loved the freedom and the adult attention. They consulted us as to what we wanted to eat, and they didn't monitor our table manners. We were allowed to drag out the old costumes, peacock feathers, and other fascinating objects stored in a former pony shed and use them to stage impromptu dramas. We could be silly and giddy in the presence of our elders without fear of reprimand. In every way it was a departure from what we were accustomed to at home.

In terms of natural setting, though, Ocean Home was an ideal place in which to grow up. Our large and airy house faced a wide sweep of the Pacific. Behind it to the east rose a steep hillside covered with wild lilac and Monterey pine. The south side of the property was bounded by the narrow canyon of Wildcat Creek, up which we sometimes hiked with our governess to picnic and gather watercress. The grounds, which Helen designed, included an eight-foot-deep diving pool, where we learned to swim and where, for a time, she raised trout—fat, shadowy fish that darted about in its depths. There were also rising terraced gardens culminating in a rock fountain which had a lion's head that occasionally spouted water. Frogs in the swimming pool made a great echoing chorus at night, but now and again dead silence would fall and I'd lie in my bed, heart-still, wondering what they had heard.

The quiet of the house focused sharp attention on any sound. Every door

had its tone. The redwood floor returned a different rhythm for each of our footfalls. My mother's clear voice, accompanied by the baby grand piano she played, floated through big rooms never invaded by the sounds of the box radio that was frequently on in the combination nursery and servants' quarters where we children had most of our meals.

Leon and I were close, but that didn't mean we exchanged deep confidences or easily expressed affection. We were confederates in mischief, allies in games and secret violations of Helen's strict protocol. We grew up sharing a strange kind of isolation, with few playmates, even though there were other families in Carmel Highlands. This wasn't because Helen and H.L. disapproved of our enjoying the company of other children. It was rather that our need for companionship would never have occurred to them. They were engrossed in their own lives, and for the most part, their children occupied a separate world.

Leon and I were allowed briefly to enter their domain on the evenings Helen read to us. Somehow, perhaps because her mother read to her when she was a child, she considered it the proper thing to do. We would eat supper in the nursery with our governess, put on pajamas, do our exercises, and then hurry into the living room, where our parents would be in front of the fire—H.L. reading in the Morris chair and Helen lying on the couch. We would settle on the floor beside her and listen with rapt attention to whatever she read. Her choices were eclectic; in those pre–World War I days there were few guidelines about what was suitable for children. The sound of her voice cast an immediate spell, and we were held in thrall by the *Just So Stories, Otto of the Silver Hand, Goops and How to Be Them, Old Mother West Wind and Her Merry Little Breezes,* interspersed with ghastly fairy tales from the Brothers Grimm.

When Helen put down our book and picked up her own, it was a signal that story hour had come to a close, and we never dared to beg for more. Instead, we followed an unvaried ritual. "Good night, Papá." (Kiss on his cheek.) "Good night, Mamá." (Kiss on her cheek.) The recipients of our kisses did not look up from their books. We then exited through the noisy sliding wooden door to the hall and climbed upstairs to our sleeping porches.

One day Leon and I discovered a secret hideaway while chasing our enormous white cat. Local fauna had made a tunnel in the long grass, which we

wriggled through, and, to our delight, emerged into a duff-floored mini-cathedral roofed by the straight lower branches of several cypress trees. It was quiet and wonderfully private. We ventured to invite Helen to see it, and I am still amazed by the memory of our elegant mother squirming down the narrow tunnel to our secret place and then standing up and looking around, clearly impressed.

"You could bring something to sit on and a book and I could read to you," she said. And on one or two signal occasions that's just what we did.

My father was such a popular writer during the first three decades of this century that most of the reading public knew his characters by name: Bunker Bean, Ruggles of Red Gap, Merton of the Movies, and Ma Pettengill. His novels were serialized in *The Saturday Evening Post*, and years later people would tell me how they had rushed home to get that week's issue in order to read the latest installment. Several of his stories were adapted for the stage and—though he disdained the results—many were made into Hollywood movies. *Ruggles of Red Gap* can still be found on classic movie channels, but a mention of my father's name today would be met with blank looks. Harry Leon Wilson has all but vanished from the literary landscape.

During my childhood my father was an imposing shadow, the man in the upstairs study whom we weren't to disturb, the phantom who paced the creaking floor overhead, the taciturn figure who sat for hours at his desk or typewriter and then came out dressed for golf when the buggy's successor—a Willys Knight—was ready to drive him away.

Communication in our household was never easy, and rarely personal; to find out what was going on Leon and I listened for hints in adult conversation and searched for whatever clues we could find. I once or twice found significant letters in my mother's lingerie drawer while putting away the camisoles I laced with ribbon for her. At the time, the absence of conversation didn't strike me as odd. I assumed that everyone else's family followed a similar course and that reticence among close relatives was part of the natural order. Later, when I learned this was not the case, I rationalized that our way must be superior, since it provided each of us with an enviable freedom to think our own thoughts unhampered by the views, concerns, or advice of the others. So it is that we are able to live with—even glorify—whatever childhood hands us.

. . .

When I was four, I was ordered to bed for a year because of a heart murmur. One day, tired of the inactivity, I got mad and threw my pillow across the room. A few minutes later I was remorseful and desperate to retrieve the evidence of my wickedness before the irascible Miss Gibson came in and spotted it. I had never broken the law that kept me confined to bed, but surely it couldn't hurt to cross five feet of floor space and grab the pillow. I climbed stealthily out of bed and instantly collapsed. My legs might as well have been made of mush. Terror gripped me. I would never be able to walk again and the adults weren't telling me. I pulled myself by my elbows over to the pillow, hurled it onto the bed, and dragged myself back, knowing I couldn't ever speak of my illicitly gained discovery. I cried into my pillow for a long time.

Did I have rheumatic fever or just a noisy heart murmur? Who knows, but all through childhood I was considered sickly, taken out of school often, and subjected to the boredom of two quarts of milk daily and two-hour naps.

My formal schooling was predictably erratic. By fifth grade I had been in and out of three schools, two private, one public. The moves were due to the assumed illness and whatever best fit with my parents' lives at the time. In the summer of 1925, while looking through my mother's underwear drawer, I discovered that in the fall I was to be sent to Katherine Branson's School for Girls, north of San Francisco. As usual, I pretended not to know until I was told.

At first Branson's proved a good place for me, so good that at the end of sixth grade I won the prize for best intermediate student. It was *The Crock of Gold,* a book about leprechauns inscribed "Intermediate Prize awarded to Helen Charis Wilson, June 10, 1927." It was presented to me on graduation day at the end of the year. No one from my family was there. I recall fleeing upstairs and watching out my bedroom window as other parents lavished attention on their daughters—all the pale pleated skirts surrounded by people laughing and talking. I felt pretty sad. It would have been nice if even Great-aunt Alice had come.

Earlier that year, while walking on campus, I had met a day student whose father had a printing business in San Francisco. She was an admirer of my early literary efforts and had won my heart by prevailing on her father to print a few copies of some of my poems. I still remember her face as it looked when she

peered up into mine to probe for a reaction as she announced, "It said in the paper this morning that your parents are getting divorced. Did you know that?"

"Oh yes, of course," I replied calmly, even though I had heard nothing. In those days I needed to appear tough and in the know. The information created a strange numbness in the weeks that followed. I had no concept of what divorce would mean in terms of my family or future.

I learned later that Leon, too, had heard nothing. He had accompanied our father to a friend's ranch in Northern California, he told me, and from there they had gone on to Portland, Oregon, and moved into the Sovereign Hotel, where H.L. evidently planned to remain. Finally Leon, who was fourteen, worked up the nerve to ask, "When am I going to see Mother again?" H.L. told him that he and our mother were permanently separated and Leon was to stay with him.

No one ever discussed the divorce with me.

That summer of 1927 proved a turning point in several ways. I lived with my mother and aunt in a house in 80 Acres, an early Carmel subdivision. Helen and Kit had wild parties there, and I'd sleep on a cot on the front porch. Maybe it was the unusual sense of freedom that made me decide I wasn't going to let myself be treated as an invalid anymore. I spent the summer swimming at the Carmel beach, often out to the kelp beds, where I would gather the kelp and lie on it, sometimes with my suit off.

When I returned to Branson's, I was soon skipped into eighth grade, but I just didn't take school as seriously as before. Starting social clubs became my thing—all kinds of clubs, including a self-control club, for which initiates had to lie still in a tub while it filled with cold water or lie on a bed while tiny frogs hopped on their bare bellies. I imported forbidden boxes of cookies and had midnight feasts. Instead of prizes for scholarship, I was earning a reputation as a "bad influence."

I spent spring vacation with H.L. and Leon in Portland. My father waited until the day I was leaving, then produced a letter from his pocket as we rode down in the hotel elevator and told me that I wouldn't be returning to Branson's. I had been expelled. No specific misconduct was cited, but it seemed I was bringing down the school's *esprit de corps*.

I finished eighth grade at Sunset School in Carmel, where I lived with my mother, her sister Aunt Kit, my grandmother, and Allie in a house at Hatton Fields. It was a fine writers' house in Spanish style, with three large rooms that served as combination bedrooms and studies. My room was between the rooms occupied by Grace and Allie. Listening to their conversations as they worked on stories gave me my first clear impression of the real work of writing. My father's method of filling a wire basket with notes and then sitting down to write a book straight through remained mysterious, but watching as Grace and Allie discussed, rewrote, and rearranged, I became conscious of the importance of the right word, the right sequence of words, sentences, and events, and the care in shaping and refining that went into producing prose that seemed effortless.

The next year I went on to Catlin, a private school for girls in Portland. H.L. and Leon were living in a penthouse at 16th and Yamhill that had no bedroom for me, so H.L. rented an apartment, where I stayed alone on weekends. In 1929, when my mother returned from a European trip with friends, H.L. returned to live at Ocean Home, and we joined Helen in Hollywood in a rented house near Hollywood Boulevard. Leon and I attended Hollywood High, where the curriculum seemed like a joke to both of us after the rigors of private school.

I went to secretarial school in the afternoons and, to a degree, was finding my own social path. I prevailed on my friend, potter Beatrice Wood, to take me to see her friends Walter and Louise Arensberg. Her descriptions of them and their house had made me wildly eager to be introduced, even though she warned me that they didn't like children. I was fifteen, a sophomore, and preparing for adult work with the secretarial course, so I certainly didn't think of myself as a child.

For many years the Arensbergs' apartment in New York—crowded with contemporary painting and sculpture—had been a major gathering spot for artists and writers. When they moved to California, the collection came with them, and was constantly augmented by new finds, so that every room in their Hillside Drive house was filled with masterpieces.

On my first visit Walter Arensberg himself took me on a brief tour. There,

on the walls throughout the home, were famous paintings I had heard about but never seen. Eager to convey the image of a young sophisticate to my host, I tried hard not to act too impressed when I beheld the originals of such works as Duchamp's *Nude Descending a Staircase* or Brancusi's *Bird in Flight*. I knew from the moment I entered that exotic living room—where Rousseau's apes peered out of their jungle at Matisse's *Woman in Blue*, and Picasso's *Guitar Player* fraternized with Miró's primary-colored, geometrical creatures—that I would return as often as possible. The Arensbergs themselves were kind, hospitable, and charming, and urged me to return soon and bring my brother. I needed no urging. I had fallen in love with both of them, their treasured house, and even their little dog Lolly.

When I got my first secretarial job typing and helping to edit a book manuscript, I thought it great good fortune that the woman I worked for lived only a few steep streets from where the Arensbergs lived. On my way down to the streetcar line on Hollywood Boulevard I would pass their house, and it was a daily struggle to refrain from ringing the doorbell. I must have stopped by often enough to be a serious nuisance, yet Walter always greeted me with a beatific smile that told me my arrival was the most wonderful thing that could have happened just then. If he really had no time to spare for a visitor he would say so, but instantly consult me, perhaps about two pictures in the entryway. He'd thought of exchanging their positions. Would it be an improvement? Or were they better as they were? I might spend only a couple of minutes there, but went away feeling important and helpful. Not only was Walter gracious, but he had a rare talent for lifting other people's thinking and articulation. By treating you as if you were a genius, he could bring you close to sounding like one.

My delight in his wordplay, puns, conundrums, and cryptic meanings behind cryptic meanings was so stimulating, I felt buoyed up for days after a visit. Under his influence I even began writing a novel in my late teens, which turned out to be so densely packed with symbolism it was close to unfathomable.

By the kind of coincidence that struck me as highly significant when I came across it years later in Edward's journal, he met the Arensbergs about the same time I did, although his path and mine were not to cross for another four years.

It was during this time in Hollywood with Helen that she told us quite frankly she had never wanted children and once she had us she wanted to have

as little to do with us as possible. Hence the nurses and boarding schools. She didn't mind having us around now that we had become reasonably intelligent human beings. In fact, she felt rather fond of us, but when we were babies, toddlers, and children, she had heartily disliked us.

Leon and I had reached a level of sophistication by then that allowed us to accept—even appreciate—her attitude and her frankness. We did our best to treat this very youthful mother as a slightly older sister. It was then that we began calling her Helen. There had never been any Mommy or Daddy in our family. Eventually Mamá and Papá had been replaced by the more formal Mother and Father, and soon after the family broke up, it was H.L. and Helen forevermore.

During the years in Hollywood I saw H.L. only for occasional holidays. The first year when I visited him at Ocean Home on Thanksgiving I asked for money to buy something in town and he said he would write a check. I didn't realize until he got his pen out and started signing his name on cigarette papers that he was thoroughly drunk. During the following Christmas holiday, in the middle of the night, he walked out on the chalk rock step behind the house, tripped, and gashed his head. He was a big man, spilling blood, but I got him up and took him in to the couch and bathed his wound. He was so far gone he kept asking me what was the matter. These were frightening experiences that made no sense to me and that I wasn't prepared to handle.

I spent the summer of 1931 with H.L. In August he ordered me to leave. It turned out that the wife of a Carmel shopkeeper had accosted him in the street and angrily accused me of having an affair with her husband. She threatened to sue for alienation of affection—never mind that she and the husband were separated at the time. The husband, my supposed lover, operated an import store and restaurant which I frequented because my boyfriend was employed there as a clerk. The detective she hired to spy on her husband had assured her he had often seen me there. I was relieved when H.L. confronted me with this, because for once I was completely innocent and knew I could prove it. But I should have known he would not listen. He never had. I found myself again forced to leave Ocean Home, the place I inevitably returned to because I had no other place to go. In my early teens I had tried to bridge the gap between my father and me by sending him samples of my poems and asking

for his opinion. A writer of best-selling fiction, I thought, could surely provide me with some pointers. But H.L., after making a whimsical disclaimer of any knowledge in the field ("I could never get the lines to come out even"), would usually offer some specific suggestions which, to my dismay, were not helpful.

There had always been a cloud over my relationship with my father. Even as a child I sensed that there was something wrong between us, that he didn't approve of me. In letters written when I was young he referred to Leon by name, but I was always "the girl" or "the daughter," never Helen. It was clear I was tainted and had been from the beginning. I later learned, first from my Aunt Kit and then from my mother, that H.L. had always doubted I was his daughter. About the time I was conceived, Helen had spent a night away from home traveling with girlhood friends. In his irrational jealousy, H.L. imagined that she was with a lover. When he brought my mother home from the hospital shortly afer my birth, he informed her bluntly: "You realize that can't be my child—I took every precaution." It made no difference to his jealous imagination that Helen was an obvious innocent, utterly incapable of intrigue, or that I looked enough like Leon to be his twin.

On one occasion, my father's perennial jealousy had taken a violent turn at one of the regular weekend picnics under the cypresses at Point Lobos where people often became quite drunk. H.L. had got it into his head that Helen and her leading man, Theodore Criley, had been too ardent in playing out a love scene in a recent Forest Theater production. He challenged Criley to a fistfight. Fortunately, according to Helen, both men were too drunk to do much damage.

Given this background, it's no wonder that my "affair" with the local shopowner weighed heavily against me with my father. It was with considerable trepidation that I approached him at the end of my seventeenth summer and presented a plan for my future: back to Catlin School for my senior year and then, after a summer of gainful employment, off to Sarah Lawrence in the fall. I had learned of the college through Ruth Catlin, founder and director of Catlin School. She had tracked me down at the camp near Laguna Beach where I had a summer job and pleased me no end by saying I was too bright to be languishing at a place like Hollywood High.

"You belong at Sarah Lawrence," she said, and described a college that

seemed made for me, where students had individual conferences with teachers, worked at their own pace, and used New York for their laboratory. "But you'll have to come back to Catlin for a year to be properly prepared."

To my surprise and delight, H.L. gave the plan his approval.

I returned to Catlin determined to do well. After two years of academic ease and near-adult freedom in Hollywood, the austere bondage of boarding school was a shock, but nothing like the one that awaited me when I went home for spring vacation and H.L. announced, "No college. I haven't any money."

"What if I can get a scholarship for tuition?"

"Well, yes, in that case you could go."

I graduated and returned triumphant to lay before him a $2,000 scholarship plus a $500 clothing allowance—just holding the paper that spoke of these sums made me giddy.

He glanced at it stony-faced and said, "It's no use. You can't go."

I knew there was nothing more to be said. Although I was not aware of it at the time, Helen paid a final visit to Ocean Home to plead my case, but to no avail.

My initial anguish gave way to a smoldering anger. Even with the scholarship there was no way I could go to Sarah Lawrence without substantial support from home. I was in no mood to accept substitutes such as helping in my mother's shop or finding a college I could afford while working to support myself. I was not about to sell books or clothes, sweep halls, or serve meals. If I couldn't learn to be a writer at Sarah Lawrence, I would go away and live my own life and to hell with everybody. As it happened, I never would go to college.

Helen arranged for me to stay in San Francisco with the Ferriers, a couple she knew who managed the French Theater, one of three surviving foreign-language theaters in the United States at the time. Here I worked up from one-liners to several lines, but never became an experienced actress. In my spare time I also was expected to solicit theater subscriptions from the well-heeled French-speaking gentry who lived in the hills. I was so terrible at this that I rarely got past the maid who answered the door.

Weekdays the cable car clanged me down steep hills to a secretarial school in the financial district, where I tried to further prepare myself for an office job

that would tide me over until my writing could support me, just as writing had supported my grandmother and great-aunt. My early attraction to words had developed into a determination to be a poet, but now that I was under pressure to earn a living, I decided to dash off a standard potboiler, a romance, for which there was sure to be a greater demand than for poetry. This proved to be more difficult than I expected. The kind of tale that looked childishly simple to my reading eye refused to grow under my writing hand. To make matters worse, with the Depression era bank closures, H.L. had trouble sending me the small monthly stipend that, despite my declaration of independence, I still needed.

I dropped out of secretarial school and went to live in the attic home of a painter I knew who needed someone to look after his place for a while. It was a delightful garret in a building across the street from the Ghirardelli chocolate factory. I had plenty of visitors, mainly young friends who were excited about such things as starting communes and raising their own food—the sixties fore-shadowed. What made this sort of Depression-era life seem romantic was the shortage of money and the gift of time. We walked to save streetcar fare, and sat and talked for hours, because it cost nothing. Pooling our resources, we ate and drank simply and went to bargain matinees.

Yet life did not go well. Whatever confidence I'd had began to ooze away and I spent more and more time in the kind of social activity that—had I been male—would have been called sowing wild oats. I acquired a number of boy-friends, and patronized the last of the functioning speakeasies, now converting to dull legality. It didn't occur to me that I was desperately unhappy, but I was secretly grateful when my mother rescued me at the end of eight months be-cause I had an inflamed appendix. I suspect she guessed I was also pregnant, although nothing was said except by our family doctor in Carmel. After an operation in which he took care of both conditions, he said if it weren't for the regard he had for my mother he would have removed my appendix, sewed me back up, and let me suffer the consequences.

Chastened is too strong a word for my mood at this point, but I did resolve on chastity as my new way of life, and held the line until I met Edward. My sexual experience in the three years since I was sixteen had been notable for quantity rather than quality. As a result, I was less than optimistic about ever

finding "the right man," and I had acquired a rather cynical view of the male sex.

Added to the adolescent hormone rush commanding my body to get into action, I was driven by a kind of angry despair and what we would now call "low self-esteem." I did not value myself at the time, and my methods of searching for someone who would value me were inevitably self-defeating. I only began to understand this phase of my life many years later, but I was aware even at the time that I was in bad shape and moving toward worse.

Meeting Edward changed everything. With the first nude session, I had to revise my views on men—they weren't all alike in the matter of sex. Here was one who could spend an afternoon in a room with a nude female and never make a move. In a very short time we achieved a degree of intimacy I had never before experienced: Edward was the person from whom I need have no secrets, the person to whom I could tell anything, no matter how foolish or embarrassing it might be. He was the person from whom I could expect understanding, sympathy, acceptance, and love. As for making love, with Edward I discovered right away that, while I had an extensive acquaintance with the mechanics, the deep exchange of feeling that can transform the mechanics into a profound fusion of two individuals was entirely new to me. With patience and tact, and without ever commenting on my lack of erotic presence, Edward gradually broke down my resistance to real participation.

In loving Edward, my heart had found a home.

THREE

When I asked Edward soon after we met why he had never learned to drive, he gave me his standard answer: "I couldn't afford a car for years, and by the time I could, I had four boys to do the driving for me." The explanation was plausible and I swallowed it easily, recognizing that I, like his sons, had grown up with the automobile and was therefore a natural driver. But the truth, I came to understand, was that this was one more way of ensuring freedom to use his eyes in the service of his camera. It also allowed him to "rest his eyes," as he often liked to do when he wasn't making photographs.

So when the chance came in early summer to make our first out-of-town trip together to visit Edward's friend Willard Van Dyke in Oakland, I drove us north in Helen's Model A Ford sedan. Willard lived at the gallery he had started with Mary Jeanette Edwards in what had been photographer Anne Brigman's studio. He and Edward had been friends since 1929, when Willard had telephoned to ask if he could study with Edward. Willard was working in a Berkeley gas station at the time. After seeing his prints, Edward told Willard that he would be glad to take him out picture making but he didn't need teaching as he already knew what he was doing.

Willard and Mary Jeanette opened the gallery at 683 Brockhurst in 1930 to

show the work of his friends who were doing "straight" photography, which was considered radical even on the West Coast, where most photographers still favored romantic pictorialism. Though pictorialism had been rejected by Alfred Stieglitz and others in the East, it still dominated the national photography scene. While straight photographers struggled for a foothold, the works of pictorialists like William Mortensen and Adolf Fassbender earned big money and were featured in art salons and magazines like *U.S. Camera* and *Camera Craft*.

Willard's first exhibition at the Brockhurst Gallery was a retrospective of Edward's work. None of his friends—least of all Edward—had any idea that they would soon be identified as a group, with a name that to this day remains synonymous with straight photography. As Edward told it, the idea for a formal group started quite casually with a suggestion from Lloyd La Page Rollins, director of the M. H. de Young Memorial Museum. Rollins had seen a show at the Brockhurst Gallery featuring several artists, and when Willard said he hoped to find a place to exhibit the works in San Francisco, Rollins offered to give the photographers a show at the museum—but the group would need a name.

Willard announced the offer during a party at the gallery, and Ansel Adams suggested the name f.64, a very small lens aperture that gives great depth and sharpness of detail. The name, he said, had great graphic possibilities.

"But f.64 is nothing!" Edward told me during the drive to Oakland. "I stop down to 256."

I would hear this line repeatedly during our first years together, whenever Edward told the story of the founding of f.64. I don't know how many times he delivered the boast before Ansel, always the best informed of the two about technology, pointed out that universal system 256 was the same as f.64. I'm sure Edward felt greater regret at losing a good story than at being corrected.

Rollins put together a show of eighty prints at the de Young in December 1932, including work by Ansel, Edward, Imogen Cunningham, Sonya, Edward's son Brett, and several others. Ansel wrote a statement for the show, a "manifesto" just six paragraphs in length that was a curious blend of the arrogant and humble: "Group f.64 limits its members and invitational names to those workers who are striving to define photography as an art-form by a simple

and direct presentation through purely photographic methods . . . Pure photography is defined as possessing no qualities of technic, composition or idea, derivative of any other art-form."

Soon after the de Young show, Edward distanced himself from f.64 as a formal member. Never a joiner, he said he didn't like the idea that people might associate him with ideas that weren't really his own. He told me how uncomfortable he had been a few years earlier when Lincoln Steffens's wife, Ella Winter, had tried to persuade him to attend a demonstration for a farmworkers' strike in Salinas. She wanted him to photograph the action from a flatbed truck so that there would be evidence for all to see.

"I told her there would be evidence all right—a smashed camera and maybe my smashed head," said Edward. He explained to Ella that he was not a news photographer, and even though his sympathies were with the farmworkers, risking his neck was unlikely to benefit them and might well interfere with—and even terminate—the photography that was his lifework. This was his attitude toward all groups, political or otherwise.

Edward was so adamant about his independence that, the year after he withdrew from f.64, he asked the organizer of an exhibition that included some of his work from the f.64 show not to mention his connection with the group in the new show's publicity.

Although the f.64 show traveled to a few other locations, the group more or less fell apart after Edward's withdrawal, which apparently didn't surprise anyone. Years later, in 1975, when I saw Willard in New York, he told me that part of the intention with f.64 had been that all of the photographers would benefit by being formally associated with Edward.

Much has been made of f.64 by photo-historians. The 1992 book *Seeing Straight: f.64 and the Revolution in Photography* was published in conjunction with a show at the Oakland Museum that included many photographs from the original exhibition. Among other claims, the book says that the group was "arguably the most influential photographic movement of the era" and that "f.64 gave an intriguing name and a specific location to a modernist movement that for the next forty years characterized American fine-art photography."

This may be so, but I believe that most, if not all, of the participants would agree that the de Young show was really the beginning and end of the

"movement." Its primary purpose had been to showcase a new kind of photography, and that had been accomplished. Still, the pond had been stirred and the ripples continued to spread. As for "f.64," Ansel was right: it was a lovely seed pearl of a name and myths grew around it.

During the drive to Brockhurst, I was aware that I was about to be sized up by Edward's photographer friends. Willard, for one, had seen a number of Edward's women come and go and remained visibly skeptical throughout the weekend. The party—a model for many to come—was strikingly different from the parties I was accustomed to with writers and painters, who poured down liquor and excelled at gossipy, self-dramatizing talk. Photographers seemed a different species of artist, absorbed in how their medium worked and alert to whatever they could learn from their colleagues. Not that this was a particularly solemn group: jokes were common currency, and in the course of this weekend I became aware that photography supplied a great mother lode of material for sexual puns. Consider the focal length of the lens, or the extension of the bellows . . . not much imagination is required.

Of the f.64 crowd, those I would get to know best were Ansel, Willard, and Imogen. All remained in Edward's orbit, particularly Willard and Ansel, who would later accompany us on lengthy picture-making trips. Ansel and Edward met in 1928; at that point, Edward had already abandoned his pictorialist leanings, while Ansel was still feeling his way—he was printing on textured paper with black borders. Neither was impressed by the other's work, but within a few years, this changed dramatically. Ansel gave Edward a one-man show in the fall of 1933 in the gallery he ran for a while on Geary Street in San Francisco. The two began a lifelong correspondence, their letters full of mutual admiration but also of the good-natured, vigorous give-and-take that would characterize their friendship over the years.

In February 1932, Ansel replied to a letter from Edward: "Such communications are very stimulating to me and you have a true genius for clear statement of your thoughts . . . I feel that we do not essentially differ in thought, but rather that we entertain several interesting variations of approach. You have had many years of knowing and growing, and I am, as yet, groping my way.

Even in the last two weeks I am aware of a new trend of thought 'coming up for air.' "

Edward and I managed a full night together at the Brockhurst party; next we wanted a weekend to really talk, as we longed to do but had so far failed to manage. It occurred to me that "proper" couples got acquainted before having sex, but it just didn't work that way for us. One of our jokes at parting after making love was "When are we going to find time to talk?"

Our opportunity came in the fall, when Edward had to make a business trip to Los Angeles, where his wife, Flora Chandler Weston, lived. Edward described Flora as a generous free-spender who, even after he left her to live in Mexico with Tina Modotti, had sent him money off and on for several years. He said, "If you asked Flora for a cup of coffee she'd give you her heart." Edward planned to introduce us in L.A. if the atmospheric signs in her vicinity were right.

I elected to drive at night, because, in those days of single-lane highways, before the era of really big trucks, there was much less traffic after dark and less likelihood of getting stuck for miles behind some local's twenty-mile-per-hour jalopy. There were no highway lights and reflectors, and if you hit a ground fog you might have to creep along for hours. We had 375 miles of driving— eight or nine hours at least—so we squeezed in a brief nap before taking off at midnight.

We had planned to pass the time swapping autobiographies as a way to learn more about each other and keep me awake at the wheel. It might seem an uneven menu to share because of the difference in our ages, but I remembered things in greater detail and had a crowded history. We were well launched into our first chapters of recollection when we reached Highway 101 at Salinas. Each time one of us produced a memory, it would call up some long-forgotten episode for the other, and time and again Edward exclaimed, "I haven't thought of this for years!"

When the first dawn light revealed the faint shapes of oil derricks and desert shacks, we were still in the early years. The image of a flaming truck tire at the

side of the road will always be associated in my mind with Edward's solitary childhood in Chicago. His mother died when he was five and his doctor father soon married a woman who had a son of her own, an older boy who lorded it over Edward. It was not a pleasant situation for him or his fourteen-year-old sister, May, but she took steps to make life better for the two of them. She and Edward moved to the second floor of the family home where she more or less raised him. May remained a figure of daily importance for him as long as she lived. Edward felt an enormous debt to her that he never could repay, and she never really gave up the mother role.

May's handling of the situation very likely kept the family from breaking up. Edward's father, Edward Burbank Weston, was a busy man and evidently wanted peace above all—if having his daughter and son live on the second floor was the price he had to pay, so be it. But it was his father who first put a camera into Edward's hands. Dr. Weston sent the camera—a Kodak that made a 3.5-inch square negative—to Edward when he was sixteen and spending the summer on a Michigan farm. Edward wrote in response: "Took a snap at the chickens . . . Tomorrow I intend to take the house when the sun is right." A few months later Edward bought a camera that made a 5 × 7 negative—and that was it. Edward was one of those lucky people who discovers early in life exactly what he wants. He became known as a lover of many women, but as I would learn, all merely mortal females played second fiddle to photography. The excitement of his early picture making was still in his voice as he told me about it, including his pride in the moment he carried his first home-developed print into the study to show his father.

Edward said he remembered little about his years in school, where he had tried to stay as invisible as possible because of his extreme shyness. I found it hard to believe that this confident man could have developed from a child who was afraid to draw any attention to himself. Even when he was learning photography, he said, it was hard to seek help because he was afraid to ask questions.

Shyness didn't keep him from appreciating odd humor; among his amusing tales from high school was a remark by his math teacher, "Now, boys, I want you to oil up the loins of your minds and push geometry to a successful con-

clusion." And to this day I carry a vivid image of the young Edward sitting on his front porch on a fashionable boulevard with a pet rat wriggling and heaving under his cap while ladies and gentlemen drove past in carriages. When the rat died he gave it a proper burial in a nearby Catholic cemetery.

No published description of Edward fails to mention his "health faddishness," his great physical energy, and his preference for simple foods. This started when he was still living with May. Worried about being small and not very strong, he built a gym in the attic of the Chicago house, worked out with weights and a punching bag, and by his teens had developed the wiry, muscled body he maintained for most of his life. He also became one of the charter subscribers—at age twelve—to Bernarr McFadden's *Physical Culture* magazine. The magazine promoted McFadden's "physcultopathy," a health regimen that included vegetarianism, fasting, sleeping in the open air, and other habits that Edward embraced, many of which he followed for the rest of his life. When I knew him he fasted when ill and gave himself enemas to remove "poisons" from his system. He was a vegetarian by preference, although he would eat meat when it was served to him, and he refused to be vaccinated—no injecting of dead horse pus into his healthy tissues.

I believe it was also due to his association with McFadden that he always squatted to defecate. It saved sitting on suspect toilet seats, and got the business over faster because it was nature's way and therefore worked better. He also was fixed in the view that a post-breakfast bowel movement was essential to good health and had discovered a system for provoking one when his colon didn't cooperate. Taking down dry negatives from overhead lines—there could be up to fifty-four 4 × 5s clipped up there after a portrait sitting—was a job he never finished without a dash to the toilet.

"I should publicize this reaching exercise to save people from constipation," he said, not entirely in jest.

With health-food stores now in every mall, and joggers common in streets and parks, it's easy to forget how recent is the revolution in matters of diet and exercise. For most of Edward's life, his behavior was considered eccentric.

When Edward was eleven, May married John Seaman, an electrical engineer. The Seamans soon moved to Tropico (a Los Angeles suburb now called Glen-

dale), and in her frequent letters May urged Edward to come West to the land of fresh fruit and fresh air. On August 14, 1905, she wrote: "I have cried my eyes out more than once for the sight of your little smiling face . . . This is the place for you without an atom of a doubt. Every year you spend back east is so much loss to you. This is the country you have been longing for. There is not an idle person in this country. Everyone succeeds. You will have to change your eastern standard of living. Who you are and how much money you have is of secondary importance out here."

Edward quit his job at Marshall Field Wholesale and arrived in California on May 29, 1906, ostensibly for a visit. Before long he succumbed to May's scheme to keep him out West by pairing him with her friend Flora Chandler. Edward fell in love, but realized he wasn't prepared to take on the responsibilities of husband and provider, so in 1908 he returned to Chicago to enroll in the Illinois College of Photography, which advertised:

> *Good-paying positions in the best*
> *studios of the country await men and*
> *women who prepare themselves now.*
> Our graduates earn $25 to $75 a week.
> *We assist them to secure these positions.*
> *Now is the time to fit yourself for an advanced*
> *position at better pay. Terms easy; living inexpensive.*
> *Largest and best school of its kind.*

Despite the claim of easy terms, several hundred dollars for tuition was an extravagant sum in those days, but Edward didn't expect to have to spend the full amount because the school's publicity said that an energetic student could finish the two-year course in one year and thereby save tuition as well as time. He did complete the course in a year, but the savings he expected did not follow. Just telling me about it made him sputter with anger.

"They wouldn't give me the damn diploma unless I paid for the second year anyway!"

Did he pay up?

"Hell no!"

This was my first glimpse of Edward's temper, but he was so clearly in the right, it didn't occur to me that he might have overreacted. He didn't get his diploma—on the other hand the school was never able to list him as an illustrious graduate.

Edward married Flora in 1909, set up shop in Tropico as a portrait photographer, and built his own studio in 1911, a "little vine-covered shack," as it has often been described. Business was slow at first, and when Flora's brother suggested that he join a fraternal organization in order to extend his contacts in the town, he agreed and picked the Knights of Pythias. As the grand finale to an initiation ceremony with such Halloween-party gimmicks as being blindfolded and made to reach into disgusting "human entrails," he was told to take off his shoes. He was led up a short ladder, the blindfold was whisked off, and he was told, "Now jump!"

Below him in the dim light he could see a splintery board studded with spikes, their points red with rust—or maybe a little congealed blood from the previous victim? When the guides released his arms he didn't hesitate.

"I made a name for myself with the Knights," he told me, amused. "No one had ever jumped that fast before, and some couldn't do it at all. But they weren't about to impale us with real spikes, I knew that." On landing he discovered that the spikes were made of soft rubber.

In his first ten years, Edward achieved wide recognition as a pictorial photographer, with soft focus, self-consciously "arty" work that carried off prizes and trophies in national and international salons. "I even dressed the part," he said, "in a velvet jacket and flowing tie." However, he confessed he had secretly admired the sharp images in the studio windows of quite mediocre photographers. He just hadn't learned yet how to handle the abundant detail a straight photograph allows.

Nothing else about that weekend is as vivid to me as the drive itself, I suppose because the rest of the events—seeing Flora, Edward's old friend Ramiel McGehee, and others—would be repeated often over the years, while the excitement of revelation en route was a one-time delight.

We arrived mid-morning in Glendale, and were welcomed by Edward's

friends Peter and Rose Krasnow, whose house was built on land that Flora had sold them—for a song, Edward said—from the homestead that also included the site of her own house. Peter was a sculptor who had had a joint exhibit with Edward in 1928 at the Seattle Fine Arts Society, and his living room studio was filled with smooth carved tree trunks of various sizes.

We snatched a few hours of fitful sleep and then went to visit Ramiel McGehee, a former dancer and tutor to the Crown Prince of Japan, who now worked for Merle Armitage as a book designer. At Ramiel's little house at Redondo Beach he and Edward reminisced as we ate a meal, and then Ramiel—apparently having decided I was part of the family—took out his glass eye. Of the numerous pictures Edward made of Ramiel, probably the best known is *Ramiel in His Attic,* 1920.

Edward told me later that his one homosexual experience had been with Ramiel. Knowing Ramiel loved him, Edward was willing to try to give physical expression to their mutual affection despite feeling no sexual attraction to men. From Edward's point of view the encounter was a failure, and Ramiel must also have recognized this, as he never suggested a repeat. More than one commentator has tried to make a case for Edward's homosexuality. The truth is that he and I agreed it was a shame we were exclusively attracted to the opposite sex, as it probably limited our range of human experience.

The next morning, Edward visited Flora to let her know he was in town and that he would bring me by if she approved. I felt perfectly comfortable with what I saw of her. Flora had a hearty, open, friendly manner, and like Sonya and me, she wore no makeup and dressed for comfort rather than style. However, I could see that Edward was on edge. It was difficult for me to understand what about her so exasperated him that even the sight of her handwriting could tie him in knots. When I asked about it later, he told me that his need for calm and hers for uproar had proved a combustible mix. "She never let peace and quiet reign for long. The minute everyone was occupied with their own things, she would start giving orders—bring in wood, move the light, bring me a glass of water. Anything to get everyone up and moving."

On the return trip to Carmel, we talked about friendships, loves, and affairs. Could we catalogue every sexual experience we'd ever had? We started taking

turns: No. 1 for Edward and No. 1 for me; No. 2 for Edward and No. 2 for me, and so it went. This was the exercise by which we discovered that as far as totals went we were nearly equal—I believe the tally came to about two dozen lovers apiece. However, Edward's experiences had been entirely different from mine, which shows how deceptive numbers can be. The most obvious difference lay in what our sexual experiences had wrought: extreme frustration and near-frigidity in me; a great delight in the expression of physical love in Edward. The pleasure he took in giving pleasure was evidence, for me, of all I had missed in the meaningless conjunctions that made up most of my sexual past.

For all my worldly gloss I was still naïve about many aspects of ordinary living. I remember my shock when Edward said something that made me realize that he still slept with Sonya on the nights spent at home. He noticed my reaction and was surprised to find that I had assumed something different: that he and I now belonged exclusively to each other. Of course, I knew that Sonya was part of Edward's family, had been with him for five years, and, quite possibly, loved him, and that he felt great affection for her and had no desire to hurt her. But in my single-minded absorption in our affair, it simply had not occurred to me that he might—out of practical necessity, habit, affectionate feeling—be less single-minded than I was. I see now that I was guilty of a callous discounting of Sonya's rights and needs. I was still relatively unscrupulous and perfectly capable of judging—so I thought—which of us was a suitable mate for Edward.

FOUR

The Depression brought no breadlines or apple sellers to Carmel—the unemployed were indistinguishable from the rest of us—but there, as elsewhere, people experienced the relentless grinding down of their hopes and plans. My mother's dress shop, the Carmelita, was the kind of small business that perished by the thousands in those years; before the store failed, it completed my business education with the knowledge that I should avoid such traps forevermore.

My mother, by nature, was not cut out for business either, but the building belonged to her and the rent from its tenant was an essential part of her income. With sales in a slump the woman who ran the shop had fallen far behind in her payments and was threatening to declare bankruptcy. The crisis was compounded when my Aunt Kit broke her back and Helen was saddled with the medical bills. Kit's injury required a long hospital stay followed by almost a year at home in bed, and in those days there was no insurance to share the cost. Helen's solution was to take over the dress business and try to make a go of it herself.

She set up a consignment arrangement with H. Liebes, a women's-wear department store in San Francisco, using AT&T stock from her divorce settlement

with H.L. as security. Her opening announcement said the Carmelita "offered femininity a complete 'round the clock' stock of Fashion's newest interpretations . . . marked in a readily affordable price range." In the end, Helen lost her investment, but she managed to keep the business going for three years despite the pall of the Depression because of her flair for fashion, her responsiveness to the needs and desires of customers, and her unflagging effort.

Once a week the items of unsold apparel had to be listed in quadruplicate, packed in boxes, and hauled up Highway 101 to San Francisco in Helen's Model A Ford; it was a grueling three-hour trip on a narrow two-lane road. The day in San Francisco was spent at Liebes selecting new stock and picking out special items for individual customers. On the way back to Carmel we took turns driving, and the person riding shotgun used the glow of the projecting dashlight to read aloud from a new lending-library mystery—anything to relieve the monotony of the long trip home.

The next morning we unloaded the items at the store, unpacked them, and checked their contents against our list. This was a painstaking process, because if anything was missing, Helen would be responsible for the cost. Even with two people working, it was a long, tedious operation and constantly interrupted by customers. To this day, the sight of densely filled invoices—white original, pink and yellow copies—makes my throat constrict. My main job was running the office, but whenever I was needed to wait on a customer, I dropped what I was doing and rushed downstairs, as we could not afford to let anyone get away. And it was selling I hated most.

Helène Vye, a delightful Frenchwoman, also worked in the shop. She was a superb saleswoman, adept at the kind of flattery that conned customers. She was equally adept at slipping French phrases into her sales pitch for my benefit, since I was fresh from the French Theater and bound to pick up on her wicked jokes, which were delivered without the bat of an eye. On a Friday when Helène and I were alone in the store, a woman came tearing in ten minutes before closing and demanded to try on the dress in the window display. We tried to convince her that the size was too small, but she had to be sure, so out it came. Once she had wiggled her way into it, she stood before the mirror and said the size was all right but what about the color? "Oh," said Helène, "I am just

returned from Paris and that color is all the rage. You see it everywhere. It's called *caca d'oie*." Even my aplomb was shaken by having to confirm that "goose shit" was just the color for this pushy woman.

Helen and I had quizzed Helène about the latest styles on her return from Paris, being especially eager to know if the newly invented zipper would now be in every placket or whether buttons and snaps would still hold their own. "Zippers won't last," she assured us. "At least not in Paris. They make too much noise in the cinema."

Having Helène and my mother as co-workers was the saving grace of my year at the Carmelita shop.

Midway through the year, Kit recovered sufficiently to be up and around, first with crutches, then with a cane. She quickly made up for lost time—boozing, driving while drunk, keeping erratic hours, and generally acting like an out-of-control teenager. She was thirty-four and, though she lived to be seventy-one, was never to learn any better. Kit had been a golden child, adored and indulged; she posed for the illustrations of her mother's book *Son Riley Rabbit and the Little Girl*, and later starred in *Alice in Wonderland* at the Forest Theater. Like Helen, she was celebrated and sought after, but unlike her sister, she never graduated to adulthood.

Kit wanted all the frosting off everyone's cake. Whatever Helen had or did, she had to have or outdo. She developed a glib tongue, a clever manner, and a style of self-mockery of the "ain't I awful" persuasion. She often described lurid misadventures to entertain her friends, but sometimes discretion prevailed. The broken back that drove my mother into the dress business had been caused by Kit leaping from a second-floor window onto a paved courtyard, but she said she had snagged her heel in a long skirt and fallen downstairs. She had a reckless, irreverent, devil-may-care attitude that captivated me as a child and teenager but lost its appeal as I matured. Her knack for stirring up trouble took a toll on Helen, who was forced to assume the role of responsible older sister when she might have preferred having a little fun herself. Helen's main solace during the gray Carmelita years was alcohol; frequent well-lubricated evening

gatherings at the Hatton Fields house helped numb the frustration of having her life on hold.

Meanwhile my *real* life, as I thought of it then, was compressed into the few hours a day, or every few days, that I spent with Edward, who continued to live with Sonya and varying combinations of his four sons, Chandler, Brett, Neil, and Cole. Neil and Cole, the younger boys, alternated between Flora and Edward—when mad at their mother, they transferred operations from Glendale to Carmel. The older two, Chan and Brett, were struggling to succeed with a portrait studio that Edward had set up for them in Santa Maria. The venture failed because the brothers didn't get on well as partners and business was as thin in Santa Maria as it was everywhere during the Depression.

At the end of one morning rendezvous, Edward showed me the carbon copy of a letter he had written to Seymour Stern, the editor of *Experimental Cinema.* Stern had published some of Edward's photographs in the magazine after saying how impressed he was with their power and originality. When irate subscribers demanded to know what kelp and peppers had to do with the class struggle, Stern had recanted and written to admonish Edward that if he didn't "go in for social subjects" he would be "creatively dead in two years."

Edward's letter in reply (four typed pages, single-spaced) assured Stern that he would not be creatively dead, "not in two years, nor a hundred years."

> *Any good technician with revolutionary understanding and an eye for news might do propaganda much better than I could; but there are few who could approach my work, take my place, the place in which I function best . . . Only by working for himself can the artist fulfill his reason for existence and directly or indirectly serve mankind . . .*
>
> *The artist can neither serve the plutocrat nor the proletarian—he must be free from all but self-imposed obligations . . . My own work is certainly anti-bourgeois. If it has no obvious propaganda, it nevertheless has a definite place today: it functions in the life of today. I have revealed to a select few the living world around them, related them once more to all*

life, shown them what their own unseeing eyes had missed. But my pho-tographs though exact copies of nature *are not understood by the masses, because the abstract essentials are not grasped. The masses can only un-derstand words or word pictures; and art begins where words end . . . Rules are never more than approximately true, deduced from the* intu-itive *vision of the artist. Dogmatically applied by* reasoning *disciples the result is decadence. Reason is used by the non-creative—calculation in-stead of invention. Everything of importance works from within outward.* Science too! We know nothing that has not started from a "hunch," intuition!

Edward realized that it was a chaotic outpouring, but felt that the writing had forced him to clarify his ideas. I was impressed, but also noted—to myself—that the letter would have been more effective with some good editing.

One sunny day, Leon and I went to the lagoon at the mouth of the Carmel River for a swim. As happened annually, a channel had been dug down the steep ocean beach, and lagoon water was rushing down it in roller-coaster waves that roiled the choppy sea water for two hundred yards offshore. In the past we had often dived into this millrace when it was opened and enjoyed a rapid ride, but today the current made us hesitate.

After a moment's consideration, Leon dived in close to shore and soon was climbing out again on dry land. As I watched him, the bank where I stood gave way. I clawed at the sand, but the current was too strong, and the next mo-ment—without time to get air in my lungs—I was rushed down the channel and out to sea, under water all the way. When I fought my way to the surface about a quarter of a mile offshore, still moving fast and gasping for breath, I saw Leon dive back into the millrace. Soon he was choking and gasping at my side, but his foolhardiness made me angry rather than grateful. I was a better swimmer and was sure he'd never be able to help me—now we were both in danger.

"Never gave it a thought," he told me later. "There you were, so in I went."

When he regained his breath, he headed for shore south of the current, urging me all the while to follow. "Come on! Keep swimming! Get going!" I had already realized that I couldn't make it back and, in my exhaustion, was beginning to feel a peaceful attachment to the alternative. I didn't want my last moments spoiled by his unreasonable exhortations and flailed in his direction to get close enough to tell him to shut up. In my deluded, half-drowned state, I didn't realize he was saving my life. Fog was rolling in, and for a long time we made no headway, but gradually we began to see things on the beach. Three boys had built a driftwood fire south of the channel, and now and then they looked our way. Time is so distorted in such situations that I'll never know what those "hours" in the water really amounted to. Twenty minutes probably. When we finally reached the beach, we collapsed on the sand, sibling flotsam and jetsam.

This was my first close encounter with death. On the drive home, I discovered I had acquired a new order of perception. What had been dull tan needles lying massed under the pines now made a radiant red-brown carpet; drab roadside weeds had been transformed into luminous flowers. Leon also saw this different world, and we marveled at the intensity of the colors.

When I got to the studio early the following morning, Edward saw my face in the flickering candlelight and realized something extraordinary must have happened. He tucked me into his warm bed, went to rummage in the supply cupboard, and returned with a shiny white sake bottle and two miniature cups.

"A Christmas present from a friend," he said as he heated a pan of water on the hot plate. "I've been saving it for an important occasion. Now tell me what happened."

Such experiences are not easily communicated. If the tale is told in too lighthearted a manner, it sounds silly or unbelievable. If told too dramatically, it seems to demand a similar response from the listener. But Edward understood the significance of the event, and when I finished my story, we pledged, between sips of warm wine, not to lose each other, to treasure our love and keep it safe for the time that would surely come when we could be together.

. . .

Edward had parties in the studio fairly often. Guests generally included anyone visiting from out of town who could be used as an excuse to celebrate, plus Sonya, lawyer Doug Short from San Francisco, Sibyl and Vasia Anikeef—she a photographer, he a Russian baritone—and a dozen or so other friends. Parties started about eight and went on until midnight, the guests separating naturally into talkers and dancers. I fell in with the talkers, but Edward mingled with both, as he loved to dance when he had a good partner. He had learned in Mexico and was particularly enthusiastic about rumbas, a dance where the man could really show off. I was not an ideal partner for him, being taller and heavier, as well as a very self-conscious stumbler.

He invited Helen to a party after asking me what she thought of *us*. I had to admit I didn't know. By now she must have been aware of my relationship with Edward, but true to family form, the subject was never raised. Edward got Helen to dance a few times, and also sat talking with her for a while on the low, serape-covered bed. He looked comfortable, open, interested; she looked unsure of herself and wary. I was pleased to see them spending time together and didn't notice until we left that she was drunk. I drove us home, and as we sat in the car outside the garage, she turned on me with blazing eyes.

"I *hate* you!"

I responded with some sort of drunk-soothing twaddle—"You don't mean that"—but I was shaken by the undisguised anger and ferocity in her tone. "I mean it. I hate you," she said again.

It took me years to understand the source of my mother's resentment. Helen was a fascinating human being, blessed by the good fairies with an array of gifts that kept me in awe as a girl: beauty, poise, grace, wit, a natural talent for singing, acting, painting, gardening, cooking, and the magical ability to make people feel comfortable and draw them out. I saw her as superior in every way and it would never have occurred to me to try to compete with her. Not until I was almost twenty did I discover that the uninvited fairy had cursed her with such a destructive lack of confidence that not one of her skills could be developed into a satisfying vocation. Her instincts identified the right projects for her and she was quick to volunteer to play the role, sing the song, design the

costume, plan the party, cook the banquet. Then, having committed herself, she suffered a thousand devils of doubt.

What I had constructed during my lonely growing-up years at Ocean Home and boarding schools was an impressive façade of confidence; the last thing I was willing to reveal to anyone, with the notable exception of Edward, was a trace of self-doubt. I had broken all the rules Helen had so circumspectly kept, carrying on a varied sex life from the age of sixteen, while she had had her first disastrous experience in the marriage bed. At twenty she already had two children and was bound to a husband completely unlike the romantic figure she had hoped for. I, too, had fallen in love with an older man. The age difference between Edward and me was almost exactly that between my father and Helen, but where H.L. was dour and suspicious, Edward was open and easy. After an evening of seeing us together, Helen, a keen observer, had undoubtedly deduced that our love was fully and frequently consummated. It must have seemed to my mother that everything had fallen into place for me with little or no effort on my part, while she was trapped by circumstances that nothing could alter.

Helen never referred to her drunken outburst and we resumed the playful bantering that characterized our adult relationship. I seldom thought of her as my mother. Despite the subterranean tension which surfaced that night and the constant drudgery of the dress shop, she and I enjoyed a close companionship in those days, sharing the casual intimacy of sisters or girl friends, living and working together, finding what fun we could in the ridiculous aspects of the retail world and the foibles of various customers. Every working day at noon, Helen and I donned stunning examples from our ready-to-wear collection and made a strategic four-block promenade to Whitney's, a popular Carmel café, hoping to impress the natives and lure potential customers. Once there, seated across from my stylish companion, I was careful not to drop bits of BLT or slosh coffee on the valuable Liebes merchandise.

One day at lunch we were talking about a friend, an older woman who was one of our regular customers. Helen commented on her impeccable grooming, saying that it couldn't be easy for her, living alone on a limited income. She added, "But she knows that a woman's first job is to be attractive to men."

I was sufficiently shocked by this assertion to make no reply. My mother had shed the Southern accent but not the Southern view of a woman's role. The

persistent image of her making up before her mirror—the little *moue* after the lipstick was applied, which seemed to beg for affirmation—still haunts me.

Since meeting Edward, I had learned that being female wasn't so bad. I had been mistaken in supposing that men had the best of everything. Even so, I had no intention of changing my views on feminine fripperies. I was unsure of myself in many respects, but I was dogmatic about this: makeup, plucked eyebrows, permanents, nail polish, girdles, silk stockings, high heels, and the dictates of fashion were in no way essential to being a woman.

I had come to terms with my gender, but I still had lessons to learn. One of the gatherings at Edward's studio that year was a "baby party," modeled on one Kit and Helen had organized some years before. The idea was that adults, when dressed up as infants, proceed to shed all inhibitions . . . I got vilely drunk on the sweet punch, and since someone was occupying the bathroom, Edward had to steer me out onto the balcony, where I decorated the two-story rose vine with recycled punch and cold cuts. The vine ended at the courtyard door of the exclusive Viennese Shop, so Edward had to return at dawn to clean up the evidence of my debauch.

Edward put up with my irresponsible behavior, although I'm not sure how to characterize his forbearance. He knew it was part of "growing up"? The faults that seemed enormous to me seemed minor to him? Whatever his view, the only time I remember feeling a sting of rebuke was after an episode involving Merle Armitage. I met Merle when he was visiting Carmel from Los Angeles for a weekend, and he joined Edward, Sonya, Leon, me, and a few others for a beach picnic at Big Sur. Edward made a few nudes of both Sonya and me, but because it was chilly, the session didn't last long. Merle ended up driving me home at dusk, but he took a detour down to the water's edge and went for my body.

He was an overpowering man and I didn't know how to react to his mixture of baby talk ("Is oo ittle nippies told?") and strong-arm style; I hardly believed it was happening. He stopped short of intercourse, but I felt ill-used and certainly thought it odd behavior for someone who was a good friend of Edward's.

When I told Edward what had happened, he didn't take it seriously, saying only, "That's Merle for you!"

Unmollified, I held on to my resentment. When Merle came to visit again—

this time with his wife—I was invited to join them at Edward and Sonya's house. I got just drunk enough to vent my spleen by obnoxiously monopolizing the conversation. What Edward conveyed to me afterward in no uncertain terms was that I'd better watch my step—he did love me but not at the expense of longtime friendships. Merle had published Edward's first book—*The Art of Edward Weston*—arranged for portrait sittings with various celebrities, and done whatever he could to move Edward's career along. For Edward, such dedication meant that character or personality flaws could be overlooked. I was hurt, but I had to accept that his tolerance of bad behavior didn't apply exclusively to me.

In the summer of 1934 Helen met Paul Peabody, then stationed at the Presidio in Monterey. A major who soon became a colonel and ultimately a brigadier general, he was a charming man, shy and reserved, who clearly doted on Helen. Paul's sweetness and affection resurrected her spirits, and she was lighthearted and radiant in his company. He was married but told Helen that his wife had taken to her chaise longue soon after the wedding and stayed there ever since. When Paul was transferred from Monterey to Washington, D.C., he made it clear to Helen that he wanted to marry her as soon as he could arrange for a divorce.

Helen drank more when he had gone. Fed up with the shop, with Kit, with Carmel, she longed to join Paul in Washington, but couldn't see how to manage it. One night she was feeling particularly morose and consumed two or three gin rickeys in lieu of dinner. We were alone in the house. Leon had recently taken a job in Los Angeles, working in a friend's puppet theater; Grace and Allie had moved to Los Gatos; Kit was off on one of her rambles.

We were sitting on hassocks watching the fire burn down, warming our shins and putting off the trip to bed, when Helen suddenly toppled over onto the sunken hearth, her head landing in the embers. Horrified, I pulled her out and brushed the sparks from her hair and clothes. She opened her eyes and said in her natural, undrunken voice, "I often think how simple it would be, just one good breath and your troubles would be over." Unnerved by the incident and

appalled at her words, I felt desperate to get her back to Paul. She seemed so frail and vulnerable that I felt something like the weight of maternal responsibility descend on my shoulders.

Among Edward's friends in Carmel, Sibyl and Vasia Anikeef were the only ones who knew for sure we were a couple. Sibyl went so far as to provide us a bedroom on one desperate occasion when Edward and I both had time off but nowhere to go. Although twenty years my senior, Sibyl seemed my contemporary; she was warm, outgoing, and strikingly beautiful, with sparkling brown eyes that gave no hint of the tragedies in her life. She had lost several family members within a brief span of time, and then in 1932 Vasia had been afflicted with throat cancer, which ended his performing career and left him speaking in a damaged croak. He continued to teach singing as well as he could, and Edward taught Sibyl photography so she would have a way to earn a living.

At Edward's request Sibyl made a set of pictures of our clasped hands in which Edward's amidol-stained nails and my twelve-stone turquoise ring are prominent features. When I look at the pictures I recall at once how warm Edward's hands always were. When I met people I made a point of shaking hands as an addition to my store of unfeminine acts and was always told that my own were cold, so I was probably even more aware of the heat he generated.

Sibyl also made a portrait of Edward newly shaven. I'd complained that his mustache was scratchy and he'd taken it off, even though he didn't like the look of his long upper lip. The picture comes closer than most to showing his dashing appearance; for once he isn't a victim of the self-consciousness that normally afflicted him in front of cameras and that gave him an unjust reputation for somberness.

Another friend of Edward's, painter Henrietta Shore, often invited us to dinner in her tiny Carmel cottage. Henry was a very large woman who spoke in a distinctive combination of childish affectation and precise eloquence. She owned a Model A Ford but was not a good driver. On long trips she sometimes got Edward's son Neil to act as chauffeur, insisting that he stop for gas in every town because she thought the car ran better with a full tank.

Edward and Henry had met through Peter Krasnow in 1927, when Edward was living in Glendale after he returned from Mexico. Henry had been a student of Robert Henri's in New York but had lived in Carmel since 1930. It was in Henry's Glendale studio, in March 1927, that Edward first saw nautilus shells, borrowed them to make pictures, and wrote in his *Daybooks:* "I was awakened to shells by the painting of Henry. I never saw a Chambered Nautilus before. If I had, my response would have been immediate! If I merely copy Henry's expression, my work will not live. If I am stimulated and work with real ecstasy, it will live. Henry's influence, or stimulation, I see not just in shell subject matter, it is in all my late work."

In 1934 Edward photographed Henry's work and wrote the foreword for a book that Merle Armitage produced about her, but by the time I knew him, his close friendship with her had cooled, in part because he had begun to find her judgmental. She lectured Edward about his nudes: she felt he was making too many of them, to the point that some of his pictures were "just naked and not nudes at all." Henry herself made some very sensual pictures of plants and—like Georgia O'Keeffe and Edward—had a lifelong struggle with people who insisted on seeing sexual imagery in her work. When viewers complained about suggestive stamens, corollas, and so on, she would simply say, "I paint what I see."

Despite his own frustration with the vulva- and penis-finders, Edward confessed in the *Daybooks* to having the same reaction to Henry's work:

> *Henry showed me the new mural she is painting. It is most obviously phallic! Now she would protest just as vigourously as I have in my recent explosion, against this label, or libel! Or would she? For I have heard her remark that sex enters into her work, as a part of life: which indicates she consciously does think of phallic symbols, while my work, if it has such tendencies, could only have them by virtue of my subconscious,— naughty—naughty subconscious!—what am I depriving you of? Of course knowing Henry, the very inhibited life she must lead, I may be constrained to at once look for phallic symbols, and especially since she is spoken of as a pathological painter! I hope Henry never hears this remark!*

But I must admit that sex is very obvious in a great deal of her work, and I'm not the kind who is on the hunt for an artist's aberrations—or a layman's either.

Edward sometimes responded to people's Freudian focus by telling them a favorite joke. A psychiatrist is showing geometric figures to his troubled patient. A triangle: "What does this make you think of?" "Sex!" A square: "And this?" "Sex!" A circle: "And this?" "Sex!" "When are you going to stop thinking about sex all the time?" "When are you going to stop showing me these dirty pictures?"

Dene Denny and Hazel Watrous were important figures in Carmel. Dene was a pianist, Hazel an artist and designer, a combination that made the Denny–Watrous Gallery known for its concerts as well as for its art exhibits. In 1934 the two women founded the annual Bach Festival, which remains a major musical event. Its launching provided two gems for Edward's repertoire of stories. When someone brought a publicity poster to hang in the window of Espandola's, the market where Edward got most of his good peppers to photograph, the clerk examined it critically and said, "Look, they spelled beach wrong."

Another Carmel shopkeeper asked, "Bach? Bach? Didn't Edward Weston photograph him?"

One day I went to the Denny–Watrous Gallery, where Edward's first exhibit of 4 × 5 nudes was being shown. A tourist came in, gave a look around, then went out and yelled up the street to her friend, "You've got to come see these terrible pictures right away. They're just awful."

Another group of women examined them more thoughtfully and puzzled over a photograph of buttocks. The first woman said, "A peach?" The second said, "No, knees." The third recognized the real thing.

In January 1934, a sale at the Denny–Watrous Gallery had offered Weston prints with slightly damaged mounts and other flaws for just two dollars each. This was low even for Edward, whose usual price was $15 a print, although friends bought them for $10. Edward always insisted on keeping his work af-

fordable. Photography, he said, is a poor man's art and anyone who wants an original print should be able to own one.

The Depression finally brought down both Helen's Carmelita shop and Edward's business. Customers at the dress shop were too often just looking, and portrait sittings were becoming scarce. Edward could not afford to support the studio and a household. There was probably no cheaper, easier place to live than Carmel during the Depression, but the overall situation there was dragging him down. Optimistic by nature, Edward was generally good at pushing economic problems out of his mind. When things got bad, he usually believed something would come along to save the situation, and he always had great faith in photography providing a livelihood. In fact, he had taught most of his women friends photography, telling them, "You'll always be able to earn a living." Now he was beginning to have doubts.

In November, Ansel wrote to express his artistic confidence in Edward's work as well as to offer some practical suggestions: "I gather that things are not entirely smooth with you in Carmel, and I have been intending to write for several weeks and just think out loud to you . . . You have made a definite contribution to photography that puts you on the immortal shelf along with Hill, Atget, Stieglitz." He advised Edward to "simplify your Carmel situation as much as possible," and then offered a four-step program that was essentially a marketing strategy in which Edward would coordinate portrait sittings with exhibits in metropolitan areas.

Merle also wrote, but with something more substantial than advice; he offered Edward a job in Los Angeles. The year before, Edward had done temporary work making pictures for the Public Works of Art Project, which had begun in 1933 as a program for supporting muralists. Originally proposed to President Roosevelt by artist George Biddle, the PWAP had expired since Edward's brief stint, but was reborn in 1935 as the Federal Art Project under the new Works Progress Administration. Knowing he couldn't survive in Carmel, Edward accepted Merle's offer.

He closed the studio in January 1935. He and Brett loaded some furniture

into Brett's car and trailer and headed south. Sonya stayed in Carmel, joining forces with Sibyl Anikeef to earn what they could as photographers. Cole and Neil had already joined Flora in Glendale. Although I realized that Edward needed to go, his private promise that he would send for me "as soon as he could" did little to reassure me.

There was nothing uncertain about *my* feelings, even though I had known Edward for less than a year. I wrote to him not long before he left: "Now I know the riddle of the sphinx—and god's first name and all the other secrets—Being with you is all there is—To live with you—Work with you—Love with you—How can I write in the midst of people noise and music? and what more can I say—I love you—and all that that means now—much that it never meant before—I want to be something to you that I have never been to anyone else—Never could be to anyone else. I love you deeply—and love you more as we grow together. I want to give you all that is mine to give and that you want and mas que."

I would be a legal adult in May, but I was unprepared to deal with the losses and responsibilities that were piling up around me. After much encouragement from me, Helen had taken the plunge and decided to move to Washington, D.C., to join Paul Peabody. I did my best to bolster her courage and promised to deal with the aftermath of closing the shop—collecting final bills, selling fixtures, and so on. When I finally put her on the train in a new leopard coat ("Oh, Charis! Do you really think I should get it?") and a jaunty new hat pinned with a corsage of her favorite violets, I could see some of her *joie de vivre* returning. To mask my distress at watching her go, I called out a playful warning as the train pulled away: "Watch out for card sharks, Helen—they'll take you for your spots!"

It was wrenching to have her gone. The Hatton Fields house was to be sold. Kit was going to live with Grace and Allie in Los Gatos and I was to stay with H.L. for the time being. Moving my belongings from Hatton Fields to my father's house at Carmel Highlands meant leaving the closest thing I'd had to a home since childhood and returning to a house from which I had been banished not long before.

Once installed at Ocean Home, I settled into a trough of depression. About

three o'clock one morning, coming back from Carmel after a day of endless chores and a night of excess drink, I fell asleep driving H.L.'s Cadillac and ran the car into a ditch. With a mile yet to go, I set off walking on foot, weaving all over the road. By the time I crawled into bed I was sober enough to realize that getting out of Carmel was as urgent for me as it had been for Helen.

Working alone to close the shop, I let my mind wheel through painful questions. What was I doing with myself? Why wasn't I writing more? Did my poetry really amount to anything? If I was so smart, why couldn't I get a job that paid well? I took little comfort in the knowledge that in those Depression days even college graduates were having trouble finding work.

I pored over notes from Edward, going through their brief lines word by word, as if trying to read my future in tea leaves. Edward reported that he and Brett had found a house in Santa Monica Canyon a short walk from the beach; it sounded idyllic, yet impossibly remote. Part of what attracted me to Edward was his certainty. He knew who he was, what he was doing, and what he meant to do, and he soon made it clear that there was no waning in his desire for my company. He sent me a Valentine print titled *Masque*—a classical arrangement of artifacts from our time in Carmel, including a brass candlestick, a pottery coffee cup, a gaily painted Mexican box, Edward's Graflex lens, the white sake bottle on whose neck hung a Japanese grass slipper, one of a pair that had kept us from blackening our feet on the oiled studio floor. Behind these objects were two envelopes, one with my name, the other with Edward's trademark sealing wax. On white mounting stock he had inscribed words and numbers that connected us during those clandestine days—pet names, significant dates, and the numbers of our mail boxes, telephones, and my license plate. There was also a sample table by which we had discovered that whereas I was then only three-sevenths of Edward's age, I would gain on him steadily, and eight years hence I would be half his age. In the center of the picture was the horn-rimmed pince-nez that spoke eloquently of Edward at work, its cord curving gracefully to end in a loop, which enclosed my special name and our magical date. With the photograph was the message "Come on down. If we are going to starve, we might as well do it together."

I reacted with such a warm rush of gratitude that I could hardly refrain from

embracing the picture. But I also had doubts. Would running to Edward for shelter be a good beginning for our life together? What did I have to offer him that could make a strong alliance—devotion? fidelity? the ability to work hard?

What I did have, I realized, was a greater command of language, a tremendous enthusiasm for his work, and a great outpouring of love. And, finally, a strong sense that his work could be even better appreciated and that somehow I could help tip the balance in that direction.

Was this enough to bring? What about the unforeseeable problems of close living with his sons, who, given Depression conditions, might be part of the picture indefinitely? And what about the pitfalls of sharing a house with Edward unmarried? It was not common in those days to "shack up," so to the outside world I would have to pass as Edward's assistant. Would I be able to tolerate the effects of this ambiguous state?

But questions were just series of words strung together, followed by a little curved mark. I had not seen Edward for eight months. At the end of summer, when things were more or less in order, I boarded the train for Los Angeles.

SANTA MONICA CANYON

FIVE

Dusk was turning to dark when the Daylight Limited rattled into the Los Angeles station, where Edward and Brett gave me a welcome so warm that my lingering doubts subsided. Brett loaded my two stuffed suitcases into his car, and we headed for Santa Monica Canyon. Like a strong undertow beneath the bright and newsy chat, I felt emotion threatening to overwhelm me, and Edward and I gripped hands in near-silence, leaving it to Brett to handle most of the talk. When we drove up to the house on Mesa Road, Brett said in his best salacious tone, "I guess you lovebirds won't be needing me around here, so I'm taking off for a while."

We only managed a half-tour of the house and a quick introduction to Satan, the black kitten, before we were in bed, and there we spent most of our time for the next few days, enjoying a long-delayed honeymoon. We were making up for a long and hurtful separation, reconnecting the circuits that letters alone had failed to maintain.

The bedroom was furnished with the familiar bookcase-desk and the serape-covered, springs-on-the-floor bed—the brass candlestick was nearby atop a Mexican chest. Some mornings I would wake with a jolt, thinking I must leap up, dress, and get out before the shopkeepers came to open up, and then I

would realize with a sigh of pleasure that there were no shops to open and no shopkeepers to hide from.

Those first few weeks on Mesa Road served as an idyllic recess between my old life and the new one. I had never lived with a man before, but with Edward the adjustment was easy. That he and I could spend whole nights together was a dizzying delight that was amplified by leisurely days. When he and Brett were occupied until midafternoon with Art Project work at Exposition Park, I would walk to the beach for a swim, play with Satan, work on my poems, and read Edward's *Daybooks*.

In most respects, 446 Mesa Road was a standard Southern California bungalow, with the long side of the L-shaped living room continuing into the dining room. There was a fireplace, and a French door looking onto a tiny patio. The big room was sparsely furnished: the dining table doubled as a worktable, and the same half dozen chairs served in the dining room or living room. There was a bedspring couch against the wall beside the front door, and the upholstered chair where Edward sat to spot prints stood near the fireplace. This left lots of bare hardwood floor visible, giving the room the look of a studio.

The old-fashioned kitchen, all space and no work surfaces, had a swinging door at one end, which led to the dining area and was kept open most of the time to avoid collisions; the door at the other end was usually closed, because the darkroom lay beyond. Upstairs were two small bedrooms with a bath between them. Edward and I shared one, while Brett, the only son in residence when I arrived, had the other. When Neil and Cole joined us later, they had to make do with box springs and mattresses on the concrete floor of the garage.

Although the interior of the house had a standard layout, the spacious sundeck that covered most of the roof was unusual. Surfaced with silver-painted tar paper and surrounded by a three-foot parapet of white plaster, the deck in full sunlight dazzled the eyes. Because he had rejoiced in such a rooftop area for photographing and sunbathing a decade earlier in Mexico, Edward was seduced into paying more rent than he should have.

The section of Santa Monica Canyon the house occupied was a steep-sided ravine with a stream trickling down the middle. A climb of three hundred steep

wooden steps had to be made to reach public transportation. At the top you could board the interurban—"Ride the Big Red Cars for ease and comfort"—for a jolting one-hour trip through squalid back yards and industrial wastelands to downtown Los Angeles. The transfer said, "Keep in plain sight. Surrender to conductor upon request."

In the opposite direction from the stairway the going was level and you soon came to the nest of hot-dog stands along the highway where the smell of old, burned grease heralded the beach. Cars were not numerous then and it was easy to hold your breath until you got across. The beach looked dirty to my Carmel eyes, but that was as much due to the color of the sand—a kind of brown-and-gray-heather mixture—as to the litter.

The new life swallowed me up so rapidly and completely that I was scarcely aware of any transformation, yet almost every aspect of my recent Carmel life was obliterated. It amazed me to realize that, although I had known Edward intimately for over a year, I had no clear idea of how his daily life proceeded. The first thing that struck me was the discrepancy in our attitudes toward work. I looked on it as a grim necessity, something to be gotten through and disposed of so that real life could begin. Edward's view was that his work was his life; everything else fit into place around the central core. But if I had pictured him rushing off to the darkroom first thing in the morning—like the man in the funny papers dashing to his office—I was due for a surprise.

My first impression of Santa Monica life was that it was a continual picnic. On days Edward and Brett didn't work for the Project, there seemed to be no mandatory hours and no pressure to get on with any particular task or complete it by a certain time. Edward and Brett usually got up at dawn, had some coffee and juice, and then started their day. I arose about seven or eight and headed for the kitchen to make breakfast. Eventually I converted to the coffee-only school, but without deep conviction since I always woke up famished. In general it was I who adapted to Edward's lifestyle, which was so well defined by then that the only impact I made on his personal habits was to get him to stop putting sugar in his coffee.

Edward and Brett took a midmorning break, ate a bite or two, and then I joined them on the roof for a sunbath. Afterward everyone got busy for a while,

and then it was time for lunch. Unless the arrival of company called for something more formal, that meant standing in the kitchen nibbling on whatever was handy—Rytak and cheese or avocado, dried figs, cold pea soup. This last was especially appreciated by Edward and Brett when it had been around long enough to become solid. As my mother pointed out when she came to visit the following year, this pudding-like dish was the original of the "pease porridge" that some liked "in the pot, nine days old."

Back to work for a short time, but midafternoon usually called for a walk to the beach, a lie on the hot sand, and a Pacific dip. Next thing you knew, it was time for afternoon coffee, and so on. Somehow, among all these semi-scheduled recreations, a lot of work got done.

Initially, I found this way of life difficult to understand. How could people accomplish so much without a fixed schedule, at such a leisurely pace, and with a small but steady stream of interruptions? People called, occasionally about sittings or exhibitions, more often asking if it was all right to come out for a visit and a swim. I was still a captive of the nine-to-five world, and this system looked to me like too much time off, but—as I gradually realized—it was a system whose every operation had been pared down to its essentials. The guiding principles for Edward were to save time and money for photography and to enjoy life while doing so.

Domestic routine was simplicity itself. The soups or casseroles that were the mainstay of meals needed little preparation and lasted for several days; a dust mop cleaned the floor quickly; clothes made of denim, corduroy, or seersucker eliminated ironing. The jeans that fit Edward in the waist were always too long, but he didn't bother with hemming; he turned them up, so he often had eight- or ten-inch cuffs. He kept a red or blue bandanna in his hip pocket and always wore white socks, because he thought they were cooler and more wholesome. Edward and I both preferred Mexican footwear—either huaraches or *alpargatas*, Mexican woven sandals or canvas-topped, rope-soled shoes. For the most part, I wore men's pants and shirts; they were less expensive, better made, and you didn't have to reinforce all the buttons first thing.

Along with simplification went money saving: we cleaned our teeth with precipitated chalk, the main ingredient of toothpaste but costing only pennies a

pound when bought in bulk. The Westons all cut each other's hair and were expert barbers. I never became proficient, but Edward put up with my bungling until I learned to do a passable job. I proved to have more native talent at giving neck rubs or back rubs—everyone's standard aspirin substitute.

Clothing and laundry costs were cut by what was then called "sleeping in the raw." I felt like a sissy for having arrived with a bathrobe and slippers, but when Sonya sent Edward a bathrobe she made him—the first he had ever owned—he found its instant warmth pleasant and decided it was unlikely to lead him into sybaritic habits. Instead, it let him go out on the deck at first light to observe the dawn sky and assess the weather for the coming day before making coffee at our bedside hot plate.

We rarely ate out, and if we did, it was usually in French restaurants where an exceptional meal could be had for less than two dollars. Brett would get there first, station himself at maximum distance from the front door to watch for our arrival, then roar "Mummy!" and stride past tables the length of the restaurant to gather me in a fond embrace. What could I do? I'd murmur "Sonny" in more subdued tones as the ballet line of turned heads swiveled slowly back to normal position. Brett would then order a steak "well done" and, when it came to the table, eye it critically, poke a fork in it, and instruct the elderly French waiter to "take it back and burn it up!" The poor men who had to carry out this grisly execution invariably winced at the destruction of good meat, and I always suspected their horrified reaction was part of Brett's fun, especially as he was likely to leave a sizable portion of the charred corpse on his plate.

My drinking habits had been swiftly curtailed on arrival at Mesa Road. Wine—a jug of the cheapest—was something purchased for a party; otherwise there was nothing alcoholic around. I had no trouble adjusting to this abstention, but I was also happy to accept such beverages when we were asked out. Edward would agree to a half glass of wine; this was sufficient to do the work of two drinks for most people, so he sipped slowly and respectfully.

Sometimes money could be eliminated altogether by bartering. Edward's first returns from this practice netted us two gallons of California olive oil from an Italian rancher in exchange for family portraits. A hunk of whole-wheat bread

soaked in this thick green liquid was a sight to turn my stomach, but the Westons considered it a great delicacy. Brett would smack his lips over the tasty treat and insist, "Marvelous, Charis—you ought to try it!" He considered me a real sissy for abstaining.

Another bartering attempt netted dental care for the whole family from a charming woman who spent her weekends at a nudist camp, but our greatest coup resulted from publicity pictures Edward made for the Abas String Quartet. We chose an evening for the quartet to play at our house and invited neighbors and friends, including people who had wined and dined us when Brett and Edward had gone out print showing. (These outings were a regular feature of Edward's life for years. They gave him a chance to show new work to old friends and former patrons, to renew acquaintances and meet new people, and sometimes to sell a print or two.) We invited about thirty people to hear the quartet and expected that half might turn up, but by the time the musicians arrived, the house was crowded.

"Where do you want us to set up?" Nathan Abas asked a little nervously when he saw no space reserved. "Right in the middle," Edward replied, after a quick head count. "We'll fit the audience in around you."

In response to our S.O.S., neighbors brought a few more chairs, but at least a third of the audience sat on the stairs, the floor, or the end of the dining-room table. However, the concert was a great success, and while audience and musicians mingled afterward, we served cookies and wine, the cheapest available. Nobody seemed to mind.

What impressed me most about the affair was how little time had been devoted to planning and preparation. The wine and cookies were picked up on a grocery-shopping trip; one of us ran a dust mop around the downstairs. In what I already thought of as my former life, I had known preparations for such an event to take hours or even days—the listing of invitations and responses, arranging for adequate furniture, deciding on refreshments and preparing them. Here, as with the parties in the Carmel studio, the spontaneous approach seemed to make the event more enjoyable for everyone.

Neil and Cole had joined us by this time, and with five of us living in the house, Edward had established a schedule of chores—cooking, dishwashing,

cleaning, watering—so that everyone took a turn at each. He made it clear from the start that I was not a replacement for the more domestic Sonya and was not there to be a full-time housekeeper. The boys were probably less than happy about that, but they had all lived with Edward for extended periods so they knew how to look after themselves. Edward believed in self-sufficiency and taught his sons to be competent, even to the sewing on of buttons. This quality spoiled me for any future conventional domestic arrangement, because I was unused to divvying up responsibilities according to standard male and female roles. It wasn't that Edward was a proto-feminist; he just wanted to be as independent as possible.

Like any new kid on the block, I had to be tested by the boys: what did it take to embarrass me? to raise my hackles? They knew from Carmel days that I came equipped with such a generous fund of bawdy jokes and limericks that they couldn't hope to compete. Now they discovered that neither vulgar language nor crude noises disconcerted me. I was even more of a disappointment when it came to goosing, a practice unknown in my former life but much favored among the young Westons. Perhaps I was too well upholstered, at least compared to their previous victim, Sonya, who was always good for a shriek.

Adjusting to an all-male household would have been more difficult for me had it not been for my smug conviction that Edward's sons were still children, even though, at twenty-one, I came right in the middle of the five-year span between Brett and Neil. Brett would be twenty-four and Neil nineteen that December. Only Cole, who wouldn't be sixteen until the end of January, was conspicuously my junior, but that didn't keep me from thinking of them as "the boys"—a handy collective that Edward used to designate all or some of them. What made it easy for me to demote them as a set was what I saw as their lack of sophistication and intellectual development. I had gone mostly to private schools and had spent far more time talking with adults than with contemporaries. Reading, which had occupied a prominent place in my life from childhood on, was, for them, only an occasional indulgence. I preferred to ignore the fact that they had mastered a number of practical skills that made them far more helpful to Edward than I was.

. . .

Brett's contributions were too conspicuous to be overlooked. In addition to converting the laundry porch to a darkroom, he had installed a gas pipe in the front of the fireplace as a kindling substitute and antidote for wet wood. For fuel, he gathered trailerloads of driftwood from the beaches after storms. For fireside furniture, he found automobile seats at the dump and secured them in box frames. These activities were squeezed into the Art Project schedule, as were such mundane tasks as shopping, driving, and keeping the car in running order. Brett was an adult in the household who shared the work and expense of maintaining it; as such, he felt entitled to tell the junior members what needed doing and to expect action. He saw his younger brothers as somewhat pesky kids, but he would increase their seniority on the spot when an enterprise required their help.

Neil had a knack for construction and usually gave Brett a hand on projects. However, his true passion was boats, both building and sailing them. As an eight-year-old, he had accompanied his father when Edward photographed World War I ships anchored in the Oakland estuary, and he was as hooked on boats as Brett was on photography. As a sixteen-year-old in Carmel, he built three boats, one an 18-foot sloop that was sold to John Steinbeck. Neil was plagued by incapacitating migraine headaches, and although he knew that drinking wine was apt to trigger them, he found the libation hard to resist if a party was in progress. It was a way to overcome shyness and join in the fun, but the next day he would turn up in such sorry shape it would wring my heart. Otherwise, Neil was the most easygoing and unaffected of the brothers. He could share ideas, agree or disagree, without having to impress people with his views or wipe theirs out.

Cole was the baby of the family. He did his share of chores, but he was also a perpetual tease, forever trying to get a rise out of one of his brothers or whining for Edward to get him things no matter how unlikely—a new jacket, a special record, or a "gemveelie" (his name for a Ford V8). I think Edward paid no mind to the nonsensical repetition, but Cole could see that it irked me, and this probably encouraged him. He also had a romantic side. He soon acquired a girlfriend in the neighborhood, and most afternoons after school he

commandeered the living room so they could get out the portable record player and waltz dreamily to the 78s of the day.

I saw Edward's oldest son, Chan, only occasionally and briefly. He was four years my senior and—having married at sixteen and fathered a son—he had already moved outside the family orbit. Still, he appeared to have a measure of that gentleness of disposition that I thought came directly from Edward.

My urgent need to have Edward to myself made me uncharitable toward all the boys, but that didn't stop us from having fun together. You couldn't live with Edward in those days and fail to enjoy life. And I daresay I had as many flaws in his sons' eyes as they had in mine.

I had first heard about Edward's sister, May, during our all-night drive to Los Angeles and been fascinated by the story of the fourteen-year-old becoming the surrogate parent of her five-year-old brother after their mother's death. May was fifty-eight now and had just returned to California from the East Coast to share a house in Glendale with her daughter, Jean. When I met her I saw at once that Edward had portrayed her accurately. She had that same inner fire and vitality that her brother possessed, the same glowing brown eyes that must have been their mother's legacy.

May and Jean had hardly arranged the limited space in their Glendale house to suit their own needs when they learned that eighty-four-year-old Uncle Theodore, recently widowed, was coming out from Chicago to stay with them. This was the uncle who had put Edward to work as a "rabbit"—messenger boy—at Marshall Field Wholesale before Edward moved West. He had told Edward that if he did well he would be put on the road as a salesman with a territory of his own. For a shy boy afraid of the sound of his own voice, the prospect could not have been inviting, and Edward fled to California.

After Uncle Theodore had taken a day or two to recover from his trip, we invited the Glendale branch of the family for lunch. We all gathered around to get acquainted with this unknown relative, who proved to be a courtly old man with a twinkle in his eye. Taking my arm to escort me to the dining table, he managed to give my breast a friendly squeeze. Only Brett observed this sleight-of-hand, and delighted to see me flustered at last, he gave me a knowing wink.

Lunch was our usual spread of soup, salad, Rytak, and Jack cheese, with canned pineapple and figs for dessert. It was served—as always—on the bare table. There were no curtains on the windows or rugs on the floor, and the furniture was minimal. Uncle Theodore must have seen these spartan arrangements as evidence of near-destitution, because as our guests were leaving after lunch to take him home for a nap, he delivered an exit speech.

"Eddy," he said seriously, "you should have stuck with me at Marshall Field. You'd be wearing diamonds now! You know all those boys I put on the road?" Edward said yes, remembering the many salesmen who had served under his uncle, traveling the bleak Illinois hinterland. "Well," the old man wound up proudly, "some of them are *still* on the road!"

Edward managed to assure him soberly that it was wonderful that those men had jobs when so many didn't, but as soon as our guests had driven off, hilarity broke forth, and the great tag lines "Eddy, you'd be wearing diamonds!" and "Some of them are *still* on the road!" joined the family collection of quotes for every occasion.

On sober reflection, a diamond or two would have come in handy, as the household income was stretched ever thinner. Edward put a cheerful face on things, but he admitted to me privately that, for the first time in his life, he feared he couldn't make a living from photography. It had never provided him with the kind of surplus that made it possible to spend more than a dollar recklessly, but even in times when disaster had seemed inevitable, a good sitting or an unexpected print order had turned up in time to save him. In these Depression days people were scared, and those who still had some money were not about to spend it on pictures, not even Weston photographs at bargain prices.

To add insult to injury, his Project salary of $38.50 a week was recompense for purely mechanical work. When Merle had first hired him under the PWAP in January 1934, it had been as an artist in his own right. But the bureaucrats who ran the FAP couldn't accept a photographer as an artist, so Edward was now reduced to making a photographic record of other people's work.

To avoid going crazy on the job, Edward boiled it down to an efficient routine. He divided the works into compatible groups for size, shape, and ex-

posure, so that his assistant could wheel them out to the courtyard—where he had the camera focused on an easel—fast enough for him to keep up a steady stream of exposures.

The system brought one change in the makeup of his equipment. For more than twenty years he had calculated exposures according to his sense of light and the requirements of the subject. Now, to reduce the time and effort spent on each picture, he bought a Weston meter (no relation), and admitted that it soon became a crutch, because it could tell him instantly what had taken up to thirty seconds to calculate mentally, and in photography seconds are precious. Later Edward used the meter as a point of departure and set exposures in terms of the values he wanted in his negatives.

We decided on a new scheme to generate income: the Edward Weston Print of the Month Club. This offered up to twenty subscribers a print each month, selected by Edward, at ten dollars rather than the usual fifteen, and if they paid for twelve prints in advance, the whole set would cost only a hundred dollars. Orders trickled in; eight or nine subscribers ultimately signed up, and most of them failed to pay in advance.

Another money-making opportunity came when *Vanity Fair* solicited "self-portraits by artists." Edward had made a heroic-looking self-portrait in Mexico in which he gazed past the extended bellows of his 8 × 10 camera to scan the far horizon. Now he would make one with the 4 × 5 Graflex, which was, after all, the right camera for portraits.

On a mildly overcast day, when the deck was not unpleasantly bright, we took down the bathroom mirror and set it on a high stool facing the Graflex mounted on a tripod. Edward stood behind the camera and looked over the hood, as he did when making portraits, but instead of the animated look that usually enlivened his features when he was photographing, he appeared uncertain and uncomfortable. I think he destroyed the negative; mine is probably the only print. *Vanity Fair* did without a picture of Edward, and we did without the money.

Our impecunious state was eased as more sittings began to come in. Merle

arranged for Edward to photograph some of the artists (Igor Stravinsky, Arnold Schoenberg, Erika Morini) who were appearing under his auspices at the Los Angeles Philharmonic. *Vogue* magazine requested a series of portraits of some of film's promising young newcomers. The first of these was Henry Fonda—"a handsome, corn-fed, Nebraska boy," Edward said. "How could you go wrong with that?" Fonda appeared with a Leica hanging on his chest, so Edward made a full-length picture of man and camera while Fonda worked in a few questions on photography. A full-page reproduction soon appeared in *Vogue*, and to our satisfaction the pay was equally prompt.

Small cameras like Fonda's were still something of a novelty in this country, but fascination with them was growing, and their owners often delighted over enlarging a tiny corner of what was already a tiny negative, producing a picture that was as grainy as a day at the beach. Edward's sons liked to tease him by referring to his camera as a Brownie and asking, "How many snapshots did you make today, Dad?" After the Fonda session, the boys' gibes were updated to calling the 8 × 10 a minicam and revising the question to "How many pix did you shoot with your minicam today?"

Edward's second assignment from *Vogue* was a starlet, a young blond woman with rather bland features. The portraits, as usual, were flattering, but *Vogue* wrote back: "We like the pictures, but what about that terrible double chin?"

On re-examining the negatives, we noted the slight rounding under the jawline—a perfectly normal feature in a woman by no means gaunt—and Edward wrote back: "What double chin? I don't see any." *Vogue* insisted the print must be doctored or they couldn't use it; Edward was hungry but not that hungry. If *Vogue* wanted his name, the work must be his, and therefore unretouched. The series ended abruptly.

A few more movie stars turned up of their own accord, as James Cagney had in Carmel, but not many people in the make-believe business were able to accept a real portrait.

Edward had photographed Dolores Del Rio in Mexico, where she had been brought to his studio as an example of a "typical Mexican beauty." Now she came for a joint sitting with her husband, Cedric Gibbons, who was head of the art department at 20th Century-Fox.

Another request for a joint sitting came from Gary Cooper; he and his wife,

Rocky, wanted to be photographed in their Brentwood home. By then I was used to playing assistant, carrying a camera case if necessary, and chatting with subjects to maintain a relaxed atmosphere while Edward set up and watched for what he wanted. But here it looked as if Cooper and wife were both made nervous by my presence. When Rocky suggested I might enjoy a swim and Edward nodded his approval, I took off down the hill, found a suit in the well-stocked bathhouse, and had a delicious swim in a perfect pool. Edward was well satisfied with the sitting, so he was dismayed to hear that though Cooper liked the proofs, Rocky didn't. She had gone through a set of about thirty and found some fault in every one—her hair wasn't arranged right, her eyes, her hands, something was wrong with the neckline of her dress.

Unwilling to lose a good order, Edward immediately offered to repeat the sitting. This time he made two Graflex magazines—thirty-six 4 × 5s. When we looked over the proofs, there were so many good ones we decided Rocky was sure to be satisfied this time. She wasn't. And since the sitting was an anniversary present for her, that was the end of it. I wanted to go back to Brentwood and push her into that perfect pool.

The first hurdle in arranging sittings was convincing people that an unretouched portrait wouldn't embarrass them. Retouched images had been the norm for so long that people were understandably nervous about doing without this cosmetic corrective. "I'd break your camera" was the typical self-conscious response to the idea of a photograph that would "tell the truth." Edward was quick to point out that there was no truth to be told—ten photographers attempting to reveal one person's truth would produce ten different pictures. What really counted in the final result was the insight of the photographer at the moment of making the exposure, followed by his or her technical skill in developing and printing.

What Edward called his "secret formula" for portraits was "to make men handsome and women beautiful" and—given enough time—he could manage it by getting his subjects sufficiently relaxed to be unselfconscious. He would draw them out, get them to talk about their real concerns and interests. Most sitters thus became more animated and inspired and also less aware of the photographic process, so Edward could watch for those moments when a characteristic gesture or expression seemed to sum up the person before him.

When I first met people I had known only from Weston portraits, I was often surprised to find them so ordinary-looking. But if I got to know them better, I came to see them more and more as Edward had portrayed them. How did he manage to select such vivid revelations of character from that changing stream of expressions while he casually exposed films and threw in questions to keep his sitter from freezing into self-consciousness? He used tricks, to be sure, such as loosening up a nervous subject by pretending to make a series of exposures and exclaiming over how fine they were until the subject realized that this wasn't a painful ordeal and began to relax, or, conversely, making a series of exposures while the sitter thought he was still getting the camera ready. But he almost never directed someone to turn or look or change a position. He much preferred to wait and be ready for whatever might happen.

Naturally, then, he was not keen on celebrity sittings, which usually gave him a limited amount of time, often in difficult surroundings. Stravinsky, for example, was staying in a Hollywood bungalow and was on his way to an orchestra rehearsal. Edward spotted the open garage door as we drove up, and that solved his background problem. He had Stravinsky stand in the sunlit driveway in front of the door, and although the garage was full of the usual clutter, there was not enough time to register anything but black in the brief exposures. The whole sitting took less than fifteen minutes, and thereafter, whenever Edward had to photograph someone in a bad setting, he immediately looked for an open garage door.

When doing portraits of famous people, Edward knew he would be lucky to get anything more than a superficial likeness, but he also knew that adding notable faces to his rogues' gallery brought him more sittings and increased interest in his exhibits, so he didn't turn down such requests. Determined to be a real assistant, I did my best to be useful in these situations—I even tried speaking French to Stravinsky—but I found I did better with anonymous types than with celebrities, whose presence made me self-conscious.

The first time I had been called on to provide distraction was the previous year in Carmel with H.L., who had met Edward only once before the session. Leon and I had badgered him into sitting for Edward by pleading our right to have a decent picture of our father. He groused and grumbled, and when Leon and I told him we were setting a date, he responded gruffly, "Who'd

want a picture of an old walrus like me?" When we insisted that we would, he countered that there were plenty of pictures of him around the house already. But those touched-up publicity photos were not to our taste, and not really to his.

Knowing he had a testy subject, Edward set up the Graflex on the front porch and used me for a subject in order to have a chair in place in the best light with the camera focused—anything to get the sitting off to a good start. Meanwhile, Leon was talking with H.L. in the living room; it was like coaxing a nervous horse out of the stable.

With his preparations completed, Edward was ready to charm his subject and started by commenting on Ocean Home's glorious setting. H.L. barked something back and, as soon as he heard the sound of the Graflex action, got up to leave. Edward protested, and H.L., incredulous, said, "You want to take another one?"

Edward explained that when he did portraits he liked to make lots of exposures and gave the reasons for this, but H.L.'s leaping-up-to-leave reflex kicked in after each exposure, which meant a lot of unnecessary refocusing. Leon and I did our best to distract him, but he was a hopeless case. In less than five minutes he went back indoors, saying enough was enough. When Edward sent him the prints, his only comment was that he certainly did look like an old walrus. However, in 1940, H.L.'s friend Booth Tarkington wrote to Leon apropos of Edward: "He is described by Sam Blyth as a genius—testimony I thought confirmed by the portraits of H.L."

When, during the same month, Edward did a portrait of Helen, I had no trouble detecting the self-consciousness that gripped her, although I had not been present at the sitting. It was as though facing Edward's camera were some decisive test. In preparation, Helen had had her "mustache" hairs removed by the hot-wax method, and unfortunately, this left a clear white line around her mouth, accenting what I'm sure she thought of as her worst feature—the thinness of her lips.

Twenty years later, I hung Edward's portraits of Helen and H.L. side by side on my bedroom wall. There they remained for another thirteen years, and it gave me an odd satisfaction to wake each morning and find them in silent communion.

. . .

The silliest celebrity sitting during the Santa Monica period came when an acquaintance of Edward's, Marcella Burke, insisted that he should make a portrait of Dashiell Hammett, who, seven years before, had introduced Sam Spade to the world in *The Maltese Falcon*. Hammett appreciated good photography, said Marcella, and badly needed publicity pictures. The order was sure to be lucrative.

ACT I Midafternoon at Hammett's swank home.

Edward and assistant arrive as scheduled, accompanied by Brett.

Met by Marcella, who says Hammett drank too much at lunch; sleeping it off; should be fine now; she would go fetch him.

Edward thinks information ominous but sets up camera in flagstone patio with chair in front of rock wall. Brett sits in chair for adjustment of focus, not tempted (as I would be) to mime drunkenness.

Marcella returns with Hammett. Obviously, hours of sleep were too many or too few.

Introductions, polite talk, maneuvering.

Hammett sits in chair. Big man. Handsome? Hard to tell; not really there. Edward fakes a few, makes a few. Decides to call it a day. We all know glazed eyes won't publicize, or do for anything else.

ACT II Amiable talk continues while photographer packs gear.

Hammett turns courtly host: food in offing; we must be his guests for dinner. Visitors exchange eye signals, decide: Okay, something for our efforts. Have pre-dinner drink.

All sit down to eat.

Hammett excuses self and wanders off. Half hour later: Marcella starts to worry; sends help to check. Hammett nowhere in house. All join search. Find Hammett peacefully passed out in wet flower bed under fig tree. Brett and Edward have muddy, heavy transplanting job—flower bed to house bed.

Marcella apologetic. We must come in by living-room fire, finish drying off, have dessert and coffee.

ACT III Dessert and coffee accompanied by a giant tray of liqueurs. Visitors not surprised.

Hammett re-enters scene. Visitors surprised: oblivion looked longer-lasting. Marcella advises eating something; dinner could be reheated or . . . It falls on deaf ears. "Somma that." Hammett points to the bottle. Marcella pours liqueur-glassful. Hammett tips it down; throws glass against fireplace bricks. Seems to enjoy sound of tinkling glass. Repeats performance. Visitors feel must exit. Do.

After what he had told me during our all-night drive about his painfully shy boyhood, I wondered how Edward had turned himself into a man who could approach someone unknown, introduce himself, and suggest a sitting. When I raised this question, he told me he hated to do it but had schooled himself early to develop the skill, as he realized that failure to advance on this front would reduce his income and limit his photography. He said he needed to see everyone as a potential friend, customer, or go-between.

Some of the people who were never photographed leave me puzzled. Marcel Duchamp, for instance, who had come from France to visit his old friends Walter and Lou Arensberg. They brought him out to the beach to see prints and someone must have suggested a sitting. Did Duchamp shy off? And why are there no portraits of Walter and Lou? To the best of my recollection, there was no such sitting, and yet Edward had known them almost as long as I had and they were valued friends and supporters. Another subject who eluded Edward was Martha Graham. We met her at a large party in a Frank Lloyd Wright house in the Hollywood Hills. She was wearing a Quakerish full-skirted gray dress with a white band at the neck and she seemed as perfectly poised as she always did onstage. She and Edward chatted briefly, and I was struck by how small she was, since she dominated the stage when performing. I was also surprised by the lines in her face that makeup and stage lights removed—when dancing she appeared both youthful and ageless. Edward's biographer, Ben Maddow, dreamed up some malarky about Graham fearing Edward would want to make nudes of her and therefore declining to be photographed, but the truth was probably simpler. Graham's face was an integral part of her cho-

reography and an unretouched portrait would link it too closely to the real world.

A dancer who was happy to have some publicity pictures was Carmelita Maracci, of whom Edward made a dramatic head against the sky. After a New Year's party at her studio, I asked Edward if it wasn't a treat to have some real dancers to dance with, to which he replied, "Are you kidding? They won't follow!"

One of my pleasures was being back in the same territory with the Arensbergs. The art dealer Howard Putzell had introduced Edward to them at a concert in January 1930. Within a week Edward had gone to show work at their house and rejoiced to hear keenly discerning comments. He wrote in his *Daybooks* that he "saw the most concentrated collection of fine art that has ever been my privilege. Four Brancusis, four Rousseaus, four Cézannes,—Picasso, Matisse, Derain, Renoir, African sculpture, early American paintings—my surprise and admiration—well, I could cover a page with names . . . I took my work. It was accepted with such thrilling understanding. 'The most important photography being done.' And Arensberg knows personally all the outstanding workers. He asked me to come again, bought two prints."

A month later, back in Carmel, Edward sent Walter his new bedpan photograph with the message: "f.f.f. or Form Follows Function, as I half-facetiously named the print," to which Walter responded: "I can't express how bowled over I was by the vision of 'f.f.f.' It is certainly one of your most profound and shall hang in my study."

Edward had no illusions about the general public's appreciation of his photographs. Many viewers responded enthusiastically but only rarely with the kind of comprehension that told him that here was a person who spoke his language; he cherished Walter's response and took new work to show him whenever possible. They had only one long-standing disagreement. It began over a 1935 close-up of a Point Lobos rock. Walter found it immensely pleasing and, after staring at it for a while, said, "I think you made a pun for a torso." I could see what he meant. If the rock had been produced by Brancusi or Arp, that's what it would have been. Edward responded that it was a rock fragment with a beautiful form, and he had photographed it not to make a pun about some-

thing it might be thought to resemble but to reveal the essential structure and beauty of this particular rock.

Edward hated things that were made to look like other things—imitation bricks, pine stained to look like mahogany—but Walter insisted that Edward must have been aware of the rock's torso-like qualities, to have framed it as he did. Edward said he had been conscious of its form as a total structure made up of elements found throughout the natural world, in wave action, in plant growth, and in the work of erosion. But for him it was a single, unique image, and to call it a pun for a torso was to limit and distort the picture.

Walter was not satisfied with this and over the years periodically returned to the argument. One evening the subject was a rock formation at Dead Man's Point on the Mojave Desert which contained a long diagonally rising cylinder. It was certainly easy to see that this particular rock resembled a giant phallus.

"But of course I saw that," Edward agreed. "Who could help it? And I could have enhanced its sexual image if that was my intention—but it wasn't. I saw the form in relation to the surrounding rock pile, the interaction of all those worn granite boulders as they divide and redivide their spaces."

On only one occasion do I recall Edward making partial concession to Walter on this matter. As it happened, it was another "torso" image, of a cypress trunk taken at Lake Tenaya in the Sierra Nevada. After much argument, Edward said, "Well, obviously when I looked at the tree I saw it looked like a torso with a navel in the middle of it. But I liked it well enough to make a picture in spite of that."

For a long time I was secretly on Walter's side of the argument. It was he who had taught me to look for the hidden meanings in pictures, to pursue the clues an artist weaves into his work to define his intentions. My eyes would need a long re-education before I began to see Edward's photographs as he saw them. As we drove home from an evening of this kind of debate, I would carry it on with more questions, sometimes playing devil's advocate in my search for greater clarity. Edward enjoyed these exchanges, because they gave him a chance in a relaxed situation to sharpen his arsenal of responses, and I enjoyed them because—through this incessant probing—I came to realize that Edward did indeed see things differently.

The real difference between the two views, as far as Edward and Walter were

concerned, was that it enriched the picture for Walter to see a pun for a torso in a Point Lobos beach rock, but it diminished it for Edward because his purpose was to capture the essence of the thing in itself. For him any connotation detracted from the image.

In his *Daybooks* Edward wrote that his pepper pictures "are more libelled than anything I have done, in them has been found vulvas, penises or combinations, sexual intercourse, madonna with child, wrestlers, modern sculpture, African carving, ad nauseam, according to the state of mind of the spectator . . . I have done perhaps fifty negatives of peppers: because of the endless variety in form manifestations, because of the extraordinary surface texture, because of the power, the force suggested in their amazing convolutions."

In January 1932, Edward responded to an article Ansel had written about an exhibit of his work. After expressing appreciation for the "intelligent consideration," he wrote:

> *The discussion on phallic symbolism should at least clear me of intention, though the disciples of Freud will not be convinced, they are as fanatically religious as Methodists!*
>
> *. . . I think first of all we must understand that Whistler (or was it Wilde?) was wrong—that nature does not imitate art, but the artist continually imitates nature even when he thinks he is being "abstract."*
> *. . . No painter or sculptor can be wholly abstract. We cannot imagine forms not already existing in nature,—we know nothing else. Take the extreme abstractions of Brancusi: they are all based upon natural forms. I have been accused of imitating his work,—and I most do assuredly admire and may have been "inspired" by it,—which really means I have the same kind of (inner) eye, otherwise Rodin or Paul Manship might have influenced me! Actually, I have proved, through photography, that nature has all the "abstract" (simplified) forms that Brancusi or any other artist could imagine.*
> *. . . I am trying to clear myself of another intention, that of making a pepper something it is not . . . I have on occasion used the expression "to make a pepper more than a pepper." I now realize that it is a*

carelessly worded phrase. I did not mean "different" than a pepper, but a pepper plus—seeing it more definitely than does the casual observer . . . Photography as a creative expression must be seeing plus: seeing alone would mean factual recording—the illustrator of catalogues does that. The "plus" is the basis of all arguments on "what is art."

. . . But after all, Ansel, I never try to limit myself by theories. I do not question right or wrong approach when I am interested or amazed— impelled to work. I do not fear logic, I dare to be irrational . . . The great scientist dares to differ from accepted "facts"—think irrationally— let the artists do likewise.

Among the most appreciative viewers of Edward's prints were several scientists we knew from the California Institute of Technology. Listening to their responses, I felt that they saw his work more directly and understood more intuitively what he was after. I don't remember any of them bringing up sexual symbolism. Years later, looking at an article on topology in *Scientific American,* I discovered that there is a whole field of physics based on the distortion of a hollow sphere, such as a tennis ball or a green pepper, in which you collapse part of it and it always comes out differently—exactly the kind of space distortions that had kept Edward fascinated with peppers and given rise to his observation that no two were ever alike.

In a more innocent—or more inhibited—generation our grannies used to see President Lincoln's face in a cloud. Edward and I used "Lincoln's-face-in-a-cloud" as a general category for people who could never look at a picture without seeing something else there—as though he had set them up with one of those magazine puzzles for children: find two woodsmen, the lost ax, the wise old owl, the innocent pussy . . . and the randy goat.

Sundays at Mesa Road were open house—a legacy from Edward's days in Mexico. Friends from town came to the beach to visit, talk photography, look at prints, and swim. We supplied coffee and little else. Usually someone brought wine or beer or some crackers or potato chips. Occasionally people brought

more substantial food, and then we would round off the day with a potluck supper and maybe dancing afterward. Brett, who at twenty-three already had adopted a stately manner, favored the tango, while Edward stuck to the pelvis-twitching rumba. Unless a visitor brought other kinds of records, the music was always Latin.

One Sunday evening when Edward and I were cleaning up after the guests had left, there was a knock on the door and in came a woman, perhaps in her thirties, whom Edward had met eight years earlier when he was living in Glendale. At the time she had claimed to be the illegitimate child of a well-known actor who refused to acknowledge or provide for her. Now she said she needed Edward's advice, and almost before he could set a cup of coffee before her, she had launched into a harrowing tale of the two men who were controlling her mind. Two doctors at the University of California at Los Angeles had managed to plant a device in her head that enabled them to direct her actions. If she tried to go to another doctor or hospital they would stop her. If she left the apartment to go to the market they might make her turn around and go back. If she tried to disobey their directions they would paralyze her or give her an electric shock. They were really driving her crazy with their directions. What did Edward think she should do?

At the time I had never heard of this particular aberration, and had no idea what other bizarre behavior might go along with voices in your head, but Edward seemed to sense exactly what to do. He asked lots of questions: How long had this been going on? How often were the directions given? Did both doctors give them? Had she tried to go see them? I noticed that each new question received a briefer answer and that her nervous mannerisms were decreasing; her main need seemed to have been for a listener who would take her story seriously. When she saw Edward's eyelids getting droopy she thanked him for the coffee and left.

Edward said, "We won't see her again." He was right. The performance was never repeated. What surprised me was the patience and tact Edward had exercised. The woman had been there for at least two hours as she unfolded the complications of her plight, and Edward must have been longing for bed, but he never once gave her anything less than full attention and concerned interest.

SIX

I would sit down in the Mesa Road house several times a week before a stack of yellow foolscap (the kind we called second sheets in those days and used to make carbon copies), most of the pages covered on both sides with Edward's sprawling, soft-pencil writing. He usually wrote across the length of the page rather than from side to side, averaging twelve or fourteen lines, and often less than a hundred words, to a page. At one stage he tried using his dip pen with blue or black ink, but the writing showed through on the back side and the cheap paper wrinkled from the wetness of the ink. The soft pencil was his instrument of choice: it ran at exactly the correct speed to keep up with his thoughts, and he seldom returned to change a word or rephrase a thought (except when expounding on photography; then there was an excruciating weighing and reweighing of words).

I had much to learn from the *Daybooks*. For one thing, they reinforced my view of the perils of apprenticeship. Even if I had been strongly tempted to study photography—I never was—I think I would have been warned off by the fates of Margrethe Mather, Tina Modotti, and Sonya, who shared a similar progression from apprentice, to assistant, to partner, to termination. As it was, I only used the comparison to tease Edward about the fate of his photography students.

The *Daybooks* also showed me the benefit of the gap in our ages. Had I been of an age to have met Edward during his Mexico years, when he was a bullfight aficionado, he would have taken me at once to see his favorite spectacle and been deeply disappointed in my reaction. Unable to face any kind of killing with equanimity, upset even over the swatting of flies, I never would have measured up. To overlook the goring or disemboweling of a horse in the excitement of watching a matador flirting with death demanded a division of self I could not begin to comprehend. I would have asked, like his friend Olga, "How can you call this beautiful?"

"Though I knew she would be shocked," Edward had written on June 22, 1924, "I could not foresee the utter horror with which she viewed the spectacle." I told myself Edward's enthusiasm for the bullfight must have been a passing phase; while I knew him, he showed no inclination for blood sports except for listening to an occasional boxing match on the radio.

I was made uneasy by passages in the *Daybooks* that sounded cranky and harsh. Particularly disconcerting were the diatribes on women, in which Edward seemed to enjoy castigating and then dismissing his paper victims. I could not for a moment imagine him talking or behaving that way in person. The voice in the *Daybooks* was dogmatic, didactic, and judgmental, whereas Edward himself was open-minded, unpresumptuous, even diffident.

However, having kept a journal myself from time to time, I didn't mistake the man in the diaries for the real thing—I knew how difficult it is to write honestly about your emotions, to resist the itch to exaggerate, even when you think you're writing for an audience of one. You cannot keep yourself out of the record, nor can you put yourself in; the self is too cumbersome, various, and confusing to be successfully transcribed, so you settle for a stand-in who can represent you by bearing a number of your salient traits. This stand-in, which these days is called a persona, had, in Edward's case, been more decisive, more critical, more exacting, and, therefore, more intolerant than he ever was.

I needed to remember, too, that Edward had mixed intentions concerning this chronicle. On the one hand, it was his "safety valve," a place to "let off steam" when he was angry or upset; on the other hand, he hoped for eventual publication. I was convinced he was right about the value of the manuscript,

so I had to ask myself how I could justify having walked into his life and brought the *Daybooks* to an end. If I doubted my culpability in diverting him from writing, the *Daybooks* themselves made it clear in numerous entries such as this one: "(8–21–'29) 5:00 a.m. My hour: alone with my coffee, and a pen to put down my thoughts." Before I came on the scene, he had been fiercely protective of that early-morning time alone. If one of his sons or Sonya came to join him, he complained that they disturbed his concentration and said he must have a locked door to protect his private hour. But when that hour proved to be the only one possible for our trysts, he gave it up without protest.

I believed, naïvely, that once Edward's hour was back in place, he would resume the *Daybooks*. I expected to wake up one morning to find him sitting at his desk, coffee in hand, cigarettes in easy reach, writing away, with finished yellow pages stacking up beside him. Now I know that when a habit has had a lengthy sabbatical it is unlikely to be resumed.

Edward saw this termination as natural. He said the *Daybooks* had been kept during a time of exploration—of a new period in his life and of the photographic medium. For most of the ten-year span they covered there had been only one West Coast photographer with whom he sometimes discussed his discoveries and ideas—Johan Hagemeyer. Thus the *Daybooks* became his alter ego. When they reflected back his own views—a day or a week or months later—he could agree or take issue; it was a way of clarifying his ideas. By the early 1930s, when his friendship with Johan had faded, other photographers who shared his ideas had begun to emerge on the West Coast, such as those in the f.64 group. His isolation over, he no longer found it necessary to spend so much time talking to himself.

The *Daybook* entries had dwindled in the final two years, many expressing regret at his inability to tell the full story of this or that for lack of time. He thought the work done during the five years in Carmel had given him a new confidence in his way of seeing and in his general direction. That meant that what he needed now was not more time for rumination but more hours to photograph and more money for film.

When I first joined Edward on Mesa Road, he envisioned a new series of nudes made in our upstairs bedroom, where the light—which streamed in

through the glass doors from the sundeck—bounced off the white walls and reflected from the linoleum floor. It was a small room crowded with furniture, and in an effort to put enough distance between camera and model, Edward tried to balance himself and his tripod on the bedsprings. We both started laughing at his perilous posture, and I had to refrain from looking at him to keep a straight face when he made exposures that included my head. Several of these nudes show me partly encased in Edward's old black cape from Mexico days. He liked most of the pictures, but the whole thing was too much of an ordeal and it wasn't repeated.

The bedroom session proved to be the last one for Graflex nudes; all subsequent Weston nudes were made with the 8 × 10. The first of these was a series of me sunbathing as I lay on a blanket on the sundeck. Brett and Edward could lie directly on that silver-painted surface, which, to my skin, seemed scorchingly hot. They could also tolerate half an hour of direct sun; my limit was fifteen minutes, sometimes only ten. After that I would get giddy and feel as though my brain was melting. The most arresting of this set of sundeck nudes is a back view from shoulders to thigh tops, made when I was tipped up on my side and reaching over my shoulder to scratch my back. One of the first purchasers of this print exclaimed, "Oh, that little hand!"

I think it was Edward's suggestion that I try sitting just inside the bedroom doorway. He was probably tired of the old gray army blanket I insisted on lying on if I was out in the full sun. He saw what he wanted right away, but in the narrow section of sundeck outside the door it was difficult to set up the 8 × 10 to fit all of me in the picture and at the same time have the camera placed where he could operate it. In the end, he had to compromise and put up with the heavy shadow on the right arm; it was that or lose the picture. When I ducked my head because the sun was blinding me, Edward said, "Hold it!" and made the exposure. As usual, I tried to visualize the image, calculating my position in relation to the furniture behind me—a wasted effort, because this was like Stravinsky in front of the garage: nothing would show past the edge of the sunlight.

When Edward first developed the print, we were both disappointed. I thought the bobby pins and crooked part line in my hair were distracting and

was surprised to find they didn't bother Edward at all. He was unhappy to have his doubts confirmed about the shadow, because he foresaw the extra time and effort it would require every time he printed the image to avoid the appearance of a freakishly thin arm.

More often than for nudes, the 8 × 10 was up on the sundeck for clouds, which mounted the western sky in a great diversity of forms. They were likely to move so fast that Edward hardly had time to focus, insert a film holder, and pull the slide before his subject started to dissolve. Or he might be focusing on a group of mare's tails in the northwest, waiting until they shifted to what he guessed would be their next position, when he would catch sight of a formation in the southwest that was just right at that very moment, and the bulky camera would swing rapidly around to catch it. On some afternoons faint wispy cloud streaks lay parallel or crossed each other at various angles. People looking at these pictures now, without considering the date, probably suppose the tracks are evaporating jet trails. When I found a book on cloud formations, I was soon bandying about terms like "cirrocumulus" and "strato-nimbus," but Edward preferred homely pictorial ones like "mackerel sky" and "mare's tails."

Sleek black Satan was well into adolescence, but he hadn't given up playing hide-and-seek with his boon companion Edward. He would lurk on the dark stair landing and, as Edward descended, leap out and whip his paws around an ankle, then scuttle off to hide so Edward could pursue him. When I arrived at Mesa Road, in spite of being forewarned, I squealed in alarm at my first ankle assault. Satan was now seeking neighborhood status as a young macho male. When he went up to patrol the sundeck, the neighbor's enormous long-haired tabby sometimes scrabbled up the outside wall via the chimney to challenge him. Usually the matter was settled with an extended duet of posturing. Having observed a few of these performances, Edward kept his Graflex set up in our bedroom to be ready for the encore.

When it came, he moved his camera outside and focused on the combatants without in the least disturbing proceedings. He recorded the opera at the height of the acrimonious scene when the stars were posed with rigid bodies, flattened ears, bristling fur, extended necks, and whiskers nearly touching. Unfortunately, the cats were too dark against the glare of the sundeck for Edward to hold

detail in the fur and faces while stopping the action of the twitching tails. When the portly tabby, exhausted from continued arias, slumped down to rest awhile, Edward captured Satan doing his slow-motion stalk away, still bristling, still singing a menacing solo, but also clearly glad to have the curtain rung down.

Not all Edward's work was confined to the sunroof. He usually took his camera on any car trips "just in case." If he saw a likely subject and time, traffic, weather, and light were no problem, he would photograph it. If conditions were unfavorable, he would keep the spot in mind for later. This was the case with the *Monument on Wilshire Boulevard,* located on a busy thoroughfare but far too delicious to pass up. Four towering, bathing-suited figures sprouted from a cement monolith crowned by the replica of a bygone beach club. Once, joyful youths had seemed to splash up out of the surf, but now heads were missing and reinforcing rods sprouted from gaping throats. The grotesque tableau was too dilapidated to repair and too expensive to remove. It had become a surreal bulletin board for political posters whose tattered remains still clung to various body parts. Edward cherished the picture for its photographic values and as a satire on advertising.

Another day we went down to the Santa Monica harbor with Neil. He wanted to see what progress his friends were making remodeling an old rumrunner they had bought from the government. They were converting it into a fishing boat. Neil had climbed up on the superstructure to survey the operation when Edward made a picture of him—back view—among the deck-framing timbers. I've seen the picture labeled *Boat Builder,* an easy mistake to make, since Neil looks so perfectly in charge of the job.

Edward seldom walked past a vacant lot without inspecting its holdings. One day he rummaged through a factory scrap pile and salvaged a delightful wooden figure with wide-set staring "eyes" that I thought gave it a whimsical appearance, although I wouldn't have said so to Edward. Back home he photographed his find against a dark background so the light edges of the sawed-out form gave some balance to the dominant "eyes." A knowledgeable observer told us it was a model for a mold. That was exactly the kind of title Edward liked: short, accurate, euphonious. *Model for Mould* it became, with the alternate British spelling we supposed distinguished the shaping kind from the green smelly kind.

When Ansel Adams turned up for a visit with his current pride and joy—a new Contax—and sporting a black beard, Edward featured the minicam in a portrait that also gave prominence to Ansel's piano-player hands. In fact, the hands, the camera, and one ear are the main visible features, and since he is dressed in what appear to be formal clothes, you probably couldn't identify the subject without the title: *Ansel Adams (After He Got a Contax Camera), 1936.* He looks like an insect-man from Mars. Both eyes are covered with lenses, the right one being compound, and a possible third eye is visible between the fingers of the two hands.

After Ansel returned home to San Francisco, Edward sent him some pictures, which brought a letter in reply, dated February 1936:

> *Many thanks for the pictures. I do not think they are as bad as you say— they are a bit undertimed, but in some way I like the harshness which obtains... Your pictures give me great pleasure; I still feel that the ploughed field [he must mean lettuce ranch] is one of the Great photographs. And by saying that I am not deprecating the others you have done. I can't tell you how swell it was to return to the freshness, simplicity and natural strength of your photography after such a dose of intellectualism, cynicism, and dialecticism received by me in the east. I am convinced that the only real security lies in a certain communion with the things of the Natural world.*

Ansel's trip East a month earlier had been made to testify in Washington on behalf of the Sierra Club, but he had also spent time in New York with Stieglitz, who offered him a show at his gallery, An American Place, a major milestone in Ansel's early career.

Stieglitz had never made a comparable gesture on Edward's behalf. I knew from reading the *Daybooks* that Stieglitz was a formidable ghost from Edward's past. At their 1922 meeting in New York he had offered a mixed review of Edward's prints. Edward, conscious that his work was changing and feeling slightly reverential, had welcomed the criticism and agreed with most of it. Then, in 1927, a friend had taken several of Edward's prints to New York, shown them to Stieglitz, and written: "Stieglitz seemed disappointed. He

thought your technique was very fine but felt the prints lacked life, fire, were more or less dead things, not a part of today." In a journal entry the next day Edward responded:

> *I am full of protest over Stieglitz' opinion, because it is biased, unfair, and Stieglitz I had on a pedestal as many others have—too many others. One admits the fall of a hero unwillingly! My work could not be "dead"—lack "life, fire": it was done with so great an enthusiasm, love, "fire,"—all that I felt must show in my work, and does, for I have profound response from so many intelligent and important persons . . . But this is what I feel: if I had lined up as one of the Stieglitz group, if I had remained a second rate Stieglitz, I would have pleased Stieglitz. He told me, "Go on in your own way." He says one thing,—but he means another.*

In a letter to photographer Paul Strand dated September 2, 1928, Stieglitz commented on Edward's article in an issue of *Creative Arts* that also included work by Strand: "Yes, I saw *Creative Arts,*—your things were more or less slaughtered.—The Weston reproductions and his literature.—The former nothing very wonderful (even allowing for reproduction). As for literature, well, it was a dead give away . . . It makes me sick, all the pseudo business. And I fear Weston, fine a fellow as he is, has a goodly streak of the American pseudo running through all of him. He is not creative. But he is not stupid and empty. If he'd only forget trying to be an artist—maybe he'd come close to being one."

Stieglitz had let it be known that he resented Edward's failure to mention him as an important influence in the *Creative Arts* article. When Edward learned of this, he assured Stieglitz that he had deliberately refrained from crediting him because he doubted that Stieglitz would welcome the association. From that time on, the few exchanges between the men had consisted of Edward placating or explaining and Stieglitz admonishing, reproaching, or damning with faint praise. I thought it likely the old man saw Edward as a pretender to the throne and was, therefore, loath to grant him recognition.

. . .

Often after making a picture, Edward would say to me, "Do you want to look?"

It wasn't really a question. There was no doubt by this point about my wanting to look on the ground glass, to see the colored shadow of the picture just taken. Rather, this query was a statement of relinquishment. He was officially letting go of his private connection with that selected image: I represented the public it now belonged to, potentially at least.

The ground glass was just as it is named—a piece of glass with the surface finely ground to remove the shine. Like a view finder, it allowed the photographer to see the image, although it was upside down. I was carried away right from the start by that wonderfully shimmering, opalescent color the ground glass provided. But I had to learn to disregard those lovely shades and to start reconstructing the image in black-and-white, with all the grays between. It helped that the image was upside down, providing the first step in abstracting from the "real world." I never mastered the trick entirely, nor did I ever get sharp enough at reading negatives to make the whole switch (from black to white) at a glance, but I did achieve a level of competence that made me react with surprise when someone else looked on the ground glass and said, "Hey! It's upside down!" and "It's all in color!" when I had become accustomed to "seeing" it right side up and in black-and-white.

When we talked, as we often did, about photographs, I avoided the flat-footed kind of question so many viewers produced: "Why did you make *that*?" I knew if Edward could give the answer in words the picture would serve no purpose. If I didn't "get" it, I should keep looking.

However, if he was not pleased with an image and I wasn't sure why, I felt free to ask. In this way I discovered the shadow on the arm was what troubled him in the doorway nude; the bobby pins and crooked hair part that distressed me, he found perfectly acceptable. This revelation became a reminder for me to try to see the image as an organized whole whose parts worked together in a relationship created by Edward's placement of camera, choice of lens, and fixing of boundaries. Learning to see that way did not come easily. My literary leanings kept me too conscious of subject matter to

let me consider an image in more abstract pictorial terms, except in brief flashes.

I worked at this problem because I wanted to understand what it was that Edward could see—sometimes, it seemed, instantly—that gave him the knowledge, as certain as a fisherman's feel for a tug on the line, that this was a live one. In the *Daybooks* I had read his admonition to artist Jean Charlot (who said he planned to draw geometrical sketches for some of Edward's pictures which seemed so exact as to appear calculated): "No, Jean, to stop and calculate would be to lose most of them." I thought Edward had missed the point of Charlot's interest by ignoring the word "appear." Charlot had seen him at work and certainly knew he didn't stop to calculate. I think his question, like mine, was how did Edward see, understand, and decide in that swift glance that preceded exposure?

Edward's answer was "Experience." By which he meant his simplified equipment and methods—one camera, one lens, one kind of film, one format, one developer—and years of honing his skills. That covered the technical part of what he did, and to it he would add, "Seeing," by which he meant the ability to recognize and respond to what he called significant form. Without that kind of seeing, he said, no amount of fine technique could produce work that would endure. He thought a combination of the two was what made it possible for him to work rapidly yet with absolute assurance.

As early as 1928 Edward had written: "I always work better when I do not reason, when no question of right enters in—when my pulse quickens to the form before me without hesitation or calculation." And in 1930, barely two years later, when chided by a friend for being "too prolific" (the same man marveled at a New York photographer who made just one negative a year "but it was perfect"), he had responded, "I can make—given time—a thousand negatives a year, not only perfect technically, but fresh and strong in seeing."

"Given time" had but one possible meaning: having enough money to forget about professional portraiture for a while. But five years later that possibility seemed more unlikely than ever. Now even sittings were hard to come by, and so far we had proved spectacularly unsuccessful with our money-making

schemes. Perhaps we had set our sights too low? When someone suggested that Edward apply for a Guggenheim Fellowship, he sent for the forms, began lining up sponsors (the final list included Walter Arensberg, Merle Armitage, Charles Sheeler, Carl Zigrosser, Rockwell Kent, Jean Charlot, and Karl Nierendorf), and started writing his "plans for work."

His photographic method and the philosophy behind it were subjects on which Edward had frequently been required to expatiate for exhibition notices or catalogues, so one might expect that he had settled on a form long since— one that would need only minor changes to be suitable for all occasions—but such was not the case. Instead, each new request for a statement brought on a prolonged bout of scrutinizing earlier efforts, finding them unsatisfactory, and then paring, condensing, and eliminating.

For a man who had filled volumes, Edward had an almost primitive belief in the power of single words. When he could reduce a whole phrase to one word he was, as he saw it, expressing his thought more precisely. I know now that, on these occasions, he was desperately seeking a magic key that would unlock his thoughts, but what he wanted to describe was much too complicated to dismiss with simple explanations.

Leon once told me about a bonsai class in which the Japanese instructor explained the importance of studying the natural form of the tree before undertaking any shaping or pruning, in order to achieve optimum character in the miniature-to-be. Then he turned the students loose to apply what they had learned to their individual specimens. In the next half hour one student managed to remove every branch from his, producing a good likeness of a telephone pole. A similar fate befell Edward's proposal for a Guggenheim project as the four pages he started out with were reduced to four lines.

I had observed this dismemberment, and Edward's growing frustration— the furious balling up of the handwritten pages, which were hurled into the desk-high wicker wastebasket, the intemperate smoking, the floor-pacing, and the occasional retrieval of one of those balled-up versions to be smoothed out for reconsideration—a performance that made me hesitate to express misgivings. At the end of several days Edward put down his pencil. "Charis, listen, I think this says it all."

I wish to continue an epic series of photographs of the West, begun about 1929; this will include a range from satires on advertising to ranch life, from beach kelp to mountains.
The publication of the above seems assured.

The terseness of the project description could not have been helped by the information Edward provided on the Guggenheim forms themselves. The ten-line grid for filling in education and professional training said only "SELF-TAUGHT." In the four lines for previous scholarships and fellowships won, the response was "NONE." The five lines for languages spoken in addition to English said "KNOW SOME SPANISH." Where a third of a page had been left blank for positions held, the answer was "With the exception of a few months of Federal work I have worked for myself for over twenty-five years." To the question "Of what learned, scientific or artistic societies are you a member?" the reply was "NONE. I avoid them." Edward attached two pages, one listing exhibitions and collections owning his work and the other milestones in his development as a photographer, beginning with "First photographs made with definite intention in 1903, age 17," and ending with "I consider the work that I have done this year the finest of my life."

Edward had convinced himself that the judges were tired of reading long-winded proposals and that they would be pleased to receive a brief, clear, no-nonsense statement like his. He read it to whatever friends we saw in the ensuing days, and grew increasingly pleased with his solution. It was such a relief to see Edward relaxed again and back to enjoying life that I could only hope he was right—that his four lines did say it all.

Meanwhile, Brett had found us a car, a 1925, air-cooled, two-seater Franklin with a lion recumbent on the hood. "In excellent condition," Brett assured us. "It cost $3,500 new!" (That made the $125 we had to pay seem a proper bargain.) Brett took me out for a lesson in double-clutching and I was ready to hit the road. Our first trial run took us to a big five-and-ten where Edward needed to get a replacement for his darkroom egg timer.

The five-and-ten of Depression days was a great cornucopia of cheap knick-knackery, with everything spread out flat on waist-level tables, so nothing interrupted your vision from end to end of the spacious store. We made our way

straight to the kitchen-gadget table, where we stood half a dozen egg timers upright so all the sand ran to the bottom, then inverted the whole set at once to time them. I could understand the concern of a clerk observing this scene, and was quick to explain our need for absolute accuracy; some timers ran for more than three minutes, some less. We needed one that ran exactly three. The clerk retired but kept a watchful eye on us. Not far off were some dandy windup toys—who could guess what we might do with them.

By now I knew that the three-minute timer was part of Edward's simple print-developing equipment. I first joined him in the darkroom to see how the developing and printing process worked; the timer came into use during the part of the operation when the green safety light was on, but it was the period of total darkness that kept me coming back, fascinated, to explore its effects. The pure blackness in a darkroom is disorienting in its intensity. At first my eyes protested by producing light shows—imaginary flashes and colorful patterns. When these subsided, and I discovered there was no difference between having one's eyes open or closed, I imagined I was poised on the ideal threshold for communicating with my subconscious, where I supposed my poetic muse resided. Sure enough, words would appear against the blackness, and I would transcribe on a shorthand pad, a few words to a page, until the safety light came on and my muse quit. Then Edward and I would talk while he finished developing, fixing and starting to wash his negatives, and my eyes would accept that dim, underwater light for standard. When the darkroom door was opened, the daylight would be almost blinding. Now I knew why Edward's eyes had that odd look when he first came out—it was like coming up from the underworld. I would hurry to read my "dark" writing, but it seldom revealed any rich poetic ore.

I had scribbled doggerel verse from my earliest years. It seemed an easy trick and poured out of me whenever I had a mind to set words down. I went through all the poet stars of the U.S. firmament, and subscribed to *Poetry* magazine, where most of them appeared. At about fourteen, I wrote a parody cycle based on Robert Louis Stevenson's Requiem—"Under the wide and starry sky . . ."—as it might have been written by Carl Sandburg, Alfred Kreymborg, Edna St. Vincent Millay, and several others.

It took Percy Bysshe Shelley to convince me that real poetry was a nobler

calling, one that could gather up all the deep thoughts and strong feelings that found no outlet in my daily life but clamored for expression just the same. I read through all the long Shelley poems and wound up plowing through the equally long verse plays. Then I discovered *The Waste Land* and recognized that it was really Eliot who was writing *my* kind of poetry. I loved his work and tended to imitate it whenever I set about serious writing in the next few years.

By the time I joined Edward in Santa Monica Canyon, I had amassed about thirty poems I thought might be publishable, and at his suggestion I showed them to Jake Zeitlin. Zeitlin had opened a bookstore in Los Angeles in 1928, where he devoted a wall and later a whole gallery to showing artwork. His first exhibit had been Weston photographs, and he remained a loyal friend and promoter of Edward's work.

Zeitlin arranged for me to talk to poet Hildegarde Flanner, who lived in Pasadena. We sat on the veranda of her pleasant home, and our wicker chairs squeaked periodically as she read through some of my poems. She asked if I was familiar with the work of Gerard Manley Hopkins (I admitted apologetically that I'd never heard of him) and said that some of my forms and phrasings reminded her of his. She went on to talk about the rewards of poetry in practical terms. "Almost no one makes a living from writing poetry," she assured me. "I look on my earnings as handkerchief money." The point was illustrated by pulling a flowered example through her fingers. "So it's all right to work at this kind of thing if you can afford to. Just don't make the mistake of thinking there's any way it can support you." We talked a little longer about poetry and various poets, and then I left—outwardly cheerful yet inwardly crushed. In my private fantasies I was a successful poet at an early age, not only supporting myself but bringing in such rich royalties that Edward would be able to dispense with the FAP and buy all the 8 × 10 film he wanted.

A few weeks later Edward, Leon, and I attended the Arensbergs' reception for Marcel Duchamp. Their house was swarming with a who's who of names from the art and literary worlds. Some people followed a "tour" that took them past every painting and sculpture, visiting bedrooms and bathrooms as well as the more usual sites—carefully guarding their wineglasses against spillage as they passed on the stairs. Going up, I met Hildegarde Flanner on her way down.

Her advice to me had been practical and well meant, but I have to admit I relished her look of astonishment at finding the girl who'd never heard of Hopkins in the midst of this distinguished crowd.

About this time E. E. Cummings and his wife came for a sitting, but he occupied such a prominent place in my poetic pantheon that I became instantly tongue-tied over the prospect of talking about poetry. Even the amiable chat with which I distracted nervous sitters seemed inappropriate with an author of his standing. And asking him to sign a book of his poems that had been given to me recently seemed impossibly vulgar, like mobbing a movie star for his autograph at a Hollywood opening. I had no idea that some poets enjoy signing books—if for no other reason than as tangible proof that another copy had been sold.

If I'd failed to hit paydirt with my darkroom versifying, my "blindness" had at least produced a fascinating new script. The shapes of the giant letters made intricate, overlapping loops that seemed to offer a new vocabulary of forms. I began to paint, using these manatee-like units as my building blocks; it rapidly turned into a full-fledged obsession. I sat in the upstairs bedroom, which was always full of light from the sunporch, and painted away hour after hour. I went to sleep at night and woke up in the morning seeing patterns of colors that shifted in kaleidoscopic fashion from simple to elaborate, from vivid to muted. I did some "serious" work, but was most successful at whimsical pieces, including a set of illustrated limericks. Had you asked me then if I was abandoning poetry I would have said no, but it is clear from the perspective of years that it was a retreat. My self-confidence, which appeared strong and solid to others, and sometimes convinced me as well, was in reality a shaky edifice that could be toppled by a random critical remark.

My move into painting was helped along by Leon, who gave me a sketchbox, brushes, turpentine, and tube paints. He was now working in the story department at Selznick Studios, reading novels and synopsizing plots, a job as mind-numbing in its way as Edward's endless copying work for the Arts Project. He often escaped to the beach on weekends to visit us and look at prints.

Leon's relationship with Edward predated mine, and he was always part of the Weston family, even though in years to come we ended up on opposite coasts. He was such a prolific and vivid correspondent that we frequently felt more in touch with him than with friends who lived close by. Edward was deeply fond of Leon and treated him as a peer despite the age difference. They had an easy rapport, and their free-ranging conversation provided a refreshing break from shoptalk. Edward's nickname for my brother was "Sturdy," an irony, as Leon was stricken by polio in the mid-1950s; still, his response to the effects of the disease was undeniably sturdy.

Howard Putzell, who had recently hung a show of Edward's work in his gallery on Hollywood Boulevard, brought the British writer John Davenport and his wife, Clem, out to the beach to meet us. They had recently come from England because one of the studios had hired John to write a screenplay. He later described the occasion in an article published in the November 1942 issue of the British magazine *Lilliput*:

> *In 1936 Howard Putzell, the American art dealer, drove us out to a bungalow in Santa Monica. It was the home of Edward Weston. He showed us photographs. He showed us literally hundreds. Charis Wilson, his present wife, made cups of tea. Or perhaps it was coffee. The whole experience was hell. I'd never thought about photography before, and was completely stunned. Photograph after photograph, cup after cup, the afternoon wore on. I became incapable of movement.*
>
> *Edward and Charis, we afterwards discovered, thought we were the most ghastly people they'd ever met. Unresponsive, and tea-logged.*
>
> *I bought two photographs—and we went away with Howard who had relished the whole catastrophe.*
>
> *Next day I returned, and charged into the house before they had time to make a getaway through the back door. I tried to stammer explanations and admirations; we drank a great deal of Pabst beer; we plunged into the grey Pacific; we ate a quantity of artichokes; Hollywood melted*

as unutterably as M. Valdemar in Poe's tale; in short, we met Edward Weston.

Physically John and Clem were an unmatched pair. She was tall and willowy and had fine, even features, large blue-gray eyes, and wavy blond hair cut in what used to be called a "boyish bob." John looked somewhat frog-like beside her, being shorter and thickset, with eyes that receded into pockets of flesh when he laughed; but what he may have lacked in looks was more than compensated for by acute intelligence. Edward made portraits of them, and I remember that Clem looked frosty and unapproachable (she wasn't, just shy), while John resembled a sumo wrestler.

John's account of the meeting aside, we all became friends and visited often over the next few months. When they came to dinner, we treated them to food they would find unfamiliar: artichokes, baked yams, eggplant, persimmons. At their house we played "shove ha'penny" on a grooved, slanted board that was used for the game in English pubs. Clem had gone to a posh girls' school in England, yet she had a capable outdoorsy look that fooled me completely. Later, when I described some of our camping adventures to her, she expressed absolute horror and assured me that her idea of roughing it was to go to a pleasant picnic site equipped with a well-appointed hamper from Fortnam & Mason. John was a more down-to-earth type, a robust drinker as well as an insatiable reader.

I had always thought of myself as exceptionally well-read, since I rarely encountered anyone who had absorbed as many books as I had or paid as close attention to the variety of methods writers used to achieve their aims. Now it was necessary to revise my view. I was no match for a Cambridge-educated intellectual who was six years my senior and had never slowed his reading pace. The revelation was painless, because it was such a pleasure to talk to a fellow addict, compare our reactions to books we had both read, and listen to accounts of masterpieces in every field that I should no longer neglect. Four books he brought out to the beach and presented to me one day show his eclecticism: *The Notebooks of Leonardo da Vinci*, *The Tale of Genji*, *Cold Comfort Farm,* and *A New Model of the Universe*.

I had grown up in a reading family where new volumes appeared too regularly

to be much noticed. For most people the Depression had put an end to such frivolous expenditures; if you wanted to read a new book, you put your name on a waiting list at the library. I felt sinful inhaling the intoxicating blend of printer's ink, paper, and binding glue as I began turning the pages of volume one of my remedial education.

For me, photography alone was too restricted a diet—I was omnivorous. What made conversation with John such a delight was that he, too, had a voracious appetite for discussion. Our intellectual meals usually began with books, but they were multicourse affairs, extending through politics, history, society, psychology, and the arts in general, possibly ending with a crème brûlée of wicked Hollywood gossip. When Edward and I spent the night at their house, John and I often continued these feasts until midnight, by which time Edward and Clem had sensibly gone to bed.

The Davenports also entertained on a grander scale. The lavender piqué dress I had worn to the Carmel concert when I first met Edward no longer struck me as glamorous, but it was my only dress-up, so I decided to wear it when John and Clem invited us to a filmland soiree:

> *The steep street is already lined with parked cars, and sounds of a party well under way pour out when the door is opened. John points us to the refreshment table in the adjacent room and introduces us to a few passersby.*
>
> *Clem is a stunning sight, covered shoulder to toe with luscious red strawberries topped with bright green calyxes printed profusely on snowy white cotton. Next time I see her the dress has been replaced with an ordinary striped one and Clem is sitting on the steps at the side of the living room, pouting.*
>
> *"What happened to your strawberries?"*
> *"That disgusting woman spilled her drink all over me!"*
> *"Which woman? Where?"*
> *"That one, right there."*
> *"Shall I slosh some on her?"*
> *"Sure. Go ahead. She deserves it."*
> *I go right out on the dance floor and avenge my friend.*

"What on earth did you do that for?"
"You said to!"
"Of course I didn't think you'd really do it!"
And from my outraged victim: "Who is that hoddible girl in mauve?"

My brother treasured the "hoddible girl" tag line, but it turned out that Edward was less than pleased with my childish behavior, because the victim and her husband had, a number of years before, bought two Weston prints, and customers were among those people he made it a point never to offend.

Later in the evening Edward acquired a tag line of his own. He agreed to dance for the crowd, but only if John would provide piano accompaniment. By the time Edward had located a woman of similar size who was willing to loan him her dress for a while, the living room had filled up with conversers, drinkers, and nibblers.

Some commanding chords on the piano and the appearance on the steps of a shy maiden with a long-stemmed rosebud clamped in her teeth and surprisingly hairy legs served to clear a central arena, and the dance was on. John played a touching medley that ranged from heartrending pathos to rapturous ecstasy, and Edward—inspired by live music played by an understanding collaborator—was probably giving a superb performance with many an eye flutter and fanny wiggle, but I could only catch glimpses of it over the shoulders of the outer circle.

John told us later that, right after the dance, a know-it-all from his studio was overheard confiding to his companion, "Of course you know Weston is a notorious homosexual." Edward thought it was great to gain some fame in a brand-new field.

I recently read an account of John twenty years after Edward and I knew him. He sounded unhappy, unsavory, and pathetic—a drunken mess of a man, but with hints of his former self flashing through. This tale of squandered talent and intellect is hardly new, but having enjoyed the splendid middle chapter of his life, I found it painful to learn that it had ended badly.

On weekdays each member of the Weston household took a turn at the accumulated daily dishes, a chore no one loved, but with five of us, it only happened

once a week. On weekends, in theory, we did our own as we went along. The idea—to have a relatively tidy kitchen when visitors came—was not foolproof. I remember pushing open the swinging door to the kitchen one Sunday and almost knocking over a cartoonist who was standing on a high stool in the corner and drawing in loving detail the dirty plates, mugs, cutlery, and open food and condiment containers that covered every square inch of available surface. He had recognized fine subject matter and couldn't resist recording it— he hoped I didn't mind. Of course not! Hadn't Edward convinced me that there was picture potential everywhere?

Occasional weekend lapses were tolerated, but the weekday assignments were inviolable. Edward thought he had solved the problem of daily family strife by treating everyone alike and assigning chores equally. However, I didn't like being treated as "one of the boys," and Brett, who was an adult and a bread-winner, must have resented it even more. Just now he was courting a new love, Cicely Edmunds, a young violinist from Eureka, California, who was living at the Hollywood Studio Club. Perhaps it was on this account that he had recently become a more difficult housemate, irascible with his younger brothers and too wrapped up in his own affairs to keep up with his share of chores.

One night Brett came home late, to find the kitchen stacked with dirty dishes, and was reminded by a tight-lipped Edward that it was his night for KP. Brett was tired and angry and demanded to know, since I'd been home all day, why I hadn't done them. I had begun to earlier in the evening, but Edward had said firmly, "No, you did yours last night. This is his job," and then stayed downstairs to see that I didn't go softhearted and violate his edict.

In those days Edward's temper flared as quickly as Brett's, and he gave Brett hell for forgetting his responsibilities. They stood in the kitchen doorway having a shouting match, which ended with Brett saying he would leave in the morning, and stomping off to bed. Next morning, when tempers had cooled, Edward warned Brett not to move in haste when times were so hard, but Brett said it was time for him to go anyway—not because of the ruckus the night before. He was just ready to have his own place.

· · ·

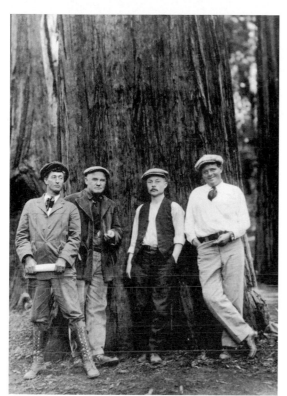

1. *Left to right:* George Sterling, H. L. Wilson, unidentified man, and Jack London at Bohemian Grove, 1915. Photographer unknown

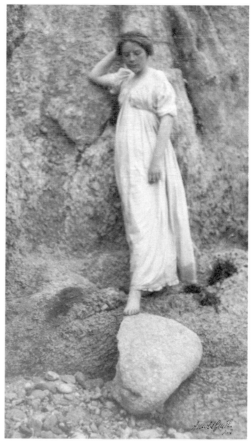

2. Helen MacGowan Cooke, circa 1911. Photograph by Arnold Genthe

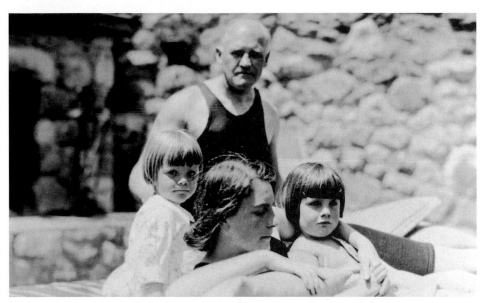

3. H.L., Helen, Charis, and Leon, 1917. Photographer unknown

4. Snooky the chimp
with Leon and Charis,
circa 1920.
Photographer unknown

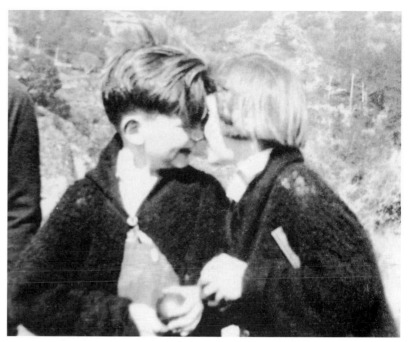

5. Leon and Charis, 1921. Photographer unknown

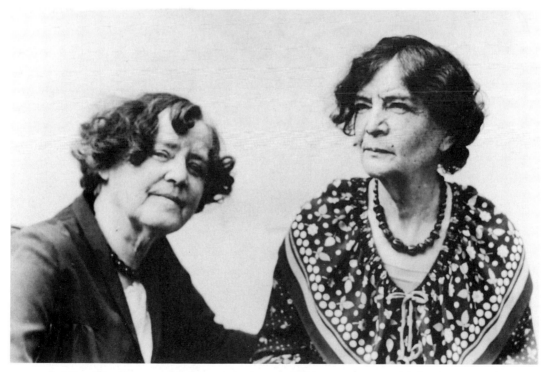

6. Alice MacGowan and Grace MacGowan Cooke at Hatton Fields house, Carmel. Photograph by Leon Wilson

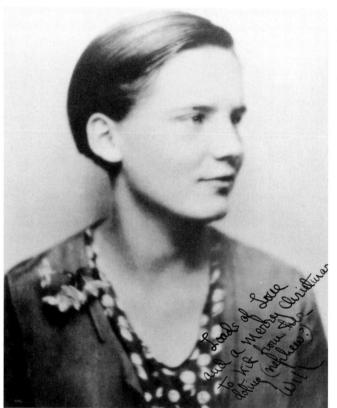

7. Charis, 1932, twelfth grade, Catlin School, Portland, Oregon. The inscription reads: "Loads of Love and a Merry Christmas to Kit from her doting (nephew?) Will." Photograph made in a self-photo booth

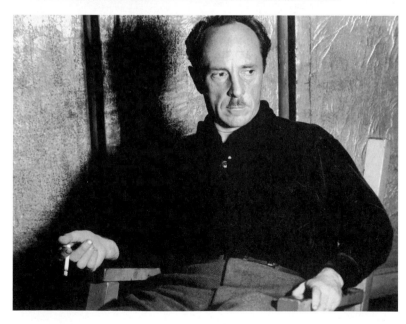

8. Edward Weston at the Brockhurst Gallery in Oakland, 1932. Photograph by Willard Van Dyke

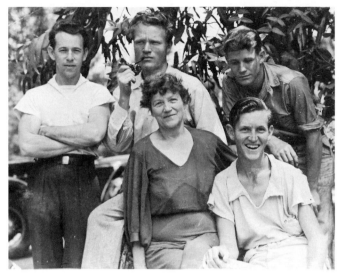

9. (*Front*) Flora Chandler Weston with Cole. (*Back*) Chandler, Brett, and Neil. Photographer unknown, 1937

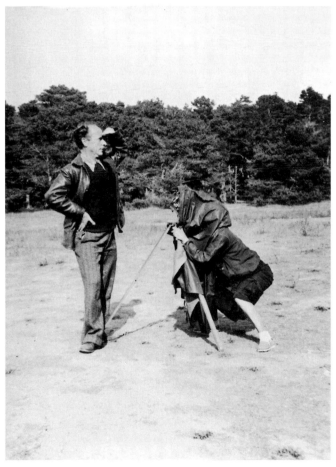

10. Edward and Sonya Noskowiak, clowning at Point Lobos, early 1930s. Photograph by Leon Wilson

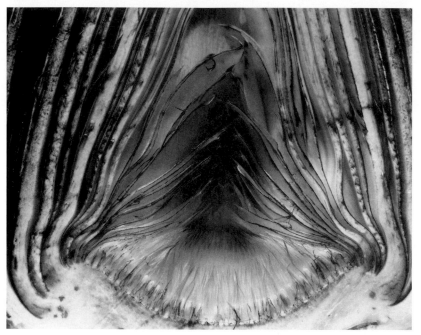

11. *Artichoke Halved.* Photograph by Edward Weston, 1930

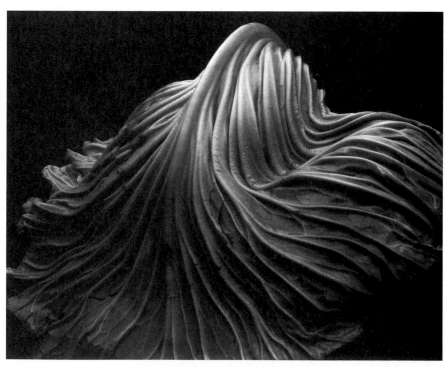

12. *Cabbage Leaf.* Photograph by Edward Weston, 1931

13. *Nude.* Photograph by Edward Weston, 1934

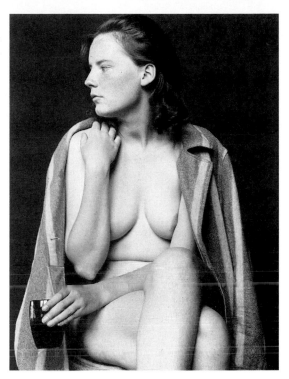

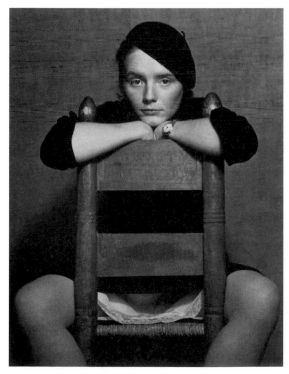

14. *Charis Wilson.* Photograph by Edward Weston, 1935

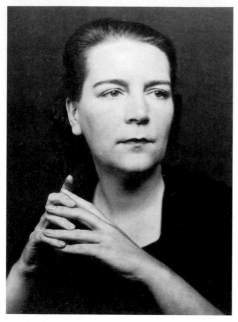

15. Helen Cooke Wilson.
Photograph by Edward Weston, 1935

16. Harry Leon Wilson.
Photograph by Edward Weston, 1935

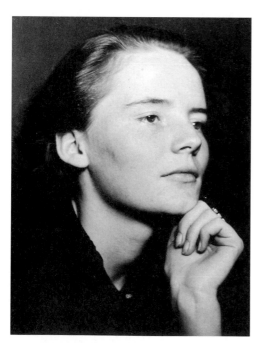

17. Charis Wilson, Carmel.
Photograph by Edward Weston, 1934

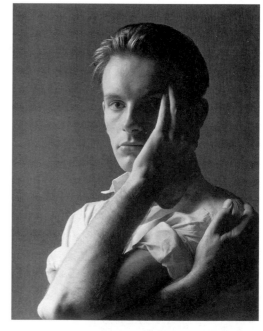

18. *Leon Wilson.*
Photograph by Edward Weston, 1935

19. Edward with amidol-stained fingernails and Charis wearing a ring given to her by Walter Arensberg, mid-1930s. Photograph by Sibyl Anikeef

20. *Masque*—a valentine arranged and photographed by Edward, sent to Charis, 1935

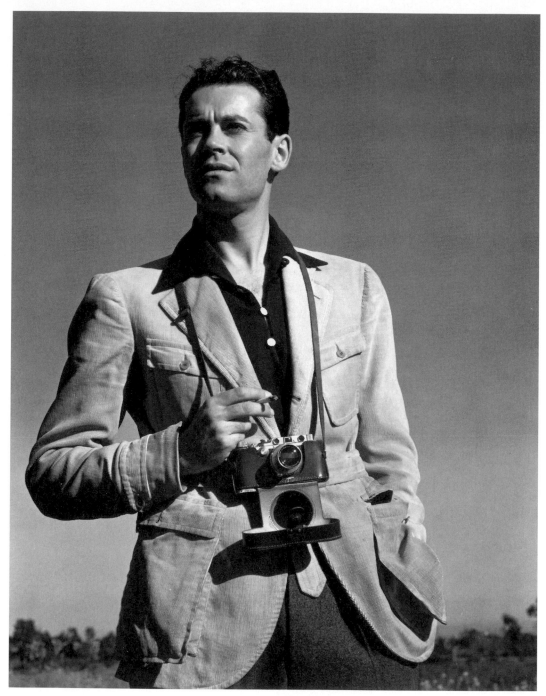

21. *Henry Fonda.* Photograph by Edward Weston, 1936

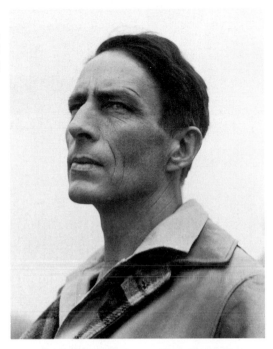

22. *Robinson Jeffers.*
Photograph by Edward
Weston, 1929?

23. *Igor Stravinsky.*
Photograph by Edward Weston, 1935

24. *Arnold Schoenberg.*
Photograph by Edward Weston, 1936

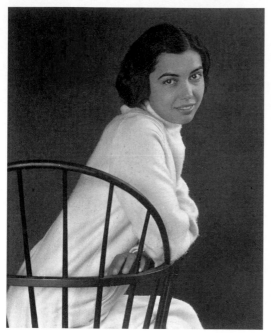

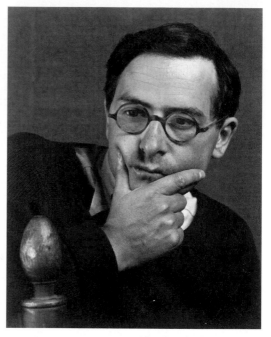

25. *Zohmah Day.*
Photograph by Edward Weston, 1933

26. *Jean Charlot.*
Photograph by Edward Weston, 1933

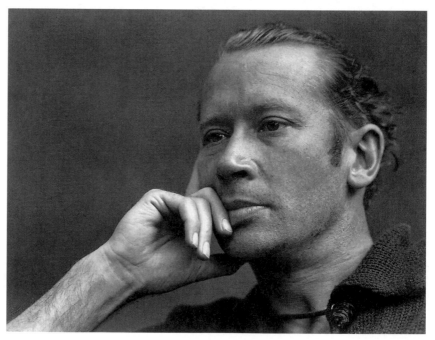

27. *E. E. Cummings.* Photograph by Edward Weston, 1935

28. Self-portrait with Graflex camera. Photograph by Edward Weston, 1935

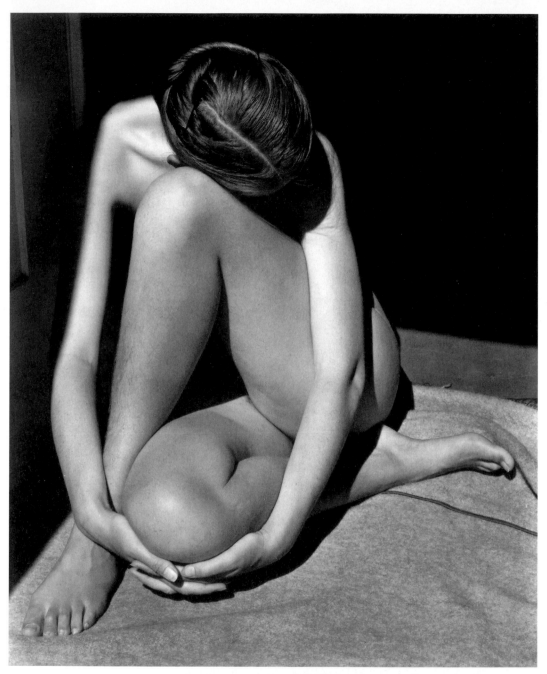

29. *Nude.* Photograph by Edward Weston, 1936

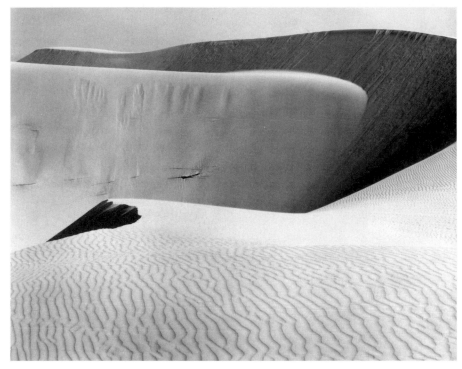

30. *Dunes, Oceano.* Photograph by Edward Weston, 1936

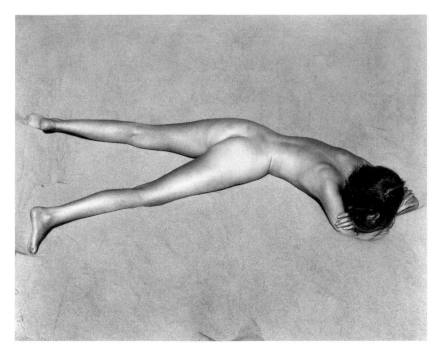

31. *Nude.*
Photograph by
Edward Weston,
1936

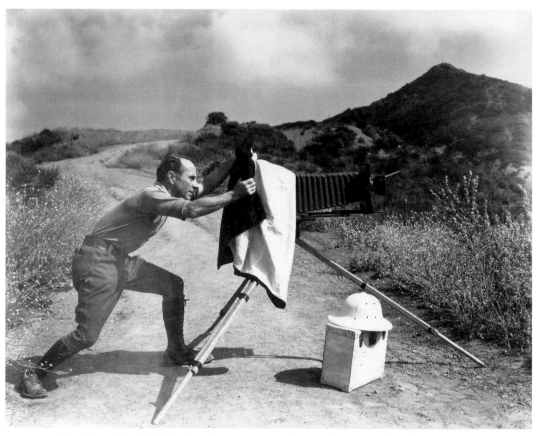

32. Edward in Griffith Park, Los Angeles, 1937. Photograph by Chan Weston

Our family days on Mesa Road had come to an end. Brett departed, Neil signed on to a tuna boat, and our landlord complained about insufficient upkeep of his premises and proposed a rent increase. It was time to find more modest living quarters, so we moved into a small beach house across the canyon at 454 East Rustic Road.

The house was one story, of single-wall (board-and-batt) construction, with one large all-purpose room, three tiny bedrooms, and a kitchen, bathroom, and back porch. The bedrooms were so small there was no way to wedge in anything larger than a single bed, and most of our clothing had to be kept in the storage wall that occupied one whole side of the living room. We told ourselves that this was a temporary solution, to last until that great year of freedom which we hoped the Guggenheim Foundation would provide.

We then heard, from two different sources, that Henry Allen Moe, the secretary general of the Guggenheim Foundation, was interested in seeing a fellowship awarded to a photographer but did not feel that Edward's statement was something he could present to his committee of judges. In fact, as one source reported, he thought they would find it downright insulting. It was a difficult moment for Edward. He now had to admit that the statement was subject to misreading—the four lines that "said it all" to him could be read by others as flippant, self-important, or evasive.

We sat together to draft an expanded proposal, listing the points from Edward's original version that he had discarded as superfluous, and adding such others as seemed to underscore the validity of photography as a medium of artistic expression. The final version of the letter was five typed pages, and it left no doubt that it was written in total sincerity by a man who believed deeply in his work.

Edward was impressed with the product and candidly admitted that he couldn't have done it so well on his own. I think what struck him most about our collaboration was that it had made writing a stress-free activity. When he didn't have the whole responsibility, when he could bat ideas back and forth as they occurred, it freed him to take a more relaxed view of what he was doing, and the fact that it came out sounding like him must have reassured him even more. Once our fate was sealed, in the mail and out of our hands, we decided a vacation was in order.

. . .

A hundred miles up the California coast at Oceano lay the dunes that Edward had first visited with Willard Van Dyke in 1934. Gavin Arthur (a grandson of President Arthur) lived there, where he functioned as patron to a collection of artistically inclined dune dwellers who inhabited a cluster of cabins at the edge of the mountainous dunes that began near Pismo Beach and stretched south for twenty miles. Gavin had invited Edward to come back any time and stay as long as he liked. Edward had been fascinated by the "made-for-photography" aspect of the place and was eager to spend a few days exploring it. "You won't believe it," he said. "Everything is black-and-white!"

I was distinctly disappointed to discover, on the afternoon of our arrival, that the sand was actually tan in color and the shadows were an undistinguished gray. Photographers see things differently, I reminded myself, but when we set out the next morning and rounded the first high dune, I saw that Edward's enthusiasm was amply justified. We entered a silent, empty world that blotted out all evidence of life. At first I kept expecting to see a head appear over the brow of a hill, but none ever did. The people in the area who crossed to the beach followed a regular path among lower-lying dunes. By heading into the high ones—some were a hundred feet tall—we were soon surrounded by trackless wastes, where it was easy to work up such a lost-in-the-Sahara feeling that it took a quick pull on the canteen to counteract it.

All the dunes I had seen before shrank to sandbox size when compared to these towering peaks and steep-sided bluffs. Sometimes the horizontal surfaces were deeply incised with a carpet of wind ripples, and sometimes they were swept smooth by the onshore wind that was carrying the top layer elsewhere. The same ripple pattern decorated the gentler slopes, but wherever there was a genuinely vertical bank—three feet, six feet, even eight feet high—a mysterious fishtail frieze would appear, the wedge of the tail at the top of the bank and half the body reaching to the bottom, so it appeared that the fish's head must be buried in the sand. If you came upon a pristine bank, you only had to touch the top edge with your finger to make the sand start sliding and the fishtails appear. No matter how often I worked this trick or how carefully I watched

the resulting landslide, I could not fathom why the sand always descended in this particular form.

The fine sand never stopped moving. From the top of the dune you could watch it blowing off the crests and—crouched in a windless hollow—you could hear it rustling as it flowed down the steep banks. In these protected corners there would be delicate crisscrossing little tracks left by creatures who had departed long before the sand warmed up—lizards, mice, small birds. The tracks would not be obliterated until the wind shifted and found an opening through which it could sift new sand over the record of their presence.

The footprint record that worried Edward was his own. From the top of a rise he would scan the surrounding formations, trying to select a downward course that would do the least damage to the fewest foregrounds. As usual he was carrying the 8 × 10 on its tripod over his shoulder and the case of loaded film holders in his other hand. (It was no good my offering to carry the case. He said he counted on it for balance.) That awkwardly distributed thirty pounds meant considerable sinking in the soft sand, and he did not want his resulting elephant tracks to appear in the wrong place in a future picture. Once the day's work was done, we would count on the night wind to tidy up after us.

Our first day in these magical surroundings ended when Edward exposed his last film. The snacks were long finished, the canteen empty, and now we were tired and ravenous. We dropped our cargo at Gavin's cabin, where we were staying in his absence, and stumbled over to the guest house. Some of the semipermanent settlers we had met the previous evening had promised to feed us, and this they did with a meal of sweet and tender bootleg clams. They informed us their other favorite was wild swan. This section of coast was on the Canadian flyway, and bow-and-arrow enthusiasts would lie in wait at dusk or near dawn and silently bring one down. We were relieved it wasn't the season for this particular dish. While we ate we heard about the benefits and perils of dune life.

Called "dune rats" by respectable folk in the area, the dozen or so residents were the dropouts of the Depression days, people who looked for places where isolation, climate, and nature's bounty made it possible to live cheaply and more

naturally than civilization permitted. Gavin supplied them with a gathering place in exchange for their services as caretakers. Most of them lived—or at least slept—in cabins that had been abandoned by earlier occupants when the sand had moved inland to overwhelm their houses. A subsequent shift in the wind exhumed these skeletons, and some, other than being slightly skewed, were still sound. None was seriously worth improving, since the sand might return at any time to re-engulf it.

Gavin's cabin, which was set farther out in the sand than the guest house, was not far from the northern edge of the dunes, and since their tendency was to move southeast, because of the prevailing northwest wind, we were unlikely to wake up and find a dune on the doorstep. Before we left to go back to Gavin's, I was instructed in the fine points of his outdoor shower. In the morning we were to fill the five-gallon sprinkling can and hoist it by pulley to the porch ceiling; in the evening we were to stand under the bucket of sun-warmed water, tip it with the pull cord, soap up, tip out the remainder for rinse, and finish off with a two-minute air dry.

We were out before dawn the second morning, when there was still a light coat of dew on the sand and the air was cold enough to require outer layers of clothing. In that pre-dawn light hundreds of tiny tracks stood out—or so I thought—on the ripple-marked sand. Edward was pleased with the complex patterns, but his trained eye told him that until the sun dropped a minute bit of shadow into each tiny footprint crater, he would lack the contrast he needed. Photography seemed always to be a muddle of contradictions. When Edward then pointed the 8 × 10 at an assembly of dune ridges that all looked the same color to me, I thought the forms would be flattened and hard to distinguish. Not until the negative was printed did I discover that the monochromatic rendering had accentuated the bulkiness of those beached-whale shapes, emphasized the ripple marks scattered on their flanks, and that light from the pale gray sky had added a fine white edge to their contours.

I climbed to the top of the highest crest in sight to reconnoiter. About a mile to the east there were hills and trees. About the same distance west, ocean waves rolled in on a flat beach that continued north and south. To the north the dunes dropped down to mere sand hills, but south of us stretched range

after range of sand mountains with valleys and plains set among them—a whole sandy geography where the straight line was outlawed and the arc and parabola ruled. How did the sand continually duplicate its favorite shapes and yet produce an endless variety of forms? As puzzling a question as the role of contrast in photography. I watched Edward tramping along the sand ridge below me and slid down to intercept him. "Down that way," I reported with a wide arm sweep to the south, "the dunes are endless. You'll never run out of new subjects." Edward, who was brimming with excitement over the material he was finding, assured me he never would run out where he was, because the dunes were changing constantly right before our eyes. He was right—if you examine his dune pictures carefully, you can almost always find a soft spot of moving sand somewhere in the landscape.

An hour later, when the sun was climbing higher and the fine, soft sand was pleasantly warm, I thought it was time for a sunbath. I called to Edward, who was working on a higher ridge and across a small valley from me, to alert me if someone approached, then I stretched out on the side of a bank where my footsteps coming and going had created a narrow shelf. When I next looked around, the camera had moved to the near side of the ridge and was aiming down at me.

After Edward had made a few back views I decided to try diving down a steeper part of the sand bank. It was a giddy experience, like going slow-motion over a waterfall, and after a trial run or two to get the hang of it, I could fling myself down with abandon. By this time I had the bank pockmarked with footsteps and gouges. Edward used these indentations to advantage in the nudes he made—they created dark accents in the monochromatic sand—and when the call came to "Hold it!" I used them to keep me from sliding farther down the slope.

I saw one of the most splayed-out of these sliding nudes in an auction catalogue recently. The picture's owner said Edward had never shown it because he considered it "too erotic." Such a statement begs for correction. In those days postal regulations forbade the mailing of nudes that showed pubic hair (what Edward considered obscene were the shaved ones the post office found acceptable), and since his photographs were often in the mail—en route to and

from exhibitors or purchasers—he found it simpler to conform to this shibboleth than to keep track of which packages could be sent only by Railway Express. Edward didn't think of his pictures in erotic terms, as he made clear in his *Daybook* comments on a 1928 nude: "From the last time I have one extraordinary negative. She bent over forward until her body was flat against her legs. I made a back view of her swelling buttocks which tapered to the ankles like an inverted vase. Of course it is a thing I can never show to a mixed crowd. I would be considered indecent. How sad when my only thought was the exquisite form. But most persons will see only an ass!"

What did bother him about some of these dune nudes—especially the face-down one, and the back view with the top hip raised, making a crease at the waistline—was having to explain over and over that he hadn't fiddled the image on the negative to produce the black line around the body. He was patient at explaining the phenomenon to non-photographers: "Any light, rounded object, against a light background, with the light straight on it and the camera likewise, will appear to have a dark line around it." My own explanation was "You're only seeing the edge of the shadow I'm lying on," but I never got up the nerve to say it out loud. Edward had used such light and background in some of his 1927 pictures of the dancer Bertha Wardell, and even before that in nudes he made in 1918. He didn't have much patience with photographers who didn't realize the dark line was natural. In his view they should already know this basic fact about light.

I thought the sand slide would be hard to beat, but back at the cabin the shower awaited us. The water was gloriously warm from the day of sun, and with no curtain to block the view while we bathed, we could watch the sunset painting the dunes with pastel. We were too tired for socializing. When Edward had unloaded and reloaded films in his improvised bathroom-darkroom, we ate the last of our crackers, cheese, and apples. A quick survey of Gavin's supply cupboard netted a bottle of whiskey, so I made us a couple of hot toddies as a reward for the day's endeavors.

We went up to the guest house for breakfast the next morning, downed our share of bacon, eggs, and pancakes, and said our goodbyes to the dune folk, as we were planning to leave around noon. After a heavier breakfast than we were

accustomed to, we set out to walk it off along the perimeter—the dune "shore"—because our leg muscles were complaining about two days of walking in deep sand. The first thing to catch Edward's eye was a mysterious circular track in the sand. While he went back to get his camera, I asked someone at the guest house what caused it.

It was the track of a doodlebug—I knew Edward would relish the name—alias the ant lion, which digs a conical pit with ultra-steep sides, then lurks under the sand at the bottom. Careless ants run too close, tumble in, and, before they can scramble out, are seized by a leg, dragged under, suffocated, and eaten. Time to repair the trap and wait for the next course. After Edward finished photographing, our informant made a quick scoop with a bit of wood, and sure enough there was the miniature predator hot-footing it back to his hiding place. And what had this cone-constructor been doing last night wandering in a great circle under the surface? Hunting? Exploring? Or possibly, like me on yesterday's slide, just enjoying the sensation of sand massaging body.

Edward and I continued our walk and soon came on a cabin losing its battle against the sand. A couple was methodically sweeping the last of the sand out the door toward the nearest hummock, which was two feet away and already higher than the window. Like most of the men here, the husband had a beard and wore only shorts and sandals. His wife wore a loose shirt over shorts and had her hair pulled back in a clasp. A baby in its diaper was asleep in a rope cradle hung across a corner of the single room. At the rate the sand was moving, they told us, they could count on two more weeks at most before it would be too dangerous to stay in the cabin. They seemed to take their coming eviction calmly, although they hadn't yet found a place to settle.

I tried to picture myself with a small baby, no future home in sight, and the sound of sand pouring in the open door all night—you couldn't close it for fear of being trapped. My imagination wasn't up to it, but the effort at least made me appreciate what comfort I had at home. On the drive back to Rustic Road we discussed the pros and cons of the dune dwellers' back-to-nature existence. Of course it wouldn't do for Edward—a photographer needed a darkroom, lights, running water, etc.

As Edward saw it, his life was already stripped down to essentials. In any case,

wasn't there a flaw in assuming that such a life represented independence? Most likely the young people facing obliteration of their cabin would be rescued by Gavin or a helping hand from relatives. Edward said this was like Thoreau reveling in the beauties of natural life in the wilderness and then going back to town for a hot dinner with his sister.

In 1964 I drove through Santa Monica Canyon once more looking for the houses Edward and I had shared. The beautiful old sycamores that filled the canyon with rustling leaves still spread their branches above the stream that ran down the canyon's center. The house on Mesa Road had vanished, but the one on Rustic still stood, looking even more weatherbeaten and remarkably small. It seemed improbable that this ordinary dwelling had housed such a significant part of my history.

THE GUGGENHEIM TRAVELS

SEVEN

In mid-March of 1937 we received the news that Edward had been granted a one-year fellowship for two thousand dollars, beginning April 1. We had practiced the next steps so often that we began preparations without missing a beat. We split the chores and arranged them in practical sequence, to be crossed off day by day. There was a great deal to do to prepare for a year on the road.

Edward was uneasy about being away for long stretches, because film could be damaged by temperature changes, moisture, and other uncontrollable conditions. We would be making trips of a week or more and we couldn't keep paying rent on a house—the fellowship money was just enough to cover our travels. Chan in Glendale and Brett in San Francisco had already agreed to provide housing and a darkroom for our periodic returns, but neither of them had enough room to store more than essential photo supplies and a few clothing changes. Edward had to leave most of his negatives in commercial storage in Glendale.

He loaned out a few belongings, but most of his furniture was carted back to the "home place." How many times had Flora seen the bookcase-desk, the captain's chairs, the print-spotting chair, the Mexican chest full of Edward's papers appear and disappear? Did she think each time they might be back to

stay? Or did she merely see it as a coming back to where they belonged and feel their absences—no matter how protracted—were only temporary?

By nature I was a collector, just as Edward was a discarder. I admired and was also horrified by his systematic destruction of letters, receipts, invoices, and records of all sorts. How could he be so sure that he wouldn't want to refer to some document again? And I knew he wasn't—I had seen too many things retrieved from the wastebasket.

"I make a mistake sometimes," he admitted. "But I don't like my mind or house cluttered with past records. My photographs are record enough of where I've been and what I've done."

I was surprised then when he unearthed a number of items saved from Mexico which he thought might be handy on our travels: a pith helmet, worn leather breeches, lace-up boots, and a leather money belt. The old black cape from those days was too useful ever to have been stored away. It served as a dustcover for whatever was packed in the trunk of the car, a foot warmer on cold nights, a picnic cloth for al fresco dining, and a blanket for sunbathing.

The money belt was a clumsy-looking thing of old, dark leather, three or four inches wide. In the thirties most businesses would accept only a local check, and even that required references; the belt would serve as our faithful banker. We had tried to get a gas credit card and been refused. Edward was furious to find that Flora had one, even though she owed money all over town. He never did recognize the advantage of being in debt.

I saw our coming travels as my great opportunity to become a legitimate assistant. While Edward photographed the physical world with his camera, I would practice my own kind of recording, keeping a log of every film exposed, every penny spent, and everything that happened. I acquired a pint-size Royal Signet typewriter with a boxy case I could use for a typing table while sitting on the ground. Most of the four hundred and something pages of the Guggenheim log were typed on this $17.50 machine.

Our preparatory errands for the trip took us to Glendale, where our chores moved along briskly. I had finished the comparative pricing of camping equipment, Edward had arranged for the storage of prints and negatives, and we were walking back to the car when he caught sight of a figure up the block and said, "There's someone you should meet."

We approached a middle-aged woman who had stopped in front of a sec-
ondhand furniture store. She turned in response to Edward's greeting, and I
was introduced to his old friend Margrethe Mather. The three of us stood
chatting for a few minutes. She said she worked with the owner of the store,
bringing in salable items when she could find them, but like everything else,
the furniture business was at a near standstill. While she and Edward talked, I
looked for some trace of the young woman Edward had known since 1912 and
made portraits and nudes of in the early 1920s—that woman of mystery and
romance who had cast such a spell over young Edward Henry Weston with her
haiku, her petal drifts on his doorstep, and her mysterious vanishings and reap-
pearances. In his *Daybooks* he had referred to Margrethe as "the first important
person in my life."

Margrethe had introduced Edward to modern art as well as to the significant
literature of the day. A photographer who specialized in pictures of film stars,
she worked with Edward in the studio in the pre-Mexico days, when his pho-
tographs began to change from pictorial to sharp focus. Edward had established
a good living by then; his reputation had spread and was beginning to attract
well-heeled clients. In 1917 he had been elected to the London Salon of Pho-
tography and was regularly winning honors and prizes. It had taken courage to
make such an artistic shift, particularly given that his new work sometimes
brought pained reactions—this man wants to peel the scales from our eyes and
our eyes are tender and we don't like the feeling of looking at naked truth.
Margrethe played a big part in this watershed in Edward's career, but standing
on the Glendale sidewalk, I could not detect evidence of that past.

We pulled into the nearly vacant lot at 4166 Brunswick and bumped along to
where three or four scaly fruit trees almost concealed Chan's one-room shack.
After parking under the walnut and extracting the key from the crotch of the
apple tree, it took us no more than five seconds to appraise our new base of
operations. A double box spring and mattress lay in the center of the main
room and took up most of its space. Our camping gear and essentials would
have to be stacked with care around the edges. The one small window was too
vine-covered to let in much light, so Chan kept the curtain closed and relied

on an overhead electric bulb. There was a narrow strip of kitchen, and a bathroom and closet next to it. We told each other this would prepare us for an even more spartan life on the road, and the cooped-up quarters would prevent any temptation to loiter too long between trips.

We had saved the darkroom out in the garage for last, maybe because the dust-laden dwelling, with ancient newspapers still rolled as delivered and stacked in odd corners, may have dampened our ardor for exploring, but Edward pronounced it serviceable, if awkward. Here he would develop the new negatives after each trip and make a few selected prints.

A silent partner in our Guggenheim adventures was Phil Hanna, editor of *Westways*, the official magazine of the Southern California Auto Club. Edward and I had joined the organization as one of our first money-spending acts, with an eye to the hazards of future road travel. Phil got around on crutches, a result of polio, I believe, but that hadn't stopped him from going over every stretch of road in Southern California—and Northern as well.

Before we met Hanna, our Guggenheim itinerary was a jumble. Since we could go anywhere and at almost any time—except the desert in midsummer or the High Sierra in midwinter—we imagined starting out and following whatever highway or byway attracted us. We badly needed someone who knew a lot more about the state of California than we did, and Hanna fit the bill. When we explained our general desires and limitations—to see as much varied territory as we could cover on trips of two or three weeks' duration (which Edward considered maximum for hauling around exposed film), with as many camping opportunities as possible to stretch our budget—Phil began whipping out maps and talking about regions we'd never heard of. He drew us six skeleton round trips, three in Southern California and three in the North, designed to cover the state and also lead to what he considered some eminently photographable sites. He assured us we would discover wonderful side roads as we went along.

"What kind of car are you driving?"

We answered with an outpouring of doubts about secondhand vehicles, explaining that we couldn't afford to spend nearly half the available Guggenheim funds on a new one. We would have to find something for three or four hundred dollars, and every used-car-lot story we heard increased our dismay.

At this point Hanna grew a white beard and sprouted a jolly red suit right before our eyes by proposing a contract with *Westways* that would provide us with enough additional income to make monthly payments on a brand-new car. Edward would supply eight to ten prints a month, which would entail only one extra day in the darkroom for printing after a trip's negatives had been developed. He would be paid $50 a month for the pictures, and I would earn $15 for writing a paragraph or two to set the scene, along with short explanatory captions to accompany the individual prints—nothing to it. I would have all the data at my fingertips from the records I intended to keep, and at our home bases I would have library access if needed.

Elation is not too strong a word for our mood as we went straight from his office to an auto dealership where we picked out a Ford V-8 sedan. For $400 down and monthly payments of $42.01 for one year, the car was ours. To save five dollars we chose black, a bit of misguided thrift we later regretted during our many days under desert sun. The car's original name—*La Puta Negra*— was based on Edward's idea that had she been leading an honest life she would never have fallen into our hands. It didn't last long, because "Heimy" immediately supplanted her and required less explanation.

Planning to follow the seasons and to camp out most of the time, we invested in basic camp gear. To save the daylight hours for photography, we decided to keep cooking to a minimum, with canned food as the base, augmented by dried fruits, cheese, crackers, honey, nut butter, and other ready-to-eat snacks.

As for camera equipment, it was equally simple:

8 × 10 Century Universal Camera
Paul Ries Tripod with tilting top
Focusing cloth
Triple convertible Turner Reich lens, 12", 21", 28"
Lens shade (Worsching Counter Light Cap)
12 film holders
K2, G, A filters
Weston meter
(19" element of a Zeiss Protar added later in the year)

2 small camera cases which hold all above equipment except tripod
Insulated wooden box to protect films

I caused a minor trauma when I asked Edward to crop off my hair to simplify our life on the road. As he cautiously removed half an inch at a time I kept insisting "More! More!" In retrospect I see that this was a difficult act for him to carry out. His December 1934 *Daybook* entry describes me with "golden brown hair to shoulders," suggesting this was part of my aesthetic appeal. Edward didn't want me looking like a boy with sawed-off locks. It may even explain why he made so few pictures of me during the Guggenheim trips—he did only one in the first eight months, and then my head was covered by a scarf. However, I think a more likely explanation is that he was thrilled to be doing new work in new places and it made no sense to spend time on a subject he could just as well photograph at home.

We selected Death Valley for our first Guggenheim trip, because the heat would be unbearable any later. We took off on April 9, 1937, with Cole at the wheel of Heimy—probably thrilled to be driving a real "gemveelie" at last. We entered the valley from the east and took the side road up to Dante's View. Friends had told us that Edward probably wouldn't like the view because everything was so far away, but we had to satisfy our curiosity. Heimy was forced to climb a vicious road; his back tires frequently lost their footing, and when we reached the turnaround on top, he was running a temperature of 212.

What we found more than made up for such a difficult ascent. As I wrote in *California and the West*:

> *North and south the valley seemed to extend to infinity—harsh barefaced*
> *mountains hemming in the narrow trough. More than a mile below us,*
> *spread over half the valley's width, lay a glistening salt bed, with tapering*
> *ribbons of white extending from its sides. The dazzling white lake was*
> *bordered with a fringe of feathery grey that melted into a background*
> *of deep chocolate brown. At the base of the cliff we stood on, the neat arc*

of an alluvial fan was rimmed by a fine black line which we presently realized must be a highway. Across the valley rose the seamed, scarred wall of the Panamints, with sweeping curves of vast alluvial aprons at its base and a sparkling coat of snow on its peaks.

A hundred miles of desolate geography spread out below us in the weighty silence peculiar to deserts. We might have been on a lost moon world where time and motion had ceased to exist. Edward was so shaky with excitement he could hardly set up his camera, and all we could say for some time was, "My God! It can't be!"

On subsequent Guggenheim trips Edward would pass by scenes that once might have stopped him, saying, "If I'd never seen Death Valley, I would probably work here."

Although we were stunned by the valley and wanted to spend plenty of time there, we were unprepared to camp in it—our canvas desert water bag had already sprung a leak, and we had not brought enough provisions (our plan to shop along the way was fast abandoned when we saw local prices). Yet we had a horror of public campgrounds. I trace this prejudice to a particularly noisy, overcrowded camp that we had passed often during our two years in Santa Monica Canyon. We never ceased to be amazed that people could be baked in such a dense pie of cars, trucks, trailers, laundry lines, radios, phonographs, babies, and dogs, and still call it recreation.

Because we needed to be near water, we had no choice but to pick a site at the only campground available. Texas Springs was set back in a fold of mud hills above Furnace Creek Ranch, and to our great surprise, it was clean and uncrowded. Large mesquite bushes acted as screens between camping parties and provided unexpected privacy. On our future trips to Death Valley, we returned to Texas Springs with a sense of coming home.

My bible for this country was *California Desert Trails* by Joseph Smeaton Chase, originally published in 1919. An Englishman with a literary background, Chase was one of those rare travel writers whose words are beautiful as well as informative: "The magic of the desert is a riddle. Not only does it defy putting into words, but I have never found the person who felt that he could even

shape it vaguely to himself in thought. For one thing, it is in its essence a contradiction. The desert is the opposite of all that we naturally find pleasing. Yet I believe that its hold upon those who have once fallen under its spell is deeper and more enduring than is the charm of forest or sea or mountain."

Phil Hanna had given us a letter of introduction to Don Curry, the park naturalist. He suggested a number of fine places for Edward to photograph and drove us to several of them. On April 12, he took us south along Volcanic Drive, which wound through hills covered with dark volcanic rock, to Artist's View Drive, whose exquisite pastel cliff, to Edward's disappointment, was too pale for black-and-white photography.

Perhaps to compensate, Curry insisted on taking us to Butte Valley in the Panamint Mountains, so Edward could photograph an impressive formation which had black-and-white stripes running diagonally across its face. The last leg of the road was too rough for Heimy, so we loaded ourselves into Curry's International pickup, Edward and me in front, Cole astride a sleeping bag in the open back with cameras, canteens, and food. We swooped and rattled and bounced down the road until, with a sickening lurch, a rear wheel flew off into the desert. To his disgust, Curry found the toolbox was missing from his truck, but he and Cole managed to reattach the wheel with baling wire and on we went over endless, spine-shattering terrain until finally there was no road to be seen. The steady jolting of the truck was like trotting in a nightmare, slowed up but not eased. Each breath was slammed out and gasped in—our necks and spines swung like grass stalks in a wind. After miles of this, we broke into open space, the wondrous butte facing us across the plateau.

Edward's expression told the story: the contrast in colors was once again too subtle. Curry drove cross-country through the bushes to give Edward a better look, his truck chewing the vegetation with gusto. We ate some lunch; Edward made a halfhearted attempt to render the butte for *Westways*; Cole explored; I lay in the sun to let my synapses reconnect. Then Curry lured me off to look for Indian spearheads, but all I found were lizards and fool's gold.

We started back down Misery Trail, Edward taking Cole's place in the back

of the pickup, and this time the jolts seemed longer and harder. Curry stopped to catch a horned toad, which I held for him on the way to Heimy, and before we parted, he invited me up to the cabin for a steak dinner with his fellow rangers. I declined, but Edward's nose was clearly out of joint. It didn't matter that I had only a friendly interest in Curry—if he was attracted to me, that was sufficient grounds to send Edward into high dudgeon.

Edward wasn't the only one suffering from jealousy. Cole and I would both have preferred to have Edward to ourselves, but I felt confident that I had more to offer as a traveling companion and Boswell. The next trip was to the Mojave and Colorado deserts at the end of April, and this time Brett came with us. He was a good camper but also accident-prone, and on several occasions our progress was brought to a halt because Brett, his camera, or his pants needed patching up. More difficult than the delays, however, was the sense of being part of a group rather than half of a pair. Edward and I had planned our adventure together and I felt it required mutual commitment.

It wouldn't have occurred to Edward to set off on a trip with no other male for ballast; he took it for granted that one or another son would always be free and eager to accompany us. This was partly habit, because the boys had always done the driving, but it also indicated his lack of confidence in traveling with only a female companion. His sons had always handled the difficult chores and emergencies—balancing the load and roping it on when they moved, changing flat tires, knowing what to do when the car was indisposed—and since they were all taller than he was, their presence gave him a feeling of security in strange places. The idea of facing the world with me alone did not strike him as at all prudent. He often brought up the story of Frank Lloyd Wright being stopped by police at a state line with an underage female in his car.

It was obvious that our traveling pattern would never change unless I took the initiative. I tried to explain my point of view, but it wasn't an easy thing to communicate to a father who loved and depended on his sons. Desperate to make my feelings clear, I wrote him a letter and left it on his pillow:

Perhaps in writing the words will come out that fail me in speech. Now, as you go out the door, I am still on the fence, wondering and hoping.

Carrizo May 17 37
PLEASE HELP SICK MAN AT CARRIZO STATION
resp Geo T Edwards

We found the man on the stream bank under the trees. He lay on his back on a piece of worn tarpaulin, his open eyes aimed at the sky and already being investigated by two or three desert flies. Geo T Edwards had done the best he could for him: a bottle of milk and a can of water sat alongside his small bundle, which was tied up in an old blue bandanna with a pencil through the knot. The man was short and emaciated, with red hair clipped close and a stubble of beard. He might have been around fifty.

We stood a long while looking at him, only the creek running below us making a soft sound in the hot silence. I had never seen a dead person, and had supposed that it would somehow be more dramatic. But this man had gone so quietly and peacefully, it was hard to believe he was really dead.

Edward decided to photograph the man before the sun dropped behind the Laguna Mountains. He made two exposures and was replacing the holder in the camera case when he realized that the signal latches were wrong. When we checked with my running negative list it was clear that one of the last two photographs must have been a double exposure, but the man was already in shadow, except for his head. Edward made a last negative, and then the sunlight vanished.

I opened the man's bundle, a heartbreaking intrusion into his life, but I felt I had no choice. A note on a scrap of paper atop the bandanna gave a name and address in Tennessee. What had California symbolized to this man—a land of milk and honey, a paradise of dates and oranges and perpetual sunshine? Though he made it only as far as the sunshine, he may still have held the vision of better things to come, even as he wrote: "Please tell my people . . ." I copied the name and address, we covered the man as best we could with the tarpaulin, and then headed back to the road.

The eighteen miles back to the southern highway might as well have been forty-eight. A hot wind roared at our backs, spraying Heimy with gravel, and in the

dark, visibility was further limited. There were great gouges out of the road, which often forked with no indication of the right way to go, and huge washboards that we maneuvered Heimy in and out of, pausing on the top so that Edward could get out with a flashlight and point the way down. Stopping was out of the question, and we began to see how easy it would be—if the gas ran out or a tire went flat—to die out here in the desert. Our certainty of being well prepared gave way to the realization that we had been relying all along on the thinnest margin of luck. When we saw a railroad track gleaming in the sand we hardly recognized it, but then came giant fireflies crossing the darkness, and we knew it must be the highway up ahead.

It was late when we reached the small town of El Centro. Too exhausted to contemplate camping, we rented a motel room and telephoned the local sheriff to give a report. He was unimpressed by our news. "Somebody dies out there every year," he said. "Thank God he's over the county line and I don't have to go get him." He wanted to know why we hadn't tied him on the car and brought him along with us.

These first desert trips brought the greatest working difficulties of the year and forced an equipment shakedown that generated some modifications, notably in the focusing cloth. When temperatures top one hundred degrees, a black rubberized focusing cloth such as Edward was accustomed to using could cause head burns. We solved this with a homemade version: two layers of black sateen topped with one layer of white, the pieces sewn together so that no stitches pierced all three layers. The whole thing was two yards square, large enough to clip onto the back of the camera and anchor around the photographer in a high wind. It was so elegant when new I threatened to wear it as a cape should we find ourselves in a fine dining situation while on the road. White cloths based on this model have since become standard for hot weather work.

Another big problem was film loading, which Edward had intended to do at night in Heimy with blankets over the windows. An account we later wrote for *Camera Craft*, told from Edward's perspective, describes the unforeseen flaws in this scheme:

> *The first night out we were camping near Victorville on the Mojave Desert, and by the time we had finished dinner a stiff desert wind was*

blowing. Accordingly we put the blankets over the car and weighted them with canned goods, boots, etc. But the night was bright with starlight and this was not enough. So the sleeping bags were unrolled and draped over the car sides—a satisfactory arrangement until a really strong gust of wind hit the car broadside, peeling off blankets and bags and sending canned food, boxes, and boots clattering down the wash . . .

An even more terrifying loading adventure took place on the last night of this trip when we were camped in Red Rock Canyon. That night the wind was so strong that there was no question of keeping anything over the car—it would have been physically impossible. So I sat on the floor of the car and draped a blanket over me from the back of the front seat. Then to my horror, every time I drew out a slide—no matter how slowly— flashes of static electricity would illuminate my "darkroom." I was sure that all of these negatives would be ruined, but they were not damaged, the eye accustomed to darkness being prone to exaggerate the amount of light . . .

After these adventures I got a heavy weight tarpaulin, big enough to cover all car windows when folded double and easy to make secure by passing a thin rope around the car under the door handles, hinges, and the handle of the luggage compartment. This arrangement has stood the test against both high wind and strong light.

By June we had finished Hanna's southern routes and would have set off to Yosemite Valley, Tioga Pass, and Lake Tahoe, except that Tioga Pass was still snowbound. We decided to take some short trips instead, and on June 4 left for Antelope Valley, an arm of the Mojave, accompanied by our friend Zohmah Day. She was the fiancée of Jean Charlot, a good friend of Edward's since his years in Mexico. I was drawn to her because she was a total original; she had named herself Zohmah because she wanted to have a name that wasn't like everyone else's. Zohmah found our primitive camping style admirable but alarming. We had no camp light, so we went to bed early. We had no folding tables and chairs, so we tried to pick campsites by rocks or ledges. We had no air mattresses, so we learned to make do with the hard earth. We had no pillows,

so we used our rolled-up clothing for a headrest. Not only did this suit our budget and allow us to devote most of the daylight hours to working but it kept Heimy uncluttered aside from Edward's bulky equipment—camera, film box, two cases for loaded film holders—which we kept handy so that if he saw something while we were driving he could set up in moments.

After our three-day adventure I received several pages in the mail from Zohmah with a note saying, "Dear Charis, In case you have been too busy to write up the trip, I have written it up for you. Zohmah." This is how life on the road struck our delightful—if tender-footed—companion.

Trip to Antelope Valley where Edward had been twenty years ago. It is now a reclaimed desert and Edward thought it a waste. He said wistfully, "Let's go to the Wonderland of Rocks."

We went on the main highway across the many miles through the towns of Lancaster, Palmdale, Mojave, noisy wicked desert towns, I hope, pinched in as they are by quiet and distance. We turned off the pavement up side roads and around the cliffs and into side gullies, and got out of the car at every turn to test the wind that was blowing strong and gustily. No matter what angled rocks we got behind the wind came gushing in too, so we settled on a place between blowings, unpacked food, stove, tarpaulin.

Edward and Charis know how to live. Among other things they can make the least effort of routines and do completely the things they like. Good dinner was ready in a moment and then slow leisurely eating and sipping of hot Weston special deluxe coffee and fun conversation all about, briefly, "Ye Gods, how can a writer write? How when he comes up against a place like the desert can he speak of it with words found alphabetically arranged in every dictionary?"

Edward said when he used to write there were not enough words for beauty. Charis said maybe it is best not to try and tell about things; we can really say only what things do to us.

All that desert and cliff and sky going beyond where we sat and off into no approximating what spaces, and now the dark had come and

blotted off the shape of the world, just space out there filled with things quite hidden. We had chosen a spot for ourselves, but maybe something in all that out-doors would come creeping, blowing in. I said an "ixnay," this spot is ours.

Charis, though, besides being a sophisticate, a bohemian, is also a "child of nature" and could walk about quite casually in the blackened world. Edward, of course, can only be touched by beauty. Like his camera-eye he is separated from all blight and time and ordinary dimensions. So he isn't brave like Charis, just superior.

When they had asked me to come on this trip I knew I mustn't speak of how snakes frighten me, but couldn't help mentioning them conversationally. Charis said, "Sure there are lots of them and especially at night." Edward said, "They won't bother you at all, but sleep in the middle and we will protect you."

We got into our sleeping bags.

Above, as the little fire I'd made went out, we could see stars enough to make Charis chortle happily. Made me wish that I would dare hang my head out of the bag and look at a few glittering million of them.

I fell asleep and woke up smotheringly warm. The sky looked so bright when I peered out from under the covers that I thought it must be near morning and so lay there waiting for the others to wake up—so many hours that it should have been afternoon instead of only the moon coming up at last, trailed by a huge star. A new sliver of moon so exciting it was well worth the sleeplessness.

Edward woke up and liked seeing it too. Charis is also a perfect sleeper. She hates to go to sleep and miss being awake but when she does it is too comfortable to bother waking up.

Finally, following the moon and the star across the sky, the sun came, and we got up quick as the light.

Off to take pictures.

Edward in his pink shirt looked like a very bouncing bit of Red Rock Canyon as he went along the foot of the cliffs looking. Charis went off to find him more places, me trailing after. Up a side canyon she found there were perfect Joshua trees.

*After Edward, happy to find so many things he liked, had been snap-
ping pictures almost as quick as he could carry the heavy camera into
position, we ate some breakfast and Edward was again at work.*

*Charis went strolling about with the air of a lady in her parlor, nicely
setting her feet down on the sand as she walked, or resting cozily on a
slope of rock. She cooed to lizards we met.*

*When Edward had worked here as long as he cared to, we went up
another canyon to see an advertised petrified forest. But I'll skip this part.
It was just a twisty desolation.*

*We drove back onto the Mojave. I began to think the sage brush too
green and thick as if the desert were trying to struggle from its reality
of silvery barren hopelessness. Desert colors should burn or blank out in
space, and this desert was trying to be green.*

*We thought we would try camping in another canyon for the night.
This one, called Jawbone-Sawtooth, wound its way up between heavy spot-
ted mountains. We were going to leave ourselves out all night down
among those green sages. We drove along miles trying to decide on a
patch of weeds and sand. I was sleepy and horrid.*

*They decided to go back to Red Rock Canyon and incidentally demoted
me from desert rat to mouse. Not even a rat! But Charis said she had been
tired and sleepy after her first night out-of-doors, which gave me a ray of
hope that I wasn't completely poisonous. Charis is also an angel. She fixed
the beds and good supper of canned beef stew and rubbed my back.*

*Edward though very tired got in the car under the tarpaulin, Charis
tying the ends down so no light would get in, and unloaded film. A furry
footed creature came up to see about our food and Charis heard it and
called to it in the dark.*

I went to sleep first; Charis and Edward said I snored.

I was secretly bewitched by Zohmah's description of me—why, that was ex-
actly how I saw myself! Zohmah also provided another classic line for Edward's
grab bag of great quotes. As we sat at the campfire our first night out, she
looked around uneasily and observed, "Gosh, there sure is a lot of outdoors
around here."

. . .

It was several months before our collaborative double-page spreads began to appear in *Westways*. When the first issue arrived we were both upset. Edward was irritated that his photographs had been tipped sideways and overlapped; if the series was to be called "Seeing California with Edward Weston," he protested to Hanna, surely there was no need to treat his pictures like snapshots.

I was unhappy because most of my captions had been changed. As simple as my contribution had seemed, the job proved to be the most frustrating I'd had to date and dealt a smashing blow to my literary confidence. Between trips I would spend a couple of days in a library doing research before turning out a batch of interesting and informative material, couched in a light vein suitable to an auto club magazine. Or so I thought. Each month *Westways* would throw out my offerings and substitute something I found silly and often pointless. Their captions were particularly distressing. I called a picture *Painted Desert*. They called it *Petrified Nightmare*. *Donner Lake* was changed to *Tragedy's Namesake*. A couple of dead agave stalks twisted together was labeled *Ghosts in Love*.

When the contract was renewed for a second year, I asked Hanna if I should dispense with the captions.

"Certainly not!"

When I returned to the *Westways* layouts in preparation for writing this memoir, I had to wonder what I was so bothered about. Yes, the titles had been cutesied up, but all the information I had carefully assembled was there, used with every set of pictures, except that anything they thought might be taken as negative or critical in tone about the California outdoors had been removed and my mistakes corrected (at that time I was still writing "Sierras" and *Westways* changed it to the proper "Sierra"). I realize now that, as a novice at publishing, I was shocked to have my work edited at all.

EIGHT

With Tioga Pass still snowlocked in mid-June, we accepted an invitation to visit a young couple Edward knew in Laguna Beach. En route, at the junction of U.S. 101 and Laguna Canyon Road, we came upon three precisely spaced trees standing in circular pools of shadow at the center of a vast field of young bean plants. No Salinas lettuce field would have permitted such a waste of lucrative land. Here we could imagine a man with a plow, or a lone bean picker, making a shady stop on his way down the endless row. Edward's photograph has remained a favorite of mine as much because of the impression the sight made on both of us as for the character of the picture.

Edward used this photograph as an example in a discussion of lighting published in *Camera Craft* in May 1939. The picture was made at midday, an hour that is widely regarded as useless for photography. Rejecting this view, Edward said:

> *The reasons for making the picture at noon are even more obvious. The clarity and meaning of the picture could be lost if the neat black ellipses under the trees were sprawled out across the foreground and the furrows between the plant rows were so filled with shadows as to hide the impor-*

tant contrast provided by the texture of the plowed earth. Noon light is by no means the only popular taboo. I have been out with photographers who felt that the day's work necessarily ended when clouds obscured the sun or fog rolled in. The photographer can function as long as there is light; his work—his adventure—is a rediscovery of the world in terms of light.

Despite its Mother Goose architecture—an uneasy mix of tourist trap and art colony influences—Laguna Beach pleased us at first because we were able to divide our time between photographing new territory by day and returning at night to the unaccustomed luxury of hot baths, comfortable beds, civilized food, and even a little private beach for swimming. We went out to dinner and were nicely settled when our host gestured toward a man sitting with a small group on the far side of the restaurant.

"That's Mortensen."

Just as Edward had come to be viewed as chief among the so-called purists, William Mortensen was the pictorialist to end all pictorialists. He had begun his photography career doing stills on movie sets and he saw no value in a picture that was not staged in some way. It made us both uneasy to realize we were in the same room with Mortensen, given the bitterness of some of the exchanges in photography magazines between followers of the two camps. Edward showed no inclination to introduce himself.

The stay with our friends at Laguna Beach ended sooner than we had planned, when our host proposed to Edward that we play musical marriage beds. We moved to a camp at Top of the World, a failed real-estate development on a hill east of town. Following an abandoned road that circled through a eucalyptus grove and past some empty houses, we found a flat spot on a ledge; on one side we looked down on tiny Laguna Beach and beyond it the endless Pacific, and on the other straight down to a little valley with Aliso Creek running through it.

In the morning we woke to find ourselves on an island enclosed by weeping fog that kept us from seeing anything beyond the foot of our sleeping bags. All day we ferried back and forth between the Top of the World and the coast, where Edward made his first negatives of surf on rocks. From the beginning,

his intention was to avoid making the water look like glass, as it so often did in photographs we had seen. His objection to the glassy effect was simply that it didn't look like water, in the same way he objected to foam or spray being pictured as a white blur. What at first seemed a simple matter of timing proved to be a complicated set of compromises whenever the water was moving at different speeds in different parts of the picture.

Edward stood too close to the water with the 8 × 10 and was hit with salt spray that damaged the wooden track on which the bellows moved back and forth. The camera was almost all wood, with a few metal hinges, the wood beautifully planed and waxed so the pieces slid smoothly. The bellows, which was in three sections, extended up to three feet, depending on which lens Edward was using.

We returned to town to get paraffin for lubrication and stayed a night with Ted Cook and his wife. Ted was the author of a humorous column, "Cook-Coos," that had appeared for years in the *San Francisco Examiner*. In the morning I suggested that we enjoy a day of vacation with the Cooks, which Edward thought a reasonable idea, but he would just set up the camera to look at some potted geraniums on the patio. Then there was the picket fence, followed by my legs in a hammock and, as my journal recorded, Ted in "Leica position one—i.e., supine, squinting up into the finder." By the end of the day the negative total was nineteen. For Edward, the idea of a vacation—of taking time off from photography—made little sense. Time was a commodity he jealously guarded against every thief, animate or inanimate: appliances that demanded care or service, a lawn that would need mowing and watering, a chatterer who ran on and on, even a buyer who might insist on unrealistically prompt deadlines. Having shaped his life to gain the maximum picture-making time out of each day, he felt no need to take a day off.

The day we left Ted Cook we got a letter from Ansel saying that Tioga Pass was clear at last and we should come on up to Yosemite any time. This was the signal to shift our base of operations north. On June 29, we left our temporary home at Chan's with the car loaded with prints for Edward's retrospective show in San Francisco. We also had Cole along, to be delivered to his cannery job in San Jose for the summer. Edward had arranged with Nellie Cornish for Cole to study acting at her Seattle school beginning in the fall.

At Hanna's suggestion we took the newly opened San Simeon route up the

coast. It was still plagued with rock slides, but we were so pleased to see this stretch for the first time we didn't hesitate. We stopped often to listen for what might be hitting the road up ahead, while we assessed whether we could get through. Not long after we started, we encountered a man at a lookout point who was so terrified of the steep drop-offs to the sea, unprotected by guard railings, that he wanted one of us to drive his car. As he was headed in the opposite direction, we had to leave the stranger to his plight. I was accustomed to such roads, having learned to drive in Carmel, and pulled over at every turnout so we could take in beauties such as fog rising against the precipices in a swirl.

We had arranged to stay at a cabin belonging to our friend Doug Short, which was near the present-day Nepenthe restaurant in an isolated section of Big Sur. Bears had left the cabin a shambles, but having no use for roofs, we settled in the front clearing, cooked supper, and called it a day. In the morning, while Edward scouted the area for pictures, Cole and I did what we could to set the cabin to rights, and then we rushed north to Carmel to put him on the bus to San Jose.

We picked up Sibyl Anikeef and spent the next several days traveling up and down the coast. Edward photographed kelp floating on the water, wave-washed rocks in little bays, waves breaking on a sandy beach as sunset light turned them to molten metal. Near Morro Bay he did a hayfield whose bright piles came down in rays from the Santa Lucia foothills. He also made two pictures that remained among his favorites, the tomato field and the grass against the sea.

I had foreseen that Edward's system for cataloguing negatives would be inadequate. The ledger he had kept for years identified negatives alphabetically— N for nudes, T for trees, R for rocks, S for shells, Cl for clouds (C had already been used for cactus)—and gave no clue to the contents of particular negatives other than a date. There were ambiguous groups; for example, A for architecture overlapped with M for mechanical. The dates could be misleading since Edward didn't enter a negative until he made his first print from it. This usually happened within a day or two, but if more time passed he had to rely on his memory or a mention in his *Daybooks* to fix the date of exposure.

My solution on the Guggenheim trip was to devise a new record-keeping

system, listing every negative as it was made and adding the where and when, as well as what was included or excluded compared to other views, particularly for a series of pictures taken in one place. For index numbers, I used an abbreviation for general category, a second one for the specific subject, followed by a numeral. Later, someone thoughtfully added "g" after the Guggenheim images. Even today, just reading the code is enough for me to call up the time, place, and subject of many of the Guggenheim negatives.

The journal itself also took note of individual exposures as made, and very often the entry was marked almost simultaneously with the exposure. If not, there was a running list in a pocket notebook. What I didn't list were f stops, exposure times, and so on, which Edward considered meaningless. When asked by students for such information, he would say, "Well, it might have been half a second at f.16 or a second at f.32, but I don't think I've told you anything useful. Exposure is something you have to learn to feel in your bones."

After we took Sibyl back to Carmel, we spent a couple of days with H.L. at Ocean Home. Although they had met when Edward took his picture in 1934, this was the first time Edward was introduced as my partner. We had read several of H.L.'s books around the campfire, but Edward was uneasy about how my father would regard him. I didn't share his concern, but I was enormously pleased when they got on well. Edward was younger than H.L. and spoke, not exactly respectfully, but with a consciousness of addressing someone who mattered. To H.L., on the other hand, a photographer was someone who made publicity pictures, so I doubt he thought much of Edward's stature in the art world. It didn't matter. The two could really talk, and I believe this marked the beginning of H.L.'s acceptance of me.

Brett's apartment, on Greenwich near the top of the Hyde Street hill, was a standard flat for San Francisco, consisting of the second floor of an old house with an outside stair and the rooms in a line front to back. Space was restricted, so we spread our sleeping bags on the floor of the front room.

Brett's wife, Cicely, was pregnant with their first child. She was sick and having difficulty, which was made worse by the fact that the bathroom doubled

as the darkroom. With Brett and Edward developing and printing, there was often a long wait to get in. I rarely stayed more than a night at Brett's when we were in town. I usually went to Los Gatos, to stay with Grace and Allie in their little board-and-batt house, where I could work on my captions in peace, with the Los Gatos library close at hand for reference work. I think it worked well for Edward and me to have these brief breaks from each other between trips. We both needed a few days for decompression, and the scene at Brett's was too disorganized to make this easy. It was not that we became irritable or tired of the other's company; life on the road was crowded, and it was refreshing simply to have individual breathing room and then to reunite with fresh news to trade.

There were a number of people in San Francisco who had bought pictures in the past, whom Edward visited to show prints. Generally he did this with Brett while I was in Los Gatos. The hosts often invited other friends who might be interested in photography.

Brett devised a lightweight easel consisting of three dowels hinged together at the top so the legs could be spread in a triangle and held in place by a narrow metal rack that hooked across the front two legs to support prints. It was a marvel of simple construction that Edward would use for years. Brett also made a handsome case for Edward to carry his prints in, and it, too, lasted for years— someone is probably still using it.

When Grace and Allie had left the Hatton Fields house for Los Gatos, they lived in a little trailer that had been parked in a bend of the old highway which had been cut off during road improvements. This was a definite step down— little better than a camp, with a table under an awning where they worked and ate—but they enjoyed the rough-and-ready life. When Kit sold the Hatton Fields house after Helen went to Washington, D.C., they bought the rickety place they still lived in. The room where I slept had cracks between the wall boards wide enough to see daylight, but Los Gatos is warm and it wasn't uncomfortable.

I always felt more at home with Grace and Allie than with Helen or H.L., but I had taken them for granted while I was young. They were self-educated, sharp, and witty, building pun upon pun, and now I appreciated them as orig-

inal and interesting women who had had a real influence on me. When I was about fourteen, my grandmother had encouraged my intellectual and literary interests by discussing ideas with me and giving me a commonplace book to write in. In it I entered my most profound thoughts, other people's thoughts that appealed to me, and anything else that seemed worthy of preservation or reconsideration. I kept at it for at least three years; the last year was mainly devoted to book reviews, and this turned out to be its death. When I read the reviews a few years later, I could not accept the jejune views as mine, and to my lasting regret, I burned the book.

Grace and Allie knew that, although they were sisters, some people questioned their long cohabitation. I remember Grace saying the same thing I'd once heard from Dene Denny and Hazel Watrous. "I get so annoyed and upset at the people who can't see that it's perfectly all right for women to live together. And they don't always have to suppose that they're lesbians."

My grandmother and great-aunt were gnome-like women, dwarfed as a result of their back injuries at Helicon Hall. Aunt Allie, the older, was sharp tongued and feisty, while Grace was quiet and self-effacing, although under the surface was a core of steel that showed when she made up her mind. Then she would not be budged even though her sweetness did not diminish.

As far as I know, H.L. never showed Helen his work in progress or included her in his writing life in any way. However, he respected Grace and Allie as fellow writers and he paid them to edit his manuscripts, even though their working methods were completely different from his. H.L. "wrote" in his head; the only written preparation was brief notes (occasionally in Pitman shorthand) jotted on envelopes, endpapers of books, and whatever other bits of paper were close at hand. These were then tossed into a basket as—mentally—the story took shape. When the basket was full, he put the notes in order, sat down at his Underwood, and began typing: Chapter 1, page 1. I always thought this was rather like Edward saying he saw his finished print on the ground glass.

With Grace and Allie, the process was far more observable. They worked with a secretary who could take dictation on the typewriter. Grace did the dictating, pacing the room with her rough notes in hand, seeming to chant the words in a singsong voice and peering over the typist's shoulder from time to time to

check her progress. This first draft was typed triple space and then delivered to Allie to cut and paste, delete and insert. If the draft was readable, they worked from it; if not, it was retyped and they read it aloud to each other and conferred on weak spots, grammar, and so on. Allie's comments were always quick and caustic; Grace's were tentative and gently delivered. I noticed the latter usually got her way.

After stocking up on fresh supplies, skid chains, and warmer clothes, Edward and I set off across the valley and up the mountains to Yosemite. Back then the one-lane control road that descended into the north side of the valley was a steep and narrow gravel track that twisted down an almost vertical slide. It let cars go up for one half of an hour and down for the other.

Ansel and Virginia Adams ran Best Studio, which was in the Government Center near Yosemite Falls. The studio had been started by Virginia's father, Harry Best, in 1902, to do photofinishing for the tourists and sell his romantic paintings of Yosemite, as well as wood carvings and other souvenirs. After Harry died in 1936, Ansel and Virginia took over the business, gradually switching to books, photography supplies, and Indian crafts. They later began producing postcards and notecards. The sale of Ansel's 8 × 10 prints of the valley became, in time, a mainstay of the establishment.

Our plan was to make a week's pack trip up to Lake Ediza with Ansel and Ron Partridge, photographer Imogen Cunningham's son. He was working as Ansel's assistant for the summer as well as doing photofinishing for the studio. Ansel had made us wary about what sort of diet we were in for. Early in our travels, when we had written to ask if he knew where we could get dehydrated vegetables, he had replied that years of camping had taught him that the needs of an outdoor diet were simple and few: salt, sugar, bacon, flour, jelly beans, and whiskey.

The evening before our departure there was a rousing party that lasted until well after midnight, with Ansel, as he often did at parties, performing on the piano with great dash. He played "Love for Three Oranges" while chasing oranges up and down the keyboard with both hands. Despite the debauch, we

were up in time to make the 6 a.m. control road, and we enjoyed witnessing Ansel's frenzied departure performance. After tossing necessities into the topless car, he leaped in and took off as we heard someone shout, "The cook set!" Ansel swung the car back to the house, and Ron ran in to get the pots and pans. We made the control road just in time—I'm sure that when the operator saw Ansel coming he held it open a little longer.

After two or three hours of gradual ascent, we reached Tioga Pass. It was a real eye-opener for anyone who hadn't been exposed to roads at that altitude. The recently cleared snow was still stacked on the inside shoulder, and no guardrail separated the steep, narrow road from the dizzying canyon depths. I would have moved cautiously in Heimy and taken twice as long as Ansel to complete the 9,000-foot descent.

We were joined by two more members of the party at Mammoth Lakes, the young rock climbers David Brower (future head of the Sierra Club) and Morgan Harris—I say "young" because that's how I thought of them at the time, even though they were only one or two years my juniors. We met the packer and his three mules at Agnew Meadow, where we were to leave the car. Edward and Ansel kept a close watch as their cameras and other equipment were strapped aboard. Satisfied that the gear would ride safely, we set off hiking uphill along unending switchbacks, during which we gained 2,000 feet. It was soon clear that I was not equipped for the climate and altitude. I struggled and gasped so obviously that Ron got behind me to push, while Edward went sailing up the mountain with no trouble at all. By the time I reached Lake Ediza, I was exhausted, and stayed that way for the rest of the week.

We laid out the campsite and, for the first time, put up our tent, as Ansel said it would rain every day, and it did for about half an hour late in the afternoon. The tent was a two-person affair that proved very cozy for six of us to wedge into, along with our sleeping bags and camera gear, when we returned to camp in the afternoons. We'd watch the rain for a while, and when it began to slack off, one of the agile young males would brave the damp to build a fire. The open tent door faced the campfire, which provided heat and light away from the cooking fire.

The rain was supposed to take care of the mosquitoes that had accompanied

us all the way up from Mammoth. As we climbed, Ansel kept saying not to mind them, they don't like altitude, they'll dissipate as we get higher. Every time a whole new batch turned up, he'd say, "Well, as soon as we get to camp we'll light a fire and the smoke will drive them away." He was still saying that four days later when we returned to Mammoth.

He also said with some wisdom, "Don't slap them. It just increases the itch." He had learned from the old settlers in Canada that you simply keep wiping your hands over your face so the mosquitoes don't get a chance to land and bite—and being clean-shaven then, he was as exposed as the rest of us were. I found that taking half a lemon and smearing it over my unwashed face made a protective film, and I kept the rest of my head securely wrapped in a thick scarf. Edward photographed me in this getup sitting against a rock (*Charis/Lake Ediza*), knees akimbo, hands crossed loosely between my legs, and a look of what I know is exhaustion on my face. One friend remarked, "You don't *do* anything and come across twice as sexy." Then there was the critic who determined that the sexuality was symbolized by the indentations in the rock wall behind me.

The picture was made on our way back from Iceberg Lake as we took shelter in rocks from what threatened to be a real storm. We had hiked up to the lake with Ron as our guide and assistant camera carrier, when the going grew precarious over snow patches. Even though it was July 22, spring was just arriving and wildflowers grew right to the edge of the retreating snow. The lake was small, with cakes of ice and snow floating over its inky surface. On the far side, rising steeply from the water's edge, was Clyde Minaret, with a diminutive glacier on its chest. It was rich harvesting for Edward; he worked like mad, on icebergs, lake, minarets, tree stumps, snow, and rocks.

Being in excellent shape from having spent many summers in the valley, Ansel climbed all over the mountains to photograph other lakes for the Yosemite Company. Edward made pictures in the general area around Lake Ediza, racking up at least twenty negatives a day. He was particularly pleased at finding a rocky point near the tent which gave an unobstructed view to the horizon in every direction. Here he set up the camera during the afternoon thunderstorms to make pictures of clouds. The wealth of material he was finding called for

nightly sessions of film loading. My journal gives this account of Edward's dilemma over how to load fresh negatives in the film holders with no dark place to retreat to.

> *For the first time on any trip he used up all the holders (made twenty-four negatives) in one day. No gracious Heimy to toss a tarpaulin over; only a silly little changing bag the very sight of which filled Edward with dismay. Lying prone on the floor of the tent, he plunged into this mockery up to the elbows. The bag had been designed for something a good deal smaller than 8 × 10 holders; there wasn't space enough in it to shake hands with yourself and maintain any semblance of cordiality. Edward did one holder at a time, closing the film box each time so we could open the bottom of the bag, eject the empty holder and pass in a fresh one. He was muttering profanity, each moment assuring me, "Now that one's scratched." It took so long to get even the unloading done that Ansel volunteered for the reloading, saying he was an old hand at this and could do it in half the time. Having thus put his neck out, he got the job every night thereafter.*

Our standard High Sierra routine was to have a hot toddy in the tent while it was raining. When the rain stopped, the photographers would go out to work, and then we would make some dinner: one night's menu was golden trout caught by Ron in Iceberg Lake and simmered with lemon and raisins, accompanied by clam-and-tomato soup and beans.

One of the interesting late-night discussions around our campfire concerned the effect of height on an individual photographer. Ansel was at least a head taller than Edward, and Edward recounted that after he had exposed his final negative for that day, Ansel set up and focused as he would have made the picture. Edward liked Ansel's way better, but said that he never would have seen it like that himself as he wasn't tall enough.

During a conversation in December 1980, Ansel told me that he couldn't remember ever disagreeing with Edward. "I know some things of mine he didn't like and some things of his I didn't like, but we had a great deal of

mutual respect . . . Stieglitz and I used to disagree, but I don't remember ever having any kind of discussion with Edward that was negative in any way."

I have said that Ansel was more knowledgeable about equipment and more interested in technical questions than Edward. Ansel put it a little differently: "I was far more craft oriented. The word 'technique' isn't right. Technique belongs in the laboratories. We really have a craft, like a musician has a craft, or a weaver or a potter."

David Brower and Morgan Harris weren't very visible on the trip; they didn't sit around with us in the evenings talking about photography or anything else. They pitched a pup tent across the stream from our spot and went their own way, including turning in very early so they could get up to hike and climb before it could rightly be called morning. They did a demonstration climb near camp on a seventy-foot rock face, with one on top to belay and the other with the rope looped around his waist, feeling for handholds. Edward made a negative although the afternoon light was too far gone to show much. I was impressed with how tiny the climbing figure was in that vast sweep of dark rock.

Edward proved himself the real Spartan of the group by taking a dip every day in the creek that flowed steeply down from Iceberg Lake into Lake Ediza. I did some hiking and tried a little rock climbing, but mainly I spent my time lying on the rocks writing, sleeping, and snacking on dried fruit and nuts from a little flour sack I wore tied to my belt.

We were amazed to see Ansel and Ron eat breakfast out of their Sierra Club cups without rinsing between courses—fruit first, then mush and bacon, and then coffee in which bits of gray mush and bacon-grease globules floated along with coarse grounds. Since water doesn't really boil at high altitudes, it was bad coffee to begin with, with plenty of large grounds to lodge between the teeth but very little flavor to make this nuisance worthwhile.

We took turns assembling meals, although Ron and Ansel did more than the rest of us. It didn't occur to me that, as I was the only female, some of the others might have expected that I would perform domestic wonders in camp. Edward and I were so balanced in this regard it didn't matter what situation we were in, the pattern of shared labor held.

On Monday, July 26, Brower and Harris headed back to Agnew Meadow along with Ansel, who planned to photograph Shadow Lake en route. The

mules were supposed to arrive by noon, but they were nowhere to be seen, and Edward and I had run out of cigarettes. During the final few days, Edward had rationed his share while I smoked mine and then suffered mightily. When the slow beasts finally plodded into view in the afternoon, we set off, leaving Ron to oversee the packing. At Agnew Meadow, Saint Ansel appeared with cigarettes and beer, which he had captured on a quick run to Mammoth Lakes while waiting for us.

We stayed that night at Red's Meadow and ate a concoction thereafter known as Red's Meadow Stew, adapted from the general formula that Edward and I had devised on earlier trips. We would size up what cans were available in Heimy, choose two or three—preferably foods we'd never heard of combining before—and mix them together in a skillet. This was quick, and filled us up nicely when we were tired after a day of wandering in the open air. We learned later that such concoctions lose their luster back home, but in camp they were delicious.

Naturally we had taken no cans to the high country, but I must have tucked some into Ansel's car before we left the valley, because Red's Meadow Stew had the following ingredients, one can each: beef stew, corned-beef hash, to-matoes, sugar peas. When Merle Armitage later compiled a cookbook, *Fit for a King*, the appendix included camp recipes with Red's Meadow Stew prominent among them. In describing the preparation, he said, "One can of corned beef hash (comes out like dog food)" just to reassure the non-hash-eating crowd that this was what it was supposed to look like.

The next morning the four of us ambled over to the Devil's Post Pile, where Edward photographed massive rock fragments, pine stumps, and a beautiful caved-in cabin, while Ansel focused first on the Post Pile and then on me. He photographed me lighting a cigarette in a cave of rocks, to experiment with using a single source of light that was included in the picture. He also wanted to give me a permanent reminder of the source of my misery from the day before.

Mono Lake then was still deep blue, with two islands, just as Mark Twain says in *Roughing It*—this was before L.A. and the Central Valley stole the water. Flocks of birds congregated there. If anyone ever does a history of Mono Lake, a picture Edward made that day should occupy a pivotal position. He liked the

lake very much, but at first wandered around watching Ansel more than any-thing else. Then he came to a spot where a mass of reeds of different sizes, shapes, and subtle color values were twined into a round formation against a background of more reeds. This photograph has always been a favorite of mine. Anyone wanting to do arty commentary on it has all the needed elements—the vertical reeds and circle of twigs representing the origins of the universe or some such thing. The picture is pure Edward, a perfect case of his seeing a terrific negative where almost anyone else would see weedy trash.

We barely made the last control into the valley at 10 p.m. and set about devouring cold roast chicken that Virginia had ready for us. A dignified woman, she seldom took part in the hilarity, although she was always gracious. Suddenly, as we were giddily recounting our adventures, a woman appeared at the window shouting, "The darkroom's on fire!" It was a fairly quick business to put it out, but then the real work began as we spent most of the night rinsing negatives in the bathtub and hanging those that were salvageable up to dry. We finished a few hours before dawn and Ansel played a Bach concert, appearing remarkably lighthearted for a man who had just lost what he later estimated to be a third of his work up to that time. There must have been hundreds of fine Adams negatives that had never been printed. Edward took Ansel to task for the waste.

"There's never time," said Ansel.

"You must make time," Edward insisted. "This is important work."

The next day, with no darkroom available, and a letter from Willard Van Dyke saying he could make a trip with us if we could leave right away, we decided to postpone the work that Edward still wanted to do at Yosemite—particularly the junipers above Lake Tenaya—and head for San Francisco. Up-permost in Edward's mind during the drive was the disaster of the previous night and the risks in making a huge number of negatives and printing only a fraction. Ansel's commercial work came first. Edward recognized that he was now in a similar position—making negatives at a great rate but printing only a dozen a month for *Westways*, plus a few to show friends between trips. This was not his normal style, but with the fellowship giving him a once-in-a-lifetime opportunity to make all the negatives that inspired him—using costly 8 × 10s—it made sense to print afterward, when the free-for-all was finished.

NINE

Willard chose to spend his seven free days in mid-August with us on the north coast, and I remember that trip with pleasure because there was finally another woman along. I'd known Gretchen Schoninger in Carmel, where she had posed for Edward before I met him. She was at home in the outdoors, a good camper, and game for anything. Like me, she had short hair and wore jeans. (An irate shopkeeper once addressed us as "you boys.") While Edward and Willard went about making pictures, Gretchen and I pursued our own adventures.

The week was also memorable for persistent fog and for introducing me to Eureka, a drab fishing and lumber town on Humboldt Bay that would be my home for two decades after Edward and I separated. Brett's in-laws, the Edmundses, also lived there, and they treated us to a dinner of fresh-caught salmon. On the trip to the dock to purchase the salmon, Mrs. Edmunds took us by the gingerbread Carson House, a lumber baron's mansion. Willard made a picture that was later published in *Life* magazine. Writing years afterward about my first impressions of Eureka, I was not complimentary:

The old town had a bleak, neglected look. Many streets were lined with wooden sidewalks, or none at all; public telephones were almost nonex-

istent; most of the buildings were tall, two-storied, few-windowed, paint-peeling structures, often with water towers incorporated, and sometimes with widow's walks on the roofs. I had never seen these before and was fascinated with the idea of early day citizens climbing to the roof with their glasses to identify the boats that circled outside the bar, waiting their chance to negotiate the risky entrance to the bay. The houses were spaced by weed-choked lots, sometimes with a flourishing bit of garden, but more often with the heaps of rusted cans, broken bottles etc. that William Brewer called "California conglomerate." For all its drabness the place attracted me because it felt so primitive, but had some gifted seer informed me that I would return ten years later, to spend the next twenty years there, I would have considered the prediction preposterous.

In those days, there was no Highway 101 as we know it, and no Interstate 5. The so-called Coastal Highway stayed inland for much of its route, but when we could we followed tiny, winding Highway 1, which traced every headland and inlet for most of the length of Northern California. Willard said it was impossible to photograph redwoods because of their scale and the perpetual twilight in their midst, so Edward didn't try—that would come on a later trip. At first, the fog-muffled shoreline also seemed impossible; it was flat and uninteresting, particularly after the strong contrasts and brilliant sunlight of the southern deserts. When Edward realized that fog was as much a part of this country as sunlight of the desert, he came to like the dark trees and buildings against blank white skies and the rolling gray waves of fog that poured dramatically down the hills. He concentrated on giant redwood stumps that had washed down the rivers and been hurled up by the sea onto long, flat beaches where they weathered to a silvery sheen. When the logs were within the tidal line, he would have to work fast before incoming waves reached his tripod legs.

Our travel routine was shaken up a bit by Willard's appetite. Unimpressed by our canned diet, he managed to work scrambled eggs into most meals. The only time we ever took the stove out during the day on our Guggenheim travels was when Willard felt a craving for eggs. This involved pulling the car off the road and unloading it, after unroping the sleeping bags

wrapped in a tarp on Heimy's rump. Looking back on the indignation and disapproval I felt toward Willard's self-indulgence, I see how completely I had adopted Edward's point of view and working habits: to stop to cook was a sinful waste of daylight hours.

During the early thirties, Edward had given Willard some advice that dramatically affected the course of his life. Willard so impressed the bosses at Shell when he worked at the gas station that they offered him a real job as a district manager at temptingly high pay. The offer was a heady thing, given the hand-to-mouth existence that so many had then, and he didn't know what to do. Willard thought he wouldn't get much photography done if he accepted the job, but maybe he could take an early retirement and then return to picture making.

Edward told him not to do it. "You're good at what you're doing, you can decide where and when to go, don't sign your working life away. To work at something just to have financial security would be to live like a cow that spent its whole life filling its belly."

Willard followed Edward's advice, and became quite a well-known photographer and photography teacher, ending up at the State University of New York at Stony Brook. Eventually he switched to film and made documentaries, including *The River*, *The City*, and others. Years later, in 1975, we had lunch together in New York during the retrospective show of Edward's work that Willard curated for the Museum of Modern Art and he said, "I don't know if I was right to stay with photography, and I don't know if I was right to go into documentaries instead of staying with still photography."

Willard had really been more Edward's friend than mine over the years. Ever since the first party at the Brockhurst Gallery, I had felt some hostility from Willard, and on the north coast trip he was direct about it. After watching me fetch a camera case for Edward when I saw that he was about to make a picture, Willard said, "Can't you stop being so indispensable?"

I didn't discover the reason for Willard's disapproval until our New York lunch. "I never should have been jealous of you," he said. "You were very good for Edward." I realized that his uneasiness had probably come from an assumption that I wouldn't be around for long, and that it was dangerous for Edward to become too dependent on me.

Edward hadn't heard Willard's "indispensable" remark—but if he had, he would have laughed and told Willard not to spoil his setup.

I've mentioned that Edward was a storyteller and over the years accumulated a repertory of heavily embellished tales. He also collected one-liners—Uncle Theodore's "Eddie, you could be wearing diamonds" was a favorite, and after this trip we added Willard's best: "Oh boy, oh boy, it makes me sexy!" This said with a wicked chortle at the sight of an empty garbage can standing on a curb or a field of waving wheat—almost anything that, if photographed, could have got the pundits and symbolists exclaiming over sexual imagery.

By August 24 we had parted from Willard and Gretchen, and pitched our tent back at Lake Tenaya, happy to be off the road and determined to photograph the twisted junipers Edward had seen on our way back from Lake Ediza. For a full day, they eluded us as we climbed over slippery, glacier-polished granite, with Edward lugging heavy camera gear. Always they were above us and out of reach, and for half the second day we fared no better. Patience was never Edward's strong suit, and after a day and a half of failure, he was ready to quit. We packed to leave, and when I suggested we try one more time on foot, Edward insisted it was hopeless. Despite his reluctance, I drove back toward Tuolumne Meadows and on the way spotted a place that looked like easy climbing and proved to be so. This was a kind of standard arrangement between us, that my fixed patience held the reins on his volatile restlessness.

We made camp again, and as I described in *California and the West*:

> *Life settled into a simple routine of eating, sleeping, photographing. We got up before sunrise, rushed through coffee, drove over to the cliff. Heimy could climb up on the first slope and roll across the polished ballroom floor between the piles of glittering boulders. There I left Edward with camera, six holders, and a pocketful of dried fruit and nuts to stay him until lunch. While he climbed up to the juniper belt I drove back to camp to*

*watch the sun rise over the lake and to feed the animals. Chipmunks
came up, took bits of cracker from my hand, and went scuttering off;
but if one didn't like the offering, he would hold tight to my fingers until
he had sniffed over the whole hand to see if there wasn't something better.
Even the birds came close for tidbits.*

*There was a sandy strip of beach by the camp and the water was clear
as plate glass. My morning swim consisted principally of a quarter-mile
walk out to where the water was waist-deep, and a frozen footed walk
back. Then I would play at being domestic, gather dead wood from the
meadow for the evening fire, spread the sleeping bags on the rocks in the
sun. After which exertion, being 8,000 feet up, I would be so sleepy I
must have a short nap. In just a few minutes the sun would be overhead
which meant lunch time. Take a box of food and canteen of water, sun
helmets, and the other six holders, and climb up the mountain to search
for Edward. By progressing from one likely looking juniper to the next I
would catch up with him, usually just as he was exposing the last of the
morning's films. We would return to Juniper One—a magnificent
eighty-ton brute with a squat trunk supporting a mere handful of feath-
ery green—to lunch and siesta on the hot rocks. Often the last film would
be exposed before we descended to the lake for an afternoon swim which
produced ravenous appetites for the evening meal. After which Edward
must rush to loading before the moon got over the gap in the trees. Then
we would crawl into our sleeping bags to be lulled off by the gentle lap-
ping of the lake water.*

For me this was the highlight of all our travels. I would have been happy to
spend a month swimming, sleeping, observing wildlife, scaling the granite fast-
nesses (to my limited capacity), and encouraging Edward to find more reasons
for lingering. Even now, I feel deprived that we spent only four days in that
magnificent setting. Despite Edward's tenacious insistence that most of his wak-
ing hours be spent making pictures, we agreed entirely on the need for free
time and both hated overscheduled days in which there was no time to play

and relax. Edward had the talent of giving himself wholly to whichever mode he was in—work or play—and at Tenaya we found a perfect mix of both.

When I returned to Tenaya in 1982 with a pair of photographers, we found the same great juniper that Edward was so fond of, and when we compared his pictures with the tree, I was amazed to see that hardly a twig had changed in forty-five years.

From Tenaya, we headed for Ansel's, where Edward went to work in the newly rebuilt darkroom, using it mainly at night because Ansel used it during the day. He suffered the usual difficulties of operating in an unfamiliar darkroom, but the Tenaya photographs were beauties.

The next morning we just made the 10 a.m. control road on our way to Mount Whitney with Ansel. For several days we wandered about from mountains to desert and back again through the Alabama Hills, which were the remains of an ancient mountain range familiar to millions of people around the world, whether they realize it or not, through the scenery in cowboy movies. It's perfect ambush country, and every time we rounded a new rock formation we expected to see a stagecoach careening along with masked bandits in hot pursuit.

We wandered down into the Owens Valley, which we dubbed the Los Angeles Desert, since Los Angeles had sucked the water out of it, leaving deserted farms edged by skeletal poplars and surrounded by former agricultural fields that were disappearing under the advancing sagebrush. Nonetheless, the valley was—and is—spectacular: from it the east side of the Sierra Nevada rises abruptly in a towering wall of granite, with an endless battlement of sawtooth peaks building behind it.

Edward and Ansel raced the elements to capture light as the clouds shifted from brilliance to rain. Because Ansel had not brought along a wire shutter release, the two shared Edward's, and Ron and I dashed back and forth carrying it to whoever needed it next. Frustrated by the inefficiency of this system, we drove down into Lone Pine, where Ansel went from a drugstore to a photographer's house, to another drugstore—where a helpful pharmacist tried to adapt a catheter for a substitute—to the doctor's house, to the bank, to the bank clerk's house, and there he found a release that actually worked. Using Ansel's admirable persistence as an example, I chaffed Edward about his readiness to

give up on the junipers at Tenaya, and later the same day I was able to rub salt on the wound when Ansel continued his resourceful streak by finding a dark-room for film loading in the Lone Pine Hotel. All this Edward took good-naturedly.

The darkroom seemed an improbable find until the owner explained it was "for movie people." Thus the public appetite for cowboy movies ended up serving us well.

Edward's show at the San Francisco Museum was to open on September 22, and when we found ourselves back in town with a week to spare before the opening, we decided to take a look at the Mother Lode country near Lake Tahoe. As we didn't expect to find much to photograph there, we took a round-about route, heading up the coast first to Tomales Bay and on to Bodega. Edward made pictures of mud flats, cows, a dead cormorant invaded by mag-gots, but the light didn't cooperate and there was the inevitable fog.

On the second day out we decided to head inland, where the heat grew so bad as we crossed Sonoma County that we switched destinations—Tahoe sud-denly sounded too inviting to resist. We spent the night of September 17 at Maple Grove Camp on the bank of the American River. For the second and last time in our Guggenheim travels, I got up first and made coffee. After this notable beginning, not much happened until we had been on the road for some time, when we came into Meyers, a former pony-express stop. The tall pine buildings that faced the road ended in a little potato cellar, its snow-polished board front crisscrossed with rust tracks from nails. I slowed down and we looked.

Photographer: "Pretty nice."

Chauffeur: "I should say so. Want to stop?"

Photographer: "N-no. I guess not."

One mile later—

Photographer: "I don't know . . . Maybe I should have taken a look . . ."

Chauffeur: "Shall I turn back?"

Photographer: "No-o-o-o. I guess the light wasn't very good."

Two miles later—

Photographer: "I'm sorry—think we better go back, after all."

Chauffeur: "Xxxx Xxxx Xxxx!"

The Guggenheim trips were like elaborate treasure hunts, with false clues mixed among the genuine ones. We were always being directed by friends to their own favorite sights or views or formations. Sometimes these tips paid off with real Weston prizes; sometimes the recommended item proved a dud but Edward discovered something to delight him along the way; and sometimes neither one happened and we drove for miles with no payoffs. By this time I was unable to take any pleasure in scenery that failed to call Edward's camera out, so he didn't risk much when he settled back against the seat saying, "I'm not asleep—just resting my eyes." He knew my eyes were at his service and that the moment anything with a Weston look appeared I would stop the car and wake him up.

At Donner Summit on September 19, as Edward made negatives of an idle steam shovel with the lake behind it, a number of tourists pulled up to try to figure out what was happening. Why take such a picture? they speculated, fortunately in low voices that were easy for him to ignore.

On the other side of the summit at Lake Van Norden, a power company creation for controlling snow melt, the water was low enough to expose a wide strip of mud flat dotted with water-worn stumps and swarming with hordes of tiny brown frogs. Stumps, lake, light, clouds—all were right, and we returned the following day for another session that went very well except for a cold-induced mishap: for the first time since 1920 Edward broke the ground glass. Luckily we had a spare.

On our way back to San Francisco we stopped at the cemetery outside Marysville to look for the grave of an uncle of Edward's who had died of fever during the gold rush. We found it quickly and Edward made a picture of the headstone: "Rufus F. Brett, Died May 5, 1852 aged 20 yrs 10 mos, God gave, he took, Be well resigned, He doeth All things well." Oddly, he found another stone engraved with the name Weston in large letters and photographed it, too, even though there was no kinship that he knew of.

We made it back to the city in time for the opening of Edward's retrospective

at the San Francisco Museum of Art, which ran from September 24 to the end of October. Reluctantly, I headed down to Los Gatos to work on captions—we couldn't afford to delay, as we were already late starting our last northern trip. When I returned, Edward reported that many people had attended the opening, including a man who introduced himself as Dr. Eloesser and asked if Edward would like to accompany him to Spain, where he was soon headed to serve with a hospital unit. Edward had to say no—not only were we in the midst of the Guggenheim project, but he still felt the weight of family responsibilities too much to go off on such an uncertain venture. Had he been twenty years younger he might well have gone, for like many people who were not necessarily of Communist leanings, he felt sympathetic admiration for the Lincoln Brigade.

Edward believed that art should appeal to all people, not just to the educated and enlightened, so he was pleased to introduce himself to a man who had been browsing for at least an hour, sometimes spending five minutes in front of one picture. He was about fifty, shabbily dressed, with calloused hands. When Edward spoke to him, the man was almost inarticulate: "They're great . . . Marvelous . . . Now this one . . ." and he'd walk back to one he'd been looking at and stand in front of it, speechless. Edward concluded that the man wasn't much concerned with subject matter—he saw a picture of cypress roots and stone crop at Point Lobos as a picture of stars and galaxies—but he was evidently very moved by whatever he was seeing. He said to Edward, "It's fellows like you that make the world beautiful for the likes of me."

Still later, Brett saw him standing in front of certain pictures muttering, "My God!" and "Jesus Christ!" over and over. As far as Edward was concerned, that one viewer made the show worthwhile.

When I made it to the show, a herd of grade-school children was being conducted around by a male leader who took a while to notice that the kids were making a beeline for the nudes. There they stood in rapt attention until he hurried them away, loudly praising the cypress trees farther down the wall.

Edward managed to spend quite a bit of time at the museum in between the usual town duties. We had taken care in selecting the pictures, and he enjoyed having so many on the wall at once where he could walk about and see how

they fit together. While his photographs had been exhibited in thirty-five one-man shows by this time—including one just six months earlier at the Nierendorf Gallery in New York—this was the first big museum retrospective. Edward cared what critics had to say (they were impressed), but maybe more important was the opportunity to see his work as a whole.

Our next jaunt lasted almost three weeks, from September 28 to October 17, and took us to Mount Lassen, Tule Lake, Lava Beds National Monument, Mount Shasta, and over to the coast of Northern California, a total of 1,900 miles that netted 151 negatives. This was to be our longest in-state trip of all, and we knew it was foolish to start it so late in the season, but there was a lot of country left to see.

We spent just one night in Lassen, camped in a pine wood in the foothills, and felt in our bones that it was going to rain but were too lazy to set up the tent. We were just comfortably installed in our sleeping bags with only a tarp folded over us when the first drops hit. They continued to hit for so many days we lost count.

By the time we set up the tent the next night at the lava beds campground and crawled into clammy sleeping bags, it was after dark. In the morning the weather granted a bit of a truce and we walked to a hillock near camp that promised a view. I described the scene in *California and the West*:

> *A strange and savage landscape it is, in the alternating sun and shadow of the clearing sky; the rough lava shining wetly, the bare branches and pale grasses motionless, dripping. This is a part of what the pioneers called "The Dark and Bloody Ground of the Pacific." Here California's last and bloodiest Indian war was fought, when a small band of Modocs entrenched themselves in the lava caves that honeycomb the region, and for several months held off a far superior white force. It is a land of violent contrasts, the surface growth is blasted by drought, but down in the caves there are rivers of ice, frozen waterfalls, ferns and moss kept green all year by moisture from steam-vents.*

We spent four days at the lava beds, four days of rain and cold, of struggling to light a fire with wet wood in the gray dawn, of pouring hot water over Heimy's doors because they were frozen shut, of driving all day in rain, or with rain all around us, of wringing out the focusing cloth as though it were a huge dishrag. We each wore three shirts and three pairs of socks, although Edward did not sink to my degraded practice of wearing pajamas under my clothes all day.

Edward photographed landscapes with black cave openings in them, lava flows, cinder cones, but mostly he photographed clouds and falling rain, working as fast as possible whenever we found ourselves in a dry center with storms all around. Some of the work done here was spectacular and, as Edward later said, could not have been done under "favorable" conditions.

Even so, he woke up on the fourth morning muttering, "Let's get out of this damned place." We put in a final, full day at the bird sanctuary and Fern Cave, and did more clouds and the cinder cone. That night back at camp we heated water for baths, which we took standing close to the fire with one bucket apiece. After fish balls in bouillon combined with a can of tomatoes, we retired to bed, warm for a change.

Next day, as we drove west through the mountains, Mount Shasta dodged in and out of view and we had to admit that it was the real thing. "I think it is only the Californian's love of superlatives that allows him to mention Mount Whitney, while dwelling in the same state with Mount Shasta," I wrote at the time. "Whitney's claim to distinction is merely that it is the highest peak in the continental United States. As a mountain it is nothing to look at; just one of the many granite tips nearly as high that make up the imposing east wall of the Sierra. Shasta—but a few hundred feet shorter of stature—rises grand and solitary above a vast volcanic plain, dominating the landscape for a hundred miles."

As dramatic as it is, not all find it beautiful. A century has gone by since the Whitney survey party ascended Shasta, and William Brewer noted in his journal that "it is entirely destitute of many of the elements of beauty [the Swiss Alps] possess." He complained of Shasta's barrenness, the long, dry summers, and the porous lava rock of the mountain preventing any alpine growth above tim-

berline. "The Alps are grand in their beauty," he summarized. "Mount Shasta is sublime in its desolation."

On our way back south Edward took pictures of redwoods despite Willard's earlier cautions. Because of the heavy shade and continuing overcast, it was not unusual for him to make exposures of five to ten minutes. He would close the shutter as soon as a breeze moved the leaves, open it again when they were still, and I would keep track of the time on a watch.

The rain finally stopped north of Garberville and the sun shone out through scurrying clouds. From the edge of a bluff above the south fork of the Eel River we looked down on fields and trees, buildings and fences sparkling with raindrops. If Edward commented at all on newly made negatives, he was most often deprecating. When I looked on the ground glass and responded with enthusiasm, he would say, "I think it's all right" or "It's not bad." Only when he was excessively pleased with the take, as he was when the last Eel River negative had been made, would he go so far as to say, "Think I got something that time."

Through all the years I lived in Eureka the highway stayed put, and on any trip south I could drive onto the shoulder and line up the Eel River Ranch just as it had looked in these pictures. Following a rain, if the sun was breaking through clouds, I might see the scene illumined with that same super radiance. When in the early sixties I saw big earthmovers tearing up the hillside to expand the highway, I felt like staking out that bit of shoulder—sitting on a camp stool with a shotgun across my knees—and fighting for its preservation.

Memory is a great simplifier, and I am astonished as I read through the journal today at the great amount of retracing our steps that was part of every trip. The light was wrong, the wind was too strong, it was raining, the afternoon shadows would make it a better picture, and so on. Time after time I'd double back, and as often as not, the scene still wasn't right. The most recalcitrant spot was, without doubt, "chicken coop hill."

The chicken farm between Valley Ford and Tomales first attracted us in August on our trip north with Willard. The hillside was dark. At its center stood

a line of fifteen little gray chicken coops, all of slightly different construction. Around the coops was a bare, pale area scraped clean by the chickens, and scattered over this were the white specks of the birds. That time it was already too dark to make a picture.

We next looked at it on our return from the north coast, but the light was wrong and the chickens weren't out.

The third look was on our coast detour before heading out to the Mother Lode. It was morning and Edward noted that the right time for a picture would be afternoon. Consequently, we checked in again on our return from Tahoe, but now the hillside was foggy and the coop shadowed by eucalyptus. Edward determined that the light would be just right at about 2 p.m. with no fog.

On our fifth and final try as we returned from Shasta, we found the sun full on the hill and the light flat. We realized that only in fog would the pale patch of earth around the coops stand out from the surrounding hill. In front of the coops half a dozen cows lay moodily about. Edward said, "It's not what I had in mind, but I'll have to take a look." By the time he was ready—poised on a steep, slippery, dry-grass bank—one of the cows had wandered out to the edge of the plate and couldn't decide whether to stay in the picture or leave. At last she lay down and Edward made the negative.

TEN

Our next interlude in San Francisco lasted a month, not by choice but because there was so much to do. George Stone, a photography teacher at San Jose State College, invited Edward to show his work and give a talk, for which he promised to raise at least $50. Edward sent some pictures down, and on November 4 we followed and found that Stone had raised $52 plus $10 from the Chamber of Commerce. At the exhibition, photographers took pictures of Edward in the usual awkward newspaper poses, while a reporter interviewed me under the impression that I was Edward's daughter.

Before the talk, we were fed an elegant dinner by the Stones, and George confessed a taste for pictorialist William Mortensen's photography. Straight photography like Edward's was headed up a blind alley, he said, because it had nothing to offer but pattern and texture, whereas when Mortensen did the head of a woman double-printed over a black cat it symbolized the Sphinx and eternal mystery. They went at it hammer and tongs until I suggested they save it for the program.

Edward's talk suffered from the same ailment as his writing—he was so set in his ideas that he expressed them in a sort of shorthand, sometimes leaving out important clues for his listeners or readers. But his great ability to get an

audience on his wavelength, to make people talk and ask questions, more than compensated. One thing he had to contend with in any public presentation was the hodgepodge of ideas and rules that had sprung up in response to the amateurs' need for guidance. The rapid popularization of photography had created a widespread hunger—more than any other beginner, the photographer wants to be told "how to do it" and, ultimately, that is what never can be told.

Edward gave the best guidance he could. He began by saying there's nothing new in "pure" photography, that his work was part of a direct line leading back to Daguerre, although many photographers had been sidetracked by soft-focus, self-conscious artiness and other distractions from straight seeing. To illustrate, he traced his own artistic development from the early Chicago snowscapes through our current travels.

"These periods are distinct only in retrospect—each new development contains the fruits of the last. In this way, landscapes can have the same 'abstract' qualities as half a cabbage. People who think that half a cabbage is 'modern' and can't see landscape with the same eye are really the ones who are bound by subject matter. A rose can be as modern as a smokestack."

He pointed out that many abstractions done by photographers could have been seen better by a painter. "I have known some of the greatest contemporary painters. Without exception they were vitally interested in photography. They laughed at photo-painting . . . There's much stupid talk about whether photography can be art. People say a photograph is made by a machine. Of course it is. And piano music is 'made' by a machine. Whether or not art comes out of a piano depends on the musician. Whether art comes out of a camera depends on the photographer."

Warning against slavishly following the vision of others, Edward urged his listeners to break away not only from the "masters" but from prescriptions such as rules of composition. "A good picture—in photography or any other medium—is most likely to be produced by the artist who upsets the apple cart, snaps his fingers at the rules, and does as he pleases. Then an art critic comes along, measures and analyzes, interprets the result, and lo! another 'rule of composition' is born. This sequence cannot be too emphatically stressed. Pictures come first, composition after. There is no hen-and-egg doubt about it.

From his earliest days man made pictures, to frighten evil spirits, to record history, to portray happenings, to express himself and his feelings, for any number of reasons except one—he did not make pictures to carry out laws of composition."

Edward did not fail to bring up another favorite theme—that photographers could teach students to look but not to see.

The talk was well received, and there was material evidence to prove it: late donations totaling $2.50.

A letter from *Life* magazine had come while we were gone, asking for Guggenheim pictures for a six- to eight-page spread. A man from the local office came to see some samples and suggested I do captions. I growled, but had them ready five days later. Within two weeks we received a letter from Willard Morgan at *Life* saying the pictures were swell but how about a little human interest to fill out the set? A man milking a cow, a pioneer on his front porch . . . Edward gave his usual response to pleas for human interest: "I have spent twenty-five years making a living by photographing people and right now I'm more interested in other subject matter."

With the rainy season under way it was past time to return to our base at Chan's. We planned to stay in L.A. for two weeks, because we had decided to apply for an extension of the Guggenheim and Edward needed time to print fifty pictures to send with the application. In addition, we needed twenty for *Westways* and a few extra for *Life*. Edward went right to work and discovered that many of the redwood pictures had not turned out because one tripod leg had sunk slowly in the soft turf during the long exposures, but the Eel River farms and the rain over the lava beds were splendid. Almost every night we went out showing prints, and made our first Guggenheim picture sales.

If we succeeded at getting a fellowship extension we would need a place of our own. We had looked into several possibilities, when we received a letter from a friend of Paul Ruthling, the owner of the Aztec Shop in Carmel, where we bought our huaraches, offering us Paul's house near Tesuque, New Mexico, rent free. The letter said Paul wanted to go to Carmel to take care of business

but didn't want to leave his house unoccupied because his former wife had predatory instincts and might steal his possessions. The length of time depended on when he vacated and how long he stayed away, but it could be up to six months. To have a whole house, free, was an offer we couldn't pass up. Marvelous—or so we thought. Reassured by letter that there was no risk of our being snowed in, we got Heimy overhauled, laid on more winter underwear, and on December 7 hit the road.

We meant to hurry east on U.S. 66, but were unable to pass up the attractions of a number of abandoned or burned-out roadside stops. At a derelict halfway house called Siberia, with a frieze of painted icicles along the front, Edward did a giant coffee cup, and at one of the burned-out gas stations, he did the black-and-white peeling pattern on the fabric top of an ancient Ford. We passed by roads to the Grand Canyon and the Petrified Forest without faltering, but I did stop for the red hills of the Painted Desert.

Ernie and Gina Knee (photographer and painter respectively) had just built a new adobe house in Tesuque, so we stopped to see if they could direct us to Paul Ruthling's. A "new adobe" led us to expect a modest two- or three-room house, but the real thing turned out to be a large, airy mansion. Ernie dismissed my admiring bouquets, saying, "I just got a few books on adobe construction and went to work on it, but it does take a long time when you have to make your own bricks."

Our brief stop at the Knees' stretched into ten days while we gradually learned the truth about our "free house" and why we never succeeded in finding Paul at home or getting a response to the notes we left on his door. We had just about concluded that it was a hopeless situation when Gina broke down and told us the real story. The house had been declared community property, and Paul was no longer free to carry out his scheme to get us moved in so that his wife would have to respect our squatters' rights—thus allowing him to maintain his claim to the place.

Edward spluttered with anger, but this development was not the disappointment it might have been. The house was little more than an open-ended shed approached by a steep and muddy road that made both Heimy and me uneasy. It was winter, and there was snow on the ground. The privy was a short walk

away, the front door a curtain, the bed smelled musty. Since there was no piped water or electricity, we puzzled over the up-ended toilet in the snowy yard and the plug-in radio indoors. Not highly desirable quarters for a photographer—the only thing that would have made it feasible was that Edward could have used Ernie's darkroom. I realized then how little appetite I had for primitive winter camping. Instead of the California coastal "wet season" of my experience, winter on that 7,000-foot plateau was harsh from the time of the first light snow.

All this was not immediately apparent, and while we waited to see what would develop, we visited pueblos, adobe buildings, and the unusual New Mexico landscape. My journal entry for Sunday, December 12, gives a good idea of the life:

> *Today we are going on a photo tour to somewhere. Gina isn't joining us; says it would be too cold to sit out and paint. Ernie, Edward, and I pile into the Knee Ford with food, cameras, and typewriter and start up the Taos Road. We cross the sandy riverbed of the Rio Grande, pass an atrocity of a trading post white-plaster-gewgawed, and are in Espanola. Head northwest on U.S. 285. Now we see pink and tan mud hills cut across with water levels, like those going into Death Valley from the south. Turn a little off road to see the church at Hernandez—formerly San Jose—and Ernie says now the oldest around here, being about 300 years. We don't get out, the light being no good; the sky has grayed over and no drop of sunlight comes through. Meet a sad-eyed burro, his front legs hobbled, making inch by inch progress down the road. Come to the trio of painted sand hills Ernie showed us a picture of last night. The sky is still dark but the photographers set up, and I grab the typewriter to catch up a three day loss. Move along to Abiquiu, pronounced as though the last two letters were missing. As we come even with the first adobes, pull off on shoulder to look over a wide river valley marked out in fields, containing a few horses and many cottonwood ghosts. Edward and Ernie set to work in a light rain. We pass many adobes in various stages of incompleteness; Ernie says they build them very slowly, making up a few*

more bricks whenever they find time to. The sheep here are much whiter than California ones—according to Ernie because it gets wetter there and they get muddy; here it's dry and they lie in the dust but shake it right off.

In 1933 Edward had visited New Mexico with Sonya and Willard Van Dyke, and they had spent a few nights with Mabel Dodge Luhan at her ranch in Taos. Luhan was a lion hunter and had entertained D. H. Lawrence, Gertrude Stein, Georgia O'Keeffe, Alfred Stieglitz, Emma Goldman, Margaret Sanger, Lincoln Steffens, and many others, but she didn't succeed in capturing Edward for her permanent collection.

Edward was always a slow eater, and on one particular evening the rest of the company had finished by the time he was ready for dessert.

"Mr. Weston doesn't want dessert," Luhan said, and waved the servants away. Her high-handedness made Edward so angry he left for home the next morning without notice. He had told me about this some years before, and I wondered if he hadn't overreacted, but now I got to see Luhan's style for myself.

Despite the earlier friction, Luhan invited us to the house where she lived with her husband Tony, a Taos Pueblo Indian. She had moved to Taos with a previous husband, painter Maurice Sterne, and embraced Native American culture, from adopting spiritual beliefs to inviting artists and musicians to join her and urging them to promote "Indian ways." Under her scheme, Robinson Jeffers and D. H. Lawrence were to write about Native American life and composer and conductor Leopold Stokowski was to incorporate elements of Indian music into his work. Stokowski was spending Christmas at the Luhans' along with his former wife, Evangeline, and their two daughters. According to Luhan, the divorced couple always made a point of reuniting to share the holidays with their children. Mabel insisted that Edward photograph the great man, and Edward agreed on condition that Mabel arrange it with Stokowski beforehand, as he had a horror of having to work with unwilling subjects. Mabel told him later that Stokowski was willing and that a good opportunity would be the upcoming Taos Pueblo dance.

We were watching the dance from a pueblo roof when Evangeline, a tall, striking brunette, came up the steep steps with her girls while her ex-husband remained below talking to Mabel. Looking down from the roof at his balding head, Evangeline said, "Oh, Stoky, you look so funny from above." He smiled but raised a hand protectively to his bald spot. Mabel caught up with Edward and admitted that she hadn't asked Stokowski about the picture, which infuriated Edward. He had no choice but to ask the conductor for permission when they were introduced.

"No, no. No pictures," said Stokowski, acting as though he had been ravaged by the mere request. It was probably just as well things went as they did, because he struck me as a vain man who might not have been satisfied with an unretouched portrait. Edward hated to be turned down, but he didn't dwell on it—for him there would always be other candidates.

As it happened, Edward had suffered another failure in connection with the Luhans. Tony hadn't liked the handsome and serene picture Edward had made of him in 1933, and when Mabel asked why, Tony said, "Makes me look old."

After two weeks we figured we had to be wearing out our welcome at the Knees'—though they insisted otherwise—so we moved to the Buckeye Auto Court down the road and got to work on the Guggenheim application. In three days we had finished, including a detailed account of how the first year's money had been spent and a project proposal and budget for the second year. To reward ourselves, we drove into Santa Fe to pick up a bottle of something drinkable and the latest issue of *Life*, which Ernie had said included Edward's pictures. We were very disappointed. The "spread" had been reduced to a modest six pictures in a small front section of the magazine, with one picture printed far too dark and clumsily trimmed. The whole was titled "Speaking of Pictures . . . These are Weston's Westerns."

We celebrated New Year's Eve by heating buckets of water and bathing in front of a roaring fire at the 150-year-old adobe house in Albuquerque where our painter friend Willard Nash was staying. Earlier in the day, Edward had

made the only nudes of the Guggenheim period as I lay sunbathing on the Mexican cape in a windless courtyard.

All New Year's Day we drove south through New Mexico under a brooding gray sky; the next day was even gloomier, the route dotted with lonesome little outposts—Florida, Tunis, Mongolia, Lisbon. We took U.S 70 south and arrived at dusk on a point overlooking San Carlos Lake, created by Coolidge Dam. Below us, at the base of a hillside of spiny brush and prickly pear, crab-claw points of land extended into the smooth water; across the vacant surface of the lake, the far shoreline was broken by dark reflections of the speckled mountains that piled up in the distance. The violent contrast of elements—the age of nature's desert mountains, the shiny newness of man's lake—gave the somber landscape an aspect of unreality, as though a mirage had come to life but might at any moment fade before our eyes.

We had intended to make our way leisurely toward Prescott, Arizona, to visit painter and photographer Frederick Sommer and his wife, Frances, but the weather was so dull and the light so flat that we headed straight there from the dam. Papago State Park was on our route, and as we approached it I realized that I was in familiar country. In 1930, during our Easter vacation from Hollywood High, my brother and I had gone with Helen on a painting trip to Arizona. Leon and Helen took care of the painting; as a practicing poet, I wrote and communed with nature.

We had made the trip in a secondhand Model A coupe, with Helen driving and Leon and I taking turns in the rumble seat. We stayed at an auto camp outside Phoenix and would drive out to Papago State Park in the mornings with bread and cheese, sardines, and a big bag of Arizona grapefruit, which in those days had a very thick rind that peeled off easily, leaving wonderfully sweet, sharp fruit to be eaten like an orange. The painters set up their easels before the desert scene while I wandered off into it, examining flora and fauna. I climbed to a great shady cave that looked out over the park lands, to read and write and admire the view.

When I pointed the cave out to Edward and told him I had read most of

Shelley up there, he said, "Oh, this is where you used to play." While he may have been unimpressed by my sixteen-year-old intellectual commitment, Edward knew a good saguaro when he saw one, and we spent the rest of the morning at Papago making pictures.

In Prescott we got directions by inquiring at the Piggly Wiggly and, after driving up a narrow road between little oaks and pines, arrived to find that Sommer had just made his first 8 × 10 of the day. We had met Sommer when he visited us in Santa Monica Canyon and showed his postage-stamp-size contact prints of leaves and twigs made from tiny negatives. Edward's suggestion that he work larger must have had some effect, because he was now using a view camera like Edward's, but he still became fixed on unusual subjects. The butcher at Piggly Wiggly had provided him with chicken entrails, which he photographed in various arrangements—with a chicken head, with an egg, and so on.

We stayed five days. Most memorable was Frederick's surprising effect on Edward. A manic conversationalist, he managed to talk Edward through his usual nine o'clock eye droops and launch him on a kind of natural speed high. They would talk and argue and kid until midnight on a great range of subjects. Frederick recounted his upbringing in Argentina, where local military officers would sit with his architect father on the veranda, sipping iced drinks and watching decrepit military ships execute maneuvers. They entertained themselves by betting on which would sink first.

The photographic find in the area was the little town of Jerome, announced with pride by the Chamber of Commerce: "You are entering Jerome, Arizona, the most unique town in America, one mile high, fifty mile view." A copper town built on the face of a mountain, its streets were precipices, its buildings stood on each other's head. Frances said they no longer mined, but in the past had tunneled beneath the town so extensively that now and then a cave-in occurred and one or two houses would slip from one street down to another. The local wags had it that any child raised in Jerome walked forever after at a 45-degree angle.

We returned to Chan's on January 11 and were greeted by the news that Edward was a grandfather for the second time (the first had been Chan's son, Teddy). Cicely and her new daughter, Erica, born at six that morning, were

doing fine. This was Edward's first girl-child descendant and he was very excited. He always had a very strong family sense—a deep awareness of the continuity of generations. Teddy had been born on Edward's birthday, which led Edward to feel an almost mystical bond with his first grandchild.

"As the first taste of human blood is said to affect certain of the larger carnivorous quadrupeds, so with Edward and the taste of snow we had had in New Mexico," begins Chapter 11 of *California and the West*. "He must have more, and immediately. We were packed and ready to depart for Yosemite Valley when Ansel wired, saying, 'No snow,' so we removed our long woollies from the clothes bag, drained off Heimy's antifreeze, and turned south for a look at Borrego State Park."

Neil went with us and was most welcome, not least for serving as an extra cart horse when we hiked up Borrego Canyon. In Borrego, as in the lava beds, contrast was the keynote. Here was a crazy riot of badlands, an infinite sea of dry wrinkled mud cliffs. The cliffs were almost vertical, and when we made it up the steep road to the top of a point from which we could look down on both sides, Edward set up the camera pointing down and said with great excitement, "Come see—it's crazy. They look right side up on the ground glass!"

Next door to the mud cliffs was the canyon full of native Washingtonia palms growing from the bed of a roaring stream. The palms, which had dry, flammable foliage to the ground, were irresistible to vandals, who regularly set the entire canyon on fire. At this time, the canyon was nearly all burned, leaving the tapering trunks a grim charcoal black among granite boulders that had been polished by water to a dazzling white. Edward was always hoping to come across this kind of black-and-white contrast but seldom found it manageable when he did because the contrast was usually too stark for good exposure. Borrego was an exception, because the burned trunks showed a lot of variation—black, brown, gray, textured—and the same with the boulders, which were not just white. In this situation, the drab winter light helped.

As Edward made pictures, Neil and I found a nice pool at the foot of a waterfall and took a bracingly cold dip. Neil had become an accomplished sailor and on this trip taught me how to tie marine knots.

On January 30, as we searched for a well-known view of Borrego's Painted Desert, a cluster of cars bearing Sierra Club hikers came winding toward us. We pulled over to let them pass. While Edward photographed, I continued to the top of the knoll on foot and found a little glass tube in which visitors had left their names and dates. On the most recent card, signed by the Sierra Clubbers, I made the next entry: "Not Sierra Club: Edward Weston and 8 × 10 camera."

For reasons that were inscrutable to me at the time, Edward insisted that I go back and remove the note, because later visitors might take it for his signature. At first I thought he was kidding, but he was adamant that he didn't want any record left in handwriting that was not his. I returned but, instead of crossing out the signature, wrote "per Charis Wilson." Although I was perplexed then, his reaction now strikes me as consistent with his strong sense of identity, which showed itself in a near-fanatical concern over anything that was said or written about him. He was determined that everything be correct; maybe the most striking expression of this was his emotional reaction even to favorable reviews if they contained factual errors. He would fuss and fume for days while he composed and discarded letter after letter to the perpetrator.

Edward's temper was nearly always triggered by one of a limited number of situations, including having to wait when he believed it was rightly his turn to be served. Although we had learned to carry enough supplies to last a whole trip, we stopped now and then for snacks such as fruit and buttermilk. After we left Borrego, I pulled over at a roadside market, and as usual, Edward went in. A few minutes later he came back in a rage. Even though he had been at the counter first, the clerk had waited on a woman in what Edward considered a misguided expression of gallantry. This happened more than once during our travels, and the worst of it was that he would come back without the food.

One of the most puzzling and difficult expressions of Edward's temper for me was his reaction to even mildly challenging interruptions by strangers while he was making photographs. Such an encounter occurred on an early Guggenheim foray when we stopped near an old ranch on the Prunedale cutoff. He'd had an eye on it for years, but the light had never been just right. On this occasion, no sooner was his 8 × 10 set up on the roadside than a woman came

out of the farmhouse and started hot-footing it down the lane to the highway. From the moment she appeared I could feel Edward tightening up with angry apprehension. I found it hard to understand his fear of strangers, since my own tendency was to expect the best of everyone, and experience had convinced me that the attitude was a wise one. Edward came close to expecting the worst whenever a stranger appeared, but his way of trying to avoid trouble was rather like a bird puffing up its feathers to scare off an opponent.

The wind was blowing, cars were zooming past a few feet from us, and the situation was tense enough without having an outraged woman bearing down on him. She demanded to know what Edward was up to—was he part of a movie company? Last month some men had photographed her ranch and right afterward she had been robbed. Edward didn't make the slightest effort to placate her but fired right back about his legal rights. He was entitled to set up his camera on a public highway if he chose to, it was none of her business what he photographed, etc. Of course this made her twice as indignant and twice as certain that she was being taken advantage of in some way. When Edward disappeared under his focusing cloth, I did my best to smooth things over so she could take the long walk back without feeling she had made a fool of herself or been made a fool of.

Edward's rage wasn't often turned on people; far more often it was aimed at any gadget or machine that failed to work instantly and properly. If the toaster didn't work, he pounded it. If a lamp failed to turn on, he kicked it. He acted as if such malfunctioning items were conspiring against him. I thought of the care and patience he had to bring to the workings of his photographic equipment and decided that he must expend his stock of self-control on picture-making difficulties.

When Edward got mad at the mechanical world he reacted physically, but when the object of his wrath was human he would sputter with inarticulate rage. I used to admonish him to exercise a little control so he could enjoy laying on some finely tuned invective, but I might as well have told a forest fire to cool down. My attempts to reform Edward's temper were rooted in my view of anger, which had been influenced by my discovery at age fourteen of a book by Arnold Bennett, *The Human Machine*. Bennett wrote that "a man with an

uncertain temper in a house is like one who goes about a house with a loaded revolver sticking out of his pocket, and that all considerations of fairness and reason have to be subordinated in that house to the fear of the revolver, and that such peace that is maintained in that house is often a shameful and an unjust peace."

Despite my youth, this struck me powerfully when I read it, because H.L. had exactly this sort of temper. Edward's temper was less disturbing than H.L.'s, because it was balanced by good humor and warmth between explosions, and also because he made some attempt to divert it away from human targets—strangers excepted. Knowing how I felt about the careless venting of anger, he got in the habit of "taking it out behind the barn," like a farmer enjoying a rank cigar.

As anyone will recall who lived in California in 1937–38, it was a season of severe flooding. We had read about it while still in New Mexico. When we headed up to Yosemite to satisfy Edward's craving for snow, we saw some of the storm's effects. The year-round highway on the south side of Yosemite had large bites taken out of it, and the railroad tracks on the other side of the river were twisted into loops of metal that protruded from newly formed rapids. Ansel had urged us to attempt the trip despite conditions, and we did make it through, accompanied all the way by heavy rain.

Edward, Neil, and I reached Ansel's on February 9, to find that the house had been remodeled and the rooms painted white, the whole effect being very light and pleasant. We were greeted with a drink and lunch, and then went out for a ride around the valley. There was little to be seen, because all the heights, including Half Dome, were obscured by thick mist and the valley floor was covered in gray slush. Back at the house, Ansel told us that the December flood had hit Yosemite hard. Water had covered half the valley and stood several feet deep in the stores and houses. Ansel said he had watched as dozens of toilet paper rolls and whiskey bottles floated past the church and rows of bathtubs from the warehouse filled with mud. He and Virginia and other locals pessimistically asserted that the rain was there to stay and the valley would see no more snow that season.

Edward and I went to bed hoping fervently they were wrong, and I woke in half darkness to hear him calling me to the window: "Everything's white!" And so it was. In the morning, with chains on Heimy, we went with Ansel up to Badger Pass, where he had to photograph the ski lodge interior. He made pictures of people around a house-size fireplace, all of them done up in the most amazing outfits—Tyrolean jackets, Swiss yodeler's hats, and a few rigs that looked something like garage mechanic suits and seemed the most practical.

It continued to snow hard, and we gathered from the radio that the weather was even more fierce elsewhere in the state, high winds having smashed windows in San Francisco, blown roofs off houses, and knocked down trees and pieces of buildings. Then came news that the all-year highway was closed by slides and that telephone lines were down—we were cut off from the world. If we hadn't been told, we wouldn't have noticed, as we had no intention of leaving and no one to telephone. It snowed furiously for two days and two nights, and then we figured it was time to reverse our plea and ask for a clear sky so Edward could make pictures.

The third day dawned a fine blue and Edward went berserk. Everywhere he looked there was something to photograph, but as the log recorded, it was "an almost impossible place to work because every minute a new load of overhead snow comes dumping down on the camera, or, once, into the open case just as we were changing holders. After that we held the case under the focusing cloth for entry and exit of holders—and still they seem to get wet from somewhere."

Neil and I used our bodies to break paths for Edward through waist-deep snow, and tramped it down hard in a circle wherever he set up the camera, to keep the legs from punching through and sliding down to China along with the camera. While he made pictures, we made living statues by falling face forward into snowbanks or falling backward and wagging our arms to create angel prints.

After twenty-three exposures we returned to the house to find that Ansel, Virginia, and the two children were about to leave. Ansel had to be back in town, and they were sure that, though it would tack on 100 extra miles, they could make it out by the Wawona Road to Fresno. They departed, Edward

loaded films, we played cards and ate dinner; then I spent a long time making taffy, with unimpressive results.

It snowed hard all the next day. Edward disappeared into the darkroom, I washed clothes, and Neil and Ron shoveled a heavy coat of the white stuff off the roof after we observed that it was beginning to sag. Snow fell often, but with breaks that allowed picture making, and by the end of the week Edward was forced to admit that he'd had enough, for the time being.

Only one member of the family suffered from storm damage. We drove to Carmel to see H.L. and found carpenters replacing part of the roof at Ocean Home. H.L. had also lost the huge old pine where we had tethered horses when I was a child; when the tree fell, he saw that the hitching rings had grown twenty feet up the trunk.

When we reached Los Angeles, we discovered that the worst had yet to hit in the area. We listened to radio accounts as the storm peaked and people along the Los Angeles River lost their buildings and property to the floodwaters. Generally, no one took the Los Angeles River seriously, but three weeks of rain filled the bed with water and swept away all the structures that had been encroaching on it since the last flood. Some buildings even washed out to sea. People would stand and watch the water level rising up the sides of their houses, and only when homes were about to float off their foundations would residents get serious about leaving.

Chan's house proved even more inconvenient than usual, as rain leaked through the darkroom roof onto Edward and his negatives while he was developing and came in through the windowsills of the shack, forcing us to pull everything into the middle of the room along with the bed. Santa Monica Canyon was flooded, houses and bridges in the San Fernando Valley had been washed away, and the streets of Glendale were lined with sand bags. Newspapers reported a hundred dead and another hundred missing.

Packed and ready to leave as soon as the water went down, we were wildly impatient. In those days we did not have a twenty-four-hour weather station to listen to, but had to get up each day and assess the situation, which involved

calling the AAA to find out about the roads into Death Valley. They remained flooded right across the Mojave. A main road, past Red Rock Canyon, was under four feet of water. How could water possibly reach that height in such flat country?

On March 7 we left Chan's for the last trip of the first Guggenheim year. We pledged to remain in Death Valley until we heard word from the committee on the fate of our renewal application, and while this proved more difficult than we expected because of continued bad weather, we were true to our vow.

When we passed the checking station on Death Valley's western boundary, the ranger told us it had been raining off and on for a week, at which a gentle shower began to fall and accompanied us to the campground. We settled as before at Texas Springs, but the rain and the season made everything different. Dante's View had been transformed. Not only had the road been paved, but the brilliant contrasts of our first visit had been replaced by soft tones of liver and blue. The salt bed was covered with a thin sheet of water that shrank away from the edge during our stay, exposing a widening margin of white minerals.

One day in Corkscrew Canyon Edward had an odd experience: he was unable to remember which pictures he had made already and which he had decided he would do only when the light was right. I had not yet filled in the record of the day's negatives and was unable to help. It really bothered Edward, but I was struck by the fact that thinking about a view had seared as vivid an image on his mind as though he had actually set up and made the negative.

Hoping to get out of the wind, we made a one-day trip through Daylight Pass to Rhyolite, Nevada, which I described in *California and the West*:

> *Here is the western ghost town at its nakedest. Rhyolite's gold boom came in 1906; its death in 1907. The town was deserted and everything movable in it was carried away. Parts of the walls of a three-story hotel, a two-story bank, and a grocery face each other across a weed-bordered desert road. Sections of worn adobe wall rise here and there from the trash heaps of broken bottles, old shoes, rusty metal, and tin cans ... Edward was fascinated with the town—Nevada's Athens, he called it— and would doubtless have found more to do in better weather. But there*

is a saturation point in a wind like this; after an hour of constant buffeting, or sand and gravel slapping into your face and eyes, you can't breathe and you can't see and you can't stand up any longer.

Rhyolite was not simply a movie-style main street with boxy wooden buildings, false-fronted and flimsy. It had begun its brief life with ambition, with tidy blocks of substantial, multistory buildings meant to last. I returned there with photographer and friend King Dexter a few years ago and found it much the same despite the passage of half a century. Interestingly enough, we found that the handful of citizens who still lived nearby were keeping the ruins patched up because they provided the basis for a cottage industry—photography workshops.

March 24 was Edward's fifty-second birthday, which seemed too opportune to fail to draw our long-awaited Guggenheim letter—but we were disappointed yet again and spent the day like the others, battling wind as we combed the valley. Don Curry had married during our absence, and he and his wife accompanied us on several trips, including the most rugged drive of all, up narrow Copper Canyon, which had just been made accessible to vehicles the day before when the boulder blocking its mouth had been blasted clear with dynamite. At points the canyon was so narrow we could reach out the window as we drove and pat stone. I climbed a little gully to get a view and brought down a slab of pink rock with amusing designs that turned out, as identified by Curry, to be fossilized tracks of a two-toed bird.

The good news arrived on March 27 about the time the desert turned gentle green from the rain. We danced a triumphant jig, took a last swim in the Furnace Creek pool, and headed back to town windblown, sunburned, and relieved. We had been granted another year of freedom from studio work—what we needed now was a real house and a good darkroom where Edward could make the most of his negatives and where I could begin turning the raw material of my log into a book.

WILDCAT HILL

ELEVEN

Leon and I had never been privy to our father's affairs—personal or professional. So when we got an urgent summons from Ralph and Ida Edgarton, a couple who had worked at Ocean Home since we were children, we were shocked by their news: they had not been paid for two months, nor had any of the household bills, and our father was too sick to handle things.

Six years earlier a young nurse had spent a social evening at his house, and when it came time for H.L. to drive her home, she insisted that he'd had too much to drink. He responded that he had been driving for years in varying stages of inebriety without so much as nicking a fender, but he ultimately relinquished the car keys. The nurse braked suddenly, going fast on a slippery road, and landed them upside down in a ditch. H.L. made light of the incident in a letter to a friend: "About six months ago I was swiped across the eyes by a big burly coward of a car and haven't really been in commission since."

However, the accident was no joke. H.L. ended up with a blood clot in his brain and as a result suffered periodic "spells" and substantial memory loss. This, coupled with years of indulgence in rich food, good tobacco, and fine liquor had taken a significant toll on his health, and under doctor's orders he attempted to modify his lifestyle. He described the experience in a letter to his friend Julian Street:

I got a clip on the bean that caused a conscientious M.D. to cut all alcohol from my diet. Not a drink of anything for a year, not even coffee. It seems like the good old blood pressure couldn't take a joke. The queer thing, after my darned near fifty years of free drinking, it was no trick at all to cut out the hard stuff. I can make highballs and cocktails with never the slightest tendency to sample, but I do miss wine and burgundy has long been my favorite tipple (Never did like champagne except as an excitant). But I go into the basement and glare wistfully at the still stuff, burgundy, haut sauterne, some Steinwein, etc., missing it as I'd miss some article of diet, say a certain perfect pie my cook makes. It is there the iron will shows. Once a week I allow myself to break rules, however. Sunday mornings I go downstairs and make my own breakfast, brewing some of the wickedest coffee known to man, and ingesting three cups thereof. Result, all by myself, I become highly oiled, perfectly pie-eyed in no time. I grow kindly, approachable and could be borrowed money from if they could get to me at that hour. I turn the radio on, smoke one cigarette after another and if some of the boys were around I'd be singing a natty tenor.

Except for paid help, H.L. had lived alone at Ocean Home since 1929, when Leon and I drove down with him from Portland. He had never bothered to fill out check stubs—there had always been more money coming in than going out—so it took Leon and me some time and research to recognize the magnitude of the crisis. We discovered the property was heavily mortgaged: H.L. had signed a note that guaranteed the loan on his brother Lester's ill-fated prune ranch, using Ocean Home as collateral, and the bank was now ready to collect on the guarantee. In addition, several hundred dollars' worth of bills were piled up, and there was no cash to be tapped anywhere.

Leon had to get back to his job in Hollywood—you didn't trifle with a job in those days—but before he left he discovered that a crooked banker from the county bank of Monterey had advised H.L. to sell him his lumber company stock for a dollar a share before tax season and then buy it back for the same amount afterward. This was illegal, but even worse, the banker knew H.L. was

suffering from a faulty memory and he never reminded him to repurchase the stock.

Before the clock ran down on the bank's foreclosure on Ocean Home, I had to find money for H.L. and a place for him to stay. I turned to his friends, knowing he had always given freely to them, just as he had to Lester. Booth Tarkington responded immediately, pledging the generous sum of $100 a month. H.L.'s sister May contributed $60. Their payments maintained H.L. for the rest of his life.

Seven years before, I had pleaded with my father to help me attend Sarah Lawrence; now I was soliciting funds for his basic upkeep. An additional irony was that three years earlier, in the depths of the Depression, with his memory already failing, H.L. had walked away from a temporary sinecure at Metro-Goldwyn-Mayer. Another letter to Julian Street tells the story:

> *Carmel, Calif., May 9th, 1935.*
>
> *Dear Julian:*
>
> *I am the rottenest correspondent in the world, yet I believe no one in the same world gets more pleasure out of letters from old friends. Whole trouble is on my desk. If I lay something there it's lost practically forever. Someday, of course—but it never comes. This morning, for example, timidly attempting some archeological work, I find your letter of March 7th. (I'd swear I never read it before.) And that isn't the worst. I also found a letter from a publisher enclosing a check, now three months old. True, the check is for only 23 cents, but it's the principle of the thing: it might easily have been for twenty-three dollars!*
>
> *Do I gather that you contemplate assaulting Hollywood? Well, the advice of this trapper, scout and guide is, do not. No matter what you have, sell it from N.Y. if you can, get your money and forget the incident. This is written two days after my return from three weeks there trying to help the MGM people make a picture about Ma' Pettengill. I had agreed to stay ten weeks, if they needed me (at a wage of $1250.00 a week) but begged off after three such weeks, and they let me go back to my honest life. They are all children. Necessarily children*

because they must please the child mind that composes their public. I have sat through three talking pictures and walked out on half a dozen others, Ruggles being one of the latter. I couldn't stay it out. Yet the audience that watched it laughed constantly, the yelling, idiot laughter that comes from just back of the chin. Easy to determine they had never read the book, nor any other book. Even my Gettysburg Address was clumsily forced in—one of the best things I ever wrote. I can believe that people who never read the book may find it a tolerable show, but the book's undoubted readers invariably call it awful. If you need any further advice on a picture career, you now know where to ask for it.

Leaving the MGM people—all enthusiastic over Ruggles (which will make Paramount several millions profit) I told them that while the Address might be my best bit, still I had once dashed off another morsel they might have Ma' Pettengill recite in the course of their picture drama, a thing long widely known, at least outside Hollywood, as the Lord's Prayer. And if you think they are not taking that suggestion seriously you don't know your picture people.

I am trying now to shape a novel on a theme Lorimer gave me two years ago—the young Intellectual with inherited wealth, who goes red. Have written Booth [Tarkington] to give me a title for same, and to Lorimer for any further hints he can drop if I can use his idea. It seems a good time for something like that. But Huey Long and Father Coughlin confirm my suspicion that the human race as a whole has the intelligence but not the dignity of rats.

And children—your speaking of Pete and Rosemary. One day my own two were kids—yesterday. Today they are telling me ribald anecdotes.

Anyway, Julian, good luck to you, even if you decide I didn't give Hollywood a fair show.

> *Truly,*
> *Signed*
> *Hank*

The letters display a witty and affectionate side of H.L. that I saw no sign of when I was growing up, but a line in the last letter indicates that his attitude toward me had begun to shift. He no longer thought of me only as Helen's daughter; I was now included as one of his "own." During the many months I stayed with him at Ocean Home we played dominoes every evening—one of his few remaining pastimes—for a thousand "dollars" a point to keep the game interesting. After our games I got him to tell me stories about his early days, which I wrote down as soon as he retired for the night. That's when I discovered his own father had been the irascible forbidding presence in his childhood that he had been in mine. Now H.L. finally seemed to approve of me and even, in his undemonstrative fashion, to enjoy my company. I had struggled for so long to win his affection that this might have given me great satisfaction, but I realized the man who accepted me was no longer the one who had rejected me. That man was gone, from my life and from the world, and in his place was a stand-in who retained his shape and some of his verbal style but none of his commanding presence.

While I sorted out H.L.'s affairs, Edward was in Los Angeles trying to print, but Chan's little darkroom was a difficult place to work. He continued to get portrait requests as well, but I wasn't there to be his assistant and chauffeur, and neither were any junior Westons. Edward had become a bit spoiled by always having someone on hand to help. He sent me a trimmed and folded print of the "Weston" gravestone he had photographed in Marys-ville, with the message: "This is a true picture of my destination unless you come down on the next train." I was unable to leave, so Edward got a ride up to join me briefly at Ocean Home. One night we talked with H.L. about our dilemma, describing our need for a place of our own with a second Guggenheim year coming up. H.L. signed a deed of transfer, giving us 1.8 acres across the ravine from the house. However, he warned us that the bank already owned the property, saying, "It won't do you any good, but go ahead and try."

I made at least half a dozen trips to Bank of America headquarters in San Francisco to confer with Kirkpatrick, who was in charge of real estate the bank was acquiring from all the people unable to pay their mortgages during the

Depression. Our lawyer friend Doug Short coached me on how to gain title to our land should the bank make difficulties. He sketched a scenario in which I would show Kirkpatrick my evidence of the lumber stock chicanery pulled on H.L. and say that we planned to sue the Monterey County Bank. I did as instructed, and at first Kirkpatrick pretended not to hear what I was saying, but when he could no longer ignore it, he excused himself, explaining that he needed to "check upstairs" on some points about the property. When he returned, he said Bank of America agreed to our proposal that we buy our corner of the land for $1,000. I remember returning home that night in a daze and telling Edward, "It worked." It still astounds me, but when I reported our success to Doug he showed no surprise, merely commenting, "Bankers have to stick together."

After some searching I found a good place for H.L. to live—with a nurse, Helen Dietjen, in a big old frame house on Carmel Point near the beach. The situation duplicated much that had been important to H.L. at Ocean Home, including the big windows from which he could look out over the ocean and plenty of floor space for pacing. He liked to take walks but often got lost, so Helen made a tag to go in his pocket telling where he lived.

Even before securing the title to our corner of the property, we sketched the building we wanted—one big room containing the living quarters, with a dark-room at one end and a fireplace at the other. Neil was just twenty-two at the time, but he was ready to act as architect, contractor, plumber, electrician, master carpenter, and bargain hunter for materials. A postcard from Edward to Ramiel McGehee dated June 1, 1938, sums up the situation: "House underway—foundation poured, floor laid. We leave for Motherlode this week. Neil is everything, a godsend. It will be close figuring but we'll make it."

After a quick sally through the Mother Lode, we continued on to Yosemite, where we again stayed with Ansel. On a mid-June day Edward and I wandered around the valley floor through jungles of greenery flickering with dogwood blossoms. We returned to Ansel's to keep an appointment with some potential print buyers, and I went out in the back yard to make my first—and only—

8 × 10. I settled on the base of a manzanita for my subject, the radiating trunks with their skins peeling off, with speckled rocks and dry leaves in the background, but every time I got under the focusing cloth I would hear some varmints rustling in the brush nearby. After a while I discovered that the varmints were Edward and Ansel pitching stones in the bushes every time I went undercover.

We took a day trip to Meyer's Ranch on the northern heights above the valley and Virginia came with us—the only time this happened in all the years I was with Edward. While Edward and Ansel worked, Virginia and I crawled around picking wild strawberries. True to character, I could not resist eating them as I went, while Virginia carefully saved her berries to share with the picture makers.

Ansel wrote after we were back at Highlands, a brief letter that I'll include in full because it represents well the mutual fan club Edward and Ansel enjoyed and the kind of technical information they swapped:

Oy oy to see you here was wonderful; I have a new lease on life be it to you. And the prints—someday I tell you what they do to me. You are on top of the wave. Never such photographs!

I have made some preliminary tests on Convira. No doubt about it—it is a swell paper. I am not exactly pleased with the tone I got, but I think I see a way to perfect that. What I did was this; I mixed Amidol according to Convira slip formula. Then I made prints, developing them (most of them) to the staining point. Then I diluted with equal amount of water. Prints from latter had nice values but too warm tone. Then I developed similar prints in regular Convira Metol-Hydroquinone. Lousy. I send samples herewith with data typed on back. As prints they are bum but as experiments they have taught me a lot.

Please come again soon. I want to see your new place and have a trip with you. You encourage me—always. But you also reveal to me that I am on a siding, and not on the main line. The problem, as you know, is horribly difficult, but I will be able to work it out I am sure.

What really impressed me almost more than anything about you two

is the wonderful mental and physical health you have. Swell kind of
living, swell kind of work. Oy oy.

Neil had the darkroom and half the house completed by the time we re-
turned, and he completed the rest soon after, for a total cost of $1,200, in-
cluding $275 for his labor. With a main room that was 20 by 28 feet and had
open rafters overhead, it felt royally spacious, even though it was only a board-
and-batt shack in construction. The three glass-paned doors across the front
faced the ocean, and a skylight in the slanted roof above provided a fine light
for portraits.

We moved into the wonderful raw pine smell of new lumber. This was soon
tempered by the acrid aroma of floor oil and, briefly, the new-paint smell as I
anointed with royal blue the three old glass-paned doors that Neil had found
at a salvage yard and sanded. The same fate befell all the wood trim in the
house, as well as the giant chest of three deep drawers that had stood in my
childhood nursery. We had retrieved the chest from the old barn and set it next
to the darkroom door, where it served as a handy storage depot in a house that
would always be shy of closets and cupboards.

The big room was sparsely furnished. Edward and I generally ate meals at
the same black model stand Edward had had in Carmel, which was about the
height of a coffee table. There were some spindle-back wood chairs. The old
brown velour couch sat in front of the fireplace, and behind it stood the big
solid wooden worktable with Edward's dry mounting press on one end and,
frequently, piles of prints being sorted for shows. Here we ate when we had
company, after stacking up the prints. The double bed, covered with a Navajo
rug, stood in the corner to the right of the fireplace. Edward's desk, where he
sat every morning to drink his coffee and write letters, and the rolling screen
that we often pushed out into the yard as a backdrop for sittings completed the
big furnishings.

To talk on the black wall telephone we had to stand and lean over the tall
bamboo wastebasket, but the phone didn't ring often.

The kitchen corner included an electric stove and a single-basin sink with
dish shelves above it, a cupboard to the side of it for food and cookware, and

at the end of it the coffee grinder. When the kitchen was more of a mess than we wanted to look at, we rolled the photography screen in front of it. As we didn't own a refrigerator in all the years we lived at Wildcat Hill, we used a cooler that Neil made out of an old print storage box of Brett's. Mounted on the wall, it had holes to the outdoors drilled in the back, screened to keep out pests.

The only picture of Edward's on the wall was a dune photograph that H.L. had admired during a visit in 1937 and that Edward had given him; it had come back to us with the breakup of Ocean Home. Also on the wall was a drawing that Zohmah made not long after we were settled, showing the inside of the house from a rafter's-eye view, with fold-up walls, that could be viewed from any orientation.

In August, Edward reported again to Ramiel by postcard: "R—Querido— We are ready to greet friends—when we are here. Moved in, and very, very, happy to really have a home—and such a home—after 16 years of renting. I hope you will see it before many moons." Despite Edward's urgings, Ramiel never visited Wildcat Hill.

The house was on a hill above Wildcat Creek and Wildcat Canyon. Even though the post office preferred numbers, I cannily insisted on Wildcat Hill for our address because I knew from Carmel experience that a name would be remembered better by everyone, including the mailman. Edward and the boys resisted at first, so we ran the risk of being No. 168A Coast Road, but as I've said before, I was powerfully persuasive.

Not long after we had settled in, we got a call from Walter and Lou Arensberg saying they were in Monterey and asking if they could drop in. We said sure and then scurried around tidying, dusting, and mopping until they arrived. Sitting in a captain's chair and looking around the room in his owlish way, Walter announced, "This is a palatial shack."

We had designed our new house with Edward's photography in mind, including the showing of prints, but I soon realized that I needed a place to write. I took possession of what came to be called Bodie Room, after the brand name on its tiny wood stove. Bodie Room was behind the house in an outbuilding that Neil originally constructed for a garage but which proved so awkward to

drive into that we put up a new one. We stored tools and whatnot in the old garage and built a room for me at the back end. The best picture of it from the outside is *My Little Gray Home in the West* (1943).

I took an old desk from Ocean Home and had Neil add legs to it so I could stand or use a high stool while I wrote, but this turned out not to have the great appeal I had expected. It was mainly at a little folding typewriter table that I wrote *California and the West.* The table, which had piano hinges in the middle, had gone with us on our Guggenheim trips and eventually finished its days in a friend's summer cabin at Big Lagoon in Northern California.

Edward began the monumental task of printing Guggenheim negatives in his new darkroom, and when he came up for air, we made brief trips to nearby country, mainly Point Lobos, which was now on our front doorstep. Edward had already spent six years making pictures there, but that had been during his period of close-ups. Now he did tidepools, landscapes, groves of cypress, long views of the rugged coastline—quite a different way of seeing the same material.

Edward's attention to this bit of coast was recognized on October 25, 1979, by the U.S. Board on Geographic Names when it accepted Ansel's proposal to give the official name of Weston Beach to a small cove on the south side of Point Lobos. Cole supported Ansel's request with photographs that Edward had taken on or near the beach, which showed not only the extent of Edward's attraction to it as a subject but how much the beach had changed. By 1979, much of it had disappeared altogether, and many rocks that were high and dry in the pictures had since been covered with waves or plants.

1938 was the year my serious writing collaboration with Edward began. In March, Al (George Allen) Young of *Camera Craft* had written to Edward about delays in a book project he had conceived. In the letter he also said, "I wish there was some way for me to persuade you to write some articles for *Camera Craft.* I know that you dislike writing but I am sure you won't blame me for trying to get the articles, at any rate. It would be a real present for *Camera Craft* if I were to succeed, since there is a tremendous interest in your work and unlike most other photographers you have done very little talking about it."

When we went to see Al at his office in San Francisco, he continued to press his point. He said he was paying William Mortensen to write about pictorialism and would like to give some of that money to us instead. Within the year we began our writing collaboration. It wasn't Al's persuasiveness that got us going, however, it was our reaction to a *Camera Craft* article, "Eclectic Photography," by Paul Louis Hexter, a spokesman for the pictorialists and a friend of Mortensen's. Wanting the best of both worlds, Hexter wrote in favor of an eclectic method that combined the romantic style with the straight approach. This was such impossible nonsense, Edward felt compelled to reply to Young, who said that instead of wasting time trying to convince him that Hexter was wrong, Edward should put it in an article. Edward gave it a try, but soon quit, turning the job over to me. The writing came quite easily because Hexter's points—although made in a very scholarly manner—were outrageous given the absolute opposition of the two methods he proposed to combine. The result of my labors was "What Is a Purist?"—the first of a series of articles—which appeared in January 1939 and begins, "A Purist, to the best of my knowledge, is a mythical creature. At least I have never known a photographer who entirely fitted the popular definitions of a Purist."

After he received the article, Al wrote back that he was delighted with it. "It is beautifully clear and logical, and I feel certain that it will make a very fine impression throughout the photographic world, and will clear away more misconceptions and false ideas than all the rest of the writing on this subject put together."

This was heady praise for my first effort, although Al did request one change. "In the opening paragraph you state that Mr. Hexter's article contains 'absurd misconceptions.' For the sake of Mr. Hexter's feelings, I would like to change this to read 'mistaken conceptions' if you have no objection." We did not object.

My goal was to make the articles sound exactly like Edward, but without the broad categorical statements found in his writing, which—in the beginning—crept into mine as well. In one article, for instance, he (I) declared that anyone who is serious about photography needs a view camera. *Camera Craft* was a little magazine that depended on amateurs who bought Instamatics and went off to shoot the Grand Canyon. They wanted advice on how to improve their

work just a little, and after the first few articles, Al Young urged us to pull our punches a bit—at least to keep in mind who was paying. I also wanted to avoid puffed-up language such as this line from an exhibition statement Edward had written for the show at Delphic Studio in 1932: "In a civilization severed from its roots in the soil—cluttered with nonessentials, blinded by abortive desires, the camera can be a way of self-development, a means to rediscover and identify oneself with all manifestation of basic form—with nature, the source."

By then I had heard him express his ideas on photography enough to know them by heart, but if I wasn't sure about a subject, we would talk about it and I'd keep him going long enough to leave the clichés behind. I'd keep asking questions until he completely clarified what he meant. Or I'd write a draft using my knowledge of his views and see how he liked it. It wasn't long before I could write the articles pretty much on my own.

In some recent books and bibliographies, the articles I wrote for Edward are listed with both of us as authors, but for years they carried only Edward's name. This didn't bother me at all. I'd always wanted to get Edward's ideas down in writing, I liked doing it, and it was far easier for me to do it than it was for him. Over the years I have enjoyed hearing often-quoted "Weston" lines that were actually mine. A good example is a passage in "What Is a Purist?"

> *The specifications for Purist that are so frequently put into print stink of pedantry, and above all things, I am not a pedant. If by printing on a sensitized door-mat I could produce something finer than either photography or painting, I would certainly do it. It so happens that to date I have found no way to achieve that beauty which is uniquely photographic, except by using photographic methods.*

I also wrote under the name F. H. Halliday, which allowed me to comment on or describe what we were doing from the point of view of a "third person." Art historian Beaumont Newhall did some sleuthing to try to discover who the third person was who had traveled with us. He mentioned this to Edward in New York during his retrospective at the Museum of Modern Art in 1946, and Edward confessed the prank.

It was also on that trip that Beaumont and Nancy took Edward out to lunch

with Gjon Mili, a photographer for *Life* magazine. Beaumont recounted the occasion in his 1995 memoir *Focus*:

> *During dessert, after a long and charming conversation, Gjon turned to Edward.*
>
> *"How can you price your photographs at only fifteen dollars?" This was the price Edward had been asking over the past years.*
>
> *"Well, you know, I live in a small shack near Carmel," he said, "I wear blue jeans, I don't pay an income tax, I get along very well."*
>
> *"Well, we photographers here in New York don't have a small house and do pay an income tax," Gjon replied. "And we don't wear blue jeans!"*
>
> *"Oh," Edward said, with some embarrassment, "I never thought of that. I'm terribly sorry. I'll tell you what I'll do. I'll raise my price for a print to twenty-five dollars, beginning right now." He was most pleased that ninety-seven prints were sold—at twenty-five dollars each.*

The book project that Al Young had originally written to Edward about turned out to be a fiasco. Young had asked five photographers to write on different aspects of photography; the photographers were Edward, Ansel, Willard Van Dyke, Walker Evans, and Ralph Steiner, with Edward's subject being the camera itself. At a party at the Brockhurst gallery we had come up with a number of comic titles for the book, including "Prints and Paupers," but Young's title was *Five American Photographers and their methods*.

Edward had managed to put together an outline of his assigned subject by the time we visited Al in San Francisco to discuss the project, but as it turned out, he would never finish the piece. Within a few weeks, Ansel got hold of some of the other sections—including the foreword by David Wolfe—and sent them to Edward. Both Ansel and Edward were outraged by Wolfe's simplistic and wildly inaccurate pigeonholing of them and the other photographers. On April 18, 1938, Edward wrote to Willard saying he was withdrawing from the book:

The foreword, which I fortunately read, is not acceptable to me. A man is entitled to express his opinion—I don't believe in censorship nor am I one to dictate—but in the foreword to a book I do object most positively to a gross misrepresentation of my aims, object to being grouped (not to the "group") in the summing up of means and ends.

I do not mind Mr. Wolfe's faint praise which damns (though I would much prefer to have my work condemned or ridiculed), and I can disregard his running commentary on our individual characteristics: "Van Dyke's air-like purity with morbid lyricism . . . Adams' bright frankness . . . Weston's darkness, ingrown sensuality, stone-like seriousness . . ." But I do take exception to being quoted and grouped in other statements as though we all had the same ends, all accepted his summing up of the next great step which would automatically make us functional—"truly contemporaneous."

The project was dropped. Years later I discovered that David Wolfe was not the writer's real name—it was Ben Maddow, author of the only biography of Edward to date. Maddow also wrote several articles about Edward's work, including "Venus Beheaded," in which he said that Edward was a perfectionist. As evidence, he noted that Edward "once went so far as to withdraw his photographs from a proposed book called *Five American Photographers* (never actually published) because he read the draft of a foreword and hated its left-wing views." Maddow did not let on that he was the author of the rejected piece.

TWELVE

The *Camera Craft* article generated a number of enthusiastic letters. When we wrote to tell Al, he responded: "Glad to hear you have received quite a stack of fan mail . . . Apparently the tried and true pictorialists are losing their nerve or something as I have not received anything but complimentary comments here, much to my disappointment as I would like to have a few howls of anguish to include in that correspondence department which I am still planning to have a try at."

We tussled a little with Al over the character of the articles; he wanted the series to run as long as possible, suggesting we stretch our material by keeping the pieces short and the topics limited. That made no sense to us. As far as Edward was concerned, photography was the whole process, from seeing a picture to ending up with a print. He knew he couldn't talk about every aspect in detail, but he didn't want to cut off one little piece at a time, and that wasn't my style either. Al immediately raised the pay from $35 to $50 per article, since he was getting more than he had expected with each one. The purist article was followed by "Photographing California," "Light vs. Lighting," "What Is Photographic Beauty?" and "Thirty-five Years of Portraiture."

In "What Is a Purist?" we listed Hexter's six main points, which state that

so-called purists work out every visual aspect of a print before exposure and treat darkroom work as a purely mechanical process in which glossy paper is always used because it gives maximum tonal separation. Purists never retouch, said Hexter, and ignore the last 500 years of development in composition in the other arts, permitting only "sector analysis and naïve good taste" to influence picture making.

These contentions are nonsense, of course. It's true that Edward insisted that a photographer "see his finished print on the ground glass, which is simply to say that he should know exactly what he is doing," but darkroom work cannot be purely mechanical. "Even in the case of a straight print it is incorrect to say that no control is exercised . . . Developing and printing should be a reasoned carrying out of the original conception. I much prefer to make a negative from which I can make a straight 'uncontrolled' print, but this is not always possible . . . My prints are controlled, when necessary, by printing down and holding back."

On the matter of tone separation, it was Edward's view that

> *sometimes I want maximum tonal separation, often decidedly not. This very naturally depends on the individual picture. In any case I am not concerned with trying to copy nature, or trying to reproduce "correct values." Quite often, for emphasis or emotional impact, I allow a shadow to go black. Sometimes the blacker the better. But at other times a suggestion of detail in the shadow may be desirable . . .*
>
> *A Purist who is going to get any results has of necessity to know a great deal about composition. The manipulator can stick some clouds in a vacant sky, paint out a couple of houses, move the gate from the right to the left of the wall, and remove the telephone wires, to get his "composition" right. But the Purist must do all this before he makes his exposure! That is, he must see his subject just as he wants it to appear in his finished print.*

Hexter did not mention print cropping in his article, but we added it because Edward was, in this one regard, very much a purist. "I can't recall a single print

from over a thousand negatives made last year which I trimmed to change my original seeing."

In "Photographing California" we described our Guggenheim travels, with emphasis on working with equipment and dealing with difficult conditions. My favorite passage addresses nature photography in general:

> *A current issue of* Time *says "Weston's (work) mirrors static Nature." This is of course nonsense. Anyone who thinks nature is static simply hasn't taken the trouble to look at it, certainly has never tried to photograph it. Too often the photographer sees his picture disappear before his eyes; the light shifts or the clouds break down . . . The painter and the photopainter may be said to have a kind of "static nature" to draw on, since they may store up fixed images in their heads . . . But the photographer deals only with the immediate present, and with only one moment of that present.*

"Light vs. Lighting" opens with a harangue against studio lighting, particularly against the emphasis placed on it in the training of beginning photographers: "The most important element with which the photographer must deal is light . . . Artificial light has its place in photography, just as the miniature camera has, but like the latter it is frequently misused for subjects that could have been photographed far better with natural light." The study of natural light is the place to begin, Edward said, and insisted that

> *for the advanced worker as well as for the beginner, there is only one rule. If your interest lies in the technical side of photography, there is nothing against trying all the gadgets and formulas you want or need. But if your interest is primarily in the picture, if you want to use photography as a medium of expression, then* keep your equipment simple.
> *It is of infinitely greater value to know* all *the potentialities of one camera, one lens, one film, etc., than it is to have a smattering of superficial knowledge about several different makes and brands. After thirty-six years of photographing, I own two cameras, and one of these I use*

exclusively for portraiture . . . I use one brand of film, one developer, one paper.

Contrary to the general opinion on this subject, Edward said in "Light vs. Lighting":

There is no time of day (or year) when sunlight is better, photographically speaking, than another. It may be better for a certain subject, that is all. The light of high noon is just as important as morning or evening light . . . In fact, partly because of the lessening of shadow intrusion, the simpler light between the forbidden hours of 10:00 and 2:00 is more often useful than morning or evening light in revealing the thing itself rather than a mood evoked by the play of shadow on it. I would guess that at least as much of my work is done around noon as before and after.

In the article "What Is Photographic Beauty?" the most important point is the ability of the camera to register more than the eye. "Guided by the photographer's selective understanding, the penetrating power of the camera-eye can be used to produce a heightened sense of reality—a kind of super realism that reveals the vital essences of things." To do justice to his vision, Edward believed that a photographer must be able to understand and use the other unique qualities of the medium—the rapidity of the recording process and the infinitely subtle gradations of tone attainable in printing.

"Thirty-five Years of Portraiture" traces Edward's career from his first box-camera portraits of friends, through early jobs with other studios, and his own studio in Glendale. At first he used the standard trappings—but never the grim headrest!—and for children even tried a flash.

I bought a device in vogue at the time (1912) which consisted of a flash-pan mounted on an adjustable metal tripod, the flash trigger synchronized with the camera shutter. The flash pan and the rod supporting it were concealed in an enormous cloth bag, the mouth of which tied at the tripod head. One side of the bag was made of semi-transparent cloth and

disguised to look like a 45 degree skylight, and the whole thing stood upright like a captive balloon. After the flash, which completely unnerved my young victims and even startled me, I would remove the bag and empty the smoke out of the window, to the consternation of my neighbors and innocent bystanders. This horror-bag, my first experiment in stopping movement, was soon abandoned.

Edward abandoned other common practices as well until, by the mid-thirties, he used natural light, did no retouching, and sought spontaneity in the sitting. "The chief charm of the photographic portrait lies in its intense reality, its ability to vividly represent a living person . . . A carefully posed, intricately lighted model looks carefully posed and intricately lighted . . . Portraiture will always be an art of discovery . . . The human face you want to record is not a stone or a stump; besides the changing daylight upon it, it has a changing light of its own."

Spotting prints is the sock-darning part of the photographic process. No matter how often and well you clean negatives, there will be some dust, and this causes white spots on the prints that have to be filled in by minute daubing. Edward was extremely careful in his darkroom, but it was hardly an archival environment. Particles also got on negatives in the field, particularly in desert winds, as we pointed out in "What Is a Purist?" No photographer could avoid the "manipulation" of spotting.

Spotting his own prints is what made Edward such a devoted radio listener, but spotting was also a good job to do whenever company appeared—of the variety not bent on looking at prints or being photographed—because it was easier to get through this tedious job with the aid of conversation. He would sit by a window so the light came from his left, and beside him on a high stool were an ashtray, his mug of coffee, and the box from which he took the unspotted prints. The Chinese black mixed with gum arabic rode on his thumbnail: into it he dipped the dozen hairs of the tiny camel's-hair brush that he had sucked to a fine point. This was a job he had learned when he worked for

a Los Angeles portrait photographer decades earlier, and he became such an expert that he had to spot his own prints forever after. When Edward got through with a print, you'd be doing well to find two or three of the thirty or so spots he had filled.

Sometimes visitors would bring wine or beer, and we would drink and talk about the news of the day and whether the country was being saved or ruined by Roosevelt. Edward would quote Lincoln Steffens on voting for Hoover to bring the revolution sooner, and we would tear that apart while he got through three prints.

In September 1938, Henry Allen Moe was vacationing in Mexico and arranged to see us before returning to New York. Moe was secretary-general of the Guggenheim Foundation from 1938 to 1954 and was considered by many of its fellows to have been its greatest director. His belief in the importance of supporting creative work, no strings attached, was absolute. He had been enormously helpful to us for the past year and a half, but even so, our expectations about what kind of man he would be were based on our unflattering notions about New Yorkers in general. During the twenty-six-mile drive from Highlands to meet him at the train station in Salinas, Edward and I created a verbal composite sketch: he would be clad in a well-cut suit with a proper tie and polished shoes; he'd be wearing a hat, something most New Yorkers still did; he would be short and dapper and equipped with a briefcase and a pen in his breast pocket.

We arrived to find that the train was running five hours late, but fate provided *Gone with the Wind* at the local theater to keep us entertained while we waited. Back at the station after the film, we competed to see which of us could pick out our man, but the figure we so carefully imagined was not there. In his stead came a great shambling clown wearing a silly grin and hauling gaudy string bags stuffed to bursting with colorful Mexican souvenirs. He beamed his pleasure at finding us there, and we fell in love with him at once. He not only seemed to know all there was to know, he was full of wonderful anecdotes about any subject that came up. Edward and I decided he was really a Westerner in disguise. I think Moe took it as a compliment.

Most of our friends brought sleeping bags to roll out in the yard, on the floor, or in Bodie Room, where the bed was flat and hard and they were likely to be overrun by cats. We found accommodations for Moe that were a cut above this, at Peter Pan Lodge. We took him to Point Lobos, as we did all important guests, and fed him pea soup while he delighted us with cosmopolitan talk. *California and the West* is dedicated to him and to the Guggenheim Foundation. (When Moe learned of this through a note from Edward, he wrote: "I am very pleased—that's much too mild, really—by your suggested dedication. I have no suggestion: it is simple, direct—and unique! For you will be interested to know, no other Fellow has dedicated a book to the Foundation!")

Moe suggested that Edward select a large group of Guggenheim prints to be presented, on behalf of the Guggenheim Foundation, to the Huntington Library near Pasadena. (In a letter written two months later, Moe said that this idea had originated with Merle Armitage—despite my personal uneasiness about Merle, he never stopped promoting Edward's work.) Edward responded eagerly to the proposal. He had realized by then that his little concrete vault at Wildcat Hill was too damp a place to store negatives. Even museums did not always keep photographic collections in archival state, partly because they simply did not know yet how to handle prints properly. We often had prints returned from exhibitions dog-eared, marked, and broken at the corners, with scratches on the mounts and occasionally on the surface of the pictures.

The possibility of a secure home for a major set of photographs was irresistible. We had heard from friends that the Huntington was well policed—visiting researchers who mishandled the collections or even powdered their noses in the vicinity were stopped by guards. I had seen this myself when I visited there years before with Walter Arensberg and was impressed by the temperature and moisture control systems.

Moe departed with great good feeling on both sides. The following winter Edward wrote to him about the proposal, detailing the estimated cost of making 1,000 prints. He explained that he had grossly underestimated our Guggenheim budget and schedule:

> *Now I come to the questionable part. A photographer's materials cost relatively little. The time and wear and tear of darkroom work are his*

real "expenditures." In the figures given, "time and labor" is reckoned as one year's living expenses. This is a non-profit basis because the living expenses will be used up before the collection is finished (and I will not have—as I do at the close of the Fellowship—my year's work to sell) . . . It would mean a great deal to me to have the collection in the Huntington, where I know it would be properly cared for, and it would mean a great deal to me to have it put there by the John Simon Guggenheim Memorial Foundation. And to get it there I would gladly do the work at cost.

He gave Moe two estimates, $2,405 and $2,105, the higher one reflecting a better grade of mounting stock.

On February 20, Moe replied:

Dear Mr. Weston,

I have your letter of February 17 and don't know quite what to say. I suppose it should have been obvious to anyone that you couldn't—couldn't afford—to print that many prints without getting paid for your time; but I confess it had not been a factor in my consideration of the matter. In my ignorance I had been thinking of a grant of $300 to $400 to pay for materials. I don't think the Committee would feel entitled to go so high as the minimum you indicate; it would amount to a third-year Fellowship and they don't judge they ought to do that.

You will understand that I am not criticizing your figures nor your point of view. I just had not been aware of the time factors and therefore had underestimated woefully. I'm sorry.

Please forgive me—both of you.

Edward wrote back immediately:

Dear Mr. Moe:

I feel that I should be the one to ask forgiveness for putting you "on the spot" in my eagerness to put over the project perhaps on too big a scale.

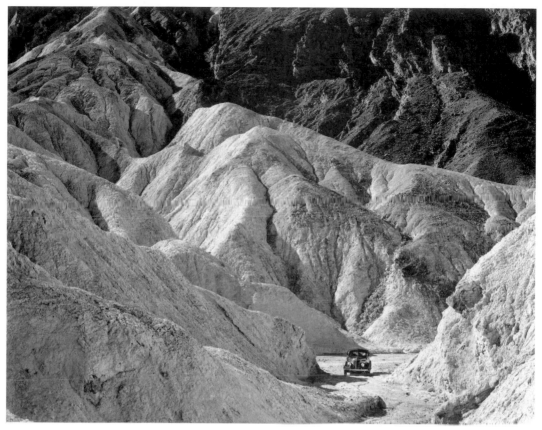

33. *Heimy in Golden Canyon.* Photograph by Edward Weston, 1938

34. *At Ted Cook's.* Photograph by Edward Weston, 1937

35. *Dead Man, Colorado Desert.* Photograph by Edward Weston, 1937

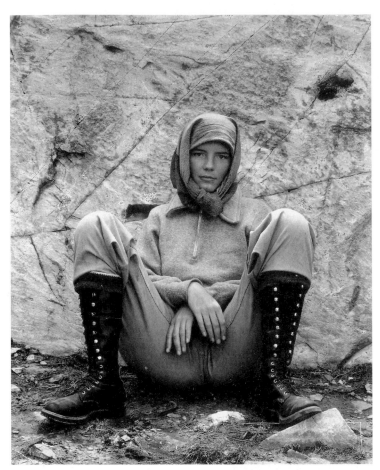

36. *Charis, Lake Ediza.* Photograph by Edward Weston, 1937

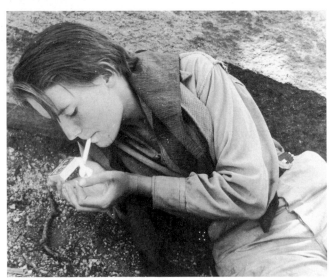

37. Charis at Devil's Post Pile, 1937. Photograph by Ansel Adams

38. *Juniper, Lake Tenaya.* Photograph by Edward Weston, 1937

39. *Meyer's Ranch.*
Photograph by
Edward Weston,
1940

40. *Rhyolite, Nevada.* Photograph by Edward Weston, 1937

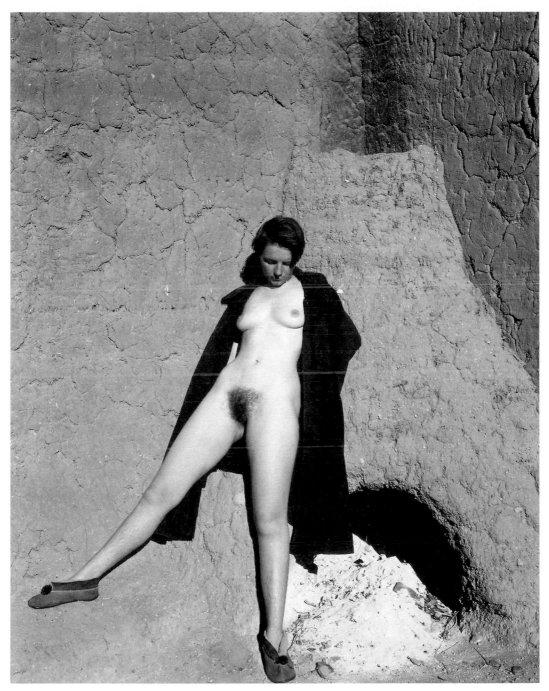

41. *Nude.* Photograph by Edward Weston, 1937

42. Gravestone photographed by Edward in 1938 and sent to Charis when she was caring for H.L.

This is a true picture of my destination unless you come down on next train.

43. First print made by Edward at Wildcat Hill, with inscription written on the back of photograph by Edward, 1938

1st print made in new home.
Tengo muchos recuerdos masque linda.

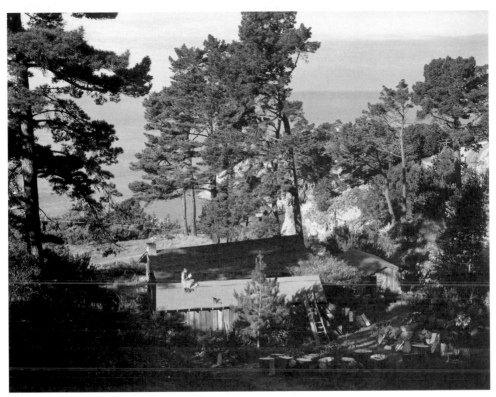

44. *Wildcat Hill.* Photograph by Edward Weston, 1942

45. Charis preparing party treats at Wildcat Hill, 1940s. Photograph by William Holgers

46. Coffee grinder at Wildcat Hill, 1940. Photograph by Beaumont Newhall

47. Charis and Edward feeding cats on patio at Wildcat Hill, 1940s. Photographer unknown

48. Leon and Charis at Wildcat Hill, 1939. Photograph by Valeska Hyman

49. Picnic at Garrapata
Canyon, 1940s.
Photograph by William
Holgers

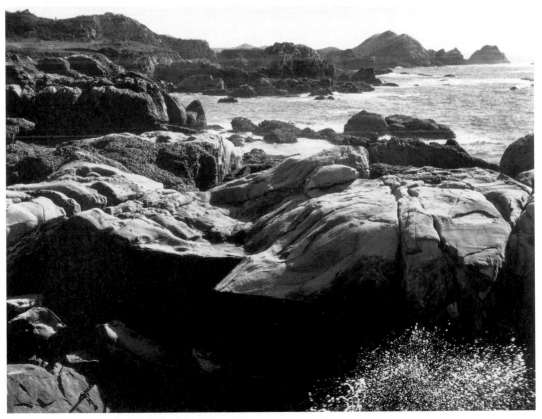

50. *Point Lobos.* Photograph by Edward Weston, 1938

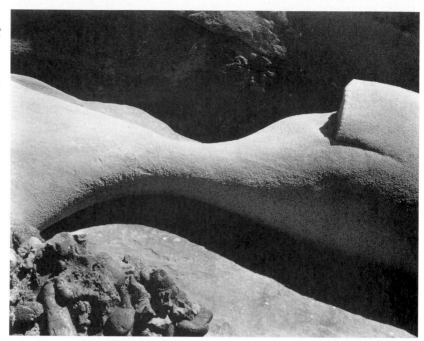

51. *Rocks, Point Lobos.* Photograph by Edward Weston, 1938

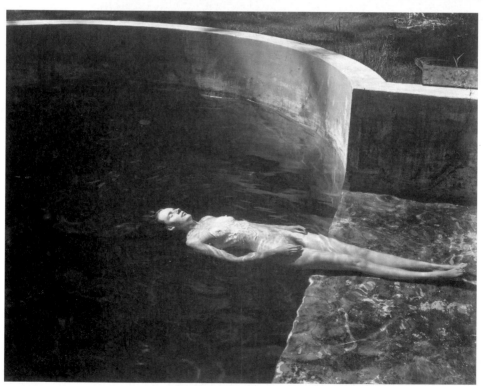

52. *Floating Nude.* Photograph by Edward Weston, 1939

53. Charis and William Holgers at Yosemite Forum, 1940. Photographer unknown

54. Yosemite Forum, 1940. Seema Aissen on left in coat, Bill Holgers with mug, Edward with thermos, Charis sitting with back to camera. Photographer unknown

55. Edward and Ansel at the Yosemite Forum. Photograph by William Holgers

56. Edward and Seema Aissen doing the "Apache" at a party at Ansel Adams's house in Yosemite Valley, 1940. (*Above right*) Charis in background. (*Below*) Virginia Adams, in glasses, smiling in background. Photographer unknown

57. Ansel Adams at a party at his house in Yosemite Valley, 1940. Seema, in white collar, in the background. Photographer unknown

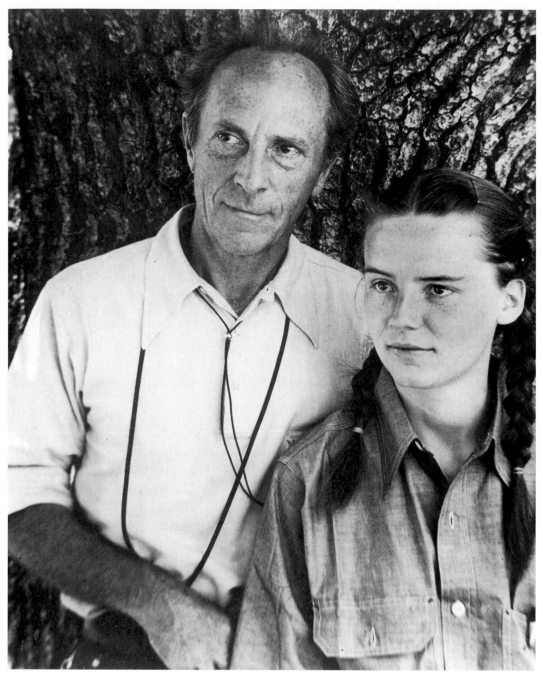

58. Edward and Charis in Yosemite. Photograph by William Holgers

Your figure on materials was very close. That you did not think of time and labor is understandable; I had to because I have no definite income ahead for the next year . . .

Here is one idea. I could cut the number of prints from 1,000 to 500—which would not hurt the basic value of the collection—and do the printing in my spare time, spread out over two years or longer if necessary. This would be comparable to having four years in which to do 1,000.

Materials for 500 photographs would cost slightly more in proportion than for 1,000, probably $175. If I could receive a grant of $400 for expenses it would give me a little extra for "overhead."

The collection took five years to complete and proceeded pretty much as Edward outlined in his letter. In March 1939, the Guggenheim Foundation set up an account of $400 with the Huntington Library from which Edward was to draw to buy materials. He added a few negatives for the Huntington collection to whatever else he was printing—orders to fill, replacements for prints sold, exhibits to prepare. The Huntington prints were spotted and dry-mounted along with the others and then segregated in a special section of the print cabinet. When they numbered anywhere from fifty to a hundred, we'd look around for reliable transport to get them down to the Huntington Library. In the second year of this long-range printing marathon, Edward and I made a cross-country trip and—with Moe's agreement—nearly a hundred images from this journey were added to the collection. When the last of the 500 photographs had been delivered, I reckoned Edward's return to be about six cents a print, but he was more than satisfied. He now had the assurance that a significant number of prints from his most productive period of work had a safe and permanent home.

Edward exchanged letters with Moe for years—rarely did he drop a valued correspondent—and they fill a fat file folder. In 1994 I got copies of the correspondence and suffered a shock: in the dozens of notes and letters Edward wrote to Moe during the first Guggenheim year I am not mentioned at all. My utter invisibility during these formative years—even when he talked about acquiring the Highlands property and building the house—was stunning to discover. I felt like one of those Russian non-persons airbrushed out of pho-

tographs taken with Stalin. I was edited out at the time our partnership was in full swing. Nothing in our years together suggested that he would exclude me in such a way.

In a note to Moe written before our first trip, Edward begins: "I am so happy over my appointment that if I let myself go I might seem even maudlin! Suffice it to say that this is the first time in my life that I have had a year free to work with no financial obligations to consider . . . I intend to keep a brief daily record of my work and travel which I will send you from time to time."

Even my log-keeping had vanished into the first-person pronoun.

Edward's first mention of me occurs in a letter dated May 31, 1938: "It is time to let you in on a secret. The land on which I am erecting this 'mansion' belongs to Charis Wilson, the girl I am to marry in October. Actually, it is not much of a secret for all our friends seem to take it for granted, even the papers ran a story, though we have never admitted anything! This is not entirely a Guggenheim romance, but last year certainly cinched matters!"

Maybe the explanation is simple: maybe Edward didn't see the need to clutter up quasi-official correspondence with references to someone he would have to explain, especially as we were not then married—and it might even be that this man who lived so unconventionally retained an awareness of old-fashioned propriety about traveling with a young woman who was not his wife. Once the deed was done, I sprang to life in his correspondence full-blown; there is hardly a letter to Moe afterward that doesn't acknowledge the partnership.

By December, after six months of domesticity, we were ready for a change of pace. Edward was tired of printing and I was tired of working on articles for *Camera Craft* and skirmishing with the bank. We had had our fill of visitors for a while; we had made our new home comfortable and convenient—it was surely time to hit the road. Leon's Hollywood job had ended, so he joined us for our third and final trip to Death Valley, and after a few days Zohmah arrived in the valley late at night by bus.

On January 3, 1939, I wrote to H.L. while in my favorite writing position, that is, standing, with the typewriter on the front car fender. We were working

our way down Titus Canyon, which had been impassable on previous trips because the road was washed out, and Edward made pictures of some folded green hills as I typed.

> *During the day we pick up wood, usually dry stumps in the washes, and have our evening stew by a roaring fire. Then if we can keep awake a while we read aloud. Most nights we have to force ourselves to stay up till nine, so we won't wake up too early next morning. I think part of our constant sleepiness is due to our present state of purity. No coffee, no cigarettes. We are so healthy as to be almost unbearable.*

Leon's presence meant we read aloud at night more often than usual, although it took little reading to put Edward to sleep. He used up his eyes on photography in the daytime and after dinner he was too tired to listen for long. When he and I did read it was generally adventurous accounts or stories—Robert Louis Stevenson's *The Wrecker* (a present from Leon), *The Woman in White* by Wilkie Collins, *Memoirs of a Texas Ranger*, and even true tales in crime magazines.

During the years I was with him, Edward wasn't much of a reader, but he could be dazzled by quotations that supported his views or stimulated his interest. One was a passage by van Leeuwenhoek about examining his feces under a microscope, in which he described the action of the little animals he was amazed and delighted to see. This in turn delighted Edward, but he did not attempt to read through the ponderous book; it sat on his shelf to remind him of an adventurous man's electrifying discovery.

Between trips, Edward continued to make pictures near home, including more attempts to catch moving water. That I took such challenges seriously—took them almost as my own—showed years later in dreams. My dream journal for May 10, 1986, records a typical "discussion" dream in which Edward and I are talking about the problems of photographing water. The attempt at Laguna Beach when his camera was drenched by spray had failed. He did better in *Surf,*

China Cove, Point Lobos, 1938, a picture he kept even though part of the water did look frozen; he liked other things about the picture too well to let it go. Prompted by the dream to look up the picture in a book, I saw why Edward considered it a success. Counteracting the frozen look is intense wave action, a rock pushing out of the water to meet the swept-back tail of seaweed on the sand and light playing off the wedge of dark rock along the top of the picture. Tipped-up water at the top right corner tells that the slamming descent of the wave is imminent.

In April 1939 we made our last Guggenheim excursion, up to Seattle to see Cole's graduation from Cornish School and meet his fiancée and fellow student, Dorothy Hermann. Cole had studied drama at Cornish, where he was supported in part by a work program that, as far as I could see, consisted of sweeping floors. When we attended a school dance rehearsal, I couldn't take my eyes off a classmate of Cole's because I was amazed that anyone so awkward—so long in the legs and arms—could be seriously interested in dance. His name was Merce Cunningham.

After putting Cole on the bus south, we headed down the coast at a more leisurely pace. While we did not announce it, we intended to get married on our homeward route, since Edward's divorce from Flora was now final. As far as Edward was concerned, it was a formality, but Flora was outraged. For years she had called herself Mrs. Edward Weston and convinced friends that Edward was simply away on a photography trip. He was a man who came and went but was still her husband and a part of her life. For an estranged woman—or man— to cling to at least an image of being married was not uncommon in those days.

Edward had known it would distress Flora, and had warned her ahead of time in hopes of easing the hurt. The most difficult part for him was having to make statements against her in the divorce papers, a measure that a lawyer told him was required by law at the time—incompatibility was not enough. He was grateful and relieved that Flora didn't contest the divorce.

Edward and I felt no need to be married, but due mainly to legal details connected with owning Wildcat Hill, it seemed the practical thing. My trip log makes no mention of the marriage aside from a cryptic entry on Wednesday, April 19, 1939: "After paying call to Ukiah Courthouse, back along highway

north for vineyards, and off to Clear Lake." We had stopped to apply for a marriage license, which we picked up three days later with our general delivery mail at Weott. Down the coast at Elk—always one of our favorite towns—we located Judge Walker, a delightful man with a peg leg and a white beard. It turned out that Walker was a photographer whose old studio faced the only street in town. He told us he had made good money with tintypes but hadn't done so well with a camera. "You'd work hard over a sitting with a baby, show the proofs to the mother, and then, oh God! you'd be in for it."

"Can you do some marrying for us?" said Edward.

"Well," replied Judge Walker, "I'm not dressed for it. Got these dirty old cords on because I was shucking abalones."

"Oh, that's all right. We've been camping, so we just have our pants and boots on."

In the little living room Walker called in his wife, introduced us, and whipped out his book. "How much do you want me to read?"

"Just whatever you want to, Judge Walker. We'll leave it up to you."

The judge flipped through pages, then asked if we had a ring. "Not necessary, of course. People think you have to have one, but there's nothing in the law about it."

We had not one ring but two, having haunted pawnshops until we found well-worn gold bands that fit us perfectly. When the ceremony was over, we spent some time filling in the papers. Walker complained that he didn't do this often and they kept changing the forms and making them trickier. Also, his eyesight wasn't what it once was. We wanted to be sure it was official, so I went carefully through all the instructions, and Walker was happy to accept my advice on what to write and where to write it. Then Edward dug out $2.50, and the judge pocketed it with a twinkle, saying again, "Not necessary, of course. But always desirable."

That night we stayed in an auto camp outside Santa Rosa, and Edward, who had conducted the negotiations, reported that when he'd said "my wife" he had stumbled over the word and the proprietor had given him a knowing look.

The first person we saw on returning home hailed us with "Congratulations!" Ever since we had resettled in the gossip land of Carmel, people had been

telling us they'd heard we were married and was it true? My strategy had been to tell people encountered on the south side of Ocean Avenue "Yes," and on the north side "No." Now we intended to proceed on the quiet, but being babes in the woods, we didn't know that such vital statistics are automatically reported to the hometown unless silver crosses some clerk's palm to prevent it. After all our careful planning, we found that the news had preceded our return. H.L. had been interviewed by an enterprising reporter and, to my surprise, was quoted as saying that he thought we would be very happy together. He sent us a letter of congratulations and Edward responded:

> *Dear H.L.*
>
> *Your letter meant a lot to me. Charis and I have worked together for four years and often under trying conditions, so we have had a severe test. Charis has been a marvellous companion and helper during this last difficult year. I really believe we can make a "go" of a permanent tie-up. Happy to know that you continue to improve.*
>
> *Until soon, I hope*
> *Edward*

THIRTEEN

Had Edward not had so much printing to do—1,400 negatives awaited his attention—we might have managed more trips, but there were other obstacles as well, including H.L.'s worsening condition. We settled in at Highlands, Edward printing and me writing *California and the West*. One day I was napping in Bodie Room when Edward woke me and said, "H.L.'s gone." My first thought was that he had gotten lost again on one of his morning walks. Edward had to repeat it several times before I understood. It was June 19, 1939. H.L. had died during the night.

By the time Leon and I got to the Dietjen house, a funeral parlor from Monterey had already sent a representative. The man clearly assumed that this would be a grand affair because of Harry Leon Wilson's renown, and by the time we had said no to everything—no notification, no viewing, no service— he must have thought we were heartless. However, H.L., who for years had kept a human skull on his desk, had no use for funeral rituals. He'd made it clear he wanted his remains disposed of as simply and cheaply as possible. We told the man from the funeral home we wanted our father's body cremated and the ashes returned to us. When the cardboard box of ashes arrived, Edward, Leon, and I took it up on the hill behind the house, dug up a rhododendron,

and poured the contents into the hole. We stood quietly for a while, then replaced the earth and the plant. H.L. would have considered it a proper burial.

On the day Ocean Home was to be put on the auction block at the courthouse in Salinas, we decided that, for the sake of education, we should go over to watch. By that time, neither Leon nor I felt sentimental about the sale. It was a done deal, and Edward and I had at least saved a piece of the land. At eight in the morning we gathered on the courthouse steps with a few officials while a clerk read an elaborate four-page description of the property, and then announced that the sale had been postponed for a month.

We were flabbergasted.

The next week I had a meeting with Kirkpatrick and asked him about it. He said, "Oh, Lord, some buyers turned up so we had to postpone it." The clerk hadn't realized it was just us coming to watch. Although we didn't go when they did hold the "sale," we heard about it—the bank made its offer and no one else was there to bid against them, just as planned. "Sold to the Bank of America." The bank later sold it to a St. Louis banker who invested lavishly in rebuilding and redesigning the place while keeping the original outlines.

Before the sale Edward made a negative of me floating nude on my back in the swimming pool, a picture that troubled him because he thought it made me look dead. In 1986, at a Weston centennial celebration in Carmel, a speaker said this was one of Edward's three greatest photographs, and in it I represent a seedpod floating on the inscrutable void.

Another response to the picture comes from *Signatures*, a beautiful book of poems by my friend Joseph Stroud:

LETTER TO RACHEL. NEGATIVE.

THE ART OF SEEING.

In Weston's 1939 photograph, your mother
Floats on her back in a key-hole shaped
Pool. For a long time it reminded me
Of Millais' Ophelia, *drowned among the lilies*
And waterweeds, a bouquet of flowers
Clutched in her hands, her dress billowing

Folds of grief the lost glimpse in sleep.
But Charis is nude—her long, slender body
Floats in a peace nothing could disturb.
Not even death. Which isn't the reason
I keep coming back to it. But to glimpse
How of art a moment might be suspended,
And how Weston must have loved her
To catch that pose. How I love
To look, catching in her grace
The likeness, the subtle, haunting trace
of you.

Even though Edward was printing like mad and I was reworking parts of my log for the book, we still had to settle on publication details. Tom Maloney of *U.S. Camera* was interested, and we went back and forth by letter through the summer of 1939 and into the next year. In August he suggested that the book could be ready for sale by Christmas. Edward replied: "Your letter left me gasping. I certainly wasn't prepared for an 'out-before-Christmas' project. I don't like to disappoint you but I don't see how it could be done." Not only would this not leave enough time to select the best pictures out of the hundreds of negatives but rushing would make good reproductions impossible.

"With all the publishers the project has been discussed with," Edward wrote, "I have stood firm on one point: that I want the finest possible reproductions. I have done the best work of my life in the last two years and I think it is important that it should be seen."

We proposed a spring book. Maloney agreed, and in the fall he came from New York to visit us at Wildcat Hill. We gave him a "tour" of pictures and text, and all seemed well, but in a February letter he shocked us again: "I feel that the pictures should be broader in scope than the group you and I looked at. I'd like to think of including some of your portraits and, as I see it, they could very logically be included because they are California in character and characterization. There are possibly some other things. One or two of the nudes, for instance."

It didn't make the suggestion easier to bear that Maloney said he had dis-

cussed the idea with Ansel, who had agreed; Maloney even suggested that Ansel come down to Highlands to help Edward select prints for the book. Edward replied:

> *If the proposed book was to be an "omnibus" then of course I would want to, have to, include portraits, nudes, my Mexican days, my industrials of 1922 and even a few of the vegetable period. But to include with no apparent reason a smattering of nudes and portraits would seem to me extraneous padding.*
>
> *With the exception of portraits and nudes, my Guggenheim period is a summation of my life-work; it includes every possible approach and seeing that I have touched before in a mature and conclusive form . . . As planned, the writing and pictures do make an integrated story, but how will you explain the popping up of nudes and heads? . . .*
>
> *And finally to Ansel: I have the greatest respect for him as a photographer, for his opinion, but his help in selection would merely mean another group, neither better nor worse. If you were the judge, or Steichen for instance, then we would have a still different "show." But this you must realize: no one—not even my sons—has seen all my work, with the exception of Charis.*

No one reading this letter today could detect the real degree of Edward's frustration over Maloney's ham-fisted proposals. We had been steeped in this project for two years, and to have someone as distant from it as Maloney trying to tinker with the work was infuriating. Edward stood by his standards and he prevailed.

Maloney did better for me, allowing plenty of room for text, and, after reading a chunk of draft, making the perfectly sound suggestion that I emphasize personalities as much as possible. Since I had already reached the same conclusion, I was happy to oblige.

Edward was not really in the business of teaching photography, but over the years he took on a number of students. His teaching style ranged from the

"you already know everything, let's go make some pictures" attitude he took with Willard Van Dyke to the demanding program he devised for Mrs. Woodward Radcliffe. I was amazed recently to discover the original, yellowing itinerary for Mrs. Radcliffe, who was to study with Edward from June 25 through 29 for a fee of $100. In these five days she was to cover all of photography—camera, filters, darkroom, lighting, color values, limitations of film—and each evening from 7:30 to 10:30 p.m. was to be devoted to print showing and discussion "unless otherwise notified." Edward wrote out the schedule because he thought he should, but ended up following his usual informal style.

The schedule included a number of statements of general principles that were pure Edward: "There is no 'correct exposure' for any subject. Meter merely measures light available. Exposure is correct when it will produce the kind of negative that will enable you to obtain the print you have visualized."

I don't recall how Mrs. Radcliffe fared, but most of Edward's students managed very well and became close friends if they had not started out that way. Valeska Hyman, whose daughter was a friend of Leon's, was one student who made a lasting contribution to our lives. Valeska was far from fluent in English, and her familiar and mournful query "What *means* this?" became part of our family lingo.

In August Edward was asked by editor Walter Yust to revise the "Photographic Art" article in the *Encyclopaedia Britannica*, for payment at the going rate of two cents a word. The article had been written by F. J. Mortimer, an Englishman and former editor of *The Amateur Photographer and Photography*. Yust sent us a copy along with the main photography section. The article was mostly devoted to a discussion of photographic chemicals, and as for the art of photography, it said little more than that a photograph can be art if it is made by an artist—and most are not. There was no real discussion of aesthetics or developments in this country in the art of "seeing" with a camera. Except for some portraits by Stieglitz and Edward Steichen, the accompanying pictures were in the pictorial tradition, including one by Mortimer himself, of gulls hovering above the surf, printed in such soft focus it was hard to recognize as a photograph.

Edward responded that he would not be able to take on the project unless he had the freedom to write an entirely new article. The current one was written by a man with a British background, he wrote Yust, "which so far as my article is concerned is peculiarly bad. The most important understanding of photography as a medium of expression has developed in America since the Photo-Secession of the early 1900s. Please note: I am not going to do any flag waving!"

Yust replied: "You have carte blanche in the re-writing of the entire article if that seems to you to be necessary." With this nod of approval, I set to work and was finished by November. In his introduction to *Edward Weston: On Photography*, Peter Bunnell notes what I have not seen mentioned elsewhere, which is that the encyclopedia article was of importance because it represented a considerable revision from past editions, "and the need to update the understanding of photography was essential."

Our only real problem concerned illustrations. As Edward wrote to Yust, he wanted to "have represented four living photographers of historical importance . . . but Stieglitz was sick, Strand was travelling, Steichen moving and no longer in business . . . I would prefer not to use my own work if there is time to get something else." In the end, the article also featured pictures by Edward and Ansel. The letter included a postscript stressing that all prints should be "reproduced in full proportion—no slices trimmed off!"

On the first of April 1940, Yust sent us the plate proofs and Edward was aghast. We drafted a response that was more strongly worded than what we ended up sending to Yust, but it's worth quoting to show Edward's distress: "I was shocked—no less—to find that several of the photographs had been trimmed (cropped) to suit the page . . . A top photographer is quite as concerned with his composition as a top painter. Would you take it upon yourself to trim the work of Giotto?"

Yust's response was all that we hoped for; the engraver and printer had trimmed all but two of the pictures despite being instructed not to, he said, and new plates would be made. We wasted no time in thanking him, and in our letter pointed out that it was particularly important that the pictures be reproduced intact in this instance since they were offered as representative samples of photographic art.

. . .

Our life at Highlands was pleasantly domestic. For years a population of half-wild cats had lived on the land around Ocean Home. Edward and I had enjoyed only single cats in the past, but since we liked cats and were interested in their behavior, we'd always wanted to have several at a time. We believed that a lone cat becomes humanized from associating only with people, and that observing such a cat would tell more about the family it lived with than about the cat itself. Only cats who associated with other cats would behave in a natural manner.

When one of the wild females gave birth to three kittens by our doorstep, she seemed so young and unprepared for the ordeal that I happily played the role of midwife. When the mother disappeared soon after the great event, we adopted Negative, Amidol, and Panic, who quickly became Tivvy, Dolly, and Nicky.

We didn't go out of our way to make pets of the cats, because of our interest in "natural" cat society, but gave them housing, food, and minimal training—mainly to wait for their dinner in silence. When housing got to be a problem, we assembled what came to be known as the Franklloydwright Addition: cardboard boxes set up in series, at angles, and in stories. One of the things we enjoyed that few cat owners experience was kitty heaps; when we sat by the fire at night, one cat would get on our lap, then another would climb up and make a few perfunctory licks at the first one and lie down beside it, the next cat would lie down on top of the first two, and so on, until there were as many as six cats stacked up and the bottom one would have to crawl to the surface or suffocate.

Even when the population soared toward two dozen, the cats kept a low profile if guests were around. Visitors might see one or two, but not enough to draw comment unless, of course, the guests stayed overnight and got in on feeding time. When people came for sittings or to look at prints, and when Edward was spotting or picking out prints for a show, we shut the cats out by blocking the cat door and woodbox opening.

. . .

Mornings at Wildcat Hill began with the sound of pine chips snapping in the fireplace and the *grrag-grrag-grrag* of the coffee grinder. When I turned over and opened my eyes, I saw Edward sitting at his desk, finishing his second cup of coffee and dealing with the last item on his spindle—a bill, a query, or a letter from a friend.

Behind the house, hills rose to steep heights, blocking the view to the east; to see what kind of weather the day promised we looked west over the Pacific. In summer, a fog bank would be there somewhere, enveloping the house or hanging some distance offshore, as though deciding whether to give us a blue afternoon or to lurk indefinitely. We craved sun, but fog was better for getting work done. On the occasions when we looked out and saw bright white specks of fishing boats shining in the early sun, and the water royal blue with turquoise veining clear out to the horizon, we knew the day would be too perfect to waste on work alone. If Edward had planned to print, he would find any excuse to put off the darkroom—a clear, sunny day was such a gift he didn't want to waste a moment of it.

If the telephone rang on a day like this, we exchanged a hopeful look as Edward picked it up. Our rare calls were most often from friends who had arrived in town and wondered if they could come out for a visit.

"Margaret? How wonderful. And Jim? And Barbara? Marvelous. We'll have a picnic on Point Lobos . . . Yes, I understand."

And so did I, by the disappointment in his voice. The visit was not for today but tomorrow, so we could only hope for another sunny miracle.

I fed the cats, then checked the pegboard to see if we were in urgent need of supplies. This was a system I had devised using an old cribbage board on which I had kept score when playing dominoes with H.L. I had attached it vertically to the wall and on either side posted a list of common kitchen items— Rytak, cottage cheese, figs. Under the board I tacked an open matchbox full of matches with the heads removed. When we ran out of something, I stuck a piece of match in the proper hole. Once or twice a week I tallied up the shopping score and headed to Monterey.

In the cooler I found a pot of pea soup that smelled suspicious and put it on the stove to be "repasteurized," that is, boiled for four minutes.

Edward filled the woodbox and took his letters and postcards to the mailbox, and now we were ready for breakfast. Dry cereal, fruit, more coffee, all consumed while we made a rough plan for the next two days. With a picnic tomorrow, we decided, I'd better make a run for Rytak and Jack cheese. We put our bowls down for the cats to polish; then I made the bed and ran a mop over the floor, which completed the day's housekeeping.

Edward wrapped a package of prints for me to mail in Monterey. He pulled a length of butcher paper from the roll that stood in one corner of the room and sliced it free with a razor. From long practice—always using the same size mounting board—he knew just how much he needed without measuring. He trimmed two pieces of cardboard, for front and back, wrapped the whole, and tied it with string from a giant spool.

He filled the Cape Cod lighter tankard and went out to split wood before taking a pre-darkroom sunbath. The Cape Cod lighter was one of our most useful possessions in that land of fog and wet firewood; it was a porous stone attached by a netting of wire to a handle and kept submerged in kerosene. We would thrust the saturated stone under paper and wood, hold a match to it, and have instant fire.

Ignoring the siren calls of the weeds in the garden, a genista hedge to trim, and other sun-drenched activities, I went to Bodie Room to finish copying an overdue article. This did not indicate great strength of character on my part, only that Edward and I had different philosophies: I was inclined to eat the cake first and save the frosting for last, while he was convinced of the wisdom of eating the frosting first, since calamity might strike and deprive you of it.

When I had finished typing and was ready for town, Edward had exhausted his last diversion and was shutting himself in the darkroom. A couple of hours took care of town chores, and I returned with groceries to find Edward temporarily escaped from the darkroom and eating his favorite lunch of dried figs and sour milk. He was looking through the mail.

"We're having guests today after all," he said. Old customers were coming in the late afternoon to look at prints, which might mean a sale.

Edward went back to printing. I made a sandwich and headed for the garden to weed and thin. The day had turned so blue and tranquil that I could no

longer resist a swim, so I changed course for China Cove, the tiny beach on the south side of Point Lobos, which I reached by climbing over a fence and crossing a field. I loved to swim through a series of "caves"—some of which had long since lost their roofs—that connected this beach and the next one over. Starfish, urchins, anemones, crabs, limpets, periwinkles, and other colorful sea life spread over the bottom and sides of these rocky grottoes.

When I returned to the house the visitors were looking at prints set on the easel, which stood near the glass doors. Edward had a stack of prints on the table and was making coffee. I took a quick shower and joined them. I still enjoyed listening to Edward, even though his talk never varied from one such occasion to the next.

"Charis has heard this already," he began with a nod in my direction as he held up a print of the dead man at Carrizo Springs. "We'd been driving all day through sand and heat on the old Butterfield Stage route across the Colorado Desert . . ."

FOURTEEN

After the freedom of the Guggenheim, Edward was not keen on going back to being a full-time portrait man, so he agreed enthusiastically when Ansel proposed holding a photographic forum at Yosemite in June 1940. Only about a dozen students signed up. There were to have been five teachers, but because of the small turnout, Ansel and Edward led the forum on their own and did very well. They were a great combination. Although their work differed, their viewpoints meshed—while each had something distinctive to say about any particular aspect of photography, they were generally compatible and complementary. Both men were lean, sinewy, and extremely agile, but Ansel towered over Edward. They would take off after photographic quarry like two hounds on different scents; while they enjoyed a bit of competition, they egged each other on in a way that benefited the students.

On daily forum outings everyone would pile into cars and take off for a promising location. As the students got to work on whatever caught their eye, Ansel and Edward would set up and do entirely different things with the same raw material. At that time they both taught by doing rather than lecturing. They were good at showing what was on the ground glass, talking about why they had framed a picture in a certain way and answering questions: "Why did

you include that?" "Will this show up in the print?" Then the students were quizzed by Ansel and Edward about their own choices. The same sort of frank exchange characterized the darkroom work and nightly bull sessions when Ansel, Edward, and the students shared freely. It was the kind of open discussion that serious students in any medium must cherish.

Forum participants often photographed Edward and Ansel at candid moments. On one occasion, the students set up in front of some giant sequoias and great burned snags for what they hoped would be a more formal picture than usual. Edward managed to look serious for a few exposures, but when the students wanted still more, he went into a crouch and hammed it up in his usual fashion. A photograph taken by Bill Holgers documents the silliness and captures the playful mood so often in evidence at the forum. Bill was a building contractor in Oakland, a friend of Willard's who quickly became our friend. On a morning when the subject was portrait photography he and several other students took pictures of Edward and me posed in front of a tree, but they insisted that Edward stand up and I sit next to him so I wouldn't be taller. This may have improved some of the pictures in an unexpected way—I'm sure it accounts for Edward's look of mild amusement.

Edward and Ansel did one more forum together, in the fall of 1940, and after that Ansel carried on for years on his own. His teaching style changed dramatically, however, when he developed what he called the zone system, a method for predicting the effects of different factors (exposure, development, and so on) on the tones in a print. In a letter to *Camera Arts* written, I believe, during the 1980s, he talked about his evolution as a teacher. In the early years, he wrote, "I found that I had nothing to teach but 'the way I did it myself.' This is *bad* teaching: the teacher should be concerned with the potential 'way' of each student." Teaching photography through the zone system, Ansel believed, would allow students greater freedom of individual expression. This highly schematic style was so far from Edward's intuitive approach that I can't imagine the two could have taught together successfully once Ansel fixed on his new method.

I remember the forum with affectionate nostalgia, because people were allowed free time to work on their own, get to know each other, use the dark-

room, or sit and drink beer and contemplate the surrounding cliffs. I have attended numerous photography workshops since, most often as a guest speaker, and have yet to encounter this approach again. Instead of unpressured guidance in the field, students now are given dizzying schedules, as though the organizers are afraid participants might complain about not getting their money's worth.

My main task at the Yosemite forums was to ferry Edward and groups of students to various locations, but I was also writing *California and the West*. I settled on Seema Aissen's cool, private cabin behind Ansel's darkroom as the quietest indoor spot to work. When Ron Partridge left Yosemite in 1938, Ansel told Edward he was looking for a replacement and Edward recommended Seema. She had been Chan's girlfriend for several years, but she was ready to move on because of his roving habits.

"They were a hard family to get away from," she told me recently. "They had a charm, a magnetism. Going up to work for Ansel was the best thing that could have happened to me."

Seema was diminutive, with a wonderful thicket of dark hair she semi-tamed into ringlets. Her size made her a perfect dance partner for Edward, and the two of them livened up more than one forum evening with their version of the Parisian underworld's *Apache* dance. When she and I both had free time, we took bicycle trips around the valley floor. No more bashful than I was about peeling off her clothes to go for a dip, Seema joined me one afternoon for a swim in the natural pool behind the local doctor's house. The doctor's wife came out with her little camera and asked if she could take our picture—she was probably studying photography, like everyone else in the territory.

When she was six, Seema and her family had been arrested and briefly imprisoned while trying to leave their native Ukraine, where her father faced conscription. Though her family was Jewish they were tolerated in their community during a time of pogroms because her father was a respected bookshop owner. The family finally made it to England and there, as in Russia, their home was a gathering place where people met to discuss the issues of the day, an early influence which helped turn Seema into a lifelong social activist.

Seema worked for Ansel until late 1941, and then lived in Los Angeles during

her forty-three-year marriage to writer Jack Weatherwax. Since his death she has lived in Santa Cruz, California, where September 2, 1992, was declared a countywide Seema Aissen Weatherwax Day to honor her "strong and compassionate leadership." Rita Bottoms, the Special Collections Librarian for the University of California at Santa Cruz, knew of our past connection and took me along to the grand celebration. There, at ages eighty-seven and seventy-eight respectively, Seema and I renewed the friendship we had begun so many years before. She likes to say we must be related and refers to me as her "ex-stepmother-un-law." Chan and his family were also in attendance at the gala. Seema and Chan maintained a close friendship until his death in 1995, and she is now fast friends with a fourth-generation Weston, Chan's grandson Jason.

In addition to her community work, and despite the onset of macular degeneration, Seema has begun to organize and catalogue her photographs and papers—the archive of a fascinating life lived with integrity. Insightful, spirited, witty, and frank, at ninety-two Seema is my role model for aging without diminishment.

Because it was set up for commercial production, the darkroom at Yosemite was far better than what most private photographers were used to. Ansel believed that having such a darkroom at his disposal made a big difference in his work. He couldn't understand how Edward put up with the darkroom at Wildcat Hill, which he once described as "simpleminded. Incredible that he could get anything done in it."

It's true that the darkroom at Wildcat Hill was as spare as a darkroom can get—walls, shelves, sink, and drawers were all made of unpainted pine; there was no enlarger, since Edward made only contact prints; a bare, frosted bulb that hung on a cord from the ceiling served as a printing light, with a wooden clothespin to secure a larger or smaller loop in the cord to raise or lower the light; the tray of developer was kept at a constant temperature by being placed over a red lightbulb in a wooden box. A printing frame, some trays, a thermometer, 8 × 10 film holders, a few bottles of chemicals—and, of course, the three-minute egg timer.

I have known high-school students with more elaborate equipment, but having survived on meager earnings for most of his adult life, Edward felt fortunate to own a darkroom built to his specifications. As far as I know, he never felt deprived. His credo of keeping it simple ran counter to the general trend among photographers, most of whom went on about filters and developers and printing, or how you treat the finished print or the negative to enhance the photographic value. I believe this preoccupation with the technology of photography remains widespread today—not many photographers choose Edward's approach, but it was ideally suited to his vision.

We did not meet Nancy and Beaumont Newhall until the summer of 1940, but we had been in touch with them since 1937, when Beaumont invited Edward to lend some of his photographs for the Museum of Modern Art's first major photography exhibition, *Photography 1839–1937*. Edward sent four pictures of the Oceano dunes that traveled with the show around the country. Beaumont was the museum librarian at that time but later helped found—and became director of—the museum's Department of Photography. He had written to Edward about launching the department, and Edward replied: "If anything is contemporary it is photography; if anything is peculiarly American it is photography. Count on me to cooperate in any way I can. Of course American museums have presented 'salons' of photography for many years, but almost always photography with a very bad smell . . . But so far as I am aware no museum, nor individual, has had any plan for acquiring a representative collection of photographs . . . In time you should have a collection worthy of a pilgrimage to see—the only one of its kind."

It was Ansel who brought the Newhalls to Wildcat Hill. They were visiting him in San Francisco while Edward was in the city speaking at a photographer's meeting. Ansel drove him home to Highlands and brought Nancy and Beaumont along; we bonded instantly, with delight on all sides. Nancy's description of this first visit is wonderful, if a bit too poetic—but doesn't exaggerate about the cats. The family now included Nicky, Gourmet, Zohmah, Isaac, Esau, Goliath, Schizzy, Dali, Paisley, and Runty Nubbins.

It was dark when we reached Carmel . . . Charis, her long hair loose and shining, came out to greet us . . . There were jubilations and embraces. Then we all went into that wide-roofed room and the firelight. Supper was a celebration. Afterward, Charis showed us the half-finished text of California and the West. *Then Edward set up a simple easel, adjusted the light, put on a green eyeshade, and began showing us some of the photographs selected for the book. They were brilliant; the variety of Weston was astonishing . . . When the prints went safely back in the cabinets, Charis opened the firewood hatch and called. Cats began to leap in, so fast they became a torrent, cats of all sizes, colors, and ages . . . The Weston way of life, we learned, involved the minimum time and effort in the kitchen or at the dishpan. Breakfast was coffee . . . Lunch was eaten in the hand . . . Around four o'clock, when light goes bleak in the west, there was a cry for "Coffee!" At nightfall, all hands dropped work and joyously collaborated to make supper a feast . . . We went to Point Lobos with Edward, and to see Lobos with Edward was to see Dante's Inferno and Paradiso simultaneously. The vast ocean, dangerous and serene, pale emerald and clear sapphire, sucking in and out of caves full of anemones; tidepools flickering with life or drying inward into crystals and filaments of salt; the cliffs starred with stonecrop; the living cypresses dark as thunder clouds, with the silver skeletons of the ancient dead gleaming among them. Then as the apocalyptic moments of the fog closed in and became cool twilight, back to the little house and coffee, firelight, the latest pages from the typewriter, and more prints.*

Nancy has combined several visits here. The first night they stayed nearby with Ansel at Peter Pan Lodge—despite Nancy's paean to the simple life, they were not a rugged pair and the comforts of even the rustic lodge were better than we could offer. They left for a time, but soon returned to the lodge for an extended stay. Beaumont made pictures around the house: of the coffee grinder, the kitchen corner, some fruit in a Mexican bowl, and my typewriter. Nancy photographed Edward photographing Beaumont in the back yard and, when the session was over, photographed the photographer sitting on a high stool, laughing.

Beaumont was shocked when, after he'd made some prints in the darkroom, Edward said, "Why didn't you dodge them?"

"Mr. Weston," said Beaumont, "isn't that against the rules?"

Having followed the arguments between the pictorial and purist schools of thought, and knowing Edward's assertion that he could see the finished print on the ground glass, Beaumont assumed that Edward would never do anything but expose the print straight, with no manipulations of any kind. But Edward took him into the darkroom and demonstrated how he "dodged" by using a cardboard disk with a twisted wire handle to block light from heavily shadowed areas in order to bring out detail. He also sometimes "burned in" by allowing longer exposures in certain areas of the print than others. Edward explained that a negative holds a much greater range from black to white than any printing paper picks up readily, and contains more detail than it's possible to get in a completely straight print. There is a real difference between burning and dodging to bring out more clearly what is on the negative and the kind of manipulations that Mortensen and his fellow pictorialists did, and that added, removed, or significantly altered what was captured on the negative.

I finished the final draft of *California and the West* in the fall and we sent it, with photographs, to Duell, Sloan & Pearce. We knew it was good, but we didn't celebrate until the moment we opened the box of copies that came from New York before the year was out. We didn't think much of the reproductions but agreed that they could have been worse.

There were favorable reviews in *The New York Times,* the *L.A. Times,* the *San Francisco Chronicle,* and so on, and I felt pretty good, until it occurred to me that most readers would leaf through looking only at the pictures. I was inclined to say, "It's really just the story of Edward's travels and reactions to things," which was true. I didn't feel I owned the story, but when some hasty readers concluded that Edward had taken the pictures *and* written the book as well, I was severely downcast. This made Will Irwin's review all the more welcome: Irwin wrote that the Guggenheim got "double value for its money" because of my text. "Whether or not she realizes it, she is a born writer—perhaps a discovery." This was just fine.

Also fine were the royalties that started coming in. We soon heard that *California and the West* was the first really successful book of photographic reproductions. It was decidedly different from others we had seen, not being an art book. Not only did it have plenty of story, but it was reasonably priced at $3.75. There was a second printing within two years, when the price was raised to $5.00.

Edward finally got his wish to cut back on portrait sittings. Now he could be pickier about who sat for his camera. As for me, the success of *California and the West* settled any lingering doubts I had about my value as a partner.

THE WHITMAN TRIP

FIFTEEN

On February 7, 1941, we received a letter from George Macy, director of the Limited Editions Club in New York, confirming what Merle, who was to design the book, had already told us—that Macy wanted Edward to make a series of photographs to "illustrate *Leaves of Grass* by Walt Whitman."

Macy's scheme was to reissue ten classics in a series, *American Faces and Places,* in the kind of luxury volumes that are now called coffee-table books. Edward didn't mind that the run would be limited to a thousand copies—most of them to go to Limited Editions Club members. He was excited by the scope of the photographic opportunities, and we saw right away that we should be able to get our own book out of it in addition to *Leaves of Grass.* We were both alarmed, however, by Macy's plan to bring out all ten classics by October—just seven months away—and by his repeated use of the word "illustration."

We replied to his letter with enthusiasm, but said making the pictures would require at least six months and we "couldn't see it as the making of a few dozen negatives that might be apropos. Rather, it would mean . . . the task of rendering visual the underlying themes, the objective realities, that make up Whitman's vision of America." Our idea was that Edward's photographs and Whitman's poems would both stand on their own—their common subject mat-

ter would do the rest. Whitman, after all, catalogued all the ingredients of the American scene and, if Edward simply did his own work, we would be bound to have suitable pictures. Edward wanted assurance that there would be no attempt to correlate the pictures directly with captions taken from Whitman's writing and Macy appeared to agree. He did assure us that we could take six months if needed, but said, "Southern California being such a melting pot of American types, I should have concluded that you could take most of the photographs where you are."

Too shocked to find this funny, we wrote back: "Photography is an uncompromisingly honest medium. The painter who finds his Minnesota farmer and Indiana banker in Southern California can ignore the evidences of transplantedness and paint back in the Minnesota or Indiana flavor . . . but the photographer who selects his New Englanders and Southerners and Midwesterners from the same source will come out with a picture of the Southern California melting pot and not a picture of the U.S."

Macy offered $1,000 for the whole project. We accepted, but knowing from the Guggenheim how expensive it is to take to the road to make pictures, we said we would also need $500 expense money along with half the pay as an advance. We pointed out that even this amount would be entirely spent on the trip and the photography—in other words, we would make no money—but Edward was willing to do this for the opportunity. As it turned out, Macy responded that none of his illustrators ever received more than $1,000.

He was also unhappy when we told him that printing would probably stretch beyond six months, possibly to the end of the year. This triggered a flurry of letters and telegrams between New York, Los Angeles, and Wildcat Hill, but in the end it looked as though we might be on the road by May. With Phil Hanna's help once again, we laid out an itinerary that would last seven months and take us through most of the forty-eight states.

We recognized this was not the ideal time to be launching a cross-country odyssey—not with the government preparing for possible involvement in the war in Europe. When Edward wanted to photograph one of the big Santa Fe engines in Los Angeles, he had to wire Washington first to get permission. We heard a story, perhaps apocryphal, of an artist in Ohio arrested for painting a

scene of steel mills. To be prepared, we racked up letters of introduction—from the Los Angeles Chamber of Commerce and chief of police, the president of Occidental College (solicited by Merle), Phil Hanna, Henry Allen Moe, and Macy himself. Macy's letter, as Edward had requested, was notarized and embellished with the Limited Editions Club gold seal, red ribbons pendant. We were ready to impress anyone who might stand in our way, whether we were being denied access to a place that looked promising or were about to be tossed in the jug for innocent trespassing—innocent because Edward would never risk the other kind.

We did not expect the letters to help us when there were concerns about national security, but they were likely to be persuasive when a reassuring introduction was all that was needed. In the course of the trip, we gave time and thought to matching the letters to the occasion. For instance, when we were about to visit J. Frank Dobie at the University of Texas, we pulled out the letter from the president of Occidental College.

On Ansel's recommendation, we proposed to Macy that the Limited Editions Club should be legally responsible for the pictures, that is, liable should any lawsuits develop from their making or publication. Macy replied that the company lawyer had rejected the suggestion and proposed instead that we get release forms signed by the subjects. This was reasonable, but his reply was strange, and maybe should have warned us that our negotiations with him were to take odder turns yet. "I have heard too many glowing things about your wife, to lend ear to the lawyer's suggestion that you might commit rape upon some of your models. But I have no way of knowing that you might not, disliking a house in the background of one of your pictures, proceed to burn it down; and I don't think The Limited Editions Club should be responsible for the consequent arson."

We concentrated on preparing for the trip and arranging for a friend to care for the house and ten cats. I wrote to Charles Pearce, of our publishers Duell, Sloan & Pearce, requesting a list of U.S. travel books. I mentioned my impression of the Eastern domination of the field and asked plaintively, "Haven't Westerners ever gone East and come back to tell of the strange land and cities?"

Recognizing that the pay was insufficient to cover nightly motel fees, even if

they were modest two- and three-dollar affairs, we decided that the only solution was to alert everyone we knew along the way about our plans and hope that hospitality would shower down. We compiled a monstrous file of names. Some were friends, some were on Edward's list of people who had bought work, and some were fellow Guggenheim veterans recommended by Moe. I typed the list onto separate pages for each state—38 pages in all—and made an alphabetical file of the states so I could organize correspondence with potential hosts and have space to add phone numbers and directions. People we were especially interested in seeing we notified in advance by mail. As for the others, if we did not find them at home, we would have to decide whether to wait or push on.

Edward arranged for Brett to do the crucial job of developing. The exposed negatives would be shipped back to him in batches along with a list I would furnish giving the "what and where" of each exposure, and to this Edward would add notes about what to watch for in developing. Brett would send us a few test prints from time to time to show how things were going. This system required that we keep to a fixed route with known mail stops, although there was no way to make firm commitments about time. We saw no advantage in setting arbitrary deadlines that might mean packing up and leaving a productive site before Edward had mined its full potential.

After the grueling miles of our Guggenheim travels, Heimy was ready to retire. We traded him in for a new tan Ford, which we christened "Walt, the Good Gray Bard." Walt came equipped with a radio to keep us posted on world events, an obvious requirement at a time when we might wake up one morning to find the country at war. I learned enough about Walt's insides not to be cowed by any roadside mechanic who might tell me that the fuel pump needed replacing or the head gasket sure looked bad.

During the weeks before we headed east, Edward delivered talks at a camera club and a gallery. As usual, he was rigid with nervousness before each talk, even though he was well prepared—overprepared, I thought—but the talks were so successful I threatened to book him cross-country.

In November, both of us had been on a radio book-review program in which we talked about *California and the West*. Friends thoughtfully taped the show and I was aghast to hear how very mannered and schoolteacherish I sounded.

Of course, there was no studio manipulation in those days to make people sound their best, but I can't blame technology for my obtrusively elegant delivery. Only in recent years have I got the hang of speaking—to groups, into tape recorders, on film—without self-consciousness.

The only sad note in our Whitman preparations was Edward having to leave his sister, May, who was recovering from a stroke. Her illness had been a great blow to him, for May was always a central figure in his life—when we lived in Santa Monica Canyon we had usually seen her once a week. Nothing else in May's life was as interesting as whatever was happening with Edward. It was clear that she saw him as the most perfect specimen to walk the planet, and she didn't hesitate to say so. Her admiration sometimes made him impatient, but it also moved him. In response to one of her tributes, he wrote: "Sis darling— When you write such fine things about me, it hurts—then I do feel inadequate, know how much more I might do. But keep on writing! I shall keep your letter always—Brother."

We visited May just before we set off on our trip. She was at home and functioning pretty well with a cane, but even so it was a wrenching experience. Her daughter, Jean, and ninety-year-old Uncle Theodore were still living with her. Jean was sure she was going to make her fortune from avocado products— soap, lotion, ice cream—and used their tiny kitchen for her experiments. She stood at the sink peeling yet another avocado while May sat close by, her right hand contorted from the stroke.

Edward handled his distress by playing court jester, gaily recounting stories of where we'd been, what we'd done, and where we were going next. May knew that we had been commissioned to do the *Leaves of Grass* pictures and would be gone for months, but now that our departure was imminent she could not control her grief. Edward promised to send her a postcard every day and was faithful to his word. He continued the postcard habit after we returned to Wildcat Hill, writing his sister once or twice a week until she died— reporting whatever news of his life was amusing and ignoring what might be sad or dull. When he had nothing worthy to pass along, he could fill a card with a few affectionate words. "To a funny little sister from a brother who loves her."

. . .

Setting out on the Guggenheim had been hectic, but this was like leaving to spend three years in a remote jungle. Packing, planning, and shopping never seemed to end, and we were going to have a late start. The route we'd planned circled counter-clockwise around the country, which would put us in the South in the hot months. But Phil Hanna pointed out that if we reversed the route— started up through the Northwest—it would be midsummer by the time we crossed Iowa, Kansas, and Missouri. We were in for heat with either route, so we stuck to our plan.

I had grown up on the California coast and by now Edward could pass for a native, so our wardrobes were ill suited for much variety in climate. Nor were my acquisitions well advised: I ordered some all-purpose denim dresses and a corduroy jacket and skirt, but they were neither cool enough for the Southern summer nor warm enough for the Eastern winter. Edward was a little better off with slacks and shirts of both wool and cotton, sandals and boots, and the old Mexican pith helmet he had resurrected for the desert chapters of the Guggenheim.

I had the heat in mind as I searched half the stores on our way out of town looking for a straw hat. My requirements were simple, I thought, and based on desert experience: a hat with a crown (to stay on in the wind) and a brim (to give shade from the sun). After an exasperating succession of head-shaking sales-girls, one explained with lofty finality: "Straws have no crowns this season— they're called *Gone with the Wind* hats."

I had what felt like a premonition as we drove over Cajon Pass, which, at just over 4,000 feet, separates the Los Angeles Basin from the Mojave. In 1849, William Brewer had visited California as a member of a government survey party. Looking down at the old Spanish-Mexican town of Los Angeles, he noted the closed-in character of the area and its inadequate water supply. He predicted that the settlement had no future.

I, too, felt doubts about the future as we entered the pass. A feeling of anguish swept through me, a pang of desolation, a sense of onrushing personal disaster. I felt sure that things would never be the same again, that our future

was being reshaped by whatever lay ahead. I told Edward what I was feeling, and he thought it might be due to the strain of months of preparation, culminating in the last few weeks of crazy intensity: buying the car, the hustle and bustle of shopping, getting the last print orders filled to build up our money supply, compiling the letters of reference, and paying last-minute visits to May, Ramiel, and others.

We assured each other that the fear was well founded: we were traveling across a country that had been declared in a state of national emergency. Just the night before, we had listened to a radio broadcast of President Roosevelt making his Unlimited Emergency Proclamation. There was every likelihood that we would soon be at war.

When we left the pass, we were surprised to find that the desert had become unfamiliar, transformed to an alarming green by recent rains. Maybe because of my uneasiness, and because this spot was so familiar, we thought more of home than of the passing landscape or what lay ahead. We thought of the new garage Bill Holgers had built for us, and the new driveway that had been graded up the short steep slope from Highway 1. We wondered whether our housesitter would be equal to keeping kittens out of the print cabinets, and cats from having kittens in the hypo barrel, and the various other problems of rural felicity.

We had traveled enough to know that the first night out is likely to be the lowest point of any trip. That night it was Baker, on the edge of the Mojave, whose blast of neon lights summoned insects from the vast surrounding desert: three-inch grasshoppers whizzed past our heads while rapidly crawling specimens that appeared to boast both tarantulas and scorpions among their ancestors went gadding about over the stony ground. Under the glaring lights of an all-night eatery we heard nothing but talk of last night's accident: because a groom couldn't bear to stay behind a truck until it got over a hill, there was a dead groom, a nearly dead bride, and a family of six wiped out.

We borrowed a flit gun—no concern for the environment in those days—to rid our cabin of the teeming wildlife that had entered with us, and Edward retired to the first of many autocamp showers to load film holders.

. . .

Boulder Dam in Nevada was our first opportunity to find out if our letters of introduction were really going to be useful. We pushed on over the desert to Boulder City, presented the letters with rather a wilted flourish, and lo, they worked like a charm. We were welcomed to the inner sanctum of Light and Power, shown albums of official photos, and assigned a guide for the following day.

Boulder City was built by the government in 1932 as a conservation and administration headquarters for the National Park Service and was planned to the teeth—wide streets that followed the curve of the hill, green lawns, shade trees, little junipers in sidewalk pockets, big parking spaces between buildings. That night, at Lake Auto Court, we were introduced to the swamp cooler: a two-foot box attached to the outside wall was stuffed with excelsior—long, curled wood shavings—onto which water dripped from a pipe. A large electric fan, set in the indoor face of the box, transformed the sizable room into a place suitable for refrigerating meat in a matter of minutes.

Next day we picked up our guide, safety engineer Earl Tucker, who was also an amateur photographer. People were pouring in for the Memorial Day weekend, but the dam was so enormous and the traffic so well regulated that the crowds didn't dull the stunning impact of the place. The gray-green-white of the dam was magical against desert rocks of rose-pink and brown.

The highway that crossed the dam into Arizona swarmed with cars but, with Tucker on board, we left the tourists behind and entered the body of the dam. As we drove about the installation, there were armed guards all along our route and Tucker kept us informed on their marksmanship ratings. I asked why he showed his pass to each guard when they all knew him by face and first name. Regulations—how could the guards know he hadn't been fired half an hour before?

Edward first made pictures looking down the face of the dam from one of the convenient little outcroppings up on top, and then from down below at Stony Gate, the tunnel where water roars out. We eased Walt down a dark tunnel filled with dripping pipes, pulled up in a parking area inside the dam,

walked along tiled corridors, climbed stairs, and reached a narrow hall with lockers and benches where we halted for lunch. Afterward, we followed a party of inspectors along a corridor that looked down into the powerhouse on red, chromium, dark green, dark red, and bright orange super machinery. We emerged among air- and water-cooled transformers with the cantilevered towers leaning out from the hillsides above us. Edward burned up film on powerhouse and valve house, while I tried to keep track of names and functions.

When we climbed back up to the world above, a fierce gusty wind was blowing. At the sight of a sleeping guard, Tucker told us that this was the only sin; guards could fight or get drunk as long as it didn't interfere with work, but sleeping on the job was a sure prelude to getting their traveling papers.

Public and industrial installations proved to be among our favorite picture-making sites on the trip; both of us were drawn to monumental human works, and we would have visited even more had it not been for wartime restrictions.

At Grand Canyon we were put up and fed in style at Bright Angel Lodge, compliments of the Atchison, Topeka, and the Santa Fe Railroad, whose advertising manager, R. W. Birdseye, was negotiating with us by letter for pictures to go in an upcoming book on the region. We spent a week driving up and down the west rim and then the east rim in wet and hazy weather, looking into the canyon from all available viewpoints, and returning at night to excruciatingly comfortable quarters. There was so much haze in the air that for the first few days we saw more of the parklike growth of junipers, piñons, cactus, and wildflowers that grew on the top edge than we did of the canyon itself. When the sky occasionally cleared, Edward made negatives of the pink-and-yellow cliffs, usually to the background chatter of fellow travelers, every one equipped with some kind of camera.

From cars with plates announcing Kansas and Missouri, Arkansas and Wyoming, New York, Indiana, the Dakotas, Iowa, Illinois, Nebraska, and, more than any other, California, whole families emerged.

Inevitable first words: "Do we want any pictures here?"

When Indiana met Indiana, the Kodak talk might be mistaken for fisher-

men's—it's fun even if you don't catch any, and most fun talking about the beauty that got away. At Grand View, Edward set up on the end of a projecting rock, where one stone teetered slightly every time he walked across it. We had carefully inspected the mooring and found it sound, but as Edward was focusing, a visiting party stacked up behind.

The women discussed the situation in heavy stage whispers:

"I'm sure he'll fall off."

"Should we warn him?"

The man of the party was reassuring. "He's been here before. He knows what he's doing."

The women were only partly convinced. "Do you suppose he might be hired to take pictures by the government?"

At this moment Edward came out from under the focusing cloth and got his meter out to take a reading. "See," said the man, now vindicated. "I told you he was a professional. Has a light meter and everything."

Are you making movies?

Are you using color?

Are you making time exposures?

But most often: Well, you're making some *real* pictures.

In Phoenix, we visited Mrs. Republican, from Merle's list, and had to extend the stay for an extra day because Walt had a bad pinion bearing. Among her treats for us was a visit with her dear Barry of the Goldwater Department Store, at that time a congressional hopeful. Goldwater's grandfather Michael had immigrated from Poland and built a dry-goods business in the Arizona Territory in the late 1800s. Goldwater's father, Baron, had established a store in Phoenix that was one of the first modern department stores in the West. Goldwater joined the business in 1928 and was just drifting into politics about the time we met him.

It was fascinating to watch Edward and Goldwater delicately probe each other to find out if this was someone worthwhile. We left with an autographed copy of Goldwater's mimeographed account of his raft trip down the Colorado River.

Mrs. Republican impressed Mr. Republican by telling of dear Barry spending *two* hours talking to Edward and even then not wanting to let him go. Goldwater talked about his raft trip and did his best to find some conversational solid ground, but there was no meeting of minds, and I don't think he had any real idea of what a photographer like Edward was up to. But Mrs. Republican was happy, and this made up, we hoped, for the fact that folks at the camera shop had never heard of Weston and didn't show much interest in her glowing account of his place in the photo-firmament, during which Edward cowered and pretended not to know her.

Dr. Edward H. Spicer (from Moe's list) headed the Anthropology Department at the University of Arizona and was studying the Yaqui Indians, who came to this country as political refugees from Mexico between 1900 and 1915. By 1941 they numbered about 3,000 in Arizona. We interrupted a lesson—Refugio Savala, a young bilingual Indian, was teaching Spicer the Yaqui language—but we arranged for a trip to Pasqua the next day, Friday.

Pasqua was as poor as anything I'd seen in my life. Dirt-floored shacks, mud walls reinforced with pieces of board and sheet metal, no running water. We called on the village chiefs, Sr. Guadalupe Balthazar and Sr. Tomás Alvarez. A rickety bench and three homemade chairs were brought to the shade of the one stunted tree in Sr. Balthazar's yard. We seated ourselves, and as tobacco was passed around, Spicer began the longest, slowest conversation I have ever been a party to, starting with inquiries about the health of the two chiefs and their relatives and moving on at a snail's pace to inquiries about the health of a good portion of the village residents. It was late June, and sitting on my uncomfortable willow branch chair in the exterminative heat I got twitchy. I sneaked a look at Edward, guessing his impatience must be nearly overpowering, only to find him perfectly in tune with the proceedings, relaxed and attentive.

An hour into this poky conversation, Spicer mentioned that Mr. Weston was a photographer and would like to make some pictures. After considerable discussion this was found to be agreeable. Spicer added that Mr. Weston would like to begin by photographing our hosts. After more low-toned discussion, this was also found to be agreeable. Edward set up his camera while Sr. Balthazar disappeared into his house and reemerged soon after in a dazzling white shirt.

I had to remind myself that this had been accomplished in a dirt-floored shack with no running water.

Sr. Alvarez carried his badge of office: a short length of bamboo with a loop of red ribbon tied through the end of it. This indicated that he was the conductor of the dance, which we understood to be an office of importance.

Refugio brought out what looked like a careful crayon drawing of the country they had been driven out of, a perfect rendition of the Promised Land. I wrote in my journal: "We see the picture map made by Refugio of their old homeland. The Yaqui country in northern Mexico is filled with blue streams, green grass, and fat trees to make the heart cry for all this dead baked mud."

Edward made a negative of the Yaqui church interior, a bare room with two small paintings by the altar and a ballooning cloth ceiling picked out here and there with a few shiny Christmas ornaments. He did another view from across the plaza, showing the bell tower constructed of stacked railroad ties and the dark open front of the church split by a center post. Sr. Alvarez showed us the nearby white plaster church the Catholics had built for them. It was locked up and used only on the correct saint's day. Spicer explained, "The front isn't open so they can't dance in and out—an important part of their religious ritual."

He suggested that Refugio read us some of the poems he was writing in English, including a long ballad about working on the railroad. The Yaquis were not citizens—a legal case was then pending to try to change this—and working on the tracks seemed to be their only source of employment. Edward said that Americans should feel ashamed in the presence of Indians and was contradicted with vehemence. "No, no! Americans took us in, gave us refuge."

Point of view makes all the difference.

We made a detour into El Paso to look up a friend of Sibyl Anikeef's, a woman from Romania. A Romanian friend of the friend was also visiting, and as we sat in the twilight in a back yard murmurous with mosquitoes, one of the women assured us that the United States is a cultural wasteland. We were quite ready to agree with her after the disgusting lunch we'd endured earlier in the day at a roadside café, at which a combination salad had turned out to be bits of ham

and cheese on lettuce rather than the fresh vegetables I craved. But when the second woman asserted that "Americans don't appreciate music. You just can't hear it over here," we did mutter a warning that El Paso is not the United States.

I was impressed by Edward's restraint as the conversation continued in this vein. He respected the fact that we were being housed and fed here, and didn't react as he might have, given his relatively newfound patriotism. During World War I, he had been a radical, generally in accordance with his friend Johan Hagemeyer's anarchist views. But between the wars this changed, partly because of his experiences in Mexico, from which he returned a patriot, a believer in his own country, ready to appreciate the creative side of an expansive culture.

In New Mexico, as we climbed the last ridge on the way to White Sands National Monument, the sky was black with heavy clouds, thunder crackled off the peaks, and long chains of lightning leaped around us. The storm was just tailing off as we drove into the monument, so all the air around us was mottled purple, orange, and gray above the dazzling white of the gypsum sands. Edward quickly did a rainbow, and then another, over the white ridges against the dark storm clouds. At sunset an orange-gold light rose above the blue-black clouds and mountain silhouettes. We watched the light go, turning the dunes lavender and finally almost blue. Although the nearest autocamp was far up the road and proved somewhat crude, Edward insisted on more White Sands, so we made the best of it, and turned up early the next morning to find a brilliant clear day.

The plants in the dunes—mostly yucca and sumac—kept their heads above the moving sand by building pedestals of roots that, said the ranger, could reach down fifty feet. In the middle of the dunes a cottonwood stood on a huge pedestal; some of its roots had been exposed and had sprouted fresh green leaves. The dune lizards and mice were white, and webs of their tiny tracks were visible on the light crust that formed on the surface of the hills. By ten o'clock the glare from the sand was so intense that we retired to park headquarters to eat our lunch in the shade.

Some lizards had just been placed into a glass-topped case in the hall and the park employees, Edward, and I caught flies to tempt them out of the sand. They had beady black eyes, moved very rapidly, and when alarmed dug backwards into the sand where they spend much of their time entirely hidden but for their eyes. The lizards would be released and new ones brought in within the week, because in that short time their unique whiteness would dim from lack of sunlight.

When the worst of the noon glare had dissipated, we took a ride with one of the rangers over the dunes in his Ford pickup, bracing camera, tripod, and case as best we could. This, of course, was well before dune buggies and off-road vehicles, and required some care in the doing. The ranger's tricks, in addition to deflation of the tires, consisted of "reading" the sand so as to avoid soft drifts, dashing over the light crust, and making sure to stop with the truck nose pointed down a bank in order to ensure some gravity for takeoff. We got stuck a few times, which was remedied with judicious employment of strips of plywood and a bit of digging. Before we finished, the films were all exposed and we were worn out with keeping the equipment safe. Even so, we sat in Walt in the parking lot for a final view of the bluing of the dunes.

Not knowing what kind of book I would end up writing about the trip, I indulged my mania for collecting information. A typical example was this odd bit from the *Report on the Little Colorado River Watershed, Part II: Recent Settlement.* I noted that the present population was 52,000, of which 24,000 were Indians, and quoted the book's studious observation that "as a whole the L.C.R. Watershed is sparsely populated in proportion to its size." Average number of persons per square mile in the U.S. was 41, in the L.C.R. Watershed, 21. The watershed includes one-one-hundredth the area of the U.S., but only one-twenty-five-thousandth of its population.

I loved such stuff and was happy when the Texas border station loaded us down with informative leaflets. The road that had been rough and pitted in New Mexico turned instantly smooth when we crossed the state line. We didn't see much in the way of pictures for a discouragingly long stretch as we headed

south, but in a green valley near Sweetwater, Edward made a negative with phone poles and highway posts, and was so happy to have the camera out, he made another exposure of almost the same scene.

We stopped for gas near Eastland. The man said, Ford's a good car. It'll get you there.

We: Yes, we like it.

He: Got a Chevrolet last year. All right in town, but get out on the highway going along about 80 and she sure burns up the gas and oil.

We (with no easy response as we never drove above 45, and much slower than that in good picture country): We're from Carmel, California.

He: What's your payroll?

We (I'm stumped, but Edward picks it up without a fumble): Lettuce. How's the weather going to be in Fort Worth?

He: Wet, I'm satisfied. Been raining over that way.

At Forth Worth, we settled in a camp at city limits and after dinner wandered for miles downtown, passing the Fort Worth Fish Market ("If it swims we have it") and the White Lake Dairy ("You can whip our cream but you can't beat our milk") but not achieving our objective—a bottle of spirits. This wasn't dry country, but it had a Sunday Law. Back to our camp to watch lightning bugs zipping about and to sleep all night uncovered right under the large wooden blades of the ceiling fan. People might say, "It's not the heat, it's the humidity," but we were ready to testify: "It's the heat *and* the humidity."

After a tiring day we'd take turns reading Whitman until we fell asleep. We liked the "Calamus" poems, but in general found Walt too grandiloquent, to use one of Edward's two-dollar words. In truth, Edward didn't give a hoot about *Leaves of Grass*—he was having the time of his life.

We had to turn *our* Walt over to Ford for a 5,000-mile overhaul, so after picking up mail at the Fort Worth post office, we looked up a friend of L.A. bookstore owner Jake Zeitlin and presented Jake's letter of introduction. The friend acknowledged this with the instant question "Is he still broke?" He then assured us that he knew just the fellow to show us the sights, Charles Renaud, oil man and amateur photographer.

Renaud was, indeed, happy to show us the sights, and when roses and ducks,

the cool green lawns and trees of the Botanical Gardens, and the architectural offerings of the football stadium and stockyards failed to elicit much response from Edward, Renaud assured us he had even better places in mind for to-morrow. The morrow began with breakfast in the ice-cold dining room of the Biltmore Hotel, which made the heat blast of our eventual exit almost unbear-able. Those were the early days of the air-conditioning art and proprietors had yet to learn that moderation is best.

Renaud took us to Hereford Farms, which had been started by a local doctor as a hobby and had quickly become a big name in the production of prize cattle. In the air-cooled barn, which seemed quite comfortable to us, the big, solid-packed, box-car-shaped Herefords panted from the heat; it took several minutes of exertion for one to get to its feet. The vast docile animals were being combed, curried, and sprayed with flit guns; their straw was changed every two hours. They traveled to exhibit sites by express, with an attendant on hand to feed them watermelon. Everything animal about them appeared to have been bred out, so that they were denatured, more like four-legged meat markets than sentient creatures.

Edward set up and focused on a windmill and silo group, to the displeasure of a large black-and-white Holstein bull, which pawed the ground and glared and stamped. Renaud assured us that he didn't belong to the farm, but I was relieved to see a real animal there. As soon as Edward looked around from the silo-windmill job, a farmhand drove up with a mule team hitched to a hay wagon, which became the next picture. I wrote "Hot stuff" after noting the negative number and description.

Finally Bonnie Prince Domino was brought out to pose before the silos. His handler carried a stick with which he nudged the prince's forefeet into position, while another helper stood out of range using orchestra-conducting gestures to induce the prince to elevate his head correctly. The first handler held the prince's rope and leaned back to stay out of the picture, being used to the newspaper ritual. It did not occur to him that for Edward he was as important to the picture as the prince he was joined to.

The two-year-old prince had won first prizes in Fort Worth and Houston. "Does he get watermelon when he travels?"

"Sure. He even gets some gin fizz!" Much laughter accompanied this statement, but I'm not sure it wasn't the truth.

With Renaud's wife, Sarah Maud, we went out to a boat club on Eagle Mountain Lake, where we ladies were served daiquiris, with beer for the gents. Edward made a picture of the sloping lawn with the three of us being served. We talked about how hot it was, and how high the lakewater had been during a recent flood, and how distressing it was to have had the beach at the club washed away. Sarah Maud insinuated that anyone could get a job during the Depression—she'd never had any problem because she had get-up-and-go. I demurred, saying I didn't think this was true, but Edward paid no heed. With him, such talk went in one ear and out the other.

On to Austin, where we wandered about the university looking for J. Frank Dobie, a Texas regionalist from Moe's list. No luck, so we left a note in his classroom and tried another Texan—from Jake's list this time—the Wrenn librarian, whom we found among the rare books. She suggested some houses for Edward to look at and then, at our mention of the name Dobie, set off on a mild tirade. How "people who glorify the rougher aspects of the old days fail to realize that our forefathers weren't content with that sort of thing, all their striving being toward the more civilized kind of life we now have. A wholly wrong impression is created by worship of old ways and Dobie is the worst offender."

We couldn't help sympathizing with such an offender, and looked forward even more eagerly to meeting him, which we did that evening. Dobie presented us with his new book on longhorns, and a copy of the December 1938 issue of *The Southwestern Sheep and Goat Raiser*, which included his essay on mesquites. Mesquites—pronounced locally m'skeet or even musskeet—were a current enthusiasm of his, and I could understand why after reading the essay.

"One of the preachers got up and gave a big talk on why the mesquites and the prickly pears have thorns on them and why the river comes down occasionally and tears up trees," the article begins. "Sin in this sin-cursed world, he said, is responsible for these things. He did not stop to explain why thorns are

so sinful, but in heaven, he assured us, there will be no mesquites or prickly pears. 'Man,' I said to myself. 'I sure will be homesick for Texas.' "

Dobie was quoting a letter from a Texas ranch boy, but the sentiment expressed was classic Dobie. A highly learned man, Dobie's interests covered a wide span of Texas human and natural history. After devoting pages to mesquite's botany, history, economic importance, and so on, Dobie ended the article like this:

"Primrose burn their yellow fires
Where grass and roadway meet.
Feathered and tasseled like a queen,
Is every old mesquite.

It is something intensely native, something that belongs. It holds all the memories of the soil itself."

Dobie was as comfortable among grizzled ranch hands and working folk as in the halls of academe, and he loved down-home talk. His technique went like this (approaching stranger with hand outstretched): "Howdy! Dobie's mah name."

Stranger (grasping Dobie's hand): "Smith's mahn."

And then they'd settle in for however long it took to get the information, the picture, or whatever it was that Dobie wanted.

At a gas station in Johnson City, Dobie asked if there were any old double-log cabins in the vicinity. A historian at heart, he had been talking these structures up since we arrived. The old settlers built them with a room on either side of an open hall, in which saddles could be left. Most that had survived had had the hall walled up to make another room, so a cabin in pristine condition was no longer easy to find. But we were in luck. Turn down the side road over there, said our informant, open a couple of gates, and drive down a lane through yard-high grass.

This was the Bruckner house, nearly 100 years old, with a smokehouse and barn, also of chinked-log construction—most of the chinking had fallen out—and in front a well capped by an enormous stone slab. The original open hall remained, but two rooms had been added on in back and a shed in front. The

new rooms were occupied by an Arkansas family: mother, father, two girls, a boy, a small baby, and a rambunctious puppy. Two big hackberry trees shaded the bare yard, and in the green field beyond stood three tall pecan trees.

The girls had a playhouse at the end of the porch (called a "gallery" in Texas) where bits of rusty metal, broken glass, and old tin cans were pressed into service for the Grand Café. The older girl prepared food and served, the younger was the perpetual customer. Dishes consisted of mud biscuits, mud cake frosted with yellow daisies, green peaches, and grass sandwiches folded in green leaves.

"I'd rather get a place than rent rooms," said the mother, holding her baby, "but we just can't seem to do it."

Back in Burnet, Dobie again asked for double-log cabins, and a man took us to see Ma and Pa Fry, whose old double was not far off. Old Bill and his wife were sitting on the gallery of their house—not the cabin but their home in town. "Come in, come in. Set down and have some peaches!" Edward photographed them, and they showed us an oil painting of their old double log; we made a date to see it the next day.

After a long drive home in the dark, during which we passed a couple of busy camp meetings, Dobie introduced us to a fine Texas institution, the watermelon garden, a square block of tree-shaded lawn set about with wooden tables. You walk in, sit at a table, and in a few minutes a waiter appears with cold slices of perfect watermelon. No debating what to order and no problem where to spit your seeds.

In the morning, Edward Graflexed Dobie in his back yard, and then Dobie took us to see Dave Dillingham, an old fiddler who, after losing an assortment of fingers, had to switch to banjo picking. Dillingham's house was a beautiful, pillared white structure set back from an oak-shaded lawn. He sat on the steps and picked out his mother's favorite song, "When I Played in Front of Mammy's Cabin Door," while Edward worked with the Graflex. I knew that such a natural for the 8×10 would call for a return visit and so had no qualms about leaving in a hurry to get to the Fry cabin; I'd have another chance to talk some stories out of Dillingham.

Even so, it was three o'clock before we made it to Burnet, picked up Mrs. Fry at the house, and drove to the courthouse to pick up Bill, who was a justice of the peace. He complained that he had married a couple the other day and

Ma pocketed the two dollars while he kissed the bride. A while later, when the kiss had worn off, there was Ma with the two dollars and he had nothing.

We also heard that one of the Fry sons was on a "mellow bender." His shoes had been hidden so he couldn't go downtown, and he was pushing quarters on the young folk to go find him a pair. Ma said he was the best tailor and the best restaurant man in Burnet when he was sober, but when he took a notion to start drinking, no one could do a thing with him.

Out we went to the old Fry home on Council Creek. Bill Fry's family arrived there in 1856; he was born in '57. Mrs. Fry made the trip up the old cattle trail as a girl and said she wished she could start right out and do it over. One of the Fry daughters, Molly Dallas, was living in the old home. She'd been canning and we went inside to inspect her put-up, having already seen that the house front was too shaded for photographing. But Edward had discovered that the back of the 8 × 10 had not been on tight when he did the Frys on the gallery in Burnet, so he did them again against the chinked wall of the house.

Traveling south through Texas I'd been admiring the "split bonnets" worn by women working in the fields. They provided a kind of covered-wagon shelter for the face against the savage summer heat that both reflected up from the ground and poured down from above. Molly had one on, so I was able to see the clever construction: the back gathered like any bonnet and tied around the neck, the front a series of stitched horizontal slots in which strips of cardboard were inserted. Ma Fry said she'd be glad to see one was made for me. "No one would think of making one out of new goods. Mrs. Boyd [another Fry daughter] will make you one from the back of my old lavender dress."

Back at the house we sat on the gallery a bit to chat. Farewells were almost painful—"Drop us a line" and "When are you coming back?" We couldn't bring ourselves to say we wouldn't be coming back. It sounded disagreeably terminal.

Ma Fry was true to her word. The bonnet came by mail to Wildcat Hill, and Edward made several pictures of me out behind the house, wearing the hat and a long dress and looking fresh off a wagon train.

Before we left Austin, we had an early date with Dillingham to catch the light on the gallery and the front steps so Edward could make an 8 × 10. I'd made

up my mind to ask how he'd lost his fingers; I had assumed it was a railroad accident, but there just might be a story attached. He must have seen me coming, because he started right off saying that he always explained to prospective banjo or fiddle students that he'd worn his fingers off pressing on the frets.

Edward and I were both attracted to Texas storytelling. One endearing characteristic was the inevitable chortle of the storyteller, a warm "heh heh heh" that was so infectious we couldn't help laughing, too, no matter the subject. Edward was delighted with the place and the people, Dobie in particular; otherwise we would have been back on the road much sooner, because he did not get many pictures.

We approached Houston through flat green fields of rice which, not yet headed, looked like rich grass. Edward stopped for some cotton rows, and we talked to the farmer who had his mules hitched to the cultivator and was resting at the row end.

"What a life! Consider the heat. Consider the government which says how much you can plant. Consider the price that may vanish. Consider the fleas that get the buds, the weevils that get the bolls, and the big old rainstorm blacking up the south right now that will knock all the blossoms off so there won't even be any buds for the fleas or bolls for the weevils."

In Houston my craving for a sandwich got us into a diner where orders were taken and purveyed by friendly young women naked to the waist. None of the locals seemed to pay much mind; the waitresses went about their work, sweating under the overhead fans; only the photographer and his model from bohemian Carmel seemed at all disconcerted.

At La Louisiane we got a clean room with an attic fan. The auto-court roadway was paved with white shells, and chickens wandered up and down between cottages and in and out of garage spaces; when Edward stepped out in the morning, two magnificent turtles were there to greet him. The proprietor, A. W. Giuffria, had made a fortune in the restaurant business in New Orleans, lost it in the real-estate crash, and come here seven years ago not wanting to face old friends from the opulent days.

He had a restaurant next door, but assured us sadly, "People here don't

appreciate good food. No matter how often you provide a glass with beer, they prefer to drink from the bottle.''

We met Ike Moore, director of the museum at the San Jacinto battleground. The monument was built out of blocks of yellow limestone and commemorated, he told us, the victory of 900 Texans over 1,450 Mexicans. I imagined the weather that day had probably been as hot as it was now and the Mexicans had sensibly been taking a siesta. The patriotic Texans had made sure the top point of the Texas star on the summit of the edifice reached four feet higher than the Washington Monument. We took the elevator up to the observation floor, climbed three flights of metal steps and ladders, and crawled through a trapdoor to emerge under the concrete star 535 feet from its base. The whole star was nine-pointed. The four bottom points joined the four corners of the tower, which meant that from any side you could see a five-pointed Texas star. It also meant that there were four pointed arches to look out from. From the south-west we looked down on a tidy area of trees and lawn designated Santa Anna's Camp. Beyond that was the shipping channel, and beyond that Galveston Bay. To the southwest there was a wide, flat stretch of green, with the park entrance road cutting through it, and, in the distance, some oil refineries. Northwest of us was the reflecting pool, now thick with algae, and a parklike area identified as Houston's Camp, and a giant sundial.

Touring the monument with us were several members of the Junior Chamber of Commerce, who were curious about Edward's work. In the course of our various meetings and greetings on this day, I learned the secret of their great capacity for remembering people's names: just repeat each new name on every possible occasion, and if there is no occasion, make one.

"I'm very glad to meet you, Mr. Weston . . . Mrs. Weston. Have you been managing the heat, Mrs. Weston? . . . I hope we'll have a chance to see some of your pictures, Mr. Weston," and so on. By this time, the Junior Chamber expert had our names nailed down and I, who had seen no need to use his name, had already forgotten it.

We went on to Galveston over the causeway. The island was a flat, marshy sandspit, and the Gulf for a long distance out was a dark café au lait. Seaside towns must have a common character the world over—crummy, crumpled,

smelly, with a little sand in everything. Dirty papers blew along the street, every square yard of ground had at least one empty pop bottle, candy wrappers floated on rain puddles. Two- and three-story wooden houses, most of them on stilts, were in serious need of paint.

The autocamps on the seawall were priced out of sight. Our first inquiry got a $5.00 quote; our second—for a little hole-in-the-wall—was $2.50. Outraged, we continued several miles along the seawall to where cars could drive at the water's edge and Sunset Beach Camp would supply us with a raised tent-house for $1.50. We did not hesitate, because there was still time for a swim.

There was no noticeable slope to the sand and no noticeable wave action in the warm brown water, which stayed ankle deep and shelly until we got tired of walking and lay down from exhaustion, so that we were just submerged. The gulls there had black heads. Little fish jumped close to shore and a turtle swam by. A clutch of cows wandered down to browse on the piles of watermelon rinds that littered the strand.

We woke the next morning drenched with sweat and unable to move in the furnace-like heat of the shack. We had slept late after a fitful night of suffocation and mosquitoes. Dragging ourselves down to the water, we crawled through the shallows and were sufficiently revived by the Gulf soup so that Edward returned for his camera and made a negative of the beach nuts with swimsuited me in the foreground.

We took the ferry to Port Bolivar and from there followed the road east along the Gulf, separated from the beach by a low hedge. At breaks in the hedge we saw logs tossed up on the sand along with the ever-present watermelon rinds. In Texas, wherever a car could drive, there you would see rinds.

Edward photographed some oil derricks on the inland side, with horses in a field before them and a rainstorm and smoke behind the hill beyond. At Sabine Pass—a pass for water crossing, not a mountain crossing, as no elevation around there was more than a few feet above sea level—we turned inland. Edward, just awake after a short nap, said innocently, "Is this where it happened to those women?"

We plunged into the forest of shiny industrial structures that made up an oil refinery. The towers and tanks that lined the docks were striking, unfamiliar

forms. When we came to an avenue of spherical tanks of shiny aluminum, supported by brick posts and capped by winding staircases, Edward was beside himself. Setting up an 8 × 10 by the highway here was asking for trouble during a national emergency, so we headed into Port Arthur to find out who could give permission. We presented the Los Angeles Chamber of Commerce letter to a secretary at the local Chamber, who said, "You'll want to see Mr. Watkins."

Mr. Watkins was a Junior Chamber man and also a photographer, and had made photographs at this very plant—Gulf Oil. He told us the president was an enlightened man, and sure enough, the president said, "Why not? There are pictures of all these things already."

Watkins would set us up with a guide in the morning and meanwhile recommended Albers Auto Camp just east of town, a two-dollar emporium that spoiled us for the rest of our travels. My journal describes it: "Fresh white paint, tile shower, fine kitchen, with Frigidaire with ice cubes with bottle of ice water all awaiting us. The furniture is clean and the bed is good, the curtains are clean, even the windowsills are clean and that is something that *never* is in any auto camp. There is a wastebasket, a garbage can, a good dressing table with mirror, an easychair covered in fresh white, a clean closet, kitchen table, three-burner gas ring."

Watkins, known as J.C., came over in the evening to see prints, and in the morning we had breakfast with him at the Goodhue Hotel across from the Chamber. Edward wired Dallas for more films. Then, equipped with passes and badges, we set off through the plant in next-to-unbearable heat and were set upon by the kind of nasty mosquitoes that bite without a warning buzz. Edward's heat tolerance had increased in proportion to his delight at available subjects, so I whipped out my notebook and learned the names and purposes of whatever the 8 × 10 was aimed at.

Soon I had a notebook full of Horton spheroids, fractionating towers, Foster-Wheeler stills, furfural plants, alkylation, hydrogenation plants, with diagrams and explanations, and could probably have started a small refinery at home if the photography business had gone slack. I found the furfural refining plant the most picturesque because they took the waste from oats—what Mr. Quaker didn't need—and used it as a solvent to refine lubricating oil.

Because of wartime restrictions we should not have been allowed to take pictures here, but Edward could not have been happier with the security lapse. This was his idea of a great place to photograph for an American book. It was one of our stops that would make Macy fume with anxiety when he learned about it—what did this kind of industrial scene have to do with the Good Gray Bard?

There was a striking difference between the seediness of Galveston, where the waterfront buildings are flimsy affairs that can be folded up before a hurricane hits, and the shining industrial spires, domes, and turrets of the Gulf Oil plant. The plant was like nothing we had ever seen, the whole massed together so that one great enemy bomb could have set it glowing for weeks.

It was Friday, August 1, and the films Edward had wired for had not arrived. Why? Because they had been sent by mistake to Corpus Christi. When could we get them? After some checking came the word: not until close of day tomorrow or Sunday morning. When they finally arrived, we headed east again, driving for a full day through more of Texas and into Louisiana with nothing to look at—that is, nothing that made Edward want to take out the camera.

SIXTEEN

At the Azalea Auto Court in Lafayette a pre-dawn wake-up call blasted us out of bed and into a rare disagreement. Our habit was to map the day's route as we stood around in the morning packing and drinking coffee. This was usually a simple matter, but today we collided over whether to leave the main route and venture down a short side road to see the Evangeline oak, of Longfellow's poem *Evangeline.*

I told Edward that he would probably find something to interest him, too, and even if he didn't, it was only two miles out of our way and we could be back on the road in no time. But, upset about the film delay and the slim pickings he'd had since Port Arthur, he was restless to push on to New Orleans, where he had been told to expect great riches. He didn't want to waste time on a side trip that might give him nothing. A tightness in his voice warned me that, as far as he was concerned, the discussion was closed. In the heat of the moment, he wanted to put me back in my place as his young follower and assistant.

I wasn't willing to go along. The success of *California and the West* had given me a keen appetite for more opportunities to exercise my talent. I was a full partner, or so I thought, and my role in the partnership required a kind of

exploration that couldn't be done given our pace. Instead of driving maybe two hours and then stopping to work as we had on the Guggenheim, we drove and drove, sat and sat, looked and looked, as though at a movie playing on the windshield. There was no way I could manage a running written account of any interest when we stuck so close to main roads, and I thought it wasteful to zoom by an area of great potential just because Edward had seen nothing to catch his attention. As the days and miles passed, I realized that the kind of thing I counted on for writing material was going by me like phone poles along the roadside.

In choosing places to explore Edward and I both went by hunch—the sense, as in a child's game, of "getting warm" that advised each of us when treasure lay nearby. I was about to remind Edward of times I'd convinced him to go see something and my hunches had panned out, when the look on his face stopped me dead. His eyes blazed with an anger I had witnessed before but never felt turned against me. All he said was "It's *my* grant," but the effect was devastating. Suddenly the picture maker had come unstuck from the man I knew, loved, and trusted. He stood there glaring at me with hostile eyes in which I could read myself as a drag, a stumbling block, and—worst of all—a stranger.

Edward and I had disagreed at times about numerous things, but our differences had been adjusted and absorbed in the constant latitude we allowed each other. This time was different and I had no defense against it. I surrendered instantly. The whole exchange lasted no more than two or three minutes and I wouldn't understand until years later how great a chasm had opened between us. At the time I told myself it wasn't that important, there was a lot more Whitman trip ahead, and if I missed out on the Evangeline oak, I would find other riches to mine. Edward's momentary anger had evaporated and we continued packing the car. We stopped at a café to fill our coffee thermos and then headed down U.S. 90 south past Broussard.

Edward did find a few picture subjects on the way to New Orleans: Contraband Bayou, where boats were pulled up for repair, hyacinth choked the channel, the

water was dark and still; on the Atchafalaya River at Morgan City two shrimp boats, *Pearl of the Sea* and *Mary Margaret*, were pulled up at dockside, long ropes of nets hanging from the masts, and out in the wide muddy river, clumps of water hyacinth floating out to sea.

The next day, Friday, August 8, we crossed the Huey Long Bridge into New Orleans, a town with the world's maddest traffic. After much searching we found the post office, then went on to the Chamber of Commerce, where we chatted with a gentleman. Not much chance of doing work from the docks, he said, and suggested—what else—the French Quarter. This seemed to be all that he and the rest of the professional tourist informants could think of. We took a guided walk past the predictable spots, and I embarrassed our escort by asking where Whitman stayed when he was there. It hadn't been marked.

We rented a room at the Dixie Tourist Court, which cost one dollar with kitchen, also with "ponies"—the delicate local name for the large friendly cockroaches that continued their researches when we appeared. There were shade trees, but with a rain squall just ended, the heat plus humidity was stupefying. For those who spend their lives in such climates it may be hard to understand what it was like for us to work in the weather we encountered all across the South. Gradually we accustomed ourselves to perpetual sweat, to parking in blazing sun and returning to find the car untouchable, to sleeping at night uncovered or, when lucky, with a fan turning overhead. It was not until we came to the riches of New Orleans that Edward realized the discomfort had been worth it. Here he would stop wilting in the heat and find new energy.

A Santa Fe friend who had given us an introduction to Clarence Laughlin described him as an "interesting photographer" who made pictures of antebellum mansions. When Edward called his work number, Clarence gave us directions to his house and said to make ourselves at home. He would be home soon and had invited some friends over to see Edward's prints.

Clarence was an energetic young man who proved to have an original method of showing prints. He would pick one up and hold it delicately—his hands flat against the edges of the mount with the picture facing his chest—while he delivered a long explanation of where and why it was made and how it should be viewed. By the time he eventually revealed the image (often a veiled phantom

posed in the ruins of a Southern mansion), his audience had moved from impatience to boredom. Clarence was a prime example of the type of photographer who did not agree that a picture is worth a thousand words but felt instead that any worthwhile picture needed at least a thousand words to do it justice.

The performance finally came to a close near midnight, and there was no time left for Edward to show his work. (When Clarence wrote about our visit years later he said: "I should add that I had not shown any of my work to Weston—because I felt it would be presumptuous of me; and, also, because he had a tight schedule. Therefore, he knew nothing of my work, while I, of course, had seen many reproductions of his photographs.") The following day was Sunday and Clarence's one day off from his job, so we agreed to his proposal to guide us to some choice spots. As we were leaving we were stopped by two of his guests, Don and Bea Prendergast.

"Are you finding what you want to take pictures of?"

We said we hadn't seen a thing yet aside from the unavoidable French Quarter, so they offered to take us out on Monday—an invitation we accepted with enthusiasm.

Sunday morning we drove out of town after collecting Clarence's friend Elizabeth and three shopping bags full of props.

We crossed the Huey Long Bridge to retrace our route as far as Race Land. It was impossible to convince Clarence that we had already done that stretch on our drive in, because he never stopped talking long enough for us to say so. From Race Land we went up the Bayou to Thibadoux, Woodlawn, and Belle Grove, all plantation ruins. Water hyacinth choked the waterways, moss and vines choked the trees, swamps brimmed with evil-looking green colors, and the bayou water looked thick. The plantation house at Woodlawn was in a poor state—the balcony ripped, the pillars chipped, the gallery roof sagging. The occupant was storing hay in it and piles spewed from window and door openings. Clarence draped me in a veil and posed me leaning through an upstairs doorway.

Belle Grove was next. In *Old Plantation Houses in Louisiana* William Spratling describes rounding the bend on the entrance lane and catching sight of the house: "A sudden, startling revelation. It is a huge place, built in a sophis-

ticated spirit, with a frank love of ornamentation in all the complexity of its detail, yet with good taste informing its lavishness. It is commandingly beautiful in its general effect; the house is worn, warm pink corroded in spots to lavender with elaborated Corinthian columns the height of the two stories fronting its deep front gallery.''

Edward was dazzled by the photographic treasures, although darkness was already settling in. Local boys gathered at a breach in the barbed-wire fence and pleasantly extorted pennies for holding one wire up and one down as we crossed back and forth with cameras and cases. When dark stopped the show, we packed up for the long jaunt home.

Clarence eventually wrote the text for the catalogue, "An Introduction to the Third World of Photography," which accompanied a show of his work with a few of Edward's local pictures at the New Orleans Art Museum. Clarence claimed that he introduced Edward to the "third world" of photography. The first two worlds are pictorial and straight: the third world of photography sees into things rather than stopping at mere surfaces. He says he taught Edward to see this way—and indeed we did see ghostly manifestations around some of the ruins, thanks to Clarence's models and draperies. Edward thought Clarence's views were such gobbledygook that he chose to ignore them rather than say what he thought and probably hurt Clarence's feelings.

On Monday, the Prendergasts pulled up on schedule, and when they asked where we wanted to go, Edward said Belle Grove. Edward worked all afternoon while Bea and I examined the premises with the WPA guide in one hand and Spratling's book in the other. We caught him in a fearful overstatement: "The capitals of the Corinthian columns . . . are made from solid blocks of cypress." When we climbed into the tottering attic and looked at one from above, we discovered the fancywork was merely stuck on a square of boards around a hollow space.

We went out with the Prendergasts again the next day, to Girod Cemetery, in a rather industrial section of town, with big gas tanks and warehouses. There is no burial belowground in New Orleans because the city is four feet below sea level; instead, coffins are placed in ovens, rectangular orifices that line the inside of the cemetery wall. The ovens were horizontal so that the coffins could be slid in. When blocks of ovens were set up in separate structures—frequently

miniature Greek temples—these were called skyscrapers. If friends and relatives of the dear departed failed to keep up dues, the remains of the coffin were removed and burned, the bones pushed to the back of the oven, and the apartment was ready to let again. A few bones were always left in the oven, because these were Catholic graves and the Lord needs material to work with to reassemble souls on the Great Day.

The place was full of rather hideous-looking five-inch crickets, which the Prendergasts told me may have earned their name, Devil's horses, from their constant presence in graveyards. Everything was covered with honeysuckle and heliotrope. Vines, ferns, and weeds sprouted from tombs, and trees split apart some of the marble slabs. Bones lay around, loose bricks in the oven fronts showed skulls and femurs within. Some paths were completely choked with growth, ditches along the open paths were full of oozy gray water and crayfish funnels.

Don and Bea told us of the cemetery culture: All Saints' Day was the principal time for everyone to bedeck themselves and their relatives' tombs. Boys scraped and washed the tombs clean days in advance. Then the lettering was gone over with gilt paint and shells were laid in the niches, along with flowers and other decorations, according to individual fancy. Bea told of seeing one grave with a pair of deep blue velvet curtains erected before it, and said it was formerly an All Saints' Day custom to catch crayfish right in the graveyard and cook them on the spot for hungry patrons.

A funeral was to take place that day, and we soon found the open oven in a lane between five- and six-story skyscrapers. On the fourth story was the gaping blackness with bones piled at the back. Below it stood a large can of White Rose quicklime and a pail of water that said, "Drink Royal Crown Cola." A board over the lime can supported a trowel and hand ax, some loose bricks, and the removed inscription: "In memory of (at rest) my dear mother Sally Webb Mar 20 1878 to June 28 1935/Gone but not forgotten."

As Edward was trying to make something of this, two amply proportioned women in funeral finery came along to inspect the site. The largest, puffing and peering into the dark opening, said, "Lawdy! Look at them bones! That mus' be Miz Sally."

Edward and I both found the All Saints' Day tradition wholesome and the

cemetery full of fascinating life, contrary to the claims of critics who say his New Orleans graveyard pictures show a preoccupation with death and decay. Dashing around in his pith helmet, with a bandanna hanging down kepi-style to protect his neck, Edward was not thinking of death and decay any more than did the students who went there to pick up stray skulls. Anywhere else in the world he would have been reduced to helplessness by the heat, but here he was making negatives so fast I could hardly keep track of them: tombs singly and in groups; lines of vaults; broken urn with mantel; exotic six-story skyscrapers with weeds and bushes springing from their roofs; the Mafia vault with its green grillwork door, Ionic columns, and a chipped pitcher on the steps; a group of tombs with a great black gas tank towering above them embellished with "Cook with gas."

To read Ben Maddow's interpretation in the biography was a real surprise: "The astonishing thing is, that in the midst of this full and happy and famous year, Weston's photographs were, a good many of them anyway, astonishingly and quite frequently funereal. Many of them are studies of cemeteries."

I can only say that Edward would have roared with laughter at this. He always had a healthy acceptance of death as a natural part of life, and had been exhilarated twenty years earlier when he first encountered Mexico's Day of the Dead celebration. He photographed dead birds on beaches and dry lakes, a child's grave in a North Coast cemetery, the dead man in the Colorado desert. The New Orleans Cities of the Dead exhibited a nicely accepting attitude toward death that appealed to Edward enormously—he felt very much at home.

The full day at Girod Cemetery was topped off by dinner in the French Quarter and the decision to adopt the Prendergasts permanently, as they had provided us with that rare combination: remarkably rich subject matter and well-informed guides.

I stayed home for the next three days to catch up on notes and play hooky from the heat. Bea and Don kept track of exposures for me as Edward reaped a rich harvest, including St. Roch Cemetery, where the chapel altar was decorated with ex-votos from the cured—miniature legs, breasts, stomachs, and hearts made of wood, ceramic, or hammered tin—discarded braces and crutches. Bea drew wonderful postage-size sketches of each picture Edward made.

. . .

All across the country we had been plagued by an ongoing flurry of letters between George Macy and Merle as Macy developed serious doubts that Edward was getting the right pictures and Merle defended Edward and, at the last, himself. Edward had been unable to send pictures to reassure Macy, but he sent him enthusiastic accounts about Boulder Dam, the Grand Canyon, and so on. These alarmed Macy all the more, resulting in frantic letters to Merle about what he feared would be unsuitable subject matter. Merle's response was to tell Macy to keep his hat on, that Edward knew what he was doing. At the same time, Merle wrote to Edward urging him to move a bit faster and send Macy some sample prints.

Merle and Macy were pre-FAX, but this is essentially what they were doing, squaring off against each other in letter after letter, each one sending copies to Edward. Edward didn't know what to do, so he did nothing until we got to New Orleans, when we wrote a letter meant to serve as assurance:

> *Dear Mr. Macy,*
>
> *Thanks for your letter and kind invitation to visit you in Vermont. I'm sorry if some of my subjects gave you a fright, but I'm glad you mentioned it so if there is any misunderstanding we can put it straight.*
>
> *Somewhere in the three-cornered parley Merle and I appear to have fastened onto an idea that you haven't—although I thought you had: that the 54 photographs were not to be tied in to any specific lines in Leaves of Grass but rather the pictures as a whole were to embody the kind of vision of America that Whitman had.*
>
> *I was sure we had discussed this point in our correspondence. The fact is illustrating any specific lines in the poems would be too easy and get you nowhere. (For example, take a poem like "Our Old Feuillage" in which are catalogued more than a hundred specific scenes, places, people, and things that could be photographed.) It is my feeling that the only photographs worthy to go in an edition of Leaves of Grass are those that will present the same kind of broad, inclusive summation of contemporary America that Whitman himself gave.*

To really "get" America in those 54 photographs is a terrific challenge and a difficult task. While to take a list out of Whitman's catalogues (1 Louisiana live oak, 1 California redwood, 1 tired oxen in barn, 1 knife grinder, 1 lilac bush in dooryard, etc.) and make pictures to fit is not even properly a job for a photographer. There is one clear limitation on the photographer—one field that belongs to him—his job is to photograph the world around him today; whenever he crosses that boundary he gets into trouble.

Sending you any prints of work to date would be practically impossible. Merle has seen some of the negatives. I don't know how much of a negative reader he is but he could give you his impression. If you wish, I could get Charis to type you a copy of the negative list of 200 and some made to date. However, it probably won't be so very long before we hit your corner of the country so unless it's urgent we'll wait till then.

All the New Orleans negatives were in the batch we mailed to Brett a few days later from Cincinnati, which included 93 exposures made in the course of nine days. As he often did, Edward made a note on one of the pages of the negative list: "Brett Boy—Some of the whitewashed graves in sun have extreme contrast so go easy on highlights. This may be superfluous warning to one used to western light, but I am getting used to haze and humidity. Love, Dad."

Our next destination was Monteagle, Tennessee, where Leon was working as librarian at the Highlander Folk School. He had gone there soon after leaving his job with Selznick and now was waiting to hear whether his appeal for conscientious-objector status had been accepted by the Monterey draft board. We didn't have much hope, because in the past only religious affiliation had been accepted as a legitimate basis for avoiding military service, but after two stints at military academies, Leon knew that even prison would make more sense for him than being a soldier. He had said on a draft-board questionnaire that he was at Highlander working as a freelance writer, studying mountain life.

Highlander had been founded in the Cumberland Mountains in 1932 by

Tennessee native Myles Horton. It was a mixed bag—community center, nursery school, residential training program for union organizers, social gathering spot for the mountain folk.

"In these times," says a brochure from 1940, "when all the enlightened forces of capital and labor are needed to 'make democracy work,' the building of responsible labor leadership is imperative. Southern workers in particular have lacked opportunities for education. By becoming informed and trained union members they can help achieve in the South the industrial democracy so vital to the progress of the whole country."

Southern educator Lillian Johnson had donated her house and farm to the new school. The house included a big room, kitchen, offices, and library—off which was our room with bath—and two or three small rooms upstairs, one of which was Leon's. There were women's and men's cottages off to the north and south for students. Myles and Zilphia Horton's cabin was down by the stream that flowed through the school grounds. Midway between their house and the main building was the pigpen for Rosebud. Rosebud gobbled the school's wet garbage, was roasted at Christmas, and then was replaced with a new Rosebud.

All the students were "on" things—on vegetables, on table setting, on kitchen, on committees. Participants were divided into the students and the "intellectuals." The students were union people, young kids mostly, who had come to learn practical things to take back to their membership, like labor history, public speaking, and how to produce a shop newspaper. The intellectuals were also young, mostly college students or recent graduates who wanted to do something useful with their knowledge, but mainly talked. The school tried to keep this group as small as possible.

The year before we were there, a vigilante group calling itself the Grundy County Crusaders planned a march on the school because of its supposed Communist character. Violence was avoided when the group met with school officials, but Highlander remained a target of this kind of attention, as did many good institutions and individuals.

Eleanor Roosevelt rallied behind the school, contributing money for a scholarship. She was pictured with Myles Horton on the front page of the April 1940 *Chattanooga News-Free Press.*

The evening of our arrival, there were four tables full of people at dinner. Everyone ate fast while spontaneous-combustion coffee came around in a huge pot. When gobbling had reached the lull stage, Leon stood up, tapped a coffee mug with a fork, and introduced his sister and brother-in-law to those assembled. Zilphia then led the congregation in a spirited sing-along, after which people rushed the dishes off the table and swept the floor, converting the dining hall back into a classroom.

The lives of the Hortons and the doings of Highlander were so interwoven that the only chance for a visit with them was before their workday started. The next morning Leon, Edward, and I wandered down through the grape arbor, past Rosebud's pen, and along the path through the woods carrying a coffee pot, pail of water, pitcher of milk, eggs, and bread. We had a delicious breakfast with Myles and Zilphia under the watchful eyes of their three black cats—Zollykoffer, Pippsissiwa, and mother Jezebel.

The Hortons were amazing people, friendly, down-to-earth, and relaxed despite the enormous amount of work required to keep such a complex community functioning. They were a complementary couple, ideally suited to the enterprise—Myles the impassioned philosopher and Zilphia the cultural catalyst. Myles admitted it was difficult for the two of them to sequester themselves long enough to plan curriculum or work on fund-raising, because the students needed to see them on the front lines: in the garden, at the washtub, or on KP.

It was easy to see what had attracted Leon to Highlander. This was my first exposure to the "extended family" created when a group of people combine their talents and energies to work for a common goal. The concept had terrific appeal, and I felt a strong urge to come back later and sign up for my own tour of duty.

After breakfast Leon took Edward and me to see the sights, beginning with old coke ovens built in the clay banks around a little lake near Tracy City. There the rain hit, and in ten minutes we had a "trash-floater." With visibility at zero we had to pull over until the deluge cleared; then we drove to a viewpoint where Edward made a negative of the Sequatchie Valley.

There were heavy clouds of mist, but under and through them we could

make out the checkerboard green fields and farmhouses and the curvy snake of trees that marked the river, with the dark line of Waldon's Ridge shutting in the valley. Mist swept in, driving everything from sight and sending us down to Whitwell for coffee. When I asked for more milk for mine, the proprietor inquired, "Too stout for you?"

After dinner that night, the students sang another round of labor songs. Edward and I joined in, most of the songs being familiar, although I did not know "Just like a tree that's planted by the water, we shall not be moved." We sang "Joe Hill," which they dragged out to lugubrious lengths.

The next day we went district visiting on the mountaintop at Monteagle, where some of the poorest in the region lived and where I saw my first swept-dirt yards. Standing in his bare, hard-packed yard talking to us, a man would hunker down and with his jackknife extract a tiny sprout and pat the soil smooth afterward. We went to see one-legged Scott Starling and his family. He had a little log cabin, and he, his wife, small son, and two little girls were at work on a woodpile across the road. We stopped to talk, and Edward photographed Scott on the porch. Edward sent a copy of this picture to Starling after we returned to California, and Starling showed it to Leon with the proud comment: "It's that little old house dead out." And later: "I wouldn't take five dollars for that picture—you tell that man to come back and make another if he's ever around here again."

We also called on old man Farmer, who was past one hundred and lived in the back of a barnlike structure with a dirt floor and flies thick in the air; then Uncle Billy, the craftsman of the community who made birch chairs; and finally Miss Bessie and Miss Willy Brower, whose garden and apple tree we admired.

The next day we crossed the river on a little ferry just as the *Cottonwood* was making its way upstream. Edward made a negative as it steamed by with its dirty black American flag looking as though the oilers had been wiping their hands on it. To catch the boat after it rounded Moccasin Bend we drove up Lookout Mountain, and as we waited, Edward made pictures of smoky Chattanooga and the river. Chattanooga was where Grace and Allie had grown up and my mother and Aunt Kit had been born, but in those days I was more interested in the Civil War memorial than in my family history.

Sunday brought clear, sunny, blue California weather. Down to the Hortons' cabin again, this time with the Graflex in addition to breakfast fixings, and between rounds of coffee, Edward photographed Zilphia among the leafy trees. Later, he did 8 × 10s of her against the dark-stained wallboards of the outdoor shower. Zilphia was pregnant and said if she had a girl she would call her Charis. I urged her to be merciful and spell the name "Karis" to spare her daughter a lifetime of mispronunciation and misspelling. She did have a girl and she followed my advice. Years later I learned that Karis had switched her name to my spelling—and regretted it ever after.

That evening we held a print showing, followed by a violent discussion that kept on into the wee hours. It began with Virginia Durr, from Washington, asking Edward why he had photographed the scratches on the old adobe wall at Hornitos and Edward innocently replying that it would be awfully hard to answer that. Virginia pounced on this as artistic snobbery and we were off.

Leon wrote to us often while he was at Highlander, about his ever deeper involvement in the school and the lives of the mountain people, particularly their music, including the traditional singing known as sacred harp. He was also swept up in the union movement, although he wrote "I would never be a militant labor activist, simply because I do not have militancy in me." He reported on the activities of hate groups, such as the White Supremacy League. "Stories are flying around all over the South that the negroes are organizing and calling themselves 'The Daughters of Eleanor' and are going to poison their employers. In Norfolk it went around that all the ice picks in town had been bought up for the attack. You get in a very critical situation, because even some of our worker students believed such things and were frightened."

In October 1942, when we were back at Wildcat Hill, he wrote to say he had been ordered to report for induction and expected to be arrested when he failed to comply. Instead, the draft board in Tennessee had given him permission to appeal the case—"It can be carried up to the President himself"—but he was not optimistic. Somehow he had got hold of a "confidential" report made by an FBI agent and a representative of the Department of Justice on their supposed "findings" in his case:

Report as a whole shows registrant has lived a rather unusual life, his father being a well-known writer of short stories. He lived most of his life in California, coming in contact with various artists, writers, and actors.

He is at present teaching at the Highlander Folk School, which informants advise is a Communist Front Organization.

His objections not based on religious belief and training but solely on what he calls humanitarian beliefs. Has no religious beliefs and appears to be an atheist. His opposition to military service of any kind grows out of his belief that war results in merely a waste of life and other things of life. He is merely a pacifist.

He had written to us earlier that a "lot of absolutists (mostly God-teched) are already in prisons for FLAGRANT defiance instead of moderate defiance. I eschew martyrdom. But I also eschew the killing machine." His request for C.O. status was eventually denied, as we expected. He was arrested and put in jail in Tennessee, where he remained for several months while his lawyer appealed to the U.S. Supreme Court to let him bypass the lower courts and free him on a writ of habeas corpus. The lawyer thought Leon was more likely to get a real trial—on the substance of the case rather than on strict legal precedent—in a higher court. The plan failed. Justice William O. Douglas wrote the decision, which rejected Leon's petition and upheld the narrow religious basis for being a conscientious objector.

Leon was held in the Tennessee jail until he was returned to California in 1943 to await trial.

On September 2, we drove into Nashville, past the grimy dark buildings and the black cobbled streets with no street signs. It was built up and down hills, and right away we felt we were back in San Francisco. The town's colossal and striking landmark was Union Station, an heroic edifice. We picked up our mail at the post office and drove north out of town in steady rain until we found a new, super-deluxe autocamp for two bucks.

The next day we went to keep a date with the Nixons. He was a professor at Vanderbilt University who had been at the Writers Workshop at Highlander that summer and had heard about our project from Leon. Nixon let Leon know that he had a hundred-year-old slave "staked out" somewhere in western Tennessee. We found out that the slave was a two-day trip away, but meanwhile, Mrs. Nixon offered to chaperone us around to the local landmarks. Her first idea sounded promising, an antiques store on Church Street run by three old bachelors who scraped and polished furniture five days a week and went on a bender together every Saturday night.

Green's Furniture Shop, at 1626 Church Street, was a nice, seedy old building, two doors with shared steps and an assortment of antiques scattered in front. Edward made a negative with Mr. Green, Mr. Hubbard, and Mr. Austin standing on the steps, prominent among the articles before them a deceased early model of a Singer sewing machine.

At the Nixons' that evening for print viewing were a Guggenheim Fellow who was working on a history of the old mercantile South and Alfred Starr, a man who ran a chain of Negro theaters that showed all-black productions made for a black audience. I read galleys of Nixon's forthcoming *Possum Trot* while the print show was in progress, and, before we left, Starr commanded us to move out of the autocamp and over to his house, which, with his family away for the summer, was big and empty. He offered to take us to see a stone cutter named William Edmondson the next day.

We met Starr at his office in the Bijou Theater, and when we left by the back alley to get our car, Edward found picture number one for the day: a two-story house being wrecked dead ahead, with brick buildings and the top of the state capitol building showing above. Every few moments a man came to the second-story door—flush with the wall—and dumped out an armload of planks. Edward captured the moment.

We drove out to Edmondson's place, where Starr left us. Edmondson's little yard was full of white stone figures, and a red, white, and blue sign on a tree in front said, THIS IS A WPA PROJECT.

Dotted over the green turf were horses, birds, squirrels, rams, imaginary animals, angels, rabbits, eagles. In front of the shed were piled uncut stones and hunks of limestone from wrecked buildings. Edmondson sat under the shed

roof on a flat-cut stump chiseling away at a stone. He was pleased to see us and told Edward to take all the pictures he wanted.

Edmondson said to me, "That man your father?"

"No, my husband."

"I have a young wife, too. She's smart. She wants a man that will work."

He walked around with us, telling about the figures: "This is a lion and this [indicating one just like the lion but smaller and smoother] is a sea lion. God, he told me to do this. He say, 'Don't you join no church. I got work for you.' I can't read and write. I told him I couldn't do this. That made him mad." A whoop of laughter. "You know, when God tells you something to do, he wants you to try. These don't have no patterns. I can't draw. I just look at the stone and figure what I can make. No pattern, just wisdom, and God gave me that. I saw the flood. I saw the waters coming over those western mountains. They were exceedingly high mountains and the waves came up, oh, twenty-five feet over the tops of the mountains."

Another whoop of laughter. "I wasn't born then, I wasn't born from no human seed. That was God's seed and no human seed. He let me see that. He made me walk right up to the edge of the flood and told me to look down in the water. The water was muddy, and it washed up trees and logs by the roots. There were two kinds of water in that flood. One was muddy and one was clear. And I saw all kinds of things in that water. You know what serphals is? Well, serphals is snakes. There was all kinds of snakes. Chicken snakes, moccasins, rattlers, black snakes, all kinds of snakes. Some had horns, and some had heads like sheep, and some had bear's heads, and I saw it all just as clear as I look at that building now. And God made me walk on the serphals. They're the enement. He commanded me to walk on the enement. But that was a long time ago, before I was born of any human seed. I was God's child and he must care for me to give me all this to do."

We gave him a reprint of an article, "Of the West," written for *U.S. Camera,* that included pictures from the Guggenheim trips and a short text. I told him how far we had traveled.

"I'd like to go through the world and see things so I could come back and make them. You send me a picture of something when you're home."

Edward made some 8 × 10s of Edmondson working in front of his sculp-

tures, and then some groups of Edmondson figures. Alfred had told us to select one for ourselves, but when we had one picked out in the back yard, the stone-cutter shook his head, saying, "All these belong to Uncle Sam." We settled for a dove from the front yard and, when we returned to Wildcat Hill, put it in a place of honor outside Bodie Room.

We returned to visit Edmondson again before we departed from Nashville and made another stop on our way home some months later. The museums discovered him, and Leon reported that five or six years after we'd met him, Edmondson's work showed up in a New York display window enthroned on velvet and priced out of sight.

We returned to Alfred's office and drove back together to his house. He had an Edmondson lion in the basement playroom, a magnificent brute, and out on the lawn an Edmondson Eve—evidently some busybody had told Edmondson what fig leaves were for, so he had given Eve a maple leaf, but instead of concealment, he had used it to enhance and reveal the part it covered. Alfred was pleased to see that Edward was as charmed by Edmondson's art as he was, and the two men playfully promised each other that whoever died first, the other would see he had an Edmondson figure for a tombstone.

Sunday was Alfred's day off, so he chauffeured us around, first to a bird's-eye view of a steeplechase course in one of the city parks—a storybook vision with curving white fences, hedges, water jumps, and a judge's stand set in smooth green hills and vales. It was a take. After lunch at a diner, we went up to Fort Negley, which had a view of the surrounding city. Edward made a negative with mills and grain elevators, and one with all the dingy little buildings sweeping back up the hill. The climax of the afternoon—my favorite—was Union Station. Edward worked from a viaduct that looked straight across at the three-tiered monster: the top section with its buttressed chimney and golden Mercury balanced on a toe; the middle part junky and impressive; the entrails lower down burrowed into by swarms of tiny trains.

Alfred was one of those rare people who had a "Weston" eye. He had an unerring sense of where to find good picture material—a special treat for Edward, who'd had his share of being led on wild-goose chases. How this non-photographer could see pictures in the locations he guided us to surprised both

Edward and me. It had taken me several years with Edward to recognize pictures in this way instead of thinking about geologic upheaval or urban decay when we came on some striking scene.

By September 13 we were in Middletown, Ohio, where we stayed with May's son, Joe Seaman, his wife, Flo, and child, Sonny. It was in Middletown that Edward had photographed Armco smokestacks in 1922, and he planned to do them again once we were armed with the needed stamps of approval. First thing the next morning, we were off to the Armco offices in town to get passes and greet Mr. Verity, the gentleman who was said to have been the making of Armco and Middletown. He came forward to greet us, not exactly sure who we were or why we were there, but willing, it seemed, to make the best of it.

Edward said, "I worked here twenty years ago."

Verity, quite naturally, assumed that he had ladled out steel soup in the mill or kept accounts in the complaint department, but played it cautiously and said, "You lived in Middletown then."

One of his assistants whispered that the work had been photography, but got nowhere, so we moved onto the surer ground of the weather and the fall coloring. After a decent interlude we bowed out and proceeded to the plant, but at the gate the watchman said positively no cameras in the plant, no siree. There was some phoning and checking while he had his moment of glory. At last we were allowed to drive through, after an additional concession—no women were allowed in the plant either.

There was a certain reverence in the way the men—the ones who went around with us—looked at the implements and spoke of them. Beyond just quoting the facts and figures of production, improvement, and so on, they showed a kind of wide-eyed wonder about it all. Fine particles of graphite—called kish—blew constantly into the ears, eyes, nose, and throat, but the men didn't appear to be repelled by it or by the griminess of everything. They saw the plant as a paean to an industrial Golden Age rather than as the drab, ugly, human purgatory it seemed to me.

That evening Edward and Joe went to have dinner and show prints at the

all-male Middletown camera club. In a magnanimous gesture they invited me, but I declined in favor of catching up on notes.

The next day Edward and Joe set out on a photographic hunt while I continued with my writing from the day before. When they returned in the afternoon, I could tell that Edward had found something good—as I noted in the journal, he looked "completely bouleversed." After hearing talk about a man who was slightly crazy and had a farm covered with bottle trees, Edward and Joe had sought out the spot and discovered the find of the area. Edward had made six negatives, and there was no question but that I must go see for myself in the morning. The bottle artist's name, we learned, was Winter Zero Swartsel.

Swartsel's farm covered several undulating acres of green pasture cropped close by sheep, and set out on this bareness like orchard trees were posts leaning this way or that and laced with wire that supported all colors and shapes of bottles and jars. There were brown beer bottles, flat whiskey bottles, little blue Vicks VapoRub jars, milk bottles, green wine bottles, two-gallon jugs. Some were whole, some broken. All were affixed by wire ends stuck into the bottle necks so the glassy fruit pointed up like pegs on a coat tree. There were twenty-five to fifty bottles to a tree and three to four hundred trees spread over the orchard. Here and there among the trees were black-painted metal silhouettes that had been cut out with metal shears and braced with rods. Near the geographic center were an arm and hand eight to ten feet high, and off to either side of it a baying wolf. Elsewhere were a camel and a wise man, a man leaning on a hoe, a female figure, an enormous owl, a noble red man astride a steed.

Closer to the house and barn, bottle bursts had been created on old brass bed ends. There were boxes or cans for birds' nests on most of the bottle trees. A chain running from the house to the barn had old shoes and hats suspended from it, each item of apparel alternating with a thermos cup or flask top. To the right and left of the house, posts had been set up with dozens of bleached cow and sheep skulls twined with old hose and topped with the metal cutout of a pair of cats. Bells were hung between headboards that stood upright in pairs. Pie plates and pans were hung on the clappers with wire so that wind of any sort would start a concert. Names were written on the bells in white paint: Copernicus, Aristotle, Henry Ford, Charlie Chaplin, Diogenes. The house was

wound with vines, and all the fences, walls, and walks were adorned with signs and mottoes: on a cross of bells—"May the melodies follow U wherever U go"; on a path—"Destroy flowers beauty u'r risk"; beside a door—"We are a part of all we meet"; and over the door of the house—"If there is a paradise on the face of earth, o it tis this o it tis this."

People in Dayton referred to the farm as a house of junk. But the bottles weren't dead—they shone and shimmered and sparkled. People assured us that Winter Zero had plenty of money and owned lots of slum boardinghouses in Dayton, also that his wife's grave in the Germantown graveyard was lushly decorated with bottles.

We were curious enough to look him up in Dayton and found a middle-aged black man with fine eyes and a quiet voice. He told us that his guiding plan had been to make beauty out of junk. Returning from Dayton, we drove into the neat hillside graveyard and found the Swartsel plot. There were no bottles. The distinguishing feature was a large boulder with SWARTSEL carved on the front. The wife's stone, a simple gray slab, had space for Winter Zero's final date as well.

Mrs. Winter Zero Swartsel
Mother of Love Nest Near Farmersville
Warm summer sun shine kindly here
Warm southern wind blow softly here
Green sod above lie lite—lie lite
Goodnite sweetheart goodnite

By the time he died in 1953, Winter Zero's bottle farm had become the biggest tourist attraction in the area, but Edward's photographs remained the only recorded recognition during his lifetime other than a film by the Ohio Department of Education that was shown in children's art classes. He willed the place to the Ohio Historical Society, which didn't want it, so it became the property of the city of Farmersville. The city kept it as a tourist attraction into the late fifties, but eventually the house was torn down and Swartsel's work was auctioned or sent off to the dump. A community center was built on the spot.

In February 1978, when Edward's pictures of the farm were being exhibited at the Dayton Art Institute as part of the "Edward Weston's Gifts to his Sister" show, the local paper ran a full-page story about Swartsel. Reporter Pete Fusco wrote: "Bottle farms were not uncommon in Midwestern America during that period, but people who visited several say Swartsel's left them with the most lasting impression." After upbraiding Fusco for suggesting that bottle farms were "not uncommon," I learned from a book on the survival of African culture on this continent that bottle trees were reported from eastern Texas to South Carolina. Believed to be of Congo origin, they protected "the household through the invocation of the dead."

Ohio, like Texas, had roadside parks with picnic tables and—unlike Texas—privies. We were sitting in a park on U.S. 22, just out of Circleville, the birthplace of General Sherman, lunching on Triscuits, cheese, lettuce, and olives. I started baiting Edward on his use of the phrase "typically American." His answer to "What are you photographing?" was always "Anything typically American."

"There," I said, pointing across the highway to a group of nondescript, casually assembled farm parts. "That's typically American. A farmhouse that is not one thing or another, a barn like ten thousand other barns, meaningless outbuildings thrown in, corn shucks tossed into the dooryard and down the rise, a tree here and one there. You don't photograph the typical. You photograph the exotic. The fancy graveyards of New Orleans aren't typical. The white sands in New Mexico aren't, Winter Zero's place isn't. This dull, anonymous, constantly repeated lack of order, lack of pattern—that's typical."

Edward said the exotic was typical in America, and we went on to other things. When we were ready to leave, he started taking the tripod out.

"Have you got something?"

"I'm going to do your typical. Do you think I'd let that challenge pass?"

He set up, did the farm, did its neighbor—equally typical—did one across the highway from those, on our side of the highway, all without moving the tripod. That would have been something of a tour de force anywhere, but right

there it was more than staggering. Hadn't I—who prided myself on seeing Westons before Edward set up—picked what I considered impossible subject matter? And Edward was not the person to waste twenty-seven cents apiece for films to make a fool of me. They were good. All three.

And as I considered the elements he had worked with—the 666 FOR COLDS signs strung down the side of the barn, the Fleetwing gasoline sign in front of the other farm buildings showing the bird with one wing up and one down, the concrete highway, the fence, the roadside ditch full of weeds, and in the foreground MAKE MINE BRUCKS, BEER'S ALE—I realized that these were all things I had looked at for ten thousand miles and were typically American if anything was.

As we drove on, I understood better why I was not cut out to do photography. My refusal of Edward's offers to teach me had been instinctive at first, but I had observed him with sufficient care by this point to have a more reasoned response. The discipline that enabled him to focus his whole attention and make decisions in a fraction of a second was as foreign to my psychology as the messing about with chemicals in the darkroom was to my physiology. My talent, for what it was worth either in writing or painting, demanded ample time for reconsideration and revision. I needed to shape my material like a potter with her fingers coaxing the sticky clay, with time for corrections and reversals of mind. Had I been a photographer by some awful mischance, I would have had someone else do my darkroom work, as Margaret Bourke-White was reputed to do, and even so, I would have reorganized the images by chopping away at the negative and all such second-thought operations that Edward considered loathsome. Instantaneous perception was beyond me.

In Pittsburgh we called George Zilliac (an old friend of a friend), and he and his wife, Dotty, took us in. With "Zil" and young George we went scouting for photographs. Zil proved to be one of those rare parents who could answer any question or solve any puzzle his offspring presented—even the reason behind the name of the fancy church built by Andrew Mellon and known as Mellon's Fire Escape. He did manage to avoid having to explain why the sky-

scraper constructed largely through the efforts of Councilor Bowman was popularly known as Bowman's Erection.

At Pittsburgh, the Allegheny and Monongahela Rivers join to make the Ohio, and the resulting triangle of land that contains downtown is called "the Golden Triangle"—the idea probably being that every square foot is worth its surface dimensions in gold. The sight from nearby Mount Washington was impressive to our Western eyes, with the massed skyscrapers and the highways cantilevered out over the water. There were nine bridges visible, all of different kinds of construction, the most fanciful being a rainbow-shaped bridge downstream across the Ohio. The two largest buildings were the Koppers with a green roof and the Gulf Oil Building with a conical top. Edward made three negatives, then we went along to examine the vista from the Monongahela Incline Station, which my map said had an "excellent view of city." It did, but the air was so dense with dirty haze no photography was possible. We were careful to heed the notice on the wall of the little trolley that took us up the incline: TALKING TO THE PILOT WHILE HE IS RUNNING A TRIP OR GIVING THE BELLS IS POSITIVELY FORBIDDEN.

Zil was fascinated by my ability to look at a map and pick out the points most likely to command a good view. His delight was unbounded when I led him up a series of short, twisted streets to Grand View Park, a small sanctuary of lawns and benches near the top of the mountain, with a traditional bandstand for Sunday concerts. Zil had lived in the area for years and, despite a parent's inclination to scout out new picnic spots, had never discovered the place. At the entrance to the park stood an empty stone watering trough with this inscription: "Water for horses/In loving memory/Of George Bells/Victoria, Australia/Founder of Water Places/Around the world."

I spoiled my map-reading record by leading a futile chase across a stretch of the Alleghenies to a viewpoint with no view, but Zil knew someone in the vicinity who was able to repair the ailing shutter on Edward's camera. We returned to New Kensington, where Edward showed prints to a group the Zilliacs had mustered and I typed away at the log in a large top-story study.

At a gas station as we left town the next day, a man said, "Pittsburgh produced more steel than all Europe last year."

CHARIS WILSON / 277

We said the dirty atmosphere was a high price to pay for it.

"Yes, but where there's a lot of dirt there's a lot of money."

We kept in touch with the Zilliacs, who remained faithful supporters of Edward's work. In 1944 they helped arrange a show in Pittsburgh at the Outlines Gallery.

It was the end of September when we arrived at Ed Hanley's big house in Bradford, New York. Hanley was a successful businessman who had visited us in Carmel and owned a number of Edward's prints. He was out of town but had left instructions for his English housekeeper, Elizabeth Wilson, to take care of us. She fed us dinner at the groaning board, and it wasn't much more than a board, being maybe four feet long and two wide. Ham steak drowned in butter, baked potatoes, creamed onions, fresh peas, soup, biscuits, salad. Hanley must have told her to feed us well, and she thought that meant we were members of the Donner Party. We ate by dim light among antiques, to the sound of opera on the radio, while Elizabeth stood at the end of the table and described—walking her skinny fingers up the table in graphic illustration—how sometimes the loneliness came creeping, creeping, creeping over her.

Elizabeth was enough to give the sanest human being the boogies and did not seem like the type who should have been spending time alone in this big, gloomy house. Originally, she said, she had worked for Hanley's young wife, who had since died. Young women shouldn't marry older men, she told us, and certainly shouldn't sleep in the same bed with them, because the older man will drain away the young wife's vitality. I don't think this was a pointed remark—and I was in no immediate danger, as Edward and I were quartered in an upstairs sunporch with two narrow single beds.

We went out the next day, and when we returned I felt the hair on my neck rise when I went upstairs and overheard a two-sided, and sometimes even three-sided, conversation in which she took all parts. While Edward was downstairs making coffee, Elizabeth showed me three pictures she had moved out of sight in anticipation of our arrival. They were painted by three friends of Hanley's, she said, who had gone to a New York school and paid money to be taught to

paint. They were terrible, and in England people would be put in jail for doing things like that. As Weston sounded like an English name, she had put them away.

There, packed in by the toilet, were the three disgraces: a nude by Leon Kroll, one by Modigliani, and the last a Pascin.

She took me to the attic and showed me the stash of overflowing books, paintings, prints, newspapers, clippings, and catalogues. Hanley, according to Elizabeth, put rubber bands around the books she shouldn't read, so she always opened those to peek. She told me in awful tones, "They're about men and women."

Elizabeth had a moth fixation and was certain that the moths came out of the very, very old boards of the very, very old house. She declared, "It's a battle to the death between us."

For years she had been trying to get U.S. citizenship, but repeatedly failed the test. It was such a long trip down to the courthouse on the bus that by the time she got there, she explained, she couldn't remember the answers.

SEVENTEEN

After saying our goodbyes to Elizabeth, we checked the Bradford post office and found a note from our housesitter saying she would have to move out the following week. No one would take her place, but Vasia Anikeef would look in daily on the house and cats The housesitter's departure was not much of a surprise: we had been getting letters from her all along the route, mostly delightful and upbeat, but a few that showed traces of moodiness as well. The first, written on May 10, began: "Oh Wanderers! What you're missing . . . The first thing I did when I woke up was to cruise once around the entire estate. Gloating. Paisley's infant was curled up sound asleep, alone . . . Had planned early rising to do all chores so I could relax virtuously and enjoy myself, but I'm enjoying myself anyway, not-virtuously, so what the hell? If this is lotus-eating, I like it."

The cats reacted to her with varying degrees of tolerance. "Paisley and Schizi like me; Zomah and Esau suffer me; and Gourmy absolutely hates my guts." By the end of July, she was still loving the garden, ocean view, and house, but the animal life was getting her down. "Esau is in hospital—came home terribly battered after fight with apparently much larger animal. Gourmy just recovered from badly infected paw. Found dead mother raccoon and baby in swim. pool.

I've decided I would like to give *nature* back to Rousseau. Hate to see animals getting beaten up and dying and everything. The hell with the cycle, I say."

It wasn't the wild and domestic life that drove her out, however, but the transfer of her soldier boyfriend from nearby Fort Ord. We didn't like the idea that no one would be living at the house, but there was nothing to be done, so we put it out of our minds.

Edward had begun using Agfa film out of annoyance with his previous brand, Defender, so of course we had to visit the Agfa plant in Binghamton, N.Y. He may have had some thought of getting free film, but no such luck. He wasn't very good at capitalizing on his name; I used to tease him about being so backward in the self-promotion department, and I would point out opportunities, even though I wasn't much of a smooth operator myself—and knew perfectly well I wouldn't like him if he were.

We were fed lunch by Agfa's Hilary Bailey, who aroused our regional chauvinism by announcing, "When you see the New England coast you'll realize what a tough bunch those Pilgrims were not to climb right back off the rock into the boat and head back home." We were polite but smugly certain that nothing we would see on this end of the continent could compare in drama with the California coast.

In New England rain dogged us almost everywhere, making this the most disappointing segment of our trip for photographic quarry. If bad weather had been the only problem, we could have kept each other's spirits up, but we were in the grip of something far more disturbing. I had fallen in love with another man.

Married, middle-aged, a father, successful in his profession, he had been our host along the way. He was mature, had a sharp intellect, and seemed to have read everything. He and I had stayed up late talking while Edward kept to his usual early bedtime, and I found it irresistible when he said that after he graduated from college, he "had to go to bed for a year just to catch up on reading." This fed me where I was starving, for it was the first time since John Davenport that I'd had anyone around to talk books with. He was well informed about many things, but his knowledge and love of poetry was the real surprise. My poetry appreciation had peaked with T. S. Eliot and to find someone who knew his work top to bottom was a tremendous pleasure.

There seemed no limits to his horizons, in thinking, reading, or feeling, and I basked in his obvious admiration of me as a person and an author. The physical attraction was strong as well, even though we shared no more than a few friendly kisses. He was going to be in New York on business when Edward and I were due there, so we planned to meet again if possible.

I had done some flirting during my years with Edward, but it had never been a threat to our relationship; I was too connected to him and too committed to our shared life. Now, for the first time, I was drawn to another man as powerfully as I was to Edward, and it was impossible to conceal my distress at having to leave him.

Edward had been jealous before, but never with reason. He reacted to men like the ranger in Death Valley, whose attentions I didn't take seriously. That his jealousy was unfounded had not made it easier to weather, and now that there was a legitimate cause, it began to undermine our relationship. I realize, looking back, that he may have feared I would abandon ship—stranding him a continent away from home, with a car full of equipment and a project to finish. But that was never a possibility. As far as I was concerned, the trip was a joint undertaking and Edward and I were permanent partners.

Edward had the look of an injured man, and as the weeks passed, my plan for a romantic rendezvous in New York began to seem a fantasy. As long as Edward and I were working in tandem on good material, I felt we were putting things back together and I would come out of the trance I was in. When we were in unfruitful country such as New England, I realized that the rift had not been repaired.

Our lack of harmony was particularly obvious in Maine, where Edward was searching for traces of his ancestors in Bethel and Farmington, though none of his relatives still lived in the region. I was too young to comprehend what this connection to the past might mean to a man of fifty-five, and maybe because my own wishes had been discounted in Louisiana, I had no sympathy for what I considered Edward's pointless nostalgia.

A letter Edward wrote to Beaumont in early October gives an idea of our dismal time in New England: "Today I worked from Cadillac Mt., Bar Harbor. The wind was almost a gale and the heavens black with rain. Except for heat, we have had marvelous luck with the weather everywhere until recently. But

Penn., New York, Vermont and Maine have given us only rain or gloom. I only made two exposures from Pittsburgh on until yesterday. Passed through beautiful landscape in Vermont without even setting up."

By now the weather had annoyed Edward past endurance, so on the way down Cadillac Mountain he insisted on getting out and making a negative of Frenchman Bay and the little string of islands, while I huddled in Walt with my collar up and my feet jammed into new wool mittens.

We did enjoy one good laugh in Maine, when we went to see the "thunder hole," a crevice in the rocks where, if you waited long enough, a wave would come in from the right direction, go bloop! and throw up a bit of spray. There was a heavy-duty guardrail around the hole and a life preserver hanging in a handy place. Compared to the action at Point Lobos on a day of moderate surf, it was nothing. The East had plenty to offer for picture making, but as we had said so smugly to Agfa's Bailey, it wasn't wild nature that got our attention.

I can see in retrospect that I was obsessed with the tameness of the East versus the wildness of the West—it really mattered to me that the mountains in the West had not been "worn down" like those in the East. Some Western mountains, including those at Big Sur, drop straight into the ocean, whereas in the East, coastal plains like the Piedmont make for a tame transition between land and sea. I was reacting to more than geological phenomena; I had a powerful physical sense of the land in the East having been walked over by too many feet. When I returned to New England half a century later, I was struck again by characteristics that made me feel claustrophobic, but this time it was the lack of vistas. Everywhere I went I felt buried in trees; every road and highway was a roofless tunnel of green, and I found myself longing for the sight of distant buttes.

With sun flitting in and out for the next few days, we wandered about making coastal pictures, of a lake—Lucerne-in-Maine—beach houses in Northport, old hulls at Wiscasset. In Kennebunkport we went to see Booth Tarkington, and the next day had dinner with him on his schooner, which was shored up on posts. Leon always remembered Tarkington better than I did, and while I enjoyed talking with him about H.L. and their old days together in Europe collaborating on plays, I was not really relaxed with him, despite his charm, and

kept the talk to safe subjects. Tarkington was a conservative of a kind we called "Black" Republicans, who were said to make the Taft Republicans look liberal. He once wrote to H.L. that he hated F.D.R. so much it kept him awake at night. The federal art projects, in his view, were the goddamnedest bit of foolery ever wasted on the country. He didn't know that Edward had worked for the PWAP.

Fortunately Edward got on well with him and kept the conversation flame burning without setting off any bonfires.

Edward had met painter and photographer Charles Sheeler in 1922 during his one previous trip to New York and was eager to see him again. We had intended to take a few days getting to Ridgefield, Connecticut, to visit Sheeler, but the rain kept us moving, and we arrived late one night at his comfortable country house. Sheeler promised good weather for the morning, and indeed, we woke to sun and continued to see it for nearly a week, during which he chauffeured us to the surrounding barns and churches. One fine red barn and silo at Brookfield had been painted earlier by Sheeler for a *Fortune* magazine cover. When he and Edward went in to ask the owner if it was all right for Edward to make a photograph, the lady of the house complained that a painter had been there a while back, done the place, and she didn't get anything out of it—and then what d'ya know, the painting came out on the cover of a magazine and she had the magazine right handy and would show us. Edward said if he got anything he would send her a print; the picture was good and I'm sure he did.

One of the finds of the week was a tiny Greek-style Masonic temple, brilliant white, perched on a dark rock that was cleft with a darker cave. After Edward and Sheeler had photographed it, they went to a neighboring house to find out what it was. The caretaker insisted that we see the inside, because that was even better, so we had to browse sedately around a hideous roomful of plush framed portraits, snake-bracketed candlesticks, carved throne on a dais, and more of the same.

Edward loved to show pictures to Sheeler, because the two men were in tune creatively. Sheeler told him in a letter that, in his view, the facedown picture of me on the sand at Oceano was the greatest nude ever made. When Sheeler was

asked to contribute an introduction to Merle Armitage's 1932 book, *The Art of Edward Weston*, he responded with the following pure-Sheeler statement:

> *I wish that I knew five hundred words which, upon being put in their proper sequence, would make an adequate statement of my appreciation of your work. Unfortunately, I do not have the gift which makes it possible. In choosing the medium of painting and photography for my language I have at least convinced myself that I have chosen the best means of communication for me. I am as yet unable to state in words an equivalent for the visual satisfaction derived from seeing a great photograph or a great painting. In fact, I am not sure that I should not question the validity of the visual satisfaction if I were able to state it adequately in the written word. The best I can say to your public is, look at Weston's photographs. If they see the qualities which make them outstanding they will not need to be advised; if they do not, then nothing I can say will make them see.*

Over the years Sheeler assembled a great collection of Edward's photographs through trading and buying. As it happened, one of the biggest collections of Sheeler's work was acquired by businessman William Lane, who, during the 1950s, assembled a major collection of American twentieth-century painting. He concentrated on work by O'Keeffe, Arthur Dove, Hans Hofmann, Stuart Davis, Franz Kline, and John Marin, among others. During the 1960s, Lane and his wife, Saundra Baker, began collecting American photography as well, beginning with Sheeler's own collection and adding work by Ansel and then nearly 2,000 prints that Edward had left to his sons, plus photographs by Brett, Imogen Cunningham, Morton Schamberg, and others. The Lane Collection remains the largest private holding of Edward's original prints.

Although Sheeler talked readily about his experiences painting and photographing the local territory, he mainly played the role of guide while we were there. He was a quiet, gracious, educated man who was clearly depressed during our visit and happy to have a diversion. Predictably, he and I stayed up late at night, because he could converse about something other than photography. As

it happened—very likely because we were both distressed but unable to discuss it directly—we ended up talking mainly about human relations in general without giving away our own painful secrets.

We arrived safely in the city after having to ask only once, "Is this the way to New York?" Leaving Walt in a parking lot, we walked two blocks to the Museum of Modern Art. The first block was normal enough, but the second surprised us by being empty of both traffic and people except for a Gypsy wearing purple pantaloons and gold earrings. We made it to Beaumont Newhall's office after persuading the forces on the lower floor that we had not come to steal the pictures. He was just back from lunch and sent us off on our own to Hamburger Heaven close by. He drew a nice map, but forgot to specify which streets in the grid ran north and south and which east and west. Edward and I wandered up and down two fancy blocks of Fifth Avenue, peering into fur stores and perfumeries before giving up and settling for a drugstore lunch counter.

That afternoon we moved into the Twenty-eighth Street apartment of Edward's old friend Miriam Lerner. They had a warm reunion, and she was most hospitable, especially considering the size of her place. She had promised us a three-quarter bed, but when we got a look at the slightly oversized single, we dragged out the sleeping bags for the first time since leaving home. The most bizarre feature of the apartment was the "kitchen"—a remodeled clothes closet, or maybe linen closet, since the actual clothes closet was a good deal bigger. In this cubicle, set one on top of the other, were a stove, refrigerator, and various food and dish cupboards. A small hand basin did duty for the kitchen sink. Before you went in you had to decide whether you wanted to cook or wash dishes. Miriam told us proudly that she had once served a dinner for eight.

Next morning, leaving Walt to rest, we walked up to 270 Madison Avenue to see Messrs. Duell, Sloan & Pearce. After a proper amount of book talk, I asked Duell how the view was from the top of the building and discovered that New York etiquette frowned on going above your own level. Duell decided it would be a fine lark to break protocol by taking us up to see the view he had only imagined.

We met Dave McAlpin at the Museum of Modern Art, where we submitted to a visitors' tea and examined the top-floor terraces, which Edward decided to come back to do first thing the next morning. Dave was a Rockefeller nephew who had visited us at Wildcat Hill with Ansel in the fall of 1938. Unlike some Easterners who came to see us, Dave had picked up right away on the truth about Edward's style—that the apparent leisureliness was really highly productive. (Edward startled friends in New York with his impatient cry, "It takes so long to get anything done here!") Where others were made uneasy by the unstructured life of Wildcat Hill, Dave enjoyed the whole scene, and therefore we enjoyed him. He served as a trustee at the museum and had a house in Princeton as well as an apartment in New York.

The next day Edward set to work on the balconies, and I stayed for the first exposure—one with the long porch floor leading off into the building tops. Then I got intricate bus-riding instructions from Beaumont and departed for Macy's to find myself a purse.

My senses worked overtime in New York; besides the smell of cooking in stairwells, dense smells of all kinds rushed out of shops and onto the streets, restaurants smelled more foody and drugstores more perfumey, the heat of rooms, apartments, and stores was very close, and I was conscious all the time of overused air.

Hoofing it down the sidewalk on the way to lunch with Beaumont after my purse foray, we heard the patter of feet and thin shouts of "Edward!" and turned to see Gina and Ernie Knee. We towed them along for lunch. Ernie told us he had blackjacked Agfa into confessing that they were using 50 percent less silver in emulsions and were also to blame for the uneven skies he'd been getting, because they cut film from the edge of four-foot rolls where brushes couldn't spread the emulsion evenly.

Our planned trip to the Cloisters was abandoned, since the day was gray. Instead, we drove "downtown," with Beaumont chauffeuring, so that Edward and I could gawk at the Wall Street canyon, Washington Square, and so on. Coming back on the highway, we saw a gutted building with debris pouring out of several demolished stories, but there was no parking or stopping, so this was one that got away.

Beaumont took us up to the Rainbow Room, and we had a drink and looked at the lights while waiting for Tom Maloney, the editor of *U.S. Camera,* and his wife, Ruth. Beaumont left, and halfway through another drink, the Maloneys arrived and rushed us off to Restaurante Suisse, a converted speakeasy that was "just like it used to be during Prohibition." We had fat steaks with too many trimmings. Like most New York eateries we had been in so far, this one was close and hot, and before I could finish the lavish spread, I began to feel queasy and had to plunge out for fresh air. Passersby eyed me suspiciously as I leaned against a building and inhaled the thick city air. Edward and the Maloneys came out looking concerned, since the plan was to drive out to their place on Long Island—as for me, I was concerned, too.

Ruth took me in their car and Tom drove Walt. I was vaguely aware of the Brooklyn Bridge going by, and soon after Ruth skidded to a stop at my urgent order so I could step out and examine some neatly placed tombstones while commuters' headlights came sweeping by. I don't remember much about arriving at the Maloney mansion except dropping into a soft bed which I spent most of the night out of.

The next day I remained bedridden and comatose. Maloney went to his office early while Edward fretted and fumed around the house with no way to get out and photograph. I rallied for a while in the evening, but it was short-lived.

I was still somewhat shaken the following morning, but we started out to see the rest of "Paumanawk," described by the Good Gray Bard as "the fish-shaped island where I was born." On our way out to Montauk we shot off on a side road to case Whitman's birthplace, a rather dull brown-shingle house with antiques for sale in the yard. Nothing for Edward there, and nothing at the Montauk Light—a black-and-white beacon on an uninteresting point in uninspired light. In fact, the whole length of Long Island was pretty dull except for the Big Duck drive-in, and even that was not good enough in the dim gray light. By the time we got back to the Maloneys' it was dark and raining.

Next day the Maloneys went off to see the Army-Navy game, and we went to town to see Beaumont, pick up the mail, and have soup in a joint on Sixth Avenue, where I heard people saying "hamboigah" for the first time and where a concoction made of ground meat, a few vegetables, and brown gravy was

advertised as "California stew." Rain poured down. We paddled down the highway and into the Holland Tunnel and out on U.S. 1. What wrong information people give you—Maloney had said it was a bad road and Beaumont said there was nothing to see, but the industrial landscape from the Pulaski Skyway was the most terrific thing we had seen in the East.

After worming through Princeton's football throngs, we found Dave McAlpin's house without much trouble and pulled up as he arrived from the game with friends, all well-cocooned in blankets and sweaters. He was about fifty but looked much younger, maybe because he practiced Yoga—he was the first Yoga devotee I'd met. We were given a fine big room on the top floor, where we cleaned off a little New York soot and came back down in time to enjoy the remnants of the football buffet. Edward was soon put to work showing pictures to an audience, which finally narrowed down to Sally Stewart, Dave's fiancée. Just for fun Dave asked her which she considered the top five pictures. After he had taken her home, he looked through the prints again, selecting Sally's favorites and several others to keep for himself.

On a photographic expedition with Dave the next day we were finally treated to sun. The first negative was of farmlands with corn shocks and cattle in the fields. We drove up the east side of the Delaware River, crossed over, and came down the west side to ruins of an old dance hall, formerly a tannery, with Delaware River pines leaning picturesquely over the top. Edward did three variations. Dave said he had also brought Ansel here, but he had done completely different views.

Back in New York, we stayed a few days with Willard Van Dyke and his wife, Mary, in their Greenwich Village apartment on Bank Street. The building had the familiar cooking stench in the stairwell, but the rooms were built to human scale with high ceilings and a fireplace. Willard had moved to New York in 1935, and since 1938 he had been making documentary films.

We had another lunch at the Swiss restaurant, went once again to MoMA, and then up to Karl Nierendorf's gallery to drink in the Klee show. Looking out the gray gallery window at the gray rain and glancing at a watch, we realized that we were due at Dave's apartment in an hour for a dinner date and concert with him and his mother. There I was in a corduroy suit and short socks, with

CHARIS WILSON / 289

the balance of my wardrobe sitting in Walt in a garage eight blocks from the subway stop in Greenwich Village. We frantically asked Beaumont what stores were handy, and when he said Bloomingdale's, we went plunging off to see if it could live up to its reputation. Edward stood over me with a watch while I assembled a dress, garter belt, shoes, and stockings. We leaped into our first New York taxi, which crawled without haste to Dave's, where I did a disappearing act into the bathroom. We then enjoyed a generous meal at the Gotham and listened to Bruno Walter conducting at Carnegie Hall.

Friday we did our final packing and went down to Willard's office, where the camera was to peer out the window all day to see what happened. The tripod and cases were hauled from the garage two and a half blocks away and smashed into the elevator; Edward concluded that the 8 × 10 was not the camera for New York.

Dave was not going to be using his New York apartment for five days and invited us to stay there. We drew up before the refined portal at dusk, and the silver-haired doorman came out, looked over the jumble of suitcases, laundry bags, camera cases, typewriter, string-tied boxes, brown paper bags, and said calmly, "Which ones do you want in?" Edward started hauling print cases out of the back while I excavated bundles from the front.

The doorman's self-possession was not quite up to the performance, after all, and finally he masked his confusion by standing on the sidewalk and counting and recounting assorted objects that came to rest at his feet. He gave up after thirteen, and when it was all over and I told him—per Dave's instructions—to ask So-and-so to come around for the car, he could only stare. I believe he thought I was going to ride Walt astride until I found a vacant lot to tether him in.

On November 20, we went to An American Place to see Alfred Stieglitz and show him Edward's work. It was a retracing of Edward's 1922 pilgrimage, but this time he wasn't a pilgrim. We had heard from several people that the gallery had become an incense-burning center where devotees were expected to pay homage to the Great Man, but there were no acolytes present during our visit. I would like to paint a vivid picture of the occasion, but the truth is, it was unmemorable. A white-haired old man looked through Edward's prints, made

occasional comments about their subject matter, but said nothing about the photography. He did ask us to return later in the day to show them to his wife, Georgia O'Keeffe. It fascinated me that she repeated, almost to the word, Stieglitz's comments from earlier; either she had been primed before we got there or she and Stieglitz came to photographs through a single pair of eyes.

Back in Dave's apartment, Edward photographed out the windows, with potted plants or venetian blinds showing from the inside. I've never liked the nudes he did of me on the bed with the venetian blinds behind, maybe because things were so awry between us. I knew by now that I could not go ahead with an affair, but neither could I bear the thought of cutting things off. My friend was in New York and came to see us in the evening, to look at prints and to take me to dinner. Edward liked many of the same things in him that I did, and the two got along well despite the undercurrents.

At the restaurant, we sat side by side on a bench seat. He attracted me just as powerfully as he had before, but I told him I now realized I couldn't act on my desire. Although stunned and despairing, I had finally figured out that my obligations to Edward included marital fidelity. Flirting was all right, but anything more would be to behave as I had vowed I never would, that is, to make Edward suffer as he had with Tina in Mexico.

"You always tell Edward everything?" he asked.

Surprised, I recognized this was true, I did tell Edward everything. "Yes," I said. "I can't imagine not telling him."

After dinner we returned to Dave's apartment, where Edward was waiting, and that was that. I was sick with regret for what I had lost and consumed with guilt for what I might have done. Despite my turning away from this relationship, Edward and I both bore emotional scars that never completely healed.

Back on the road a few days later, we turned off our favorite Pulaski Skyway to descend on William Carlos Williams and his wife, Flossie. Edward and Bill were instant soulmates—Williams was what Edward would have been had he been a poet. Edward made some pictures of Bill and one of a toy cannon and a gaudy model heart—from Bill's son's medical-school days—against the aluminum-painted radiator.

We left the Williamses' pleasant household after just one night and, following Bill's urging, found fig orchards in the town of Lyndhurst. They were everything he had said they would be, with their branches pulled down and tied together and the trunks wrapped with straw, then with linoleum and oilcloth. The resulting mummy was topped with an inverted fruit basket. Edward had a field day in spite of dull weather, while I talked with Mrs. Ida Sangi, the owner of it all.

We drove on down through New Jersey in thick gray weather, along odorous tidelands, and then inland through low sandhills and scrubby pines. Edward made one negative: an abandoned-looking farmhouse in a waste of grass with tall bare trees around it.

While we waited for the ferry to cross the Delaware to Wilmington, we stopped in a little soft-drink joint to phone our Yosemite Forum friend, Hank Robertson, who had said we must come to stay with him in the East. He met us at the ferry. A nephew of Pierre Dupont, he lived near other Duponts in a mansion designed for him by an architect so committed to the modern that even the furniture followed a sleek pared-down style. The only exception, a lone Morris chair like the one H.L. had used at Ocean Home, had been banished by the architect to the basement. Hank had his butler retrieve it and put it in his study.

Hank was the first person we had met with a Coca-Cola habit—at Yosemite he had to have one every few hours—but we had discovered during our Southern tour that this was common to the region, where they consumed soft drinks the way people now drink coffee. It was also our introduction to the soft-drink machine, except in those days it was a simple cooler that could be found on even a one-car ferry.

In Wilmington in late November it was already winter and no kind of weather for Californians, so we arranged to get a heater for the car. Meanwhile, we sallied out in Hank's car to the country of the barns with hex signs. There were good ones at short intervals all along our way, and in addition to the brightly colored hexes, barn construction was very different from the Pennsylvania specimens we'd seen. We went on west as far as the Landis Valley Museum, which Moe had told us about, where we found handsome metal cutouts that recalled Winter Zero's.

On Sunday, November 30, we were invited to the Duponts' for tea. Sunday

was open house, when the public was welcome to tour the grounds. Edward went about making pictures, including one of empty, scattered metal chairs on the lawn looking like lost relics from an ice-cream parlor. I expressed an interest in horticulture, and Pierre Dupont offered to escort me around. When we passed numerous beds of giant chrysanthemums, he confided, "The gardener likes this sort of thing. I prefer single blossoms."

An enormous organ in the garden house boomed out over the grounds as people strolled about. Inside the garden house Hank's mother and aunt—both near deaf—were ensconced in overstuffed chairs, each with her hearing-aid apparatus. These were little boxes the size of large transistor radios that sat on either end of the table between them and acted as sound receivers. From each box a wire disappeared into its owner's clothing and reappeared at her neck to attach to the hearing aid in her ear. As they conversed with one another and the visitors in the room, each woman discreetly turned her box to face whoever was speaking. It was a marvelous performance to watch.

There was soon to be a wedding in the family, and Hank's English butler confided to us that a great deal of research had been done to see if the betrothed couple were too closely related to marry. The family was so extensive that it employed a special person to perform this function and keep track of records.

With work to do, and other people around us most of the time, Edward's mood had improved, and on December 2 he wrote to Beaumont and Nancy: "I have happy memories of New York—one of them our visit with you. I regret all the unfulfillments and my own rather low physical and mental state. However I stage a come-back rather easily."

A few days later, Hank had to go to New York, and we were left on our own with his butler and cook. Trying to trace a middle course home across the country that would neither freeze us nor make us jog back East first, I had littered the floor of a large bedroom with maps. Edward was down in the library reading.

About noon the butler burst into the library exclaiming, "Turn on the radio, Mr. Weston! The Japs are bombing Pearl Harbor!"

That settled it. The middle course had to be torn up—no more weather reports, no more tires. We would have to go back South, and decided to travel

by way of the Charlots in Athens, Georgia, where Jean had a job at the university. We left Hank's on December 9, and scurrying down the East Coast, we stopped in a couple of towns to buy a copy of *Time*, which we hoped would have more war news than the radio provided. In a good-sized drugstore the proprietor said, "*Time*? Is that a magazine?" Another said, "We used to carry it, but nobody read it." We were nonplused. As Californians, we thought no town in the country would fail to have such news staples as *Time* and *Life*.

We arrived in Athens to be welcomed by Jean, Zohmah, Ann Maria (eighteen months), and John Pierre (eight months). Jean and Zohmah took us to dinner at the home of their friend Frances Ison, with the select citizens of the city, including the De Wrenns, who invited us for tea the next afternoon. Before we went, Zohmah explained the Athens Sunday-visiting rules: one could call on anyone but one could not stay more than fifteen minutes. She said that she and Charlot had been taking their ease in slippers and housecoats on their first Sunday in Athens when people they had never seen before entered unannounced, kid-gloved and hatted. Since then, she and Jean had learned to spend their Sundays "making calls" to avoid being called upon.

I was troubled all during our stay in Athens by what I saw as Charlot's efforts to make Zohmah more conventional, as well as by his insistence that she be called by her given name, Dorothy, rather than the name she had given herself. He didn't want Zohmah to speak as irreverently as she used to in my company, and didn't want her to make fun of the people, their habits and traditions. In the latter respect, he was right, of course—but I was too much of a programmed rebel to go along with that. As far as I was concerned, Zohmah was a kindred spirit, the first woman my age whose company I really enjoyed, and he was trying to tame her. He also clearly disapproved of me.

I finally got to ask Zohmah about this when I visited her in Hawaii during the 1980s after Charlot had died. Did she know why he hadn't approved of me? "He thought you did too much talking for Edward and were always putting his ideas in your words," she said.

After some thought I realized that this charge was probably true. I was not aware of it at the time, but can see how easily it might have happened, particularly once I was in the habit of selecting and fine-tuning his words for the

articles. It was only a small step to doing the same in conversation—his speech patterns seemed so limited in terms of what I knew could be wrung out of him when he was pinned down and forced out of his formulaic mode. It was the kind of overstepping of boundaries that is easy to spot in other people's relationships but hard to recognize in one's own.

While we were in Athens, Frances Ison gave Edward a tour of homes with Corinthian and Doric columns, as well as the black church and an old slave's grave. "Erected in memory of Fred Yarborough. Died Jan 8, 1867 aged about 80 years. Former slave of the McKeans. Honest and Faithful."

With Leon, who had just come to join us from Highlander Folk School, we set out for St. Simon's Island, where we had been invited to stay at Ison's cabin. The country might have been nice in other seasons, but now it was awful: red clay road cuts, sodden fields, and straggly pine woods. Outside Savannah we investigated the Bonaventure Cemetery, which had magnificent ranks of elderly oaks trailing gray moss over black iron railings and white marble tombs. Edward photographed the Jones plot with railing, oaks, and moss curtains.

As we drove south, the thin woods turned to thick jungle, and when night came there was an orchestra of small animal and insect noises from the swamps beside the road. At St. Simon we found the Ison cabin easily, and Frances took us on an island tour of churches, jungles, marshes, and the remains of the old Retreat plantation, which still had a good double row of mossy oaks. Edward wandered back and forth trying to avoid spotty light and finally made a negative that turned out to be one of his rare double exposures. On Monday we went to the tip of an adjoining island, where Edward did a fine jungle with palmetto, palm, and oak, as well as several negatives of the marshes of Glynn County, where the inhabitants still seemed to feel the familiar spirit of their favorite son and great immortalizer, poet Sydney Lanier. "Oh, what is abroad in the marsh and the terminal sea?/Somehow my soul seems suddenly free,/From the weighing of fate and the sad discussion of sin,/By the length and the breadth and the sweep of the marshes of Glynn . . ."

We went to visit Mrs. Maxfield Parrish, who was deep into her theory that the Gullah language, spoken in other parts of the Georgia Sea Islands, had originated in India. Blacks, she claimed, were too ignorant and primitive to have come up with this language on their own.

Before we set out on our cross-country trip, I'd had a Westerner's naïve asumption that I knew about the South and understood its legacy. But when I came face to face with the first pair of drinking fountains—one labeled WHITE and the other COLORED—I stood staring in disbelief. All I had read and heard of Jim Crow had failed to prepare me for the real thing. No matter how hot and dry I got during our Southern travels, I could never quench my thirst at a segregated fountain.

It struck Edward and me that some Southerners had an insatiable need to convince us "Yankees" of the rightness of their position, as if bringing us round to their point of view would somehow justify it. We were told repeatedly that "ni-grahs" were unhappy in the North because no one understood them there, but here in the South they knew their place, so everyone was happy. It was fruitless to argue about something so inherently and abhorrently wrong; we learned to bite our tongues and walk away. However, like the Ancient Mariner's wedding guest, we had a hard time escaping the "skinny hand" and "glittering eye" that bid us hear the tale. This insistence on picking at an ugly scab, as if that would somehow heal the wound, tainted our experience in the South and made us appreciate more keenly the fresh air that blew through Highlander Folk School.

Mrs. Parrish had scheduled a sing for our final evening on the island, so after dinner we went over to the corner cabin, where a group of local Negroes performed decorously under her watchful eye. We arranged to photograph singer Bessie Jones in the morning before starting back to Athens for Christmas with the Charlots.

In the pitch dark of Christmas morning Edward and I were startled awake by the sound of gunfire coming from all directions and steadily increasing in volume. It seemed impossible that the war had already reached American shores, but we stumbled out of bed in alarm. Before we could search for a safe refuge, Zohmah appeared in the doorway to reassure us. "You can go back to sleep. It's not an invasion. Southerners don't celebrate July 4, because they think it's a Yankee holiday, so they save their firecrackers for Christmas."

Zohmah wanted to have a picture of us to commemorate the visit, but like the Yosemite Forum students, she didn't want me to be seen as taller than Edward. We went around to the side yard of her house and she had Edward stand on a box while she did the honors.

Racing against weather and the expected shortage of tires and fuel, we didn't linger for long once we headed west, although we made a brief stop at Highlander and couldn't resist a visit to William Edmondson and Alfred Starr in Nashville. Alfred's wife, Elizabeth, and their brood of four children were home now, and he greeted us with the apologetic words "Well, I'm going to have to take you people to a hotel tonight. I have the misfortune of being married to someone who believes in Santa Claus. You can't even walk across our house."

We checked into a hotel room, and as the bellhop was leaving, he asked, "Anything else I can do for you?"

"That's okay," Alfred said, and gestured at me. "She'll do for both of us."

In response to our startled looks he explained—all the hotels in the area did a brothel business on the side.

We ended up spending a week with the Starrs, because it was snowing hard and the road west was frozen. Elizabeth was a dazzling woman—vibrant, intelligent, open, and fun. She was a great match for Alfred, and they appeared to have a level of easy communication that few couples achieve. She saw me shivering one morning and gave me a wonderful quilted cotton housecoat; it was deliciously warm, and I wore it gratefully for the next ten years. Edward managed some picture making between snowfalls, and Elizabeth went with us to see Edmondson, whom Edward photographed standing in front of his shed, dressed for winter work. We rang in the New Year with exceptional good spirits, given the world situation and our own recent trials. The Starrs knew how to give an all-out bang-up party, and for a few hours at least, the assembled company enjoyed a separate, if riotous, peace.

By Sunday, January 11, we were west of Post, Texas, making a run for Santa Fe. I wrote in my trip log:

> *Another clear blue day, almost California weather. Up the lonely road between the bare brown fields; scrappy little settlements—Sudan, Muleshoe, Levelland with cotton gins and little elfs. Between Lubbock and Farwell, E. makes two negatives of a railroad crossing which has been on the list since the first. Then into New Mexico to see the amazing sight of the West beginning—the first tumbleweeds appear and then fences stuck*

full of tumbleweed, flat-topped houses, and distant lines of mesas have us
nearly weeping with joy . . . It's hard to tell at first what makes the biggest
difference but then we realize: the horizon is distant again, you can see
for miles. Plains and clay hills, and all the geography really spread out
to look at.

In Santa Fe we spent a week with Dave and Sally McAlpin, who were hon-
eymooning in a wonderful adobe house. Our bedroom had a fireplace in the
corner, and each morning a fire was lit in it before we were up. I was especially
charmed by a tiny fireplace set into the bathroom wall right about where toilet
paper would usually go and surprisingly efficient in providing quick heat. We
went on several trips with Dave and Sally, on which Edward made a number
of good negatives, including an adobe house with tall cottonwoods in front,
the pink church at Cordova, and a cliff dwelling known then as Montezuma's
Castle, where we were able to go inside the tiny rooms.

Edward and I managed to carry on well as a working team. The visible trauma
of our time in the East had begun to fade after we crossed the Mississippi, and
once back in the familiar landscape of the West, we seemed to have returned
to our old selves and rediscovered our partnership. Our thoughts were mainly
on getting home. We had heard reports of Japanese submarines just twenty
miles off the coast at Carmel and rumors that one had shelled the oil installation
at Santa Barbara. We half feared we would be evacuated before we had time to
reclaim Wildcat Hill.

We arrived at Highlands on January 20, having gone through twenty-four states
in eight months and seen roughly a third of the country—at least portions of
a third. In a summary I sent to Merle to give an idea of how a book on the
trip (in addition to *Leaves of Grass*) might go, I ended with the following:

Finis

Extracurricular comment:

1. I shall never again complain about the weather anywhere in Cal-
ifornia.

2. The thrill of getting home came when we crossed the Texas border into New Mexico and the landscape had WESTERN *written all over it.*

3. Drove 19,000 miles and returned with tires (one replaced early due to rock break) in excellent condition. (Pat on back dept)

4. (Pat on back followed by left to jaw dept) Drove through all kinds of absurd and wild traffic with never a tiff, came home and dented fender on side of own garage backing out and forgetting I was in it.

5. (I wonder why dept)

a. People think New York is hard to drive in.

b. Anyone ever thought Southern cooking good.

c. Everyone doesn't move to California.

By which I'm sure it's clear we were glad to be home. We did suffer one shock on our return: not a single cat remained of the seventeen dear felines we had left behind.

59. *Boulder Dam.* Photograph by Edward Weston, 1941

60. Tomas Alvarez, a Yaqui Indian leader, Pasqua, Arizona.
Photograph by Edward Weston, 1941

61. Charis and beach shacks, Galveston, Texas. Photograph by Edward Weston, 1941

62. Gulf Oil, Port Arthur, Texas. Photograph by Edward Weston, 1941

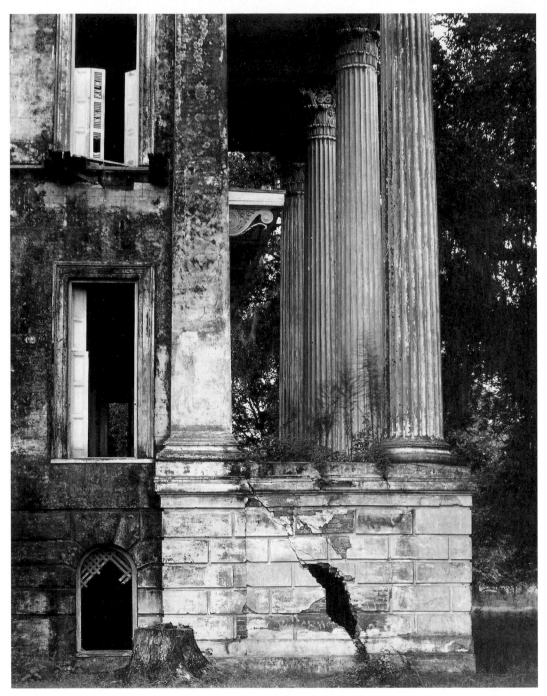

63. *Belle Grove.* Photograph by Edward Weston, 1941

64. Zilphia Horton, Highlander Folk School, Tennessee. Photograph by Edward Weston, 1941

65. Charis, Alfred Starr, and Edward in Nashville, 1941. Photographer unknown

66. Charis, holding a copy of *California and the West*, and Edward at Alfred Starr's, 1941. Photographer unknown

67. *Scott Starling.*
Photograph by
Edward Weston,
1941

68. *William Edmondson—Sculptor.* Photograph by Edward Weston, 1941

69. *Winter Zero Swartzel's Bottle Farm.* Photograph by Edward Weston, 1941

70. *Old Deerfield, Massachusetts.* Photograph by Edward Weston, 1941

71. *Charles Sheeler.*
Photograph by Edward
Weston, 1941

72. *David McAlphin.* Photograph by
Edward Weston, 1941

73. *Fig Trees, New Jersey.* Photograph by Edward Weston, 1941

74. *Nude, New York City.* Photograph by Edward Weston, 1941

75. *Edward Weston Dry-Mounting Prints.* Photograph by William Holgers, 1940s

76. *Charis Weston's Typewriter.* Photograph by Beaumont Newhall, 1940

77. Edward spotting prints at Wildcat Hill, 1940s. Photographer unknown

78. Victory Garden, Wildcat Hill, 1940s. Photograph by William Holgers

79. Zelda Holgers, Edward, Charis, Jean Kellogg, and Flavia Flavin at a beach party for the Belgian ambassador, Baron Silverkreuse, 1942. Photograph by William Holgers

80. Charis, Vasia Anikeef, and Marjorie Wurzman at a Wildcat Hill party, 1940s. Photograph by William Holgers

81. Señorita Edwardita dancing with Marjorie. Photograph by William Holgers

82. *Cats on Steps.* Photograph by
Edward Weston, 1944

83. *Exposition of Dynamic Symmetry.* Photograph by Edward Weston, 1943

84. *Civilian Defense.*
Photograph by Edward
Weston, 1942

85. *Charis and Imogen.* Photograph by Edward Weston, 1945

86. *My Little Gray Home in the West.* Photograph by Edward Weston, 1943

EIGHTEEN

On the table beside me, yellowed with age, is the November 1942 monthly newsletter of the Limited Editions Club. The entire issue—four pages—is devoted to promoting *Leaves of Grass*, and among other extraordinary claims, it says, "We asked Edward Weston to travel across the face of America, to make photographs of American faces and American places which, when printed in an edition of *Leaves of Grass*, would form for the reader a clear, real reproduction of the America which Walt Whitman celebrated in his poems."

Of course, had it been left to Macy, we would have done the entire project in the "melting pot" of Southern California. Our attempt to reassure him with the letter sent from New Orleans had failed. When Edward sent some pictures from Texas on our way home, Macy became even more distraught. It was not until we sent a packet of seventy-four finished prints after we were back in Carmel that Macy came around—although still with characteristic clumsiness and inaccuracy. On April 10 he wrote to Edward:

> *You have done a wonderful job. Not only are the photographs among the best photographs I have ever seen, a statement which is not really a great compliment, since I don't know much about photography; but they form*

a complete and a true picture of our country, and therefore they become a splendid set of illustrations for Leaves of Grass. *As I wired you, I am not only proud of you for having made the photographs, I am proud of myself for having thought of the idea. I can't even resist rubbing my hands with satisfaction over the fact that I told Merle and told you that we ought not to quarrel about our ideas, because in the end the photographs which you would make would be just exactly what each of us wants.*

No one could guess from this passage that, on the very same day, Macy wrote a letter to Merle Armitage firing him as the designer of the book. By this time, Merle was an Air Force major stationed in Detroit, but he had continued working on a design and had sent a rough plan to Macy and to us. In the letter Macy repeated his enthusiasm about the pictures and his pride at having thought of using Edward, and then, out of the blue, said, "Until now, all of us have been taking it for granted that you would design the book and Ward Ritchie would print it. Therefore, I earnestly hope you will not grow apoplectic when I tell you that I would like to change this plan. As you know, I was not happy over the dummy you prepared, although I was unable to express my unhappiness in words. But now I want to have your permission to turn about and give this job to Kittredge at The Lakeside Press in Chicago."

Merle fired right back, reminding Macy that it "was my suggestion that you do a book with Edward Weston's photographs. I have a written agreement with you to design *Leaves of Grass* with photographs by Edward Weston."

Macy replied to Merle's short, punchy letter with a two-pager damp with wounded goodwill, but he was nonetheless definite about wanting Merle out of the project. He concluded: "It is exactly true that you spoke to me about getting a book illustrated with photographs by Edward Weston. But so have dozens of people. Many years ago, Miguel Covarrubias and Alexander King joined in presenting me with a copy of your book about Edward Weston, and at that time said that I ought to get some photographs by him to illustrate a book. The idea, that Weston should illustrate *Leaves of Grass,* was originated by me and not by you."

CHARIS WILSON / 301

Merle's reply, dated April 22, filled four pages. He told Macy that he would "resist with every legal, physical and moral device" at his command having someone else design the book. After detailing his twenty-year association with Edward and his work, he wrote:

> *I keenly recall your verbal opposition when I proposed that Edward Weston should illustrate a book for you, during my visit to your summer home on the mountainside in Vermont, in the Spring of 1940. I have your letters of protest against photographs as book illustrations, in which you cite the work of Steichen as achieving only the effect of "stills" from a motion picture, in a book which he illustrated for you . . . There is, in addition, the very curious letter you wrote me while Weston was en route, explaining that you were very much frightened by the type of photographs and subject matter that Weston was making . . . Certainly you suggested that Weston should illustrate* Leaves of Grass, *but only after I had been campaigning for it for nearly two years and after it was impossible for you to get our first choice,* Death Comes for the Archbishop.

Meanwhile, we wrote to Macy asking why he had not only failed to pay our second installment of the $1,000 but ignored an earlier letter asking for the money—we had already given him the pictures, he was happy with them, and we were broke. Within a week Macy responded with another strange letter:

> *I don't suppose you can afford to keep a television receiving set in your house until the publishers for whom you work agree to pay you a better fee for your work; therefore, you are not able to turn on your television receiving set and observe me as I am at this moment, on my knees and begging your forgiveness . . . In view of the fact that your note requesting the check was dated April 21, it is obvious that I have been most remiss in failing to send it to you. I am attaching a check for $333 now.*
>
> *The truth is that this war, which has already proved a nuisance for Lindbergh and Coughlin, has proved a great nuisance for me . . . At the time I had your letter dated April 21, I had a violent and revolting*

letter from Merle Armitage. I just didn't know what to do about it. So unpleasant a letter as his takes, out of the possibility of publishing this edition of Leaves of Grass, *most of the pleasure involved.*

The following day he replied to Merle: "The letter you sent to me on April 22 is the damfoolest letter I have ever received in my life." Macy offered Merle three alternatives: Macy could release Edward's photographs to any printer who would pay him what he had already paid us and would agree to publish them, he could pay Merle $250 for his work to date and Merle would then leave the project, or Merle could continue as designer. A string of conditions was attached to this last alternative to assure Macy that Merle could do the job, get military clearance, and create a new design.

Merle promptly sent a statement from his commanding officer giving him permission to "proceed on this project to any extent" desired; he also sent a new design dummy.

Macy's reply was swift: "This is, so far as I can see, the identical dummy which you sent me over a year ago and which I told you I did not like." The design, he said, would produce a big, clumsy book, the cover was "different only for the sake of being different," the idea to print actual leaves of grass on the endpapers was "too obvious for it to be placed in so fine an edition as ours," the lettering on the title page "is no good," the text type would be hard to read.

Merle replied with a defense of his design and an indignant reminder that he and not Macy was the designer, to which Macy replied that he was no longer the designer and the attached check for $250 ended the association.

On July 20 Macy sent us copies of Merle's letters along with a letter giving Edward three choices: get another publisher to buy the photos; insist on Merle's involvement, in which case Macy would put the pictures in a vault and forget the project; or allow Macy to proceed with another designer.

This was all very hard on Edward, because of his loyalty to Merle, but things had reached a point where he could no longer stick up for him without losing the book; he told Macy to go ahead. Neither of us had been impressed with Merle's design, and we had no way of knowing at that point that Macy's would

be even worse. The same Limited Editions Club newsletter I quoted above came out with this glowing account of how the design came to be:

Shiny coated paper is usually considered out of place in the printing of a fine book. Yet we resigned ourselves to the production of a book printed in rich black ink upon shiny white paper, for the sake of the Weston photographs; until Frank Henahan came to us with a suggestion which seemed to us to be born of pure genius.

This Mr. Henahan suggested that the text of the book be printed on a pale green paper, the green paper being just such an antique sheet as would be used in the production of a fine book; and that the illustrations be printed on a shiny white paper which would then be tinted a matching green! . . . We say that the green "matt" makes each photograph sing out for very joy, and, if you believe this to be sheer hyperbole, we suggest that, when your copy is in your hands, you try placing sheets of white paper on top of the green, so that you can see for yourself the difference between dumb simplicity and singing joy in a photograph.

There was more to come. Within weeks Macy informed Edward that he was expected to sign 1,000 colophon sheets to be bound into the volumes, and "It would be a good idea if you use either dark green ink or a dark green crayon-pencil." Edward signed until his hands cramped. In green. Despite Macy's disdain for Merle's idea about grass-patterned endpapers, he freely used the grass motif, including on the front and back covers. When Macy sent Merle a copy of the book, Merle responded with a note saying that "as the gap between our thinking is so wide, there seems little to be gained by any further discussion of the results you have achieved."

This was not the last word. On the following day Merle sent another brief letter. "I took *Leaves of Grass* home last night and have changed my mind in regard to my comments, as I think, in justice to you, something should be said. You and your associates have succeeded magnificently in turning out the world's most deluxe 'Grass Seed Catalog.' "

THE WAR YEARS

NINETEEN

The war was very much with us, as it was with everyone we knew, and affected us some way or other around the clock—we blacked out the windows at night, bought war bonds, joined the coastal watch, were conscientious about rationing, and disapproved of those who indulged in black-market trading. As soon as we were settled at home again, I volunteered for the Aircraft Warning Service (AWS), a network of plane-spotting posts up and down the coast. The local director was Olga Wellman, whose husband, Whit, wrote for the Carmel *Pine Cone*.

The observation post was located on Yankee Point, within walking distance of Wildcat Hill and just above where Ansel and Virginia Adams would build a house in the early sixties. The view was clear from Big Sur lighthouse in the south across Point Lobos to the Monterey Peninsula in the north. The western horizon was determined by the presence or absence of the fog bank. Little more than a shack, the post had heat and ventilation, but it still felt exposed out on the point, so I organized a crew of AWS observers to build a wall with chunks of granite that we hacked out of the ground nearby. About four feet high, the wall gave at least a sense of shelter and a little protection from the wind.

Volunteers put in two-hour shifts during the day and three hours at night,

three times a week. If a plane was spotted, we were to call the central office in San Francisco to give the altitude, direction, and type of aircraft; that is, a single-wing, biplane, or multiplane. As observers along the coast reported in, the movement of any aircraft could be tracked.

People of all ages and kinds volunteered, including some nine- and ten-year-olds. To train them to figure the position, I made a demonstration board with toy planes from the five-and-dime that I attached with black thread. The kids were good at this and seemed happy to have a new entertainment, but then I quizzed them. I said, Suppose a plane were to land on the highway behind the post and burst into flame, what would you do? Without exception, they would have dashed over to put out the fire or help the fliers. In the imaginative world that kids inhabit they saw themselves as rescuers, when their real responsibility was to report the incident and stay on the phone to continue giving information. This was a kind of revelation for me: as simple as an observer's job seemed, it required the maturity to follow orders, not to toss protocol out the window as soon as something out of the ordinary happened.

Jean Kellogg and I often took the midnight to 3 a.m. shift, a fine time to observe stars if the sky was clear. We had no telescope, but Jean knew most of the constellations and had a good star book. Jean was a painter who lived in a studio on the other side of the coast highway from the observation post. Her parents, Vernon and Charlotte Kellogg, had been active in the Hoover Administration's Belgium relief program following World War I and had moved West when they left government service. Jean had been raised, in part, in the White House and thought that "Uncle H. H." was a great but misunderstood man.

Edward joined the airwatch as soon as he finished printing the Whitman pictures, which took several months of work. Because he loved being up to see the dawn, he took the 3 to 6 a.m. shift for a while. He wasn't nearly as gung-ho as I was—I was soon second in command—but he was steady and would take unfilled shifts in a pinch. He was also fire marshal, which meant that others were to report fires to him so that he could call for help from Carmel. Fire was a real worry at Wildcat Hill, because everything—including prints and negatives—would have burned in a flash in that small wooden house, even though Edward kept the regulation ladder and buckets on hand.

Edward was sufficiently worried about such a scenario to bring it up in his letters; to Beaumont and Nancy he wrote that the negatives had to stay nearby so he could print orders, but "I can begin to disperse my prints." In fact, he had always sent prints to friends, but now he would have been willing to send away a whole group to a secure situation. Had MoMA been more enthusiastic about photography at the time, they could have scored a great bargain on a collection of Weston prints.

We never did spot any enemy aircraft and never were hit with incendiary drops; our sole emergency was a dirigible that went down off Big Sur in a storm, and the one dropped flare that Edward reported was, in fact, a meteorite. The only real danger turned out to be from war games. One night some of us watched an aeronautics display off the coast put on by the U.S. military that involved a whole squadron of low-flying planes and the dropping of colored flares like fireworks. At first we watched from a hill above Yankee Point, but the cold drove us down to Olga Wellman's yard, where we had a few drinks while we watched the end of the display. Next morning I was going up to the post when Olga said, You'd better come see this. The ground around their house, including where we'd been sitting, was covered with little bits of shrapnel—twisted pieces of highly polished metal. They looked lethal, and we couldn't figure out why no one had been hit.

Wildcat Hill was no longer the quiet place it had been. Planes patrolled the coast, and some dragged targets for practice fire from antiaircraft guns in place on the shore—the sound of "ack-ack" bothered Edward more than it did me, but as with everything else, we both accepted it as a necessary part of defense.

One day I came home with the gas mask I'd been issued and modeled it for Edward.

"Let's make some nudes."

Both of us were repelled by the mask, and he found it harder to deal with than he had expected. He said repeatedly that it was an awful thing, and difficult to make part of the picture rather than *the* picture; for a counterweight he tried a fern frond from the yard, and then a plate of peaches. I'm sure Edward meant the image to be shocking, but those who suggest that it was an expression of social consciousness on his part are mistaken. He greatly resented infringements

on individual liberty, but he did not seek out messages. The picture was called *Civilian Defense*, because that was the purpose for which the Army had issued the mask. Opportunism played a big part in Edward's work; reality was handed to him, and all he needed to concern himself with was—in his favorite phrase— "the strongest way of seeing." In a 1944 letter to Nancy and Beaumont about a show they were planning at the museum, he wrote: "I can honestly say that I never based my way of seeing on moral grounds."

As part of the propaganda effort in Europe, the Office of War Information organized an exhibit of paintings and photographs meant to show that artists were free to do what they wanted in the United States. Edward sent one hundred prints, for which he charged only five dollars each, as a patriotic contribution. The $575 check we received was more than half what we had been paid by Macy for our many months on the road. We bought war bonds with some of the money and thought it was a great deal, for patriotism and profit. In ten years we would be able to redeem each $19.75 bond for $25—by which time, of course, inflation would have eaten up the difference, but we didn't care.

Edward took great pleasure in seeing the hundreds of Whitman negatives for the first time. While he knew that just about any picture he made would be worthwhile in some way, he could not really know what he had until he was in the darkroom printing. My awareness of the different stages in Edward's work had come gradually. The making of the negative was the first real unfettered creative burst, and although there were often obstacles to be overcome—wind moving a branch or difficulty getting the right distance and angle relative to the subject—the moment was electric no matter how long it had to be sustained. He was entirely and contagiously excited when he exposed film.

This was followed by development of the negative (although for logistical reasons Brett had developed most of the Whitman film), which involved a kind of reseeing, to determine whether he had successfully captured what he first saw. Finally came printing and the rewarding moment of watching the image form. The first few prints of an image excited him, but too many repetitions became tiresome. Periodically Edward would go through a stack of mounted

prints with a very critical eye and cull the few—if any—that seemed to have lost their spark.

He was spending as much time in the darkroom as he could stand. A card he sent to May in February read: "Darling—Program for a typical day: clear off chores such as kindling, wood, garbage, read Whitman for lines to illustrate; take sunbath when there is any—to gather vitamins x, y, and z for dark-room counteraction; mix chemicals and sort out negatives for printing; print until 8 or 9 p.m., eat and to bed; repeat same next day."

In fact, reading Whitman was my job. I spent several months going through *Leaves of Grass*, choosing passages to persuade Macy that what the book said was related to what the pictures said. Edward had made a halfhearted stab at this, but had no patience for the process. Neither of us anticipated that Macy would use my selected lines as captions for the book's "illustrations."

Still, Edward's note gives a good idea of the simple routines of our life together. If he was working in the darkroom, I made dinner. If I was working and he wasn't in the darkroom, he made dinner. If both of us were working, no one made dinner, but there was always soup on hand, and the inevitable Rytak. It was often foggy, the hillside weepy with drops coming off the pines. A fire burned on most days, even in summer, so we almost always had hot water from the pipes that were coiled at the back of the fireplace.

We ate dinner at the model stand in front of the fire and then read aloud or listened to the radio, generally either news broadcasts or drama, particularly tales of crime like *Calling All Cars* and *Gangbusters*, which were well done, with great sound effects. If we had company, I got out my knitting in anticipation of the inevitable repetitions that went with Edward's print showing. He is often recalled fondly as an accomplished raconteur, but I no longer found his tales so endearing. Maybe it was because I had an excellent memory, but I have always found it hard to sit through the same story over and over again, particularly when the details become more exaggerated with each telling. Knitting allowed me to get lost in my own thoughts without being too obvious about it. Following an instruction book, I managed to produce a sweater to send to the troops as well as a copy of this success for Edward and, as my skill improved, a fancier specimen for myself.

Guests were invariably delighted with the way Edward made them feel welcome. He was Johnny-on-the-spot when anyone came to visit; no matter how his reputation grew, he never played the famous photographer, and he had a great talent for combining social activities with work. If he had to pick out prints for an exhibit, for instance, he could show pictures to a visitor while he went through them himself, perhaps not making final selections but dividing into two piles those he would choose from and those he wouldn't. He had such focus and organized his time so effectively that it often struck me his life seemed to run itself.

Robinson Jeffers stopped in one day to urge Edward to photograph the lime kilns beyond Big Sur, where he had just been hiking. This was probably a good suggestion, but Edward never followed it—he had been satisfied with the lime kilns at Death Valley. Edward had met Jeffers in 1929, writing in his *Daybooks* afterward: "I feel that we will become friends. And I am to photograph him, when I know him better." He did make several fine pictures of Jeffers, one of which was used for a *Time* magazine cover in 1932.

The first time Edward showed Jeffers his work was at the invitation of Una Jeffers. She was entertaining a friend of Stieglitz and Walter Kuhn, both of whom had recommended a visit with Edward. Writing about Jeffers's appreciative response to the pictures, Edward said: "A man may be a fine poet, and yet not respond to other art forms. But Jeffers is a great poet plus—." Jeffers's reputation for unapproachability was due, at least in part, to Una's fierce defense of their separate existence at Tor House. It seemed to Edward that she shielded Jeffers more than he needed or was good for him; it's one thing to keep curious admirers at bay and another to discourage potential friendships. Una was never inhospitable, but she did not encourage spontaneous socializing. She did, however, admire both Edward and his work, evidenced in the tribute she wrote in 1935, shortly after he'd left Carmel for Santa Monica: "Fine artist, hard worker, generous friend—that is how we at Tor House think of Edward Weston. During these years we have watched his disciplined intensity when at work and his determination to present sincerely each subject he undertook, whether it were

a fissure in granite or a string of kelp, the face of a child or thunderclouds over Taos Pueblo. And always his response to other people's work has been eager and appreciative. I hope he will think of Carmel as home and come back often with new brilliant tokens of work in progress."

Every few weeks we pushed the big table back against the print storage cabinets and the couch against the glass doors, set out an array of homemade goodies along with wine or beer, rolled up the rugs, and had a dance party. Edward would play rumba and tango 78s on the record player by the desk. Rarely would he drink more than a two-ounce glass of wine, but even that would soon put him to sleep, while the rest of us enjoyed our revelries long into the night.

Our house could comfortably hold about fifteen people; when we invited more, which we frequently did, the party spilled onto the front deck and out back onto the patio. If space became too limited, an intrepid couple might climb up on the long outdoor table to find some elbow room for dancing.

We always included the "regulars"—friends from Highlands, Carmel, and Monterey—and Bill Holgers often came down from Oakland. He was an avid photographer and once or twice documented party preparations and the subsequent merrymaking. We also invited soldiers from the Monterey Presidio and Fort Ord whom we had met through friends or who had come by to look at Edward's work. I'd don my version of party garb—a skirt stitched together from a length of material, an improvised top, Cuban heels, and bobby socks—and then throw myself into the festivities. If Edward spotted a woman his size, he might borrow her dress to do his female impersonation. He looked pretty silly with his short, muscular legs, but a solo dance by Señorita Edwardita never failed to bring down the house.

One night I drove a thoroughly intoxicated lieutenant back to Fort Ord, worrying all the way that he might be thrown in the brig for "conduct unbecoming to an officer." When we were stopped at the entrance gate, the sentry on duty leaned down to peer in the car; seeing his superior sprawled on the back seat, he snapped to attention, saluted, and waved us in. It was an illuminating glimpse of the power of rank in the military.

Our free-spirited parties were undoubtedly a welcome relief from the isolation and boredom of life on the base. It was hard to believe that our fellow revelers—these healthy, exuberant young men—were about to be shipped off to war, and difficult to accept that all we had to offer them was an evening or two of distraction before they went.

On February 19, two months after the bombing of Pearl Harbor, President Roosevelt signed an order that designated California, Oregon, and Washington as "military areas" of strategic importance because of the coastline. This vast area was off limits to whomever the government wanted to exclude. Within months, more than 100,000 people—most of them Japanese—were banished from their homes, businesses, and farms and sent to camps away from the coast. Among them was the Japanese family that had a truck garden on the flat by the Carmel River where Edward and I often stopped to buy vegetables.

In one of his few overt political acts, Edward wrote a letter of protest to the local paper. He was furious at this senseless indecency, and unlike some who quietly disagreed with the "relocation," he was not afraid to make noise about it, even though he knew it wouldn't save our neighbors from being hauled away. The following year, Ansel photographed the Manzanar Relocation Camp in the Owens Valley and wrote an eloquent portrayal of the injustice being done there. The first of many to be built, the camp covered 560 acres with barracks-style housing surrounded by guard towers and barbed wire. I assume this is where our local farmers spent the remaining years of the war; we did not see them again.

Because of food rationing—and to work off my outrage over the ongoing absurd correspondence with Macy—I had started a "victory garden" in the spring. My mother had grown an amazing array of flowers at Ocean Home. Now I set out to grow all the vegetables I could coax out of the earth on the remaining corner of my childhood terrain. Edward helped till a level area below the house, and I did everything it said to do in the *Sunset Vegetable Garden Book*. The garden wasn't very impressive to start with, but soon I roped in some neighbors,

including Olga Wellman, to help. Eventually we used the entire front slope, and had I learned the French intensive method, I could have fed most of Highlands. I grew all the produce we ate during the season; however, my domestic enthusiasm didn't extend to "putting up."

That first year the regular tomato plants turned into old-growth timber, with such an exuberant and towering production of leaf and trunk I was smugly convinced we would be swimming in tomatoes by August. Like other novices in the garden, I hadn't yet learned that plants—like humans—can do one or two things well at a time but not excel at everything simultaneously. We may have picked two ripe tomatoes from the garden that year. I solved the problem the following year by switching to cherry tomatoes (planted at the end of each row as a treat for harvesters). From then on we had all we could eat.

Except for some pale pink impatiens, which I started from the plants at Ocean Home, I didn't grow flowers—there were plenty around, wildflowers and fuchsias and nasturtiums. Bright purple foxglove grew down the side of the ravine, the flowers standing tall and crowded. I enjoyed the profusion of flowers outdoors, friends used them to make bouquets, and Edward sent blossoms in letters. I taught him the names of all the native plants and naturalized flowers, and he would reel them off in correspondence: "Spring flowers are just starting to bloom; wild iris, solomon seal, nasturtiums, lilies of a dozen kinds, heliotrope, impatience, geraniums, acacia, succulents, poppies, mustard, and on and on." I had first learned wildflowers from Helen and added more when I was doing captions for *Westways*. I still like the idea of being able to name my surroundings; to know the name of something is to see it more clearly.

Along with gardening, I took up stonework to shore up the various levels of the side hill. I'd always loved the pictures of terraced rice fields in Asia, so beautiful and well managed. Ocean Home was like this, with an up-and-down geography that Helen had had a fine time shaping into terraces. She had even drawn H.L. into the project. My only image of them working together is of my father heaving large stones into place according to my mother's direction—I see her indicating the placement with gestures rather than words, a silent movie image that may or may not give an accurate picture of their actual communication but certainly reflects my impression of their marital distance.

Working with smaller stones than Helen had used and following the contour

of the land, I built a number of rock walls; once they were partially buried in plants they looked as if they'd been there forever. Between the house and the former garage, we made a chalk rock patio with a cement wall at the back to keep dirt from washing down into the house. Many pictures were made here, of the cats, and of visitors whom Edward sometimes photographed in front of the rolling screen.

The garden and landscaping remained my project for the rest of our years together at Wildcat Hill, with Edward contributing the yearly spading and occasional trapping of gophers.

One day Jean Kellogg came to us in a panic: her mother was sending the ambassador from Belgium to visit—on his own—and Jean didn't know how to entertain him. We figured that everyone loved the ocean, so we suggested a picnic at Flavin's Beach. In addition to Baron Silverkreuse, Edward, Jean, and me, the party included Bill Holgers and his new bride, Zelda, Vasia Anikeef, Eliza Clevenger, and Flavia Flavin, whose parents' house fronted on the beach. The bay was choked with kelp so thick we could almost have walked across it, but most of us, including the ambassador, managed to swim through to the open water beyond. A photograph Bill took at the end of the outing shows Edward apparently surveying his harem, while Jean and I wipe the sand off our feet and Flavia begins to replace her stockings. Zelda stands demurely in the background, averting her eyes from this carnal scene.

Our most treasured guests of the season were Don and Bea Prendergast, who came in July and stayed until September. They had moved to Tucson, where Don was going to start teaching art at the University of Arizona, a welcome relief from his previous position at a women's college in New Orleans, where the young women had no interest in learning—they were waiting to get married, and that was occupation enough.

I sent them what I hoped was an irresistible invitation: "WESTON DARKROOM MYSTERIES REVEALED! . . . We have decided just how you should behave this summer. Come to Wildcat Hill . . . PHOTOGRAPHING WORLD'S MOST MAGNIFICENT SCENERY! . . . PRINT! . . . DEVELOPING! CLICKS! PEEKS! LOOKS! . . .

PACIFIC OCEAN IN FRONT YARD! SANTA LUCIA MTS. IN BACK YARD! LOTS OF CATS! GRATE FIRE MORNING AND EVENING! CYPRESS TREES! ERODED ROCKS! AIR RAID THRILLS! . . . Bring cameras and paints . . . CAN'T WAIT. HURRY UP." With Edward's addition—"What more can I say—except to O.K." It worked.

We found them accommodations in a guest cottage above Gibson Beach, just beyond Point Lobos. The house it belonged to was poetically named Sea Girt, so we dubbed their diminutive quarters Sea Gertie. It was Bea who discovered the dead pelican on Gibson Beach and came to tell Edward. He photographed it just as she found it, and Bea later wrote about the picture: "The bird looks as if it sat on the beach spreading its wings for balance against the tide, too sick to move, finally putting down its head and long curved neck to die."

Don and Bea fit right into our lives at Wildcat Hill. They were great companions and we saw them almost daily. There was no distinction between hosts and guests—if they wanted to look at prints they got them out for themselves; they both photographed and worked in the darkroom with Edward; we prepared and ate meals at our place or theirs. One memorable evening Jean Kellogg had joined us for dinner at Sea Gertie when a pungent odor assailed our nostrils. Jean rose to the occasion in good AWS form, announcing, "Now we must all be calm—I think we're being gassed." After a minute or two of alarmed investigation we concluded that we were under attack, but the enemy agent was the Prendergasts' refrigerator.

Bea and I were close, and she may have noticed a subtle shift in my relationship with Edward. If so, she didn't mention it, and it was unlikely I could have expressed what was happening inside me even if she had. Besides, there was always a leavening of the household mood when friends were around. A note Edward sent to May after the Prendergasts left expressed how we both felt: "We shall miss them. We took turns shopping and cooking; it was practical community sharing."

After Roosevelt declared the Pacific Coast an area of strategic importance, new restrictions were enforced on the use of parks and national monuments. Once it was officially designated as a state preserve, Point Lobos became subject to

these measures. The new custodian, R. E. Wilson, stopped Edward as he was on his way to make pictures and pointed out that he would need one of the special passes that were issued to people with legitimate reasons for being at certain coastal sites.

"Of course, passes are for artists," Wilson added, "but I think we could make an exception in your case."

Amused, Edward added this to his stock of anecdotes, but in September even the special pass couldn't get him onto the point, because the Army closed it to civilians. We had already begun a campaign to protect Point Lobos from damage, which was mainly caused by people who sought the place out because of its beauty. The worst offenders were movie companies, for whom the point had become a favorite filming spot. They thought nothing of changing it—of driving vehicles all over the landscape, tearing up what they didn't want, and nailing bogus scenery to the trees.

Edward and I, along with Mary-Lou and Laidlaw Williams, Valentine Porter, Cynthia Criley, and others, started the Point Lobos League. We decided to find someone who could speak knowledgeably to a state legislator who served on the proper committees to protect outstanding natural areas. We invited an ecologist from the Hastings Reservation, a university biological observation and experiment center in Carmel Valley. This was my first exposure to the science of ecology and it left me impressed.

Despite his committee appointment, our legislator turned out to have no knowledge of Point Lobos or ecology, but the man from the university gave him an earful. It was a lovely sunny day and killer whales were cruising the rocks where baby sea lions occasionally slipped into the water. This wasn't something that could be seen there every day.

As we walked around the cypress trail, the ecology man pointed out that the red fungus growing on the old trees was native to this one spot. Using an ant trail as a demonstration, he talked about the impacts of human use; that is, the ant trail could go on and serve out its natural time according to ant cycles or be wiped out by the tramping of careless human feet on the steep and erodible hillside.

We plied the legislator with data about the uniqueness of the Point, and

apparently sold him on it, because he went back to Sacramento and got a bill passed to turn it into a state preserve. Most of our effort over the course of a year consisted of writing letters and publicizing the campaign, emphasizing what preservation would mean to future generations. The Point was not only protected, but to this day, other than the addition of a few toilets and picnic tables, it has been spared development.

Like most other civilian activities, the league included more women than men. Cynthia, Mary-Lou, and Valentine had young families and came to the meetings with baskets of work—socks to darn and buttons to sew on. While I had happily taken up knitting and gardening, I saw these occupations as additional creative outlets, not chores I was saddled with to meet the demands of others. Instead of being impressed as I would be today by the ability of the women to combine child-rearing and social action, my primary reaction to the sight of these industrious young mothers was a disinclination to have children—a conviction that would hold for another five years.

Like many locals, I responded to a call for help from the Monterey canneries, which were short-handed because of the draft and the boom in well-paying war jobs. Leon had been released from jail in Tennessee and was staying near us while he awaited his federal trial in San Francisco. He went to work at Hovden Cannery, where the Monterey Aquarium now stands, while I took a job at the Del Monte Packing Corporation a little way up Cannery Row. I drove over the hill each day despite gas rationing, and Leon rented an attic room in a wonderful building on the main street of New Monterey that had once been a nursery where Helen bought plants, and was now a Mexican restaurant. Leon had a regular job while I was only "on call," but there was no shortage of work.

My first job was to pack what they called Monterey sardines—which were really pilchards—prior to their being cooked. The fish were seven to nine inches long. The trick was to get the right number in each tin to add up to the right weight, which required choosing the proper sizes and placing them head to tail. If you had to keep taking them in and out of the tin, you made very little

money because it was piece work. As it turned out, I had no eye for sizing sardines and always had to try to fit in more fish or dump them out and start over.

I was such a lousy packer that the forelady, as she was known, pulled me off the packing line and put me on the belt. Sardines rode the belt through a machine that trimmed off the head and the finny end of the tail. The fish then cascaded down a slope to another level, where a number of us stood on each side of the moving belt ready to pick out damaged fish. The woman who taught me worked with an efficient rhythm as she reached, plucked, and tossed mangled specimens into the waste transport ditch. While I didn't get dizzy watching the fish flow by and keel over as some people did, I simply could not spot any blemishes. After watching dead sardines swarm past for a while, I started picking up random fish and throwing them off because I had to be doing something. I didn't last long on the belt. Next they sent me over to the fillet plant, but I fared no better there, finding it impossible to master the delicate wrist movements. Despite my ineptitude I was kept on call—a good indicator of the desperate need for workers.

Over at Hovden, Leon was having better luck with his duties, which included taming catsup; he kept an eye on giant steaming cauldrons, and whenever the catsup formed a crust he dashed to the pot and beat the red goo down with a big wooden paddle to keep it from boiling over. I never had a chance to witness him in combat with tomato sauce, but it was my impression that he found it more pleasant than summarizing plots for Selznick.

TWENTY

When I came home from the cannery at night smelling like sardines, the cats would climb me wildly. I made sure to have enough scraps in my lunchbox to spread around in the dishes so I could escape their voracious attention. While my part-time employment at the fish factory was a great boon to the feline population, it wasn't about to support the human inhabitants of Wildcat Hill. The question once again was how to make a living. We got royalties from *California and the West* but none from *Leaves of Grass*; the pay had been a set fee for the pictures. Edward was determined never again to be entirely dependent on portrait sittings, and he began to give serious thought to publishing his *Daybooks*. He felt confident the section dealing with Mexico was salable because of his firsthand accounts of Diego Rivera, José Orozco, and other prominent Mexican artists. He had considered its possible publication as far back as the late 1920s, when his friend Crystal Gang, an accomplished stenographer, had taken the manuscript home promising to straighten out his grammar and punctuation. When she brought back her neatly typed version of the opening section, he hadn't been at all happy with it, but his original pages had been discarded and he had no way to restore his own words. As a result of that fiasco, when Ramiel McGehee offered to perform the same service, Edward insisted that his handwritten pages be preserved, and was glad he did.

"It simply wasn't me," Edward wrote. "It wasn't my way of saying things and as a result it didn't say the same things, and even Ramiel—who knows me so well—could not understand that."

Edward's voice was recognizable in the *Daybooks* as they stood, and a good editor would find a way to maintain the rhythms of his written speech while making the minimal changes necessary to render his dash-studded text acceptable to readers. Nancy Newhall agreed to help, and in preparation Edward went to work expurgating—a violent business in which he didn't just cross out embarrassing passages or names of friends he wanted to protect but attacked the journal with scissors. Such ruthlessness seemed excessive to me, not only because I am a hoarder of notes and records, but because he had not led a sufficiently riotous life to warrant that kind of censorship.

He was neither promiscuous nor a Don Juan. A real Don Juan is always looking around the room to see who else is there. When Edward was attracted to a woman he gave her the same focused attention he gave his work, and a series of women had found this irresistible. He didn't pursue sex for its own sake; he wasn't interested in racking up conquests. He was drawn to the inspiration that falling in love provided—the deep connection and communion with a new person. The best evidence that most of his relationships with women were not mere dalliances was their endurance. He maintained friendships with many of his former lovers until the end of his life.

Nancy eventually made several lengthy visits to Wildcat Hill to work with Edward on the *Daybooks*. She understood Edward's style, and managed to do what his earlier well-meaning helpers had failed to accomplish; that is, she made his writing easier to read but kept it sounding like Edward. She tamed his breathless rambling style, and even punctuated it, without trying to turn it into standard English. In defending his own punctuation, Edward said that this was "how the sentence feels to me." A pause called for a dash, and a long pause called for two dashes or a series of dashes or dots. That this could exhaust a reader didn't occur to him.

Like other keepers of successful published journals, Edward established a persona he was comfortable with as he wrote and that would also be accessible to a wider audience of friends and, he hoped, the general public. His account was

lively and readable, but he was also driven by a real hunger to exercise the kind of critical judgment—on others, on his surroundings, on art—that he usually soft-pedaled in conversation so as not to offend people. As he cheerfully admitted, the *Daybooks* were full of complaints and bellyaches that he could safely vent in a journal.

The *Daybooks* were published posthumously in two volumes by the International Museum of Photography at George Eastman House: *Mexico* in 1961, *California* in 1966. In her Introduction to Volume I, Nancy modestly asserts that, aside from punctuation, her major contribution as editor was to remove repetitive references to daily activities (parties, bullfights) as well as "a few vulgarities and sentimentalities of the kind Edward could no longer stand."

While she got a great deal right, Nancy misrepresented Edward in at least one important way. "He never laughed out loud," she wrote. How could she be so mistaken? She had known him since 1940 and we four—Nancy, Beaumont, Edward, and I—had enjoyed many an uproarious bout of laughter. Edward loved to joke and clown and make fun of almost everything. He wrote in his *Daybooks* while at Redondo Beach in December 1928: "A good laugh is cleansing. We screamed with laughter." Nancy noted in 1955 that he told her, "One reason I miss Charis is that we could laugh at the same things." Perhaps because Nancy spent her most concentrated time with Edward after his face had taken on the wooden cast of the Parkinson sufferer, she had forgotten what the healthy Edward was like.

Edward had little choice but to work close to home during the war, which may account in part for a new turn in his work: portraits "with backgrounds," as he described it. He did Neil against the garage door, Cole squatting and whittling a stick, and Ansel in front of a rough board wall. Edward and I were amazed when Ansel pointed out that the picture had strong religious overtones, as he appeared to be holding an Old Rugged Cross. Edward also photographed me reading on the roof of the house, and nude behind a window screen. He described the nude in a May 11 letter to Nancy and Beaumont: "Figure very classic, pine boards very rough; on the exposed plumbing sit a couple of bat-

tered shoes Neil mailed from the desert; chimney on one side, vine covered and fuchsia in opp. corner. Of course, I rely on the same old model. Old? She was 29 Sunday."

Edward's work was not all that was changing. Our lives, which had once been parallel, were beginning to diverge. In letters, at least, Edward blamed our busy schedules. In September he wrote to the Newhalls: "Charis and I never find time to get together on anything; she spends half her life on A.W.S. clerical work (and just got a medal for 500 hours observing). My time is full up too, what with victory garden, A.W.S., printing, sittings, selling prints."

Edward often mentioned the victory garden in letters, and one day when he was showing off the garden to one of our many guests, I overheard him take credit for the work. I was shocked, because he had always made a point of telling people the garden was my creation. I know now from postcards and letters he wrote during that period that much of my work got described as his chores, even writing the photographic articles. In letters to close friends, he regularly used the term "my victory garden," and would say "in between A.W.S. and victory garden, I do make photographs." This need to claim as his what I did was particularly puzzling given Edward's success in what he cared about most, in what he spent most of his waking life thinking about. He had always been generous in acknowledging my contributions to our joint endeavors, and as far as I could see, he didn't need ego-boosting or affirmation from the world.

I suppose I expected Edward to credit my work because he was furiously protective of the fruits of his own creative labors. A letter dated February 1943 is a good example. It was addressed to a Mrs. Warren and—ironically—had been drafted by me, as was still the case with most of his serious correspondence. Mrs. Warren had made copies of some of Edward's pictures that had been published in a book and a New York newspaper and wanted permission to exhibit them. Edward, of course, said no,

for the simple reason that these copies would not be reproductions of my work in any sense of that word. My original photographs are contact prints from 8 × 10 negatives. The fineness of detail, gradation, texture,

etc., in these original prints can only be adequately reproduced by the finest, most painstakingly executed, half-tone reproductions . . . These copies that you have made are, in the legal sense of the term, bastards . . . The thing that fools people is that the medium is photography and that it seems more unlike other mediums than it is. If someone wrote to a painter saying, "I have had a hand-painted copy made by a skilled painter from the reproduction of your picture 'Still Life with Cabbage Sprout,' that appeared in the Art Review, *may I exhibit it as your work?"—that the answer would be no is more easily understood by most people.*

I'd like to think that Edward took credit for the garden because of the pleasure it gave him. In April he wrote to May: "Had mustard greens and tiny lettuce leaves (thinnings) to eat from our garden. Good! The edible pod peas are flourishing, also broccoli and Brussels sprouts."

Edward had gradually developed a disconcerting habit of tapping his heel on the floor while he sat at his desk. At first I assumed it was a nervous reaction to giving up smoking. During our Whitman travels, his knee had given out, and at Alfred Starr's urging he had made the unusual decision to see a doctor. The diagnosis was tailor's disease, or poor circulation in the legs; the cause, said the doctor, was smoking. Unable to quit during that stressful trip, Edward had vowed that he wouldn't smoke again once he got home to Highlands. To my surprise and admiration, he lived up to the vow, making him something of a paragon in my eyes.

I went through the motions of quitting, too, because it seemed too terrible for Edward to have to be around someone who was indulging, but I soon started again, at first only outdoors or in Bodie Room. Once resolved, Edward never wavered and stayed resolute even when others smoked in his presence, so I slunk my way back indoors. It took another twenty-eight years to free myself from the grip of nicotine.

There are several pictures of me playing the recorder, including one Edward made of Imogen Cunningham photographing me as I piped away at Point Lobos. First Leon took up the instrument and thought it was playable without

too much work, so he bought one for me. I practiced whenever I could, and eventually developed enough skill to play duets with Leon and to join a small group of fellow players in Monterey. I have come across written cracks by Ansel, a *real* musician, describing my "racketing on the recorder" and swearing there must be crickets in it producing all the harmonies. Edward seemed to accept my new pastime gracefully—at least he never begged me to desist—but a comment in a letter to a friend offers another impression: "Charis is playing (?) the flute so hard I can't think." A small sign, perhaps, of the circumspection that was beginning to restrict our once easy flow of communication.

Despite our deteriorating relationship, to all appearances life went on smoothly at Wildcat Hill. Friends continued to visit in great numbers. Ansel came for a two-day visit in April—a long one for him—and, as usual, brought steaks and alcohol, knowing full well that the only thing we were likely to have on hand was cheap red wine for parties. This time he brought gin, vermouth, a jar of pickled onions, lemons, and a sack of ice cubes to mix us a "Gibson," which he considered an improvement on the martini. Whether they included an olive or a pickled onion, they were all martinis to us, and all equally lethal.

Even though Ansel knew us well, he was accustomed to a more refined lifestyle than ours, and after showering he called loudly to Edward, "I need a *face* towel." Edward and I exchanged raised-eyebrow looks before he pulled out another towel and handed it into the bathroom. We were so used to one all-purpose towel apiece, it had taken us a moment to make sense of the request.

Often, during these years, Ansel would say how much he envied us, how much he would delight in being able to live the simple life and make photography his main occupation.

"But it's not true," Edward observed. Ansel would never have given up his own life—the chance to travel, know important people, write articles, organize trips for friends; in short, do a little of everything. He was an operator and would not have been satisfied with less than an arena to operate in. "Living the simple life" just represented wanting some time to himself; after a few days of isolation, he had to break out and return to the front line.

Back in Yosemite, Ansel responded to the portraits Edward had sent him, including the Old Rugged Cross:

Apart from the photography, I think I should grow a beard! But you can't help that; Gawd hath made mountains but he did a louzy job on my nose. Maybe the kind of beard I should grow would be one that looks like one of those Scotch Scurriers—those Dawgs that look like (and through) a section of a hair mattress . . . As far as I am concerned I like them tremendously; it's the first time anyone ever got a true mood through my face. The only thing is that the mood that was there was one of fatigue . . . However, there is a glimmer of the fine mood I was getting into with you and Charis—but Jeez, I was pooped that day. The gesture of supporting the cross—or have I just descended??—has a connotation all its own . . . How is it with you and Charis? And news? And new work? Still wardens and spotters? Feel OK? Any trouble getting materials, etc? How is the Acrol? What's the Pyro stock? Who goosed your grandma? Any more cats? Need any film? Jeez, I wish I could see you soon. Well, maybe it will be soon. Anyway, write and let me know how you are. I have VERY affectionate feelings for E. and C.

One of our cats did reappear after the Whitman trip. He had come back within a few days of our arrival home, and made our hearts leap, until it struck me that he looked suspiciously like Nicky, the resident bully that we had hoped *would* disappear. Uncertain of this loner's identity, I said, "Nicky, shake hands," and he stuck out his paw. Only Nicky and his two sisters had been taught this trick.

With Nicky's willing cooperation we built up the population again. At first we allowed the tribe to expand at its own pace, but it didn't take long for us to realize that cats would never have banded together in such an unwholesome way without the food and shelter we provided. Where the experiment really broke down was in the breeding. I still feel remorse when I remember the poor, sad females exhausted and thin after producing as many as four litters in a year. Edward wouldn't hear of having the males neutered and would become indignant when I even brought it up, as would other men who happened to be on hand. When I remarked that one of the tomcats would have a better life if he didn't have to fight all the time to protect his territory, Willard said, "What do you mean a better life? Did you ask him?"

The men clearly thought sex was worth any price. My view was different, for plenty of reasons, including the fact that I was the one who always got up at night to break up fights and the one who doctored the poor battered toms after their battles. Unable to stand the suffering of one wounded warrior, I took him to the vet despite the cost.

Today I would simply pack them all up and have them neutered, but then I was too much under Edward's influence to act against his wishes. To spay females was too expensive, so our solution to overpopulation was to drown most of the kittens. This Edward did right after they were born, although he found it a distressing job. Believing that a simulated return to the womb was the kindest death, he'd put the kittens into half a bucket of warm water and, to hold them down, place on top of them a second bucket with holes drilled in the bottom. The few kittens that were allowed to live were increasingly in-bred.

I thought people might be interested in reading a description of the real life and behavior of a large group of cats, so Edward and I started to document our menagerie in writing and photographs. No book I could find at the time did this—cats in books and magazines wore ribbons and chased balls of yarn.

In the beginning Edward said he would be limited to the Graflex, because cats move so much, but one day when he had the 8 × 10 out for some other reason, he made a picture of a cat that happened to be arranged just so. The cat was very interested in what he was doing and not inclined to twitch or jump, and the result was beautiful. This success led to others with the 8 × 10, although inevitably, more negatives than usual were wasted, particularly during the period when we were learning how to manage our feline subjects.

Many of Edward's fans were inclined to think he had gone off on a foolish tangent with the cat pictures—they either insisted that it was my influence that made him do this or that he was getting soft in the head. In an essay Minor White wrote about Edward's work, he suggested that Edward had terrorized our cat Johnny to get the handsome portrait Edward took of him sitting on a piece of driftwood in September 1944. In response, Edward wrote: "By no stretch of the imagination could [Johnny's] alert exhibitionism be construed as terror. I started photographing cats because Charis goosed me on. I certainly didn't use them in any symbolic way."

The truth is, Edward enjoyed the challenge of figuring out how to get a cat to hold still long enough for him to make an 8 × 10. One trick of mine was to put butter on their whiskers, after which they would sit still to lick it off. At the moment of exposure Edward used a very effective noise he had developed for photographing babies, a high squeak using the lips and cheeks. The cats would look up alertly and he'd click.

The result of our experiment was the book *The Cats of Wildcat Hill*, published in 1947 by Duell, Sloan & Pearce. Their first response to the manuscript was not what I had hoped. As far as they were concerned, a book about cats should be geared for children or grandmothers. They weren't prepared for an unsentimental and occasionally horrifying account of the behavior of real animals. They asked for changes. With plenty of humorous material to draw on, I pruned and rewrote, and ended up with a book that was half and half—half cat behavior and half light entertainment and therefore, in my view, not really satisfactory in either category. Nonetheless, I considered it a great improvement over most cat books of the time.

As for our theory that cats would behave more like cats and less like their human owners if allowed to reproduce and congregate naturally, my introduction to the book makes short work of that:

> It was not long before the flaw in my "cats should associate with other cats" argument became apparent. We soon found that the cats themselves considered it unnatural—or at least highly undesirable—to have a lot of other cats around. Only our constant vigilance could keep the group from being broken up and dispersed.
>
> The dominant male always did his best to drive his rivals off the premises, and would certainly have succeeded except for our intervention. The older females tried to drive away the younger females, and were only thwarted by our counter efforts.

Most of the notes and photographs for the book were made between 1943 and 1945. Maybe because he spent so much time at home during this period, Edward became very involved with the cats and included news of their doings in letters to cat-loving friends. In January 1944 he sent a letter-

describing the cats of Wildcat Hill to Nancy and Beaumont Newhall's cat Euripides.

Dear Rip old boy,

 Here is a tracing of the picture we are sending you, all numbered so you may identify your country cousins. We are: 1. Keddsy (named for a famous tennis shoe), the grandma or great-grandma of the whole bunch; she's a fightin' Hell cat who will take on any Tom or dog in the neighborhood. The other day she chased a big Mongolian cheese hound all the way down to the highway—and he was yelping!

 2. Bodieson (son of Bodie who is grandson of Keddsy, and the prize young Tom of last spring). 3. Johnny Jack Horner (named Johnny for Long John Silver who only had one eye, or was it leg?). Anyway we had to bathe one eye open every day for weeks. Johnny is the lovingest kitty. He knows we saved him from angels' wings.

 4. Bodie (born in Bodie Room which has the pot-bellied little stove called Bodie), who is papa's pet of pets—and doesn't she know it! She rides in the wheelbarrow or bucket, helps me cut wood; she is a fighter, too, comes home with one eye shut and a torn ear, tries to spray like a Tom cat.

 5. Targy, from our only summer crop of kittens, is so named on account of a rear-end bullseye. He had lung and eye trouble but has recovered. 7. Rosemary Syringa—a member of Junior League, carries her tail on one side, very sweet, a catty cat—the only virgin in the family, and makes the most of it.

 8. Kelly (after a friend Jean Kellogg) who just distinguished herself by spending two full days and a night atop an 80-foot pine tree which had no branches on way up. She got treed by two dogs belonging to our new neighbor, and just wouldn't come down. When she did with help of Charis entreaties, it was a hair-raising episode. The other females are very jealous of Kelly's winter fur coat; pick on her, cast insinuations.

 9. is Riley (who was born in bed with a friend Zilpha Riley, the first night of her visit here. Quite a welcome!) Riley and Bodie and April-is-

the-cruellest-month were the first born from Keddsy. April—who was "Miss Americat for 1942"—has gone to live with a friend up Carmel Valley; with her went Spottsylvania Jones, a cousin marked like a pinto pony—Enough!

Visitors to Wildcat Hill naturally had mixed reactions to our ever-swelling population. Some were enchanted, some repulsed, and some simply puzzled or indifferent. Regardless of their persuasion, few failed to put us through some part of what we dubbed the Variable Catechism. As I described it in the book:

Q. But what do you do with so many?

A. We don't do anything with them.

Q. You mean you actually have names for all of them?

A. It would be confusing just to name every other one.

Q. I didn't know you could teach a cat anything.

A. Most people don't. Nicky, shake hands with the gentleman.

The Cats of Wildcat Hill attracted dozens of reviews and articles from a wide range of publications: *The Nation, The New York Times, The Boston Post, Science News Letter, San Diego Union, L.A. Times, Ladies' Home Journal, Publishers Weekly*, and more. All were appreciative, though some hedged their praise with the caveat that the writer was not a cat lover. The New York *Herald Tribune*'s John Hersey wrote that the book "is what seemed to me a slightly nightmarish account of a mob of cats who lived on, and ran riot over, a tract of land in California." Frederick Yeiser of *The Cincinnati Enquirer* observed that reading about the cats was "a great deal like reading about such families as the Jukes and the Kalikaks."

Describing the photographs as "wonderful," *Life* magazine said, "Edward Weston, the famous photographer, is best known for his sharply defined pictures of objects that stand still, like tree trunks, sand dunes and sea shells. Before he got interested in cats he used to feel that even a cow was too active for an ideal camera subject."

My favorite comments noted the difference between this and typical "kitty" books because of its solid information about cats, like the following from *The Montreal Gazette*: "Although it is too informal and full of fine humor to be

classed as a scientific paper, the book is actually an absorbing report on cat behavior in an environment designed to minimize the effects of association with people and encourage behavior 'in a naturally catty manner.' "

Not only had Edward ventured into new photographic territory, he had departed from his custom of using straightforward titles. Always before a nude was called *Nude*, a shell was *Shell*; trees were called by name—cypress, Joshua, cottonwood; objects were specified—egg slicer, wrecked car, whale vertebra. When objects were given longer titles it was usually to forestall questions about unfamiliar subjects, e.g., *Eroded plank from a barley sifter, Model for a mould, Cement-worker's glove*. Sometimes he came up with a title whose aptness tickled him, like *Form follows function*, for his picture of a male bedpan. Some names had been chosen because he liked their sound. He was sensitive to rhythm in these matters, and his first thoughts of *Lily and junk* or *Lily and trash* quickly gave way to *Lily and rubbish*, which he rolled off his tongue with obvious pleasure.

The mockery in some of the new and more complicated titles was evident, particularly *My Little Gray Home in the West*. I stand nude in front of Bodie Room with an apple in one hand, the other holding a sign over my pubic area that says EDWARD WESTON (CARMEL, CAL.), while Leon leans out the window playing the recorder.

Another in this vein was *Exposition of Dynamic Symmetry*. This shows the back of Jean Kellogg's studio, with four figures in the windows: Neil holds a kettle, Leon dangles a doll, I am dressed only in a sweater and hold a lamp in my lap, Jean stands with her palms against the screen. The picture is a spoof of a book on composition bearing a similar title. These photographs and others done during the same period drew wildly mixed responses, maybe the strangest from Nancy Newhall. She was not amused by the titles or the pictures, and in response to her letter of protest Edward wrote:

> *Sorry to have upset you (and Sibyl!) with my "backyard set-ups and their titles." You guess that the war has upset me. I don't think so, not more*

than the average dislocation. I am much more bothered by the antics of some congressmen . . . No darling, don't try to pin pathology on me.

Your reaction follows a pattern which I should be used to by now. Every time that I change subject matter, or viewpoint, a howl goes up from some Weston fans . . . So I am not exactly surprised to have you condemn (though I don't get your "Surrealist" classification; now Nancy!) work which will go down in history. Victory is one of the great photographs on which I will stake my reputation. I could go on, but you might think me defensive.

Edward showed his real annoyance with Nancy more clearly when he wrote to Bea Prendergast after she expressed appreciation for his Christmas gift—a print of *My Little Gray Home in the West*. In it he described a friend's reaction and said, "I am so ashamed of or for her that I'll not use names." As he did with Merle and others, Edward was able to keep his friendship with Nancy wonderfully intact despite this and several other moments of frustration and anger.

When Nancy said she wanted to show the picture *White Sands* to Stieglitz, Edward responded, "You take *White Sands* to Stieglitz because you think he might enjoy it—it's safe and sane. Why not take him *Victory, My Little Gray Home, What We Fight For*—and watch the fun. I would like to be backstage." He said plainly that these titles were symbolic—but of what, he added, he would leave to future generations to ponder.

Although none of Edward's sons served on the front lines, they all were involved in the war effort. Neil and Cole had worked in aircraft manufacturing before Pearl Harbor, and after the United States entered the war Neil served as second mate on a seagoing tugboat to New Guinea. Cole attended a Midwestern naval academy, but did photography after he graduated. Brett and Chan also worked as photographers during the war.

In July, Leon was finally put on trial for refusing induction. I went with him to San Francisco, where it took all of half an hour for him to be convicted as

a felon and sentenced to two years in prison. Although this was the outcome we all expected, it made me sad and angry, and undermined my ardent patriotism. Edward didn't see it this way. "I think Leon is sincere," he wrote, "and knowing some of his background understand him; but I don't think that he has a leg to stand on, and I can't sympathize with his viewpoint. If we had many who took Leon's direction, the Japs would be camping on Wildcat Hill, the Germans in Central Park."

Leon was sent to prison on McNeil Island in Puget Sound, where he first worked felling timber and then was assigned to a record-keeping job in the parole office. After he had been there for a year, a new draft board was formed, made up of civilians as well as military types. The board reviewed Leon's case along with those of other COs, granted him the 4-E status he had originally requested, and put him on parole. He chose a hospital job in Washington, D.C., to be near Helen, who was ill.

During his time on McNeil Island Leon was allowed to send one letter a week. He wrote to me and on the back in tiny script he made detailed notes on prison life and inmates. He eventually wrote a novel, not about prison but about the "variety-in-monotony" of life in a Southern jail. *Sinners, Come Away* was published in 1949. Nelson Algren wrote that it was "told with the same sort of first-hand ring that made *The Grapes of Wrath* so convincing," while a review in the *Boston Globe* said: "Compassionate and understanding, Mr. Wilson, a man of character, intellect, and talent, has somehow peered deeply into jail life and can let the reader see what he sees. Frankly, we owe it to ourselves to look." Leon later published two wonderful books for young people, *This Boy Cody* and *This Boy Cody and His Friends*, drawn from his experiences with the mountain folk of Tennessee.

TWENTY-ONE

Carmel residents still made their daily pilgrimage to the post office on Dolores Street. Those of us who lived outside town had rural delivery, but during the war our mail came later and later, sometimes not arriving until after dark. Since most of Edward's business was through the mail—including print orders and correspondence about books and articles—this was serious. When I complained to the assistant postmaster, he said if I wanted to get mail on time I should deliver it myself.

"When do I start?"

As soon as I took over the route, I could see why the mail was always late. Even though the horse was long gone, I was supposed to carry letters in saddlebags, and they were the real thing, made of heavy leather and designed to throw across a broad horsy back. Despite postal regulations, half the boxes on the route failed to meet code, that is, be positioned so that the carrier could reach them from a vehicle. My predecessor had spent all day rummaging through saddlebags and getting in and out of his car to fill the boxes.

Having come to fancy myself as something of an efficiency expert, I constructed cardboard trays that fit beside me on the front seat. They held the mail neatly sorted according to route and ready to stuff into boxes. I had the twenty-

seven-mile route around Carmel Point, past the Carmel mission, down to the head of Carmel Valley, out to Highlands, and up the hill on the narrow roads that went inland from there. By the time I came by our place, it was noon and Edward would have left lunch for me in our box—generally avocado, Rytak, and a little cheese or fruit.

Always meticulous about the proper way to do things, I read the postal code and discovered that the punishment for assaulting a postman on his rounds was no more than a one-hundred-dollar fine, whereas malfeasance by the carrier— throwing mail over a hedge—was treated as a real criminal act. Seeing how the deck was stacked, I decided it was only right for patrons to live up to their minimal responsibilities by providing properly placed receptacles for their mail.

I put notices in the boxes that they had to be brought up to code, and naturally no one paid any attention. The next week I repeated the notice and said that if a box was not in compliance I would hold the mail back to be picked up at the post office. The owners of the Mission Ranch, which offered guest cabins, restaurant, and bar, raised a ruckus with the assistant postmaster, but he had to back me up, since I was following U.S. regulations. Seeing that there was no alternative, the owners fixed their box, as did the rest of the noncon- formers. In the past our mail had come as late as 5 or 6 p.m., but I usually finished the 350 boxes on my route by one or two o'clock.

Some Sundays I played chess with a Viennese psychoanalyst who lived along the route. Even though he consistently trounced me, it was fun to match wits with someone who had played against Freud. One day in the middle of the game he asked me, "Why did you take the delivery job? Was it to get away from home?"

"No, we just like to get our mail on time," I replied. Yet I realized later his question had been astute. The hours and routine of the postal job suited me per- fectly. I got up before Edward and was at the post office by 5 a.m. to sort mail, a task which took several hours. When I was done I'd go to a restaurant and get a wicked non-Weston breakfast of bacon and eggs or waffles and read the paper be- fore I started my route. I didn't get home until midafternoon, which meant my job was keeping me away from Wildcat Hill for at least half a day.

Edward had begun to sit silently for long periods, and sometimes wouldn't respond even when I spoke to him. As long as we were working on a project

together, all was fine, but when we were between articles or other jobs and no visitors were there, he often reverted to silence. His heel would start tapping the floor in what sounded like repressed irritation, until it drove me out of the house—up to Bodie Room or into the garden.

It is clear to me now that he was suffering from depression, but in those days we didn't know what that meant; no one considered it a serious medical matter. I feared Edward's moodiness was a reaction to my presence and thought the wisest thing to do was give him some breathing space.

I became active politically, spurred by the creation of a new congressional district that included Carmel, Monterey, Salinas, and extended down to San Luis Obispo. George Outland was the Democratic candidate. My first taste of registering voters took me up Garrapata Canyon with a fellow Democrat, who was also a neophyte at knocking on doors. At our first house we encountered a dilly, a woman who not only refused to register but went into a forty-minute tirade about politicians and their ilk never doing her and her neighbors any good. "We had a fire in the canyon and we put it out ourselves. The fire company never came to help . . ." and a good deal more about the nonsense that goes on in public schools and she would educate her own children, thank you. Dazed, we decided against trying to get past her to reach other potential voters farther up the road. She was a forerunner of the rabid anti-government types who, these days, call Brian Lamb on C-SPAN to vent their frustration. Unfortunately, we didn't possess his consumate skill at cutting people off.

George Outland was a Roosevelt man. A group of us organized a Democratic Club, got Outland to speak, and rounded up an audience for him. This seemed to me a modest accomplishment, but after his successful election, much was made of my efforts when I spent a day with the congressman's wife in Washington, D.C. Mrs. Outland took me around to see the House, Senate, and Supreme Court in action, as well as to a party for newly elected Democratic women. She introduced me everywhere as a hardworking campaigner for having done, as I saw it, practically nothing. At the end of a receiving line I was dumbfounded to find myself shaking hands with my heroine, Eleanor Roosevelt, and only had time to blurt, "I'm glad to meet you . . ." before the line rushed me by.

Some prominent members of the Carmel Highlands Democratic Club had told me, "Now be sure when you see our congressman to get some advice about what we ought to do next, because we're organized here and ready to go."

When I put this question to Outland in his new congressional digs, he said, "Do absolutely nothing. The election's over, it's time to take a rest, and I'll let you know when to gear up again."

But I was interested in year-round political action, in having something to work on; I didn't want to quit just because our man was elected, and I said so. With a tolerant smile he explained, "You're going to wear people out. They won't last."

I was in Washington because I had received a letter in the fall of 1941 from my stepfather, Paul, saying that Helen was terminally ill. She'd had her breast removed, but the cancer had spread and further surgery would be pointless. He added that Helen didn't know and he didn't want her burdened with the knowledge. She had been living on her own off and on for most of the year while Paul did a military intelligence stint in England. His letter said he would return in early January, and I had decided to stay with Helen until then. I wrote to Nancy Newhall saying I would arrive in Washington on December 11, be there through the holidays, and then make a brief visit to her in "bigtown."

Carrying a portfolio of Edward's prints that I hoped to sell in New York, I caught a plane East, but was bumped by military personnel in Kansas City and continued by train. The train, in turn, was delayed, and we were pulled over for hours on a siding as snow fell heavily outside. I didn't care. I was deep in a poker game with fellow travelers and we were all merry on Southern Comfort that one of the soldiers had managed to buy during a brief stop. When I cleaned out one opponent, he said he would have to send me a check for the fourteen dollars when he got home. I told him fine and gave him my address, but I knew I'd never see the money. Hadn't I warned Helen to watch out for card sharks when I put her on the train nine years before?

She and I had a good laugh about it when I got to Washington. It was snowing when I arrived, and I had taken a taxi to her downtown apartment. For the next several weeks it was just the two of us, and it was wonderful to be with her again. She was amusing and full of spirit despite her illness. She

worried, though, about the cause of her current pain and weakness, and complained that the doctors never told her anything. I went to her doctor and demanded, "For God's sake, why don't you tell her what's wrong?" His answer was matter-of-fact: "She hasn't asked."

As difficult as this was to accept, it didn't surprise me. She had told me years before that having me just a year after the trauma of Leon's birth had torn her up so badly she had begged the doctor to "fix" her so she'd never have another baby. She never did get pregnant again, but had no idea what the doctor had done. Her deliberate ignorance about her body applied to matters of health as well as birth control. While she gave time and attention to cosmetic rituals and took care with her outward appearance, the inner landscape remained a mystery. Now that her body was failing, she was defenseless and bewildered. Even though she was getting regular radiation treatments, she speculated that her pain was caused by back trouble—a problem with her "sacroiliac."

Unsteady on her feet and frequently in pain, she had to struggle out in the snow and bitter cold of the Washington winter to take a taxi for her X-ray treatments. All I could offer was my company on the long, exhausting cab rides to Walter Reed Hospital. What a blessing the hospice movement would have been, with its commitment to quality of life, helping people to live decently— with comfort, meaning, and dignity—until they die. Instead, Helen suffered unconscionably while her doctors limited pain medication in strict adherence to protocol. After a particularly excruciating bout of pain—during which I had gone out on a Sunday to find a doctor who could give her a shot of morphine— Helen turned to look at me and said tentatively, "You know, Charis, sometimes I think I may even have cancer. If I really believed that, I'd want to find the place in Arizona where a friend of mine stayed. She ate fresh fruits and vegetables and quit smoking, breathed clean air, walked a lot, and she got better." It seemed criminal not to be honest with her, but I felt bound to honor Paul's wishes—he was the one who was Helen's emotional mainstay, who would live through this with her after I had gone—and I couldn't be sure they weren't her wishes as well.

Leon came over on Sundays and evenings when he was free after work. We read mysteries aloud as we had done in the old days of Hollywood and Hatton

Fields. He and I prepared a Christmas dinner of whatever delicacies were available that appealed to Helen's diminished appetite, and did our best to create some seasonal cheer. Even though the circumstances were harrowing, it felt good to have our small family coalesce again.

After the Christmas holiday I went to New York, where I stayed first at the Newhalls' apartment and then in the Village with Dan and Lilith James. Dan had grown up in a house less than a mile from Ocean Home, but given my isolated upbringing, I hadn't known him when we were children. He and Lilith had written a musical about the suffragist movement, called *Bloomer Girl*, and they took me to see it. They kept asking for my "honest opinion," but I was so dazzled to be at a Broadway production in the company of the playwrights that I was entirely uncritical.

While in New York I had my hair cut and got my first cold wave. I told the woman at Harper Method to cut it as short as she could and still do the permanent; the result at day's end was a curly cap that felt even shorter than Edward's pre-Guggenheim cut. I loved it. Brett, who was in New York on a photographic assignment for the Army, told me I looked "marvelous, just like a poodle."

I saw Sibyl Anikeef, who was now living in New York. She and Vasia had divorced, and she was married to Simon Freed, a research scientist for the Manhattan Project. I visited Sibyl again in the early 1980s, and she accompanied me to the Museum of Modern Art. My object was to find out what Weston prints had ended up in the permanent collection, and to my surprise, there was a picture of Sibyl in 1921—a sweet young thing with orchids in her hair. She had gone with a group of high-school classmates to have their portraits done at Edward's Glendale studio. Sibyl had donated the picture to the museum, and it was the only photograph in their collection from Edward's semi-pictorial phase.

During my visit forty years before Sibyl and I got standing-room tickets to see Debussy's *Pelléas and Mélisande*, Helen's favorite opera. I remembered her listening to a recording of it when we lived in Hatton Fields, humming or singing along with some of the arias. When the curtain rose and I saw the garish stage set, it opened a floodgate in me that was waiting to burst. I began silently weeping. Throughout the opera, standing next to Sibyl with tears streaming down my face, I was unaware of anything but the story of lonely Mélisande,

who was trapped in marriage to the old king and ended broken and dying, falsely accused of unfaithfulness for loving the king's young brother.

My tears at the opera were the most dramatic expression of an underlying sorrow that stayed with me the whole time I was in the East. Wretched and lonely, sick about what was happening—at home with Edward and here with my mother—I clung to a certain level of unconsciousness about what was going on around me as well as what was to come. I could not face anything squarely, certainly not the inevitability of Helen's death. I did the town, was wined and dined by various people who wanted to see prints, and avoided my own company. Overcome with a sense of helplessness and shame, I wanted to drown myself in the river of Lethe, but all I managed was a night of oblivion when, longing to be held and comforted, I went to bed with a man I hardly knew.

I returned to Washington and regaled Helen with the high points of my big-city adventure. She enjoyed my stories, but she was visibly weaker and in nearly constant pain. Paul came home from England and together we took Helen to the hospital. She never left it again.

Edward wrote to Nancy after I'd left New York:

> Box of chocolates from three even sweeter sweeties—Nancy, Brett, Charis—came yesterday. Yum, yum! but with whom should I share them? I'm sure they are an aphrodisiac . . . My Mrs. Weston must have taken leave by now after—of course—taking N.Y. by storm. I should have been there to protect her, poor lamb! Has anyone tricked her after plying her with likker?

Nancy responded in the same light vein:

> Your wife was in much demand. I was totally unable to keep tabs on her. My general impression was that with her new clothes and hairdo and overall ability that it was the others who needed looking after. I have no idea how many city slickers she may have plied with likker.

I wrote to Nancy when I got back to Highlands:

How the old lady got home or oh how did she get home an old lady? I guess I didn't age so much at that, everyone here says I look fine and my new wig meets with general approval . . . If you could see me now draped in bluejeans and canoe shoes, looking out on the sparkling blue Pacific and green green grass of Wildcat Hill you would choke with envy. Sun, blue sky, and cats wherever you look. I have spent the last three days since return gaping and opening my mouth like a silly goldfish saying over and over my god how beautiful I don't believe it my god how etc. Preliminary tally shows I sold thirty-seven prints while East!

Despite my relief at being home the thought of Helen haunted me. Leon wrote describing a scene in which Helen begged Paul to take her home, insisting that she would make breakfast for him as she used to. Paul was steadfast in his belief that he was protecting Helen from the horror of hearing a death sentence, but I knew instinctively that what was happening at Walter Reed Hospital was wrong. I longed to go back to her, to whisk her away to the clean desert setting she had wistfully described, to give her another chance at life.

When Helen died in July 1945 at age forty-nine, I didn't lose a beloved mother or even a sister or friend. It was a grief that ran too deep to name or classify. I lost the part of myself that always yearned to know her and now never would. What I saw as the tragedy of her circumscribed life forced me to examine and reevaluate my own I tried to talk to Edward about what I was feeling, but the scar tissue that had formed between us made such deep communication impossible. Trudy Bour, a new Highlands friend, had also lost her mother; she and I spent many long nights drinking and delving into our respective pasts. It was an enlightening if painful process.

There was one tiny bright spot in this morass of despair. The poker player on the train sent me a check for fourteen dollars.

TWENTY-TWO

A picture can be viewed in many ways. Over the years I have taken umbrage at some people's insistence on reading symbolism into Edward's work; however, even I can see the potential to be mined in *My Little Gray Home in the West*. Its title came from a popular sentimental song that Edward remembered from years before, and at first glance the picture may seem a lighthearted spoof.

But let me practice what I have inveighed against. I stand naked on the steps of Bodie Room like Eve about to be banished from Eden, with the incriminating half-eaten apple in one hand and in the other a sign saying EDWARD WESTON (CARMEL, CAL.), held as a fig leaf to cover my shame. My brother plays his recorder out the side window, a disinterested accompanist, while I stand in the middle of a mosaic of my years with Edward: our pre-dawn trysts engraved on the sign from his Carmel studio; the weathered boards of Bodie Room standing as well for our "palatial shack" and all the promise of starting our own home together at the end of the Guggenheim travels—Bodie Room, which later became my refuge from Edward's displeasure; Edmondson's beautiful stone dove signifying both the sadness and delight of our Whitman odyssey; and finally the rock walls of the war years carefully constructed to shore up, but ultimately serving to separate.

The emotion at the end of our relationship was as overwhelming as it had been at the beginning, only now, in place of idolatry and carnal obsession, there was almost unbearable pain, compounded on my part by guilt and shame. I had betrayed Edward in impulse if not in fact. There were no scenes—no battles, vituperation, accusations, tears, or periods of short-lived truce. Rather, a portcullis had dropped between us and I could find no way through. In some ways this was worse than if we had fought, because everything was left to the imagination, and mine assigned me all of the blame. I became ever more fixed on the idea that my behavior, and finally just my presence, accounted for the disintegration of our shared lives.

Our lack of communication bewildered me. Fleeing from silence, I filled my days with as many outside activities as possible. When I returned to Wildcat Hill, I would give Edward a report of what I had seen and done and sometimes he would say nothing at all. If we weren't talking about an article or an upcoming show or some other project we were both working on, I felt at times I might as well not have been there. Although we still slept together, we seldom made love, partly because the act of joining without fully communing was too painful a reminder of how far our relationship had deteriorated. We often had visitors in the evening who had come to see prints but were inclined to stay late talking. On such occasions Edward, still a 9:30 clock puncher, would say good night and retire to Bodie Room to sleep.

In the fall of 1945 a young woman came to study with Edward for a weekend, and her interest in the man as well as the subject of photography was abundantly clear. It was like seeing a version of my nineteen-year-old self in single-minded pursuit of what she wanted. I decided to go camping that weekend with Trudy Bour, knowing perfectly well that Edward's student would have him in bed by nightfall. I was fairly sure the experience would not mean much to him, but I wanted him to know it was all right with me—that if I was unable to keep our relationship in a steady glow, I was willing to have a substitute fill whatever gaps she could. I didn't think, consciously, what a sign of finality this was. When I returned from camping Edward said only that they had had sex and that it had been unsatisfactory.

Today it is hard to believe I could have assumed our problems were all my

doing, but circumstances made it easy to think so. Edward was not diagnosed with Parkinson's disease until after we separated. When he wrote to tell me the news, his handwriting was already becoming labored; eventually it would take him half an hour to write a postcard. A doctor told me years later that a severe depression often accompanies the onset of Parkinson's, and had we had a name for Edward's malaise, it would have explained part of what was going wrong and thereby saved us some suffering. Still, I suspect the outcome would have been the same. It was what was happening between the two of us that drove events, and a doctor's diagnosis of the cause of Edward's difficulties would have been unlikely to change the behavior that made our life together impossible.

My flight from Edward was also partly an escape from photography, which had taken up so much room in my life for so many years. I needed a richer diet and the freedom to tackle a project of my own. As early as 1942, I had corresponded at length with Erskine Caldwell, the editor of the Folkways Series published by Duell, Sloan & Pearce, about doing a book on Northern California and the Mother Lode. It was the publisher's idea that I include the Mother Lode; my interest was the neglected coastal region north of San Francisco and not the overromanticized gold-rush country. In September 1945 I got a letter from Caldwell proposing a new start: "I think it is pretty well agreed that you are the ideal person to do this particular book. As a matter of fact, we have held off having anyone else do it until we could talk you into doing it." There was also discussion of the possibility of doing a book using photographs made on the Whitman trip that had not gone into *Leaves of Grass*, with my journal as the basis for the text—a "companion volume," as Charles Pearce described it, to *California and the West*.

Nancy Newhall was corresponding frequently with Edward at this time to prepare for his retrospective, which was to be held at the Museum of Modern Art the following year. The exhibition had been postponed for several years, and at this point Edward was less than enthusiastic about the work it would require. He had written Nancy late in 1944: "Yes, Dave McAlpin is a 'swell guy.' You know that I am really going through with this show for such as he, and you, and Beau, and a few more: otherwise I would much rather make new photographs, play with cats, work on place, aid the war effort, or just lie in the

sun—don't misunderstand; I appreciate the opportunity and the honor, but the older I get, the less I seek out publicity."

The museum directors were apprehensive about including frontal nudes, but Edward and Nancy insisted. In a letter to her in January of 1945 Edward responded to the directors' objections to prints with visible pubic hair—or "public hair," as he liked to call it: "By all means tell your board that P.H. has been definitely a part of my development as an artist, tell them it has been the most important part, that I like it brown, black, red or golden, curly or straight, all sizes and shapes. If that does not move them let me know." In a March letter he added: "I have a swell idea: hang all P.H. nudes in convenient to see places, rent for 25 cents pocket 'spy-glasses' to desirous visitors (special discount to service men) and you will pay for show, for catalogue, for museum upkeep for a year. Just leave selections to me." In June I sent the Newhalls a negative Edward had made of me holding a giant fig over the disputed territory, with a note saying, "This is to show what your fastidious museum has done to Edward. Lucky we had fig trees growing on the place."

The lighthearted spirit of these letters gave no indication of the emotional nadir we had reached. Edward made a trip to Los Angeles in the fall. While he was there I wrote to tell him I was leaving, and then moved in to Trudy Bour's house, which was just up the hill near Highlands Inn. Despite the obvious breakdown of our relationship Edward and I had never discussed separating, and I lacked the emotional fortitude to broach the subject in person.

After receiving Edward's response, I wrote him again on November 18:

> *Your letter makes me realize I have been up to my old trick of trying to put myself in your place and do your thinking for you. I'm sorry if I was preaching at you: I didn't mean to do that.*
>
> *You say "Awaken to a picture of yourself." Do you imagine I have not been scanning that picture in all its bitter, gruesome details for the past month? And do you imagine that has been a pleasant pastime? My problem is simply to learn how to live like a decent human being—be my own Rock of Gibraltar—and it is going to take hard work to do it. The reason I wrote as I did about you and your plans is that I have enough*

sins to account for already, and I cannot bear the idea that in working them out I should be doing further harm to you.

. . . Please understand, Edward. I have been going through a difficult upheaval: a reexamination of all my actions, ideas, ways of thinking, trying to find myself and to establish—not to "get back to," because I have never had one—a normal way of life. While I was in the midst of this, I could not see you; for many reasons, but the main one: I have loved you very deeply, and beneath all the wreckage and mess that our union has generated, I still love you. But since we are so ill-adapted to living together, I must force myself to put that love in its proper place in relation to the rest of my life and activities. And, perhaps because I have become a weak character, I could not do that with you near me.

. . . I desperately didn't want to see you again until I had some problems worked out clearly enough to feel sure of myself. But I am straightened around enough now that I would rather see you at once than feel that you were only agreeing to my dictates on how to handle things. That is the last thing I want.

At first Edward suggested we might avoid an absolute separation—since we were out of synch with each other, we should just build a house for me farther up the hill. If I wanted to travel and write, I would be free to do that, but we could remain friends while sharing the property. This was a fairly common arrangement around Carmel and Pebble Beach; often the former lovers or marrieds would have dinner together and share social occasions. We had been talking for some time about building a bigger house, so to have two houses was not such a strange idea. But I was too emotionally traumatized to manage this. I couldn't have stood a prolonged, strained relationship with Edward after having known the pleasures of a supportive and congenial union.

On November 29 Edward wrote to Leon, who was living in New York and had recently married Carolyn Finkelstein, a fellow alumnus of Highlander Folk School.

Charis and I are divorcing. Several years of deterioration came to a sudden climax. We remain best friends. ¡Asi es la vida! We had eleven years together—most of them rich, fertile ones . . . I'm not too sure about my (it's hard not to write "our") eastern trip. I think that I should go on with it, though I have no great urge. Guess it will depend on how settled my future seems. And, if I'm still on W.C.H., whether I can find a cat-sitter. This is not an easy letter to write. Tears in the background. But separation will be better for both of us.

After Leon responded, expressing his concern, Edward wrote again saying there was no hope that we would reconcile.

Most of the years were beautiful and constructive, but the last several were not. We were surely destroying each other. Whose fault? If I could answer clearly and honestly, I would know the difference between right and wrong, good and evil . . . I will not take all the blame for that would be cheaply sentimental. I do think I was more than fifty percent at fault, but I'm not in the mood to admit my shortcomings, not today, not so soon. I have set up housekeeping, tried to make a permanent home with, a woman four times (Flora, Tina, Sonya, Charis) and failed four times. I'm beginning to think the fault is mine, all mine.

I had no idea then that he saw himself as even partly to blame, and certainly not as bearing the lion's share. Later in the same letter, perhaps to reassure Leon and Callie about their marital future, he wrote:

If two persons as different in ways and means and years (a 30 year span between us) can have at least 8 years together of love and teamwork, 8 years in which more was done than some accomplish in a lifetime—why you two should be really inspired by our example.

Edward also wrote to the Newhalls, announcing: "You will never again have coffee with Charis *and* Edward on Wildcat Hill. We are divorcing."

Nancy replied immediately:

> *The news was not altogether unexpected, at least by me, and yet it was a shock. Beau brought it home to me, and neither of us could settle down to anything the rest of the day. And yet the actual separation from Charis seemed to us the best possible thing for you both. Charis may now actually focus her abilities; she may have needed such a catalyst, it seems to me. And you, darling, are free once again. Hail to the new work! Flight from women seems always to agree with you. You do ever more wonderful things.*
>
> *No—the real shock for those who love you is I think to an ideal to which we have all made pilgrimage—the austere and simple beauty of your life. For recent ones like us it lay on Wildcat Hill and Charis was part of it, and it lay in our hearts like a glow and a challenge to our own frantic and cluttered lives. People are selfish, even when adoring. And that you should be in Glendale, of all places, with a hernia, confound it, and no place of your own to put head or negatives—that really hurt us.*

Despite my initial concern that it would be difficult for Edward to stay on at Wildcat Hill without a companion who could drive, we ended up deciding that, for the time being, he would remain there. I didn't want to deprive him of a home that had been built to suit his needs, with a darkroom, a view of the Pacific, and a population of sixteen well-loved cats. In addition, Edward was suffering severe hernia problems at the time. I was young and healthy and could manage for myself. My instincts told me the best thing for me to do was to make a clean break from my home turf.

I left behind most of my books, the prints Edward had given me, and the drafts of articles and other writing, although I did take the Guggenheim and Whitman journals. Bodie Room was crammed with stuff that I never retrieved because I felt it really belonged to Edward. I destroyed much of my personal writing, which seemed too much to drag into a new life.

I also left friends behind. I felt that these people were essentially Edward's

territory and I didn't want to put them on the spot. They included people I was very fond of—Ansel and Virginia, the Newhalls, Prendergasts, McAlpins, Imogen, Willard, and others. Beaumont Newhall had written to me on December 8:

> *When I got Edward's letter at the Museum telling of the separation I was shocked and went home immediately to show Nancy. And all that we could say is that it is a goddam shame. Both of us met you and Edward simultaneously, and it is difficult to think of you as separate individuals. We are fond of you both, and we have gotten a great deal from our friendship with both of you. If anybody were to write my history (which God forbid!) they would find that the two trips to Carmel were landmarks—in 1940, when I first began to photograph in a meaningful way, and in 1945 when, after the isolation of foreign service, I rediscovered photography and began to create again. I can't separate what you gave me from what Edward gave me, and I have no desire to do so. And Nancy—who's had the chance of seeing much more of you—could write the same thing. We regret the separation and we feel it very keenly. That it has taken place is itself evidence of its inevitability, for you and Edward are so sincere, so true and so direct, that you could not and would not prolong a relationship that has altered. We have come to accept it, as you and Edward have. And we want to assure you that our friendship for you is nowise altered . . . All our best to you, Charis, and if there is any way we can help, you know that you can count on us.*

Beaumont's letter was generous and honest, but I still felt the need to cede our mutual friends to Edward. More than twenty years later many of these friendships would be renewed, but initially I chose to disappear.

I stayed with Trudy for several weeks, making frequent visits to Edward to discuss how to settle practical matters. We arrived at a simple property settlement, which I later sent to Doug Short to look over for us and translate into legal language.

This is our mutually agreed settlement in full:

Charis	Edward
Wildcat Hill property & house	*Photog. business & all mat., equip. etc.*
Car ('41 Ford Sedan)	*All furniture, books, etc. orig. his*
½ cash on hand: $1871.11	*½ cash on hand: $1871.12*
½ War bonds: $1500 ($2000 mat. val.)	*½ War bonds: $1518.75 (mat. val. $2025)*

(bond division on basis more smaller older bonds incl. in lesser total)

Agreements:

1. *Royalties on Calif & West (pub)*
 Cats of Wildcat Hill (to be pub. in fall)
 ??? (Whitman trip) (not yet completed)
 To be divided 50–50 at source.

2. *I am renting the house to Edward for $20.00 a month until such time as either of us wants to change arrangement.*

All negotiations date from Jan 1st this year.

Once Edward and I had resolved all the essential issues, I moved to Los Angeles and, through friends, met Fern Shea. She was just divorcing her husband, a bit player in films, and had a spare room in her large, two-floor duplex. Fern wrote scripts, including some for a radio show that featured the character Corliss Archer. Her last big project was a screenplay for a film that was to be set at Saks Fifth Avenue. While working on the movie, Fern told me, she sat at the writers' table for lunch, and of the ten or so writers present, she was the only one without a nervous tic or twitch. She decided to give up screenwriting while she was still ahead of the game. However, a year later she married one of the breed—a fellow member of the Screenwriters' Guild named Arthur Strawn.

Free to follow my desire for year-round political engagement that focused on

something beyond the perpetual cycle of election campaigns, I became active in the progressive movement. I had begun work on the Northern California book and decided that a lumber strike on the north coast was something worth investigating. I got the names of figures involved on both sides of the strike and then drove up to Eureka.

One of the people on my list was Clara St. Peter, whose husband had worked in a lumber mill. She proved a wonderful source of local history, and while staying at her house, I met Noel Harris, a young trade unionist. A friend of his had brought him over, saying, "There's a progressive woman you ought to meet."

Twenty-seven years old, Noel had lived in the area most of his life. He had been committed to the labor movement since the age of sixteen, when he'd witnessed a bloody lumber strike in which three workers were killed. An honor student interested in history and political science, Noel had gone to Humboldt State College for a year, married, and had a son, before enlisting in the Navy in 1942. By the time he came home from the war, his marriage had ended and his son, Stephen, was being raised by his parents.

When we met, Noel was very involved with the local strike—distributing leaflets, attending meetings, getting people to turn out on the picket lines. The attraction between us was instant and mutual, and I spent as much time with him as I could during my stay. I met his parents and son in the little bayside community of Fields Landing south of Eureka. His father was struggling to make a living as a commercial fisherman and Noel was working with him that summer. We spent a day out on their boat, the *Pollyanna*, so I learned a little about fishing in addition to the lumber strike. At the end of the week I had to leave to continue working on my book, but we arranged to meet again as soon as possible.

The intensity and significance of this new connection is evident in a letter I wrote to Noel on September 7 from Ukiah, California:

> *The two days we had were a monumental experience—it was like being born again or shriven of your sins. I feel so clean and new and bright now—and at peace with the world. And I have a curious sense of my*

own chemistry changing and modifying whatever I do. One quaint no-
tion I have always had is that the individual can and should "know
what he is doing." And darling I have no more idea what *I am doing*
now than the man in the moon. I know without any doubts that it is
good and right and wonderful—but what it is and where it leads, I
can't tell. So I have a little humility (which I never had before) because
I can see that this is a question of your life as well as mine—and others
besides—and that there is no neat black and white direction sheet where
I can read off the answers and determine the policy. If this had happened
a few years ago I would surely by now have our whole futures settled and
arguments to prove each point. But I have never been less sure of myself—
nor so willing to wait and see. And that—for me—is wonderful because
it knocks me off my fiery chariot and sets me down on everyone else's
level—I am becoming human and loving it. And (although it doesn't
look it right now) my demands are becoming more reasonable (i.e. de-
mands on life). There isn't any safeguard to guarantee that anything
will last forever—or to guarantee that you aren't building up to a crash
that will knock you silly—and why should there be? As if we weren't all
people.

And later from Redding on September 20, I continued the self-analysis:

I was sent to summer camp when I was ten, boarding school when I was
eleven. I started in then picking up all the misfits and problem children
and "straightening them out." Of course what I was really doing was
feeding my own starved ego, self-esteem, demand for affection. All
through school and after it the basic pattern continued; as long as I could
dominate—have the stronger position in any relationship—things could
proceed on all cylinders. But those who were indifferent to my many
talents were a bad risk: they might cease to like me and that was some-
thing that couldn't be permitted. I've been almost a year in the process
of ceasing to play God and learning to live on the level. But I still have
hangovers from it that have to be guarded against and weeded out. You

can see how doggedly I still have to watch my actions, how much distrust I still have to marshal when I look for motives . . . Just to be with you knowing we won't be wrenched apart in a few hours or another day— that is the lodestar of my life tonight. Good night darling and all my love.

I can see now that falling in love with another person finally allowed me to leave Edward, something my physical absence from Wildcat Hill hadn't accomplished. I still carried him deeply in my heart and always would, but I was able to slough off the old snakeskin of guilt and recrimination that our last years together had encased me in. Love is a healing agent. The doubt and self-questioning remained, but I no longer saw myself as a poisonous presence.

At the end of September Noel and I set off traveling together around California so I could talk to ranchers, turkey farmers, produce growers, and others, while taking copious notes. Our destination was Reno, where we settled into a trailer until I could establish legal residency. I spent the six weeks writing and Noel took a temporary job in a lumber mill.

On December 13, 1946, I filed divorce papers with the Washoe County, Nevada, district court. Edward waived filing a reply, making the procedure as simple as possible. In a letter to Beaumont and Nancy he included the news casually: "Charis is in Reno getting a divorce. Cole in L.A. getting new Chevrolet." Noel and I were married on December 14 by Judge William McKnight, the same man who had granted my divorce the day before. Edward wrote to the Newhalls a few months later: "Charis writes now and then. We remain good friends. I have not the vaguest idea who she married."

Edward ultimately decided to buy the property at Highlands, but only after some soul-searching, evident in a letter to the Newhalls:

I may try to buy Wildcat Hill! I say "try"—Charis has already agreed to sell—because it will be a last noble try. For what? Maybe so that I can do some new Ektachromes! Why don't I move? I ask this of myself. Starting all over in a new place is not too easy now. Just thinking of change brings on inertia. I'm sentimental about the place. My major life work

has been done here. Just from a "business" angle, change would be bad. And there are probably deep down reasons which will not surface. But enough— This is a long letter for me to write— it carries much love.

I sold the house and land to Edward for $10,000 to be paid off at $60 a month with no interest. His letter said: "Your agreement draft is clear, liberal, and the first legal document I could understand. I can send you down payment when you are ready. I may be quite mad to assume this obligation, but I'm relying on the old intuition. I hope you will have no regrets. My love, Edward."

Edward made his last photograph in 1948, but he continued to print into the fifties, and when he could no longer manage in the darkroom, he supervised others as they worked from his negatives, mainly Brett, Cole, and his new assistant, Dody Thompson. He continued to have shows including the retrospective at MoMA and major exhibitions in London and Paris. Willard Van Dyke spent several months filming Edward at many of his old haunts—Point Lobos, Oceano, Death Valley—to produce a documentary film called *An American Photographer*. Articles and books appeared regularly, including *Fifty Photographs: Edward Weston* (1947), edited by Merle, and *My Camera on Point Lobos* (1950). In 1952 *A Fiftieth Anniversary Portfolio* was published, with twelve prints made by Brett under Edward's direction.

After 1947 my main contact with Edward came in the form of letters he sent to accompany his monthly house payments. His handwriting deteriorated steadily, yet the essence of Edward was there on the page.

From January 9, 1953:

Dear Charis—

Such a long letter overwhelmed me. I have not expected answers to my hurried scrawls—not with the children pulling at your skirts. Are you a good mother? I should think so. Yes, the Neil Westons have had plenty of bad luck. [Neil's wife and daughter had been stricken with polio.] The baby, Jana, is gaining rapidly; Kraig much slower. They are home now.

But it costs Neil as much for a practical nurse as he can earn as a foreman carpenter! What's the answer? Brett, I may have told you, married Dody, a beautiful & intelligent girl. Brett is here 5 days a week printing from a thousand negatives. Chan married Jo. We like her the best of all his recent trials. I suppose I don't mention Chan because I rarely see him, and he never writes. Cole & Helen are expecting again. He has had more trout troubles. Someone set fire to a nearby hill, burned the cover off so that when it rains mud fills up his ponds. Jean opened a candy shop in the Glendale house. Joe of Middletown has been very sick, nervous break-down. Better now. Yes, I see Flora, not often. She has a home in Carmel proper. Does baby-sitting to pay off the mortgage. She will outlive us all. Seems I have spent myself answering your questions. I could go on with news of Print Project and the new shower-bath which Dody paid for and Neil built, but I have just enough energy to write the enclosure, and to sign off with love,

 Edward

From September 1, 1954:

Ansel here yesterday. Krishnamurti coming tomorrow. And then there come days when I see no one. Except a young man who gets room & board & $40.00 a month to sweep, shop, do dishes, shave me, drive me. Not very inspiring! He is a writer! O yes, he cooks too. I don't envy him, cooking for me. Cole left last week for L.A. where he will try out for M.C. on a TV outfit. Brett & Dody are in L.A. too, trying to pick up some Motion Picture technique. Too many "just plain photographers" in Carmel. I'm sure that I told you about the "print project." Brett printed 6 prints each from over 800 negatives (mine of course). It took him a year. First order from "George Eastman House"—50 prints @ $25.00. The Lord sure threw down a cloud full of manna. Business has been terrible. Cat business remains good as usual. I have 10 pretty pussies for sale @ a penny a piece and more on the way.

 Well, I hope you will find time to drop me a line. I could write much

more than just this. One stumbling block is that I can't imagine what would be of interest to you.

 Best wishes to Noel—
And to the children—
 with love—
 Edward

P.S. Belle Grove burned down.
Edmondson died.

From October 1, 1954:

The old homestead has been the scene of much confusion. Louis Stouman has been here filming the Wild Cat Hill scene. It now seems likely that what started to be a "short" will turn into a full length picture & may be released by U.P.A.

 A major catastrophe has struck the Cats of W.C.H. Two weeks ago I had 16 cats—4 were kittens—today I have none! Dotty & Princess were sick; I took them to Dr. Weston (the vet) who pronounced them dangerous to other cats, & men too. Said unless they were gassed along with the rest of my cats he would report them to the "County Health." I did not have time to think or act. Even now I don't know what else I could have done. Now I am suffering over the needless slaughter of as sweet a bunch of kittens & cats as ever graced a hill.

 Bob Nash is here to help me out in unexpected moments. Just now he is roaring with big belly laughs over passages in "The Cats."

 Much love
 Edward

From April 22, 1955:

Since advising you of my title "Great G.Pa" I have become a grandpa again! Cole & Helen had a 9 ½ lb boy, with red hair. It gives them

three boys. No use trying to keep track of these Westons. I now have 7 grandchildren & 1 great-gran. Erica is in school at Ojai. I sure would like to see you and yrs this summer, and to offer you a place to stay as an inducement. "Bodie Room" is taken by a young man who is there to watch over me (sounds terrible). Brett has a spare bed, but it may have an advance deposit on it. I have one sleep bag. Doesn't offer you much. But my love and greetings all around. Edward

From June 10, 1955:

I'm sure weeks have passed since writing you; seems like months! Everything I do takes me so much longer than it used to, even thinking about doing it. I question whether the time & energy involved is worth expending—and usually the answer is no! This is a fine way to start a letter.

Bill & Zelda came down last Sunday. Said that you and Anita had spent the night with them. They were lavish in their praise of Anita, "how well-mannered" she was.

The next "movie" on my "life & work" will be ready for release early fall. Wish you could see it. I am sure it can never mean as much to me as Willard's does. But that is understandable. I can't recall whether you saw it or not.

Merle & Isabell (his latest wife) were here a month ago. She is quite a person with quite a background. They have built quite a home (so it is said) on or in the "Wonderland of Rocks," I guess from description. Anyway it's not far from "29 Palms."

I thought I could make a real letter out of material I have on hand but no, not today.

So—my love—Edward

From September 7, 1955:

So we may see you down here—that's fine— To answer a few questions: you have quite a few books—several (2) shelves full. I would like to keep

autographed copies, the Armitage books & some for sentimental reasons.
I would like to give you (guess they are already given) a stack of photo-
graphs—of you, Helen, H.L., Leon & some landscapes. People drop in
& out, but I will not let anyone interfere with a visit from you. Of course
many come with no appointment which is disturbing. From here to Big
Sur there must be a place to camp. Labor Day begins the exodus . . . "The
Bankers" across the gulch will possibly greet you. I would love to see your
children & have you see "mine."
* Love, Edward*

We didn't manage to get there in 1955, but I did visit Edward one last time, bringing along my two young daughters, Anita and Rachel. Except for the addition of a small bedroom facing the ocean, I found everything as before—the old split bamboo wastebasket on one side of the door, the cat door on the other, the chair by the fire, H.L.'s print on the wall, the writing table, the Mexican chest—all was the same, except for Edward, who was locked in a body that had become a prison. His eloquent eyes peered out through eye holes in the mask that Parkinson's had made of his face and seemed to say, "Isn't this a mess—but we can't do anything about it."

Humor hadn't deserted him. Speaking in a halting whisper, which was all that was left of his voice, he told me about ending up in a corner of the room and not being able to turn around. "I stood there pedaling my feet like a cat making bread."

In August 1956, he wrote a brief letter in a very cramped hand, but still the humor was there: "My back is so lame I can hardly wiggle . . . I have one serious complaint about my age: my salivary glands fill up and overflow, and this with no warning. I feel and look like old 'Cesare' in the 'Thieves Market' in Mexico."

Edward died early on New Year's morning in 1958. When I learned of his death, I was moved to hear he had gotten up and into his chair to face the sunrise. Then, as always, it was his time of day.

ACKNOWLEDGMENTS

A project like this memoir, which has been so many years in the making, inevitably results in a long list of people to thank. Some are old friends, some are new friends made as a result of the work itself, some are people who responded eagerly to a request for help or information and may never be part of our lives again, and some are no longer living.

Wonderful people have provided assistance of every sort: housesitting opportunities (the poor woman's Yaddo), ranging from two weeks in a cabin to three years in a converted potato chip factory; secretarial services—transcription, editing, filing, and research; original photographs and reproductions; personal reminiscences; physical, mental, and moral support; care packages and hot meals that arrived at the door when the authors were too busy or tired to cook. It isn't possible to list every individual or the nature of every contribution, but to all of you who have played a role in the creation of this book we offer affectionate and deeply grateful appreciation—without you there would be no memoir.

In particular we wish to thank the following people and institutions: Ethan Nosowsky, our deft, delightful, and incredibly patient editor at North Point Press; Susan Schulman of Susan Schulman Literary Agency; Saundra and Bill

Lane, the generous owners of the Lane Collection; Ted Stebbins, Susan Ricci, Karen Quinn, and Karen Haas at the Museum of Fine Arts, Boston; Dianne Nilsen, Rosanna Salonia, Robert Gorecki, Keith Schreiber, and Leslie Calmes at the Center for Creative Photography at Tucson; the Holgers family—Bill, Zelda, Janet, Bruce, and Breta; Carl Battreall; the Ansel Adams Trust; the Harry Ransom Humanities Research Center at the University of Texas at Austin; The John Simon Guggenheim Foundation; The Limited Editions Club; the University of Missouri Press; the Weston family—especially Neil, Cole, Brett, Chan, and Jason; Virginia and Ansel Adams; Sibyl Anikeef; Zohmah Charlot; Imogen Cunningham; Beaumont Newhall; Willard Van Dyke; Maudelle Bass Weston; Susan Stebbins; King Dexter; Alan Ross; Tim Hill; Amy Conger; Alan Jutzi; Bill and Sally Wenzlau; Rita Bottoms; Carolyn Caddes; Vini Carter; Elizabeth and George Joseph; Robert and Nancy Katz; Tom Knight; Marion Patterson; Gerald Robinson; Dennis High; Chama Armitage Rogate; David Scheinbaum; Miriam Fomanek-Brunell; Megan J. Scott; Vas and Arden Arnautoff; Dan and Helen Brant; Kirk and Betty Cooper; Casey Douglas; Virginia and Robert Dille; Peg and John Frankel; Peg and Duncan Holbert; Miriam, Christine, and Roberta Maloy; Thomas E. Murray; Jim and Carolyn Robertson; Anita Wilkins; Kirby Wilkins; Callie Wilson and Dan Rubin; Linda and Woody Bookout; Linda Dobson Fox; Mercedes Avelar; Marco Luis Salazar; Jacquelyn Marie; Alice Muller; Toni Miras; Sandi Chestnut; Arnold Leff; John Stenovich; Anne Cowan; Catherine Forest; Amanda Sears; Barbara Clawson; Patricia Noel; Karen Siechen; Lindsay Johnson; Magdalena Zschokke; Dennis Corliss and his computer students at Corvallis High School; and finally our immediate and extended families—the Gilroy Clan, especially Duncan and Barb, and Scott and K.C.; Rachel Harris, Noel and Ina Harris, George and Christy Hedges, Phyllis and Byrd Helligas, Bruce Hobson, Laurel and Kurt Madar, Paul E. Peabody, Lori Perry, Ellen Scott, Ademir Silva, Fern Strawn, Joseph Stroud, Dennis Tamura, Jane McCauley Thomas and Duncan Thomas, Seema Aissen Weatherwax, Leon Wilson and his daughters, Tamsen and Charis.

INDEX

Cézanne, Paul, 82
Charis/Lake Ediza (Weston), 144
Charlot, Jean, 96, 97, 130, 293, 295
Charlot, Zohmah Day, 130–33, 189, 204, 293
Chase, Joseph Smeaton, 123
Chattanooga News-Free Press, 263
Chattanooga Times, 17
Cincinnati Enquirer, The, 331
City, The (film), 151
Civilian Defense (Weston), 310
Civil War, 17, 265
Clevenger, Eliza, 316
Collins, Wilkie, 205
Colorado Desert, 125–29
Commonweal, 18
Communists, 157, 263, 267
Contax camera, 93
Contraband Bayou, 255–56
Cook, Ted, 137
Cooke, Grace MacGowan, 17–22, 27–31, 54, 59, 140–42, 265
Cooke, Katherine (Kit), 17, 18, 27, 45, 47, 53, 54, 59, 140, 265
Cooke, William, 18
Coolidge Dam, 169
Cooper, Gary, 76–77
Cooper, Rocky, 77
Copper Canyon, 178
Corkscrew Canyon, 177
Cornish, Nellie, 137
Cornish School, 206
Coughlin, Father, 184
Covarrubias, Miguel, 300
Creative Arts magazine, 94
Criley, Cynthia, 318, 319
Criley, Theodore, 30
Cummings, E. E., 101

Cunningham, Imogen, 35, 37, 142, 284, 325, 350
Cunningham, Merce, 206
Curry, Don, 124, 125, 178

D

Daguerre, Louis-Jacques-Mandé, 163
Dallas, Molly, 248
Dante's View, 122–23
Davenport, Clem, 102–4
Davenport, John, 102–5, 280
Davis, Stuart, 284
Daybooks (Weston), xi, 28, 66, 87–89, 93; publication of, 321–23; quoted, xix, 56–57, 82, 84, 88, 89, 94, 96, 112, 119, 122, 312
Dayton Art Institute, 274
Death Valley, 122–25, 177–78, 204–5
Death Valley and Other Poems of America (Ross), xii
Debussy, Claude, 340
Defender film, 280
Del Monte Packing Corporation, 319
Delphic Studio, 192
Del Rio, Dolores, 76
Democrats, 337–38
Denny, Dene, 57, 141
Denny-Watrous Gallery (Carmel), 57
Depression, 3, 4, 16, 60, 61, 98, 104, 109, 183, 245; bank closings during, 32; federal art projects during, 5, 58, 66, 67, 74, 100, 101, 283; foreclosures during, 185–86; Helen's dress shop during, 45–46
Derain, André, 82
Deverich, Loretta, 21–22
Devil's Post Pile, 147